In an

Influential

Fashion

In an

Influential

Fashion

An Encyclopedia of Nineteenth- and
Twentieth-Century Fashion Designers
and Retailers Who Transformed Dress

*Ann T. Kellogg, Amy T. Peterson,
Stefani Bay, and Natalie Swindell*
with illustrations by Kamila Dominik

GREENWOOD PRESS
Westport, Connecticut • London

Library of Congress Cataloging-in-Publication Data

In an influential fashion : an encyclopedia of nineteenth- and twentieth-century fashion
designers and retailers who transformed dress / Ann T. Kellogg . . . [et al.], with illustrations
by Kamila Dominik.
 p. cm.
 Includes bibliographical references and index.
 ISBN 0–313–31220–6 (alk. paper)
 1. Fashion designers—Biography—Encyclopedias. 2. Clothing trade—
Encyclopedias. 3. Fashion—History—19th century—Encyclopedias. 4. Fashion—
History—20th century—Encyclopedias. I. Kellogg, Ann T., 1968–
TT505.A1I5 2002
391'.0092'2—dc21 2001045124

British Library Cataloguing in Publication Data is available.

Library of Congress Catalog Card Number: 2001045124
ISBN: 0–313–31220–6

First published in 2002

Greenwood Press, 88 Post Road West, Westport, CT 06881
An imprint of Greenwood Publishing Group, Inc.
www.greenwood.com

Printed in the United States of America

The paper used in this book complies with the
Permanent Paper Standard issued by the National
Information Standards Organization (Z39.48–1984).

10 9 8 7 6 5 4 3 2 1

Contents

Introduction
Amy T. Peterson

The word fashion conjures many ideas in people's minds: trendy styles, a person's external appearance, or the work of an elite group of designers. But fashion does not exist in a vacuum; its context is the society around it. "Fashion is a style . . . that is temporarily adopted [by a social group] . . . because that chosen style . . . is perceived to be socially appropriate for the time and situation" (Sproles and Burns, 1994).

Fashion and social development have a dynamic relationship; each one influences the other, affecting numerous aspects of people's lives from gender roles to political expression and social acceptance. This book examines this relationship through the designers and shapers of fashion in Western society from the late nineteenth century to the year 2000. This book looks at the prevailing fashion trends through the years, places those trends into historical context, and examines the ways in which they impact social history.

The entrants in this book were not selected on their artistic merit alone. Instead, they were chosen because their influence on fashion is reflective of societal, political, or economic change. For example, Coco Chanel's 1920s knits, Christian Dior's 1947 New Look, and Yves Saint Laurent's 1960s pantsuit reflect the ever-changing image of women and their role in society. Companies can be as influential as designers; their marketing influences and reacts to fashion trends. For this reason, select companies have been included in this book under the same merits as designers. In a similar sense, movies reflect society, and costume designers have an impact on fashion trends; therefore, they were included as well. Although this book contains entrants from around the world, it focuses primarily on America and its designers.

Each entry includes basic biographical information about the designer or founding information about the company. This information includes birth and death dates, birthplace, founding dates, awards, honors, education, and training. Each entry describes the entrant's signature styles and outlines

the career or company history. When appropriate, the entry summarizes any licensing agreements and influential marketing innovations. Finally, the entry defines the entrant's significance within fashion. Throughout the text, illustrations that were specifically drawn for this book are included. The illustrations are interpretations of the designers original works and are intended to represent some of the key changes in fashions trends. At the end of this book, appendixes list cross-references of each entrant by decades in business, primary country of business, and specializations.

FASHION: A SHORT HISTORY

Fashion emerged at the close of the Victorian period, an era when the predominant Christian values of virtue and moral piety were contrasted by outward displays of affluence and luxury. The last half of the nineteenth century witnessed the rise of a new class of money born out of the Industrial Revolution, a movement in which the nations of Europe and the United States gradually shifted to economies based on factories and industry rather than agriculture. This monied group was called the nouveau riche (new rich), and many of them spent their wealth on the abundant new material goods produced by the factories of this new industrial economy.

The Industrial Revolution impacted all social classes, not just the wealthy. A middle-class began to emerge, and the standard of living of the lower-class began to rise. Many products that had been too expensive for the lower and middle-classes could be produced more efficiently and less expensively in the new factories. Soon, people from every class could afford these new material goods and adopt elements of the latest fashions. Visual class distinctions, previously displayed through dress, began to erode. The elaborate trims and richly colored fabrics fashionable during this period fit into the budget of the socialite and maid alike.

The wealthy, who deplored the erosion of class distinction, found new ways to separate themselves from the other classes. One way of retaining the class distinction was to have one's clothes designed by a high-priced, exclusive designer. Charles Frederick Worth is often cited as the first fashion designer. He catered to wealthy Americans and Europeans in his private Paris salon. His popularity was immediate, and he influenced fashion changes with his opulent designs.

Worth's influence also strengthened the Chambre Syndicale de la Couture Parisienne, an organization of couturiers founded in 1868. The group, which originally served as a guild for craftsmen, evolved into a governing body which controls the standards and guides the marketing of couture fashion. Currently, the Chambre Syndicale's main function is the organization and oversight of twice-yearly collection showings. The Chambre Syndicale schedules the showings and organizes the press and buyers. The

group also helps protect designs by copyrighting the designs that are registered with it. Furthermore, aspiring couturiers can be trained by the school operated by the organization. The Chambre Syndicale protected and nurtured couture during the twentieth century.

The dawn of the twentieth century saw significant changes in society. People had witnessed how technology and science had improved their lives during the end of the previous century, and they looked forward to the new century with its promise of modernity and innovation. Inventions that modernized everyday life had an effect on fashion as well. Electricity powered clothing and textile factories, trains sped the goods to the marketplace, the telegraph facilitated communication between buyers and sellers, and photography disseminated new fashion trends.

As technology was changing the everyday lives of Americans, the demographic composition of America was also being transformed. An influx of immigrants from Europe came to America in hopes of taking advantage of the opportunities offered by the numerous factories. Over 50 million Eastern and Western Europeans migrated to the United States during the nineteenth century, radically altering the makeup of the population. While some immigrants retained their cultural dress and customs, others adopted fashionable dress in an effort to seem more "American." For these newcomers America was the land of opportunity. With hard work, more and more lower-class immigrants and their families acquired the comforts of middle-class life.

The growth of the middle-class resulted in an ever-increasing democratization of society and fashion. The factories of the Industrial Revolution began to produce ready-to-wear clothing for men and some accessories for women. Men's sizes became standardized, allowing them to purchase clothing off the rack instead of having it custom made. Soon, men and women could purchase clothing from mail-order catalogs such as Sears and Roebuck. These catalogs allowed people who lived in rural areas to purchase mass-produced goods, continuing the spread of a democratized American society.

Just as clothing sizes and production were becoming simplified, women's clothing was becoming less complex. Sumptuous swathes of fabric and elaborate decoration disappeared. Clothing became more functional, allowing women to work, play sports, and move about more freely in their garments. One of the key silhouettes of the era, the Gibson Girl, featured simple, bell-shaped skirts and separate shirts with exaggerated, puffed, leg-of-mutton sleeves. This look was starkly different from the bustles, brocades, and heavy velvets of the preceding period.

The onset of World War I (1914–1918) stimulated further simplification of clothing. The rationing of fabric and metals was responsible for women's fashions that served multiple purposes with fewer fasteners and shorter

lengths. At the same time, the United States was emerging as a global power and solidifying authority at the same level as European powers. This new-found authority helped establish America as a fashion leader.

The 1920s were known as the *Roaring Twenties* because the booming economy and the shortened workweek gave Americans more time to spend on leisure activities. Nearly every cultural aspect of the decade revolved around leisure time. Movies, magazines, newspapers, and books documented the raucous parties characterizing the decade.

In January 1920, the Volstead Act outlawed the sale of alcohol and led to the era commonly referred to as Prohibition. Many Americans routinely broke this law. An entire criminal enterprise organized to sell illegal alcohol, and Americans from every class frequented speakeasies where they could purchase it. Alcohol became a uniting factor in a country where intolerance of blacks and Communists was dramatically increasing.

As class distinctions were becoming blurred, the status symbol aspect of fashion was losing its importance. Inexpensive copies of couture garments proliferated despite designers' efforts to copyright and protect their work. Although France was the undisputed fashion center, America was becoming known for its mass production of clothing.

Women's roles changed during the 1920s. In 1919 the Nineteenth Amendment, granting women the right to vote in national elections, was passed. More women started practicing such traditionally male pursuits as working, smoking, and drinking. Sex became more permissible than it had been in previous generations. Trojan began to market condoms, allowing people to engage in casual sex with fewer repercussions. Also, young people freely discussed sex, an activity that shocked their parents.

These changes in women's roles were personified in the image of the flapper: a brazen, young woman with a boyish silhouette, bobbed hair, short skirt, exposed arms, turned-down stockings, and makeup. Clearly she was not the caretaker of home and family as was her mother. The rebellious flapper defied the conventions of feminine behavior. Actresses like Colleen More, Clara Bow, and Louise Brooks helped define and popularize the flapper look. Even women who did not adopt the flapper fashion extremes wore short hair and short hemlines.

In October 1929 the U.S. stock market crashed, and in 1930 a drought struck the heartland of the United States, which led to the greatest economic recession in United History. For the next ten years, unemployment hovered close to 20 percent, and numerous American banks failed, wiping out the savings of their customers. Many people found themselves standing in breadlines and accepting charity for their daily needs. Some lost their homes and lived in shantytowns built of crates and boxes. During this bleak period, few could afford to replace their worn clothes, and fewer had the money to follow fashion trends.

Americans, however, still had an interest in new fashions even though

Introduction

they could not necessarily afford them. Elegant, body-skimming, elongated lines became popular, and sumptuous fashions dominated this otherwise sparse period of American history. U.S. movies began disseminating fashion information through the glamorous garments of the stars. The international popularity of movies helped solidify the reputation of the American fashion industry.

The entry of the United States into World War II (1941–1945) ended the Great Depression and spurred economic growth. Just as Americans were beginning to enjoy economic stability, however, the government imposed rationing on building materials, clothing, food, and fuel. The fighting in Europe forced many of the couture houses there to close their doors, and those that remained open had to bend to the will of the Nazis occupying France. With America cut off from European fashions by the war, the U.S. fashion industry gained power and prominence in an industry that previously had been indisputably dominated by the French.

After the war, Americans focused on improving their standard of living and promoting family values. Many people moved from the city to the suburbs and purchased homes, cars, televisions, and convenience items. Soon, it seemed that everyone could afford the trappings of the middle class, and these trappings could be purchased at the suburban mall which now catered to the masses. Fashion design was no longer the realm of the elite; it was becoming big business.

Women, many of whom had worked in factories to help in the war effort, focused on raising families. It was considered unpatriotic for women to work in a job that could be filled by a returning soldier. They were expected to live up to the ideal of the feminine mother and wife, and fashions reflected this change. Stiletto-heeled shoes, confining girdles, and voluminous crinolines hampered movement and accentuated the womanly, hourglass figure.

By the end of the 1950s, a new emphasis on young people had emerged. In previous generations, age and wisdom were valued, but in the fifties youth and energy became more important. Rock and roll, a new music style, featured youthful performers and helped fuel the focus on youth. The youth movement continued and flourished throughout the 1960s.

The 1960s were characterized by upheaval and change. New attitudes about the Soviet Union, civil rights, and sexuality shook the foundations of the "family values" society that had predominated during the 1950s. These new attitudes began to take shape during the late 1950s.

When the Soviet Union launched its first satellite, *Sputnik*, in 1957, it ignited the space race and intensified the Cold War between the Soviets and the Americans. The two sides were pitted against each other in a war that did not involve warfare and battles. Instead, it focused on global dominance and the threat of nuclear attack. Bomb drills and nuclear weapon stockpiling characterized the Cold War during the 1950s. The space race,

a competition to be the first country to land on the moon, characterized the Cold War during the 1960s.

Twenty days after Alan Shepard became the first American to be sent into space on May 5, 1961, President John F. Kennedy committed the nation to landing a man on the moon before the end of the decade. Throughout the 1960s, the United States and the Soviet Union sent dozens of rockets into space and fueled the public's passion with the future and technology.

The popularity of outer space and the future was translated into vogue fashions. Designers such as André Courrèges and Pierre Cardin unveiled space-inspired clothes. Other designers used plastics, metals, and Velcro to create futuristic designs.

While the space race was fueling the interest in futurism, the Civil Rights movement was awakening an interest in ethnicity. As the Civil Rights movement evolved from the 1955 Montgomery bus boycott to the lunch counter desegregation in 1960 to the passage of the Voting Rights Act of 1965, the message of African Americans changed from the moral appeals of Martin Luther King, Jr., to militant demands of black power groups. After 1965 the message of black power gained an audience and helped spread black pride.

As African Americans began embracing their heritage, ethnic fashions gained popularity. Many blacks adopted traditional African styles such as dashikis, afros, corn rows, and kente cloth. By the mid-1970s, some of these styles, including dashikis and corn rows, had moved into the mainstream and were worn by whites as well.

While African Americans were revising their image, women's images were thrown into turmoil. In the 1960s, the notion of sexuality was transformed from a secret activity that was relegated to the bedroom, to a public topic that was discussed in best-seller books and films. While young people were focusing on immediate sexual gratification and individual pleasure, their parents were still trying to maintain high moral standards. Fearing that the newly introduced birth control pill would encourage promiscuity among their children, many parents enforced curfews, established dating rules, and fought to ban sexually suggestive media images.

The contradictory images of sexuality in society were expressed in a diverse hodgepodge of popular fashion styles. Some women dressed like little girls in tidy, conservative suits and dresses complemented by flat shoes and bows in their hair. Others wore more provocative styles, including micromini skirts, bodysuits, and, for the most daring, Rudi Gernreich's topless swimsuit. Yet other women sought to redefine womanhood by wearing unisex hippie clothing and jeans. This diversity of women's styles continued into the 1970s.

The activism, social change, and radical ideas of the sixties entered the

mainstream during the seventies. Hippies became part of middle America. Men wore their hair long, women wore gypsy dresses, and both sexes wore bell-bottom pants.

By the end of the decade, the free-spirited hippie look evolved into a more glamorous form of self-expression. Hot pants, platform shoes, and leisure suits came into vogue. This new look reflected the self-indulgent lifestyle that characterized the 1970s. People were so focused on instant gratification and getting in touch with themselves that the seventies were called the "Me" decade.

This emphasis on individuality caused some elements of the culture to splinter into a variety of popular styles. For example, rock music split into soft rock, hard rock, country, disco, and punk. Each one of these styles was complemented by the appropriate look: Western shirts and cowboy hats for country music; three-piece suits and body-skimming dresses for disco; jeans and t-shirts for hard rock; and leather, spiked hair, and safety pins for punk.

Advances in the civil rights and women's movements brought changes to the images of women and blacks. In 1973 the *Roe v. Wade* Supreme Court decision legalized abortion. This decision along with the availability of the pill brought women unprecedented control in planning their lives and careers. Without the fear of pregnancy, women suddenly had as much freedom with sex as men did. The black pride movement brought black culture into the homes of middle America. With their immense Afros, coordinated suits, and towering platform shoes, stylish urban blacks appeared in films, television shows, and on the covers of magazines.

The individuality and self-expression of the 1970s erupted into unabashed greed and materialism in the 1980s. Money and status became the goals of Americans. Binge buying, purchasing on credit, and designer labels became a way of life for many.

The popularity of designer jeans illustrates the transformation to a society that was enamored with conspicuous consumption. In the 1970s, most Americans wore blue jeans as a casual garment. In the 1980s, designers like Sergio Valente and Calvin Klein adjusted the fit and detailing of jeans to make them more sophisticated. Soon designer jeans came to embody the status consciousness of American fashion.

Designers' names began to take on a life of their own as licensing grew dramatically. Bridge and contemporary lines expanded to meet the demand for designer clothing at more affordable prices. Designer labels on any item from housewares to shirts made the item instantly desirable. Also, it became voguish to place the designer's label or logo in a visible place on the garment or product.

Designers created a demand for their names through advertising. Advertising campaigns seemed to overshadow the products by focusing on shock

value and controversy. Ads became about creating an image or lifestyle, like Ralph Lauren's Polo ads. Cable television aired the ads in countries around the world, helping designers expand into global businesses.

During the 1980s women's roles were changing. Women were joining the workforce in larger numbers than before. Also, more women were earning college and advanced degrees. When they married, they had fewer children, divorced more often, and were more frequently part of a dual-income family.

The working woman's image of aggressive femininity was expressed in her clothes. Early in the decade, working women wore a version of a man's navy suit, with a skirt instead of pants and a bow instead of a tie. As the decade progressed women's clothing became bolder and more feminine. Bright colors and exaggerated, masculine shoulders characterized the new look.

America had become more diverse by the 1980s. Immigration rates rose, and over 40 percent of immigrants were Asian, while most of the remaining immigrants came from Latin America. Latin and Asian influences can be seen in 1980s dress. Japanese designers achieved immense popularity during the decade, and Latin flounces and off-the-shoulder styles were widely used by designers.

Body consciousness rose to a new level during the 1980s. Many Americans became focused on physical fitness. After toning their bodies with exercise tapes like Jane Fonda's workout, people squeezed into body-revealing spandex, which seemed to come in every conceivable garment from dresses to shorts.

Fashion lost several of its most prominent and promising designers to a newly recognized disease, AIDS. Initially the controversial disease shocked people, but later brought them closer together. The losses of designers like Halston made many Americans realize the gravity of AIDS and prompted many to support research and care efforts.

At the end of the nineteenth century, fashion helped level diverse social classes and bring about democratization. At the end of the twentieth century, it brought about homogenization. Instead of narrowing the gap between social classes, fashion dissolved the visual differences between classes. The effects of the expansion of mass production and mass merchandising of the 1980s led to the homogenization of the 1990s.

Self-expression lost importance as people focused on conforming to the ideal image. Both men and women underwent plastic surgery to achieve the bodies and faces of models. Couture suffered a demise; clothing was simplified; and people of every class, lifestyle, age, and geographic location wore khaki pants, jeans, t-shirts, and button-down shirts for every occasion. Functionality became the most important quality in clothing.

During this decade, clothing lost a sense of time. Earlier in the century, people dressed up for dinner, going shopping, and even going to school. In

the 1990s, casual clothing became acceptable for most occasions. Many workplaces instituted "casual Friday" when employees could wear less formal clothing than suits and dresses.

Clothing stopped following seasons also. Advances in technology produced fabrics that remained cool in the summer and warm in the spring. Colors were no longer limited to specific seasons. White and pastels showed up in winter clothes, and black and dark colors were worn in the summer.

Although clothing had become homogenized, retailers and, to a lesser extent, designers were focusing on specialized markets. The shape of America was changing. The baby boomers, Americans born between 1946 and 1964, were aging and their bodies were maturing. Also, an increasing number of Americans were overweight. By the last half of the 1990s, retailers and designers began putting more emphasis on creating styles for a variety of body types. The number of petite, womens, junior, and plus size lines expanded, and separates became extremely popular, because consumers could get a more customized fit.

Technology played an important role in the 1990s. Fashion information was disseminated in seconds through satellite feeds, television, and the Internet. People could purchase the latest trends on-line, allowing even the most rural consumer to dress fashionably. International distinctions in fashion continued to erode, as people around the world were exposed to the same images.

It is hard to predict what direction fashion will take in the next century. Certainly, there will be changes and the evolution of technology will play a role. Fibers, fabrics, and construction and manufacturing techniques will evolve, making clothing more functional and more comfortable. Everyday clothing may become more streamlined and uniform, but special occasion clothing will continue to reflect the individuality of our lives. For weddings, school dances, christenings, and other events, people will chose clothing which celebrates their individuality.

Fashion and society have shared a symbiotic relationship since the emergence of the former at the end of the nineteenth century. Each one influences the other, with fashion often reflecting the society in which it exists. As society continues to transform and evolve in the twenty-first century, fashion will undoubtedly continue to reflect the values and events of the times.

A

Abercrombie & Fitch

See The Limited, Inc.

Adidas

The origins of Adidas date back to 1920 when Adolph (Adi) Dassler began a footwear business which specialized in manufacturing slippers. In 1924 his brother, Rudolph, joined the company then called Gebruder Dassler Schufabrik. Soon the company expanded to produce football boots and track shoes.

The brothers achieved recognition during the 1936 Berlin Olympic Games when Jesse Owens won four gold medals while wearing their shoes. The company weathered World War II but could not withstand a serious argument between the brothers in 1948. After splitting up, Rudolph founded Puma and Adolph formed Adidas, a name derived from his nickname and surname.

By 1949 the three-stripe logo identified the Adidas brand. Adidas became a pioneer in developing specialized shoes for sports, and it dominated the sports shoe industry until Nike surpassed it in the late 1970s. Adidas has clothed and shod such prominent sports figures as Muhammed Ali, Kareem Abdul-Jabbar, Kobe Bryant, and Martina Navratilova.

When Adolph died in 1978, his son, Horst Dassler, took over the business. During the early 1980s, the Adidas brand was popular among break-

dancers and hip-hop musicians. After Horst's death in 1987, his sisters sold the company to Bernard Tapier, whose inattentiveness to the business plunged it into financial losses and blurred its brand image.

Adidas was rejuvenated in 1992 when Robert Louis-Dreyfus took over the company. Louis-Dreyfus's expansion of the company's marketing coincided with the resurgence of 1970s fashions. The former utilitarian sport shoe company became the fashion statement of the mid-1990s.

In the 1990s, the company focused on strengthening its sporting goods image by splitting the business into units by sports such as basketball, cross training, soccer, and tennis. Also, it purchased the French ski, golf, and bike gear maker Salomon to form Adidas-Salomon. In 1999 the company was the second largest maker of sporting goods worldwide, rivaled only by Nike.

Website: http://www.adidas.com

REFERENCES

Rigby, R. "The Spat That Begat Two Empires." *Manage Today* (July 1998): 90.
Sloan, Pat. "Back to the Essentials: Adidas Introduces Equipment to Capture U.S." *Advertising Age* 4 (February 18, 1991): 62.
Wallace, Charles P. "Adidas." *Fortune* 176 (3) (August 18, 1997): 146.

A.T.P.

❧❦

Gilbert Adrian

B. 1903

D. 1959

Birthplace: Connecticut

Awards: Coty American Fashion Critic's Award, 1944

Gilbert Adrian, born Adolph Greenburg, is considered by many to be the greatest costume designer in Hollywood history. He was discovered by Natasha Rambove, the wife of Rudolph Valentino, who commissioned him to design costumes for Valentino. Thus began the career that landed him at MGM, where he practiced his craft from 1928 to 1942.

Having studied in both Paris and New York, Adrian was greatly inspired by historical clothing and decoration. This love of lavish fabrics and attention to minute details was never more obvious than when he worked with Greta Garbo, whom he dressed for a number of historical films including *Queen Christina* (1933), *Anna Karenina* (1935), and *Camille* (1936). The little velvet hat with ostrich feathers that he created for Garbo to wear in *Romance* (1930) became a real-life fashion "must have" and was widely

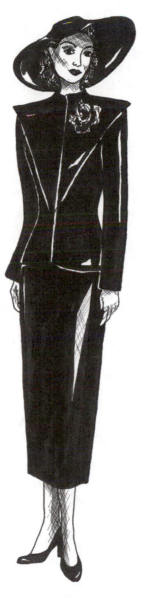

Gilbert Adrian: Adrian redefined the fashionable silhouette by creating tailored suits and evening gowns which emphasized broad shoulders.

copied for years afterward, continuously referred to as the "Empress Eugenie" hat. In 1932 Adrian designed a wedding gown for Joan Crawford's portrayal of Letty Lynton, in the movie of the same name. The ruffled white organdy dress was so angelic that the dress was copied in many price ranges. Macy's supposedly sold 50,000 of them.

Adrian designed for many movies other than those starring Garbo, such as *Romeo and Juliet* (1936) and *Marie Antoinette* (1938). In both of these films, starring Norma Shearer, Adrian demonstrated that he was not as interested in authenticity and historical accuracy in his costumes as he was in dramatic effects and extreme opulence. In *Marie Antoinette*, for example, MGM is said to have brought as many as fifty women to Hollywood to sew thousands of sequins on 2,500 costumes. Many of the fabrics used were made in France according to Adrian's specifications. From a historical perspective, the costumes were not completely accurate, but the public loved the extravagant display.

Perhaps Adrian is best known for the shoulder-padded ensembles he created for Joan Crawford which became a signature look during the 1930s. In 1942, largely as a result of the impact Adrian's costumes had on the fashion industry (his costumes for film were so often translated into garments sold through retailers that he was voted one of the top three designers by 1,000 U.S. buyers in 1940), Adrian opened his own salon, headquartered in Beverly Hills, which was an instant success, and produced clothing based on many of the ideas he popularized in film. In 1952 Adrian Gilbert suffered a heart attack and eventually retired to Brazil with his wife, actress Janet Gaynor. He was working on the costumes for the Broadway musical *Camelot* when he died.

REFERENCES

Englemeier, Regine, Peter W. Englemeier, and Barbara Einzig, eds. *Fashion in Film*. Munich: Prestel-Verlag, 1990.
LaVine, Robert W. *In a Glamorous Fashion: The Fabulous Years of Hollywood Fashion Design*. New York: Scribner, 1976.
Maider, Edward. *Hollywood and History*. New York: Thames and Hudson, 1987.

S. B.

<div align="center">❧❧</div>

Azzedine Alaïa

B. 1940

Birthplace: Tunis, Tunisia

Awards: Designer of the Year, French Ministry of Culture, 1985

To those familiar with his work, it is not surprising that Azzedine Alaïa originally planned to become a sculptor. His garments are known for their sensuous tension, their voluptuization of the female form, and their accentuation of womanly curves. In other words, the "King of Cling," as he is called, is renowned for creating the sexiest clothing in the world.

Raised by his grandmother, Alaïa attended L'Ecole des Beaux Arts in Tunis where he served as a dressmaker's assistant before arriving in Paris in 1957, planning to work for Christian Dior. His time with Dior was quite brief, however, and he set out on his own. After taking apart old garments designed by Madeleine Vionnet and Cristóbal Balenciaga, he studied their construction closely and then put them back together. He worked part of the time for both Guy Laroche and Thierry Mugler, but he supported himself primarily by functioning as an au pair for several stylish young families. In addition to his housekeeping duties, he created custom clothing for his chic employers.

Throughout the 1960s and 1970s, the diminutive designer continued to teach himself the techniques of Parisian haute couture and became a master tailor. His clothes are actually quite complex, featuring not only beautiful draping but also combinations of many individual pieces, all cut by him and fitted right on the body. He is satisfied only by perfection—thus, the shape and fit of each garment can be compared to an architectural structure; every piece serves as part of a well-built framework, each one supporting the other, all of them held together by corset-like seaming which also functions as stylish detail.

Alaïa began designing at a moment when women were becoming more and more interested in exercise, fitness, and showing off the results of their hard work. Tina Turner, Raquel Welch, and Paloma Picasso were among those who visited the apartment out of which Alaïa worked, eager to order his body-hugging knits. In 1980 he introduced his ready-to-wear line, featuring stretchy dresses, body suits, and bicycle shorts, all of which ultimately defined the decade—his use of Lycra and other elasticized fabrics was revolutionary, paving the way for fashion's ongoing glorification of the female shape. *See also*: Christian Dior; Thierry Mugler.

REFERENCES

Koda, Harold, and Richard Martin. *Flair*. New York: Rizzoli International Publications, 1992.

Seeling, Charlotte. *Fashion: The Century of the Designer*. Cologne: Konemaan Verlagsgesellschaft mbH, 1999.

Sischy, Ingrid. "The Outsider." *The New Yorker* 168 (5) (November 7, 1994): 70.

S. B.

Linda Allard

See Ellen Tracy.

Hardy Amies (Edwin Hardy Amies)

B. July 17, 1909

Birthplace: London, England

Awards: Harper's Bazaar Award, 1962
 Caswell-Massey International Award, 1962, 1964, 1968
 Ambassador Magazine Award, 1964
 The Sunday Times Special Award, London, 1965
 Personnalité de l'Année (Haute Couture), Paris, 1986
 British Fashion Council Hall of Fame Award, 1989

Amies, who became dressmaker to the queen of England and known for his impeccable tailoring, did not begin as an aspiring fashion designer. Although his mother was a dressmaker, Amies did not follow along the path of fashion. He chose foreign languages as a tool to provide a career. After learning French and German, he worked as an English tutor and teacher in France. Soon thereafter, he used his multilingualism to get jobs at three international companies.

In 1934 he made the transition into fashion when he accepted a job as managing designer at LaChasse, a couture sportswear company. His primary innovation during the 1930s was to lower the waistline of women's suits, placing it at the top of the hip instead of at the natural waistline. This gave his suits a more elegant, feminine look.

With the arrival of World War II, Amies left LaChasse and enlisted in the army as a linguist in the Intelligence Corps. During his leaves, he designed for Bourne and Hollingsworth, and he showed his own designs at Worth of London. Also during the war, he helped found the Incorporated Council of British Fashion Designers, which designed clothing that adhered to the government's austerity regulations.

He opened his own house in 1946. Specializing in suits and coats, he created tailored yet feminine garments from fine tweeds and wools. In 1950, soon after opening the couture house, he established a ready-to-wear boutique which offered suits, sweaters, coats, and accessories. Both establishments were financially successful and popular. Finely tailored suits remained his trademark until the 1980s and 1990s, when the woman's suit

became too formal for everyday use. Amies and his designing partner, Ken Fleetwood, then shifted to separates.

Amies began designing for Queen Elizabeth II in 1950, and in 1955 she appointed him as one of her three official dressmakers. From this royal appointment, he became known for sumptuous yet refined ball gowns. Also, he created the costumes for the film *2001: A Space Odyssey* and corporate uniforms for hotels and airlines.

When Amies began designing menswear in 1959, he was one of the first women's couturiers to design for men. He tended to be more conservative than other menswear designers; he shunned the frivolous fads and emphasized youthful, yet rich-looking clothing. By following this philosophy, his work, and reputation outlasted the flamboyant fashions that dominated the Peacock Revolution in men's clothing, a movement that resulted in the overnight fame and subsequent rapid fall of many menswear designers. He induced greater success of his menswear by signing numerous licensing agreements in various countries to produce the popular garments.

In addition to menswear licenses, Amies has sold licenses for bridal wear, home furnishings, knitwear, leather goods, lingerie, men's robes and loungewear, shirts, and ties. By 1995 he had fifty licenses. Hardy Amies, Ltd., was purchased by Debenham's in 1973 and remained under its ownership until Amies bought it back in 1981. *See also*: Charles Frederick Worth.

REFERENCES

Byrne, John A. "At the Age of 70, Hardy Ames." *Chicago Tribune* (May 19, 1980): S3, 6.

McDowell, Colin. *The Man of Fashion: Peacock Males and Perfect Gentlemen.* London: Thames and Hudson, 1997.

Peacock, John. *Men's Fashion: The Complete Sourcebook.* London: Thames and Hudson, 1996.

 A.T.P.

John Anthony (Gianantonio Iorio)

B. 1938

Birthplace: New York City, New York

Awards: Coty American Fashion Critics' Award, 1972, 1976

Anthony, a native New Yorker, attended the Academia d'Arte in Rome for one year and the Fashion Institute of Technology in New York City for two years. He spent twelve years designing suits and coats for other companies including Adolph Zelinka and Devonbrook, where he designed

low-priced sportswear. After Adolph Zelinka disbanded, Anthony formed his own company in 1971. He and his business partner, Robert Levine, wanted to offer fashionable clothing at moderate prices.

Working with a limited and subdued color palette, Anthony created tailored designs that epitomized the 1970s. He was known for his slim silhouettes which ended in slightly flared skirts and trousers. He coupled this slender shape with natural fabrics, earning him the title "the minimalist of American fashion" (O'hara, 101). In addition to his gaucho suits and blazer suits, he created separates with similar silhouettes.

Anthony designed ready-to-wear and petite lines. Also, he licensed his name to lines of menswear, shirts, neckwear, sweaters, and rainwear. Joan and David produced a line of shoes for him, and Jan Originals created his furs.

During the 1980s, Anthony shifted his focus. He began using opulent materials such as fur, silk embroidery, and beaded geometric patterns. In 1984 he left the business, but two years later he opened an atelier to focus more closely on his clients. Although the collections were small, about thirty pieces, Anthony attracted many clients who were interested in made-to-measure clothes. *See also*: Joan and David.

REFERENCES

"Friedricks Inks Pact for New Anthony Line." *Women's Wear Daily* (August 10, 1982).

"John Anthony Purchased by D.J.'s Thing." *Women's Wear Daily* (February 13, 1984).

O'hara, Georgina. *The Encyclopedia of Fashion*. New York: Harry Abrams, Inc., 1986.

Shelton, Patricia. "Fashion's Anthony One-Man Dynamo." *Chicago Daily News* (July 26, 1972): 17.

A.T.P.

Giorgio Armani

B. July 11, 1934

Birthplace: Piacenza, Italy

Awards: Neiman Marcus Award, 1979
 Cutty Sark Award, 1980, 1981, 1984
 Gentlemen's Quarterly Manstyle Award, 1982
 Grand Officiale dell Ordine al Merito Award, Italy, 1982
 Gold Medal from Municipality of Piazenza, 1983
 CFDA, International Designer Award 1983, 1987,
 L'Occhio Oro Award, 1984, 1986, 1987, 1988, 1994

Cutty Sark Men's Fashion Award, 1985
Bath Museum of Costume Dress of the Year Award, 1986
Grand Cavaliere della Republica, Italy, 1987
Lifetime Achievement Award, 1987
Cristóbal Balenciaga Award, 1988
Media Key Award, 1988
Woolmark Award, 1989, 1992
Senken Award, 1989
Fiorino d'Oro award, Florence, 1992
Golden Effie Award, United States, 1993
Aguja de Oro Award, Spain, 1993
Academia del Profumo Award, Italy, 1993

Giorgio Armani grew up in Italy with his younger sister, Rosanna, and his older brother, Sergio. Armani attended the University of Bologna where he studied medicine and photography from 1952 to 1953. In 1953 Armani was drafted into service in the Italian army for one year. After his term of service he decided not to return to medical school but took a position with La Rinascente, a local department store. His first position at La Rinascente was as a window display designer from which he worked his way up to a buying position in the menswear division. In 1960 Armani was offered the menswear design position at Nino Cerruti, where he stayed for ten years.

In 1970 Armani left Cerruti, and, with the help of his new business partner, Sergio Galeotti, formed a design studio which contracted freelance clothing designers. By 1974 Armani had launched his own menswear label, Giorgio Armani. The line was an immediate success, and Armani was dubbed the "King of Jackets." The collection was so successful that Armani decided to launch a women's line the following year.

The revolutionary unstructured silhouette that Armani created for men's suits was the menswear equivalent of Christian Dior's 1947 New Look for women. This new look for men quickly gained prominence, especially in the United States, after Richard Gere appeared in *American Gigolo* wearing Armani suits in 1980. Armani's women's line also became an immediate sensation after Diane Keaton appeared in *Annie Hall* wearing an Armani tweed jacket. Unlike the suits of other menswear designers, Armani's suits were softly tailored, not rigid. The signature Armani jacket became the standard for the well-dressed man of the 1980s. In the corporate climate of the 1980s, an Armani suit brought respectability and authority to the wearer. Armani's broad-shouldered suits gave women the authority they needed to enter the boardroom with confidence.

Throughout the 1980s and 1990s Armani continued to expand his product offerings by adding new labels at varying price points. Armani added Emporio Armani, a contemporary bridge line for men and women; Armani Jeans, for men and women; Giorgio Armani Le Collezioni, a tailored menswear and women's wear line; Mani (Italy) and Giorgio Armani USA, a

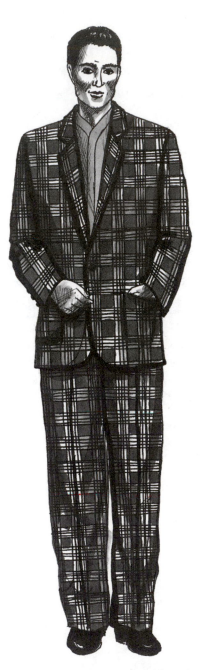

Giorgio Armani: Armani's elegantly draped and softly tailored men's suit provided the first alternative to the traditional, rigidly tailored men's suit.

better priced women's wear line; and Armani Exchange Footwear, traditional footwear for men and women. Armani also lent his prestigious name to licensed products for athletic wear, accessories, cosmetics, and perfume. He licensed his name to Skinea in 1996 to produce a line of men's and women's skiwear under the Neve label, which was followed by a line of men's and women's golfwear. In 1997 Armani licensed his name to Fossil, Inc., for a new line of watches under the Emporio Armani Orologi label. Armani debuted his first fragrance in 1983, Armani le Parfum for women, and its male counterpart, Armani Eau pour Homme in 1984. Armani's next perfume, Gio, was released in 1985 through Helena Rubinstein, but the license was transferred to L'Oreal in 1993. The relationship he began with L'Oreal in 1993 allowed him to add two additional fragrances, Acqua di Gio for women and Acqua di Gio pour Homme for men, in 1996, under L'Oreal's newly created Prestige et Collections division. L'Oreal also took the Armani name into cosmetics in 1999 under the Beauty Components label.

Giorgio Armani's success stems from his passion and drive for the fashion business. Armani incorporates such fine fabrics as cashmere, alpaca, and suede into refined, understated, sophisticated apparel coveted by both business executives and fashion gurus, as well as some of Hollywood's most elegant stars. Celebrities such as Ben Affleck, Annette Bening, Richard Gere, and Jodie Foster don Armani for both business and leisure. *See also*: Nino Cerruti; Christian Dior.

Website: http://www.armaniexchange.com

REFERENCES

"Armani, by the Numbers." *Women's Wear Daily* (August 2, 1999): 4.
Bachrach, J. "Armani in Full." *Vanity Fair* 482 (October 2000): 360.
"Giorgio Armani." *Women's Wear Daily* 177 (May 1999): 128.
Milbank, Caroline Rennold. *New York Fashion: The Evolution of American Style.* New York: Harry N. Abrams, 1989.
Perschetz, Lois, ed. *W. The Designing Life.* New York: Clackson N. Potter, Inc., 1987.

N. S.

Laura Ashley

B. 1925
D. September 17, 1985
Birthplace: Merthyr Tydfil, Wales
Award: Queen's Award for Export Achievement, 1977

Laura Ashley elevated the romantic style and warmth of a cozy English cottage to one of the most popular fashion themes of the twentieth century. From sweet dresses trimmed in lace, to charming wallpaper and upholstery fabrics, Laura Ashley combined her love of the English countryside, her knowledge of antique textiles, and her belief in the traditions of past eras to create affordable, wearable items which appealed to many who came of age in the 1960s. It was a moment when young people were embracing the notions of simplicity, love, and peace and harmony—what could have matched more perfectly with the sixties concepts of flower power and brotherly love than the little floral patterns and innocent silhouettes created by Ashley and her husband, Bernard?

Ashley began creating textiles in the kitchen of her London home during the early 1950s, which she used in the production of scarves, placemats, and tea towels. She and her husband/partner opened their own factory in Wales in the early sixties and their first retail store in London in 1967. Soon the couple had opened stores throughout England and Scotland and then expanded to France, Germany, and Austria. In 1974 the first U.S. shop opened in San Francisco. By 1985 the company, Laura Ashley, Ltd., boasted 500 stores around the world.

Although she never actually studied textile design, Ashley's extensive research coupled with her elevated sense of color resulted in assorted traditional prints with universal appeal. Coordinating fabrics were used in the creation of clothing lines that included women's wear, children's wear, and accessories, as well as wallpaper, furnishings, linens, and bath products. Each retail store was designed as a total environment in which all of these items were cleverly showcased. From natural fabrics like cotton and linen to velvet, corduroy, and wool, each item represented Ashley's desire to maintain the traditions of quality and custom.

Ashley's business continued to thrive during the 1980s, with Laura Ashley Holdings PLC handling all design and distribution. Remaining true to the distinct, identifiable English country style, the company enjoyed extremely profitable licensing agreements with Burlington Industries and J.P. Stevens for bed and bath ensembles which included all the elements of a total look, from pillows, sheets, and window treatments to terry towels and shower curtains.

The company went public in 1985, the same year as Ashley's untimely death from an accidental fall in her home. During the early 1990s, the business began experiencing difficulties. Stores in the United States and elsewhere failed to generate adequate sales, and at the end of the century, vast quantities of unsold goods and huge debt plagued the ailing business. In 1999 the business, which had little choice but to dispose of all of its U.S. operations in order to settle its finances, sold its entire North American business for $1.

As of this writing, the company is trying to regroup, planning to present

Spring and Summer 2000 lines. The current owners plan to continue the home furnishings division and are currently offering franchises worldwide. Whatever the future holds, Laura Ashley's delightful, always recognizable prints will undoubtedly maintain their place in fashion history; true classics, after all, never lose their appeal.

Website: http://www.laura-ashley.com

REFERENCES

Bond, David. *The Guinness Guide to Twentieth Century Fashion*. England: Guinness Superlatives, 1981.

Dickson, Elizabeth. "Laura Ashley: Her Life and Gifts by Those Who Knew Her." *The Observer* (September 22, 1985).

"Laura Ashley: A Licensing Legend." *HFN Weekly Home Furnishings Network* (December 26, 1988).

Stegemeyer, Anne. *Who's Who in Fashion*. New York: Fairchild Publications, 1996.

S. B.

B

Cristóbal Balenciaga

B. January 21, 1895
D. March 24, 1972
Birthplace: Guetaria, San Sebastián, Spain
Award: Chevalier de la Légion d'Honneur

At the age of twelve, Cristóbal Balenciaga began his self-education as a tailor. Thirty years later, this fisherman's son became the premier couturier of France, dressing the most elite women of the world. Balenciaga's first entrée into the fashion arena came in 1915 through his tailoring business in San Sebastián, Spain. In 1922 he established the Eisa fashion house in Barcelona, which relocated to Madrid in 1932. Balenciaga emigrated to Paris during the 1937 Spanish Civil War where he founded the House of Balenciaga and showed his first collection in August 1937.

Balenciaga was a master tailor. A perfectionist in every detail, he could engineer a design out of a single seam. Unlike Christian Dior and Charles James, who used elaborate interior support structures to develop silhouettes, Balenciaga combined the principles of geometry with the properties of fabrics such as gazar, satin, shantung, ottoman, and double knit to create his architectural forms. The result was a garment that could carry itself, sculpted to drift over the body, flattering the not-so-perfect figures of "women of a certain age." His designs were often copied by American manufacturers because this same framing concept allowed a single off-the-rack garment to fit a wide range of figure types.

Balenciaga refused to participate in the politics of the French fashion

industry. He did not bow to fashion trends, nor feel the need to redefine the fashionable silhouette every season. Instead, with every collection, he continued to refine his design concepts. Balenciaga refused membership in the Chambre Syndicale de la Couture and would not participate in the media hype that surrounded every fashion season. Instead, he showed his collections a month after the season, the only designer other than Hubert de Givenchy to stand against the establishment. As a result, he was often ostracized by the press, and his contributions to fashion were overlooked. Christian Dior, a media darling, often received the recognition for launching fashion innovations that were first featured in Balenciaga's collections.

Boxy, semifitted suits; tunic dresses; 7/8 length sleeves; stand-away collars; voluminous evening coats with dolman sleeves; and magnificent ball gowns were Balenciaga's hallmarks. As early as 1950, he began experimenting with the silhouette that would dominate the 1960s: the chemise. He was also the first to show the sack dress in 1956. His designs reflected brilliant colors and rich textures inspired by the Spanish baroque. Black lace, flamenco ruffles, jet beads and fringe accented his designs.

The new emphasis on the youth market in the 1960s disheartened Balenciaga; he was not interested in designing miniskirts, and in 1968 he closed his doors. During his thirty-year reign, he designed timeless fashions, trained designers such as André Courrèges and Emanuel Ungaro, mentored Hubert de Givenchy, launched two fragrances (Le Dix in 1948 and Quadreille in 1955), and designed uniforms for Air France. In 1972 Balenciaga quietly passed away and, for the next fourteen years, the House of Balenciaga lay dormant.

In 1986 the house was purchased by Jacques Bogart S.A., and a new ready-to-wear label, Le Dix, was created under designer Michel Goma. The first collection was shown in October 1987. For the next five years, Goma struggled to define an image for Balenciaga. In 1992 Dutch designer Josephus Melchior Thimister replaced Goma, but he also failed to create an image for Balenciaga. Nicolas Ghesquiere, a license designer for Balenciaga, was promoted to head designer in 1997. Ghesquiere, like Balenciaga a self-taught designer, was apprenticed to Jean-Paul Gaultier and Agnes B. The hip, fresh interpretation of Balenciaga classics, such as the semifitted jacket and the sack dress, caught the attention of the media as well as such celebrities as Madonna and Sinead O'Connor. Now, all eyes remain on Ghesquiere to see if he will be able to return the House of Balenciaga to its former glory and restore the couture line. *See also*: Christian Dior; Charles James; Hubert de Givenchy; André Courrèges; Emanuel Ungaro; Jean-Paul Gaultier.

REFERENCES

Jouve, Marie-Andrée, and Jacqueline Demornex. *Balenciaga*. New York: Rizzoli, 1988.

Koda, Harold. "Balenciaga." *Threads* (June/July 1987).
Milbank, Caroline Rennolds. *Couture: The Great Designers*. New York: Stewart,
 Taboria, and Chang, 1985.

 A. K.

❦

Banana Republic

See The Gap.

❦

Travis Banton

B. August 18, 1894
D. February 2, 1958
Birthplace: Waco Texas

 Mae West, Marlene Dietrich, Claudette Colbert, Carole Lombard . . . as designer extraordinaire at Paramount Studios from 1925 to 1938, Travis Banton costumed Hollywood's women of style, both on and off the screen. His career in dressmaking began in New York when he was hired as an assistant to Madame Lucile and then to Madame Francis. In 1917 he created the costumes for the movie *Poppie*, starring Norma Talmadge, but it was *The Dressmaker from Paris* (1925) that put him in the spotlight, along with the wedding dress he created for Mary Pickford's secret marriage to Douglas Fairbanks. Ultimately, however, it is his work with Marlene Dietrich for which he is best remembered. Among his most memorable creations is the one Dietrich wore in *Shanghai Express* (1932). Banton clad her as a black swan in a lavish gown of feathers and wrapped her in veils and crystal beads.
 Banton's attention to elegance and detail positioned him as an American couturier, of sorts, who by dressing actresses in sables, brocades, and velvets, as he did Dietrich in *The Scarlett Empress* (1934), encouraged women, fresh out of the Great Depression, to dream. Having sumptuously costumed such silent screen sirens as Pola Negri, Lillian Gish and Clara Bow throughout the 1920s, he became well known during the 1930s, for dressing actresses, especially Dietrich, in masculine clothing with broad shoulders, trousers, and ties. For Carole Lombard he created slinky, bias-cut gowns and for Claudette Colbert he devised a special collar that appeared to lengthen her neck.

When Banton dressed Tallulah Bankhead in a backless dress for the film *Thunder Below* (1932), this daring new look became the rage. His costumes were often featured in magazine spreads and copied for retail distribution. *Harper's Bazaar* suggested that fashionable readers might carry a parasol or don a lace scarf as Dietrich did in *The Devil Is a Woman* (1935).

His last film with Dietrich was *Angel* (1937), in which she wore a gem-studded fur-trimmed evening suit, which reportedly cost the studio $8,000. Banton continued his work at Universal Studios and Columbia Pictures after leaving Paramount in 1938 and eventually launched his own line of women's ready-to-wear. In 1940 he was voted one of America's favorite designers in a poll of 1,000 buyers from across the United States. He continued designing until his death at the age of sixty-four.

REFERENCES

Englemeier, Regine, and Peter W. Englemeier, eds., and Barbara Einzig. *Fashion in Film*. Munich: Prestel-Verlag, 1990.
LaVine, Robert W. *In a Glamorous Fashion: The Fabulous Years of Hollywood Fashion Design*. New York: Scribner, 1976.
Maider, Edward. *Hollywood and History*. New York: Thames and Hudson, 1987.

S. B.

Jhane Barnes (Jane Barnes)

B. March 4, 1954

Birthplace: Baltimore, Maryland

Awards: COTY Award, 1980, 1984
Inaugural Council of Fashion Designers of America Menswear Design Award, 1981
Outstanding Menswear Designer of the Year by Cutty Sark, 1981, 1982
Woolmark Award, 1991
Designer of the Year, Neckwear Association, 1997

Barnes studied fashion design at the Fashion Institute of Technology in New York City. She began her design career in 1976 when she produced 1,000 pairs of pants for a retail executive. Barnes emerged on the menswear scene during the Peacock Revolution of the 1970s when many men adopted more expressive, flamboyant forms of dress. During this decade, Barnes's futuristic designs attracted many customers including rock stars such as Elton John and John Lennon. Molded shoulders, button-up collars, and bag pockets represent some of her early innovative design elements. By 1980 Barnes had shifted from using unusual features to employing unique

textures and fabrics to create visual interest in her designs. In 1979 she teamed up with Erasmo "Eddie" DiRusso, a master tailor, to design her menswear collections.

Although Barnes continues to produce menswear, in the late 1980s she reallocated much of her creative energy to designing textiles. Using Macintosh computers, mathematics, and fractal geometry, she creates textile designs for clothing, accessories, furniture, upholstery, and carpets. In the 1990s she gained prominence for men's neckwear featuring her unique designs.

Barnes has licensing agreements with Knoll International for textile designs, Bernhardt Furniture Company for furniture, and Collins and Aikman for carpet. In 1998 Jhane Barnes, Inc., collaborated with Bernhardt Furniture Company to form Jhane Barnes Textiles, a company which markets textiles for furniture. Los Angeles became the site of Barnes' first freestanding store in 1997, and two years later she opened another store in Scottsdale, Arizona. Both stores feature Barnes's clothing and accessories.

Website: http://www.jhanebarnes.com

REFERENCES

Babcock, M.K. "Just 26, Jhane Barnes has Designs on Range of Men from Mork to Elton." *People* (March 2, 1981): 15.
Ettore, B. "Success Looms." *Working Woman* (June 1981): 6.
Strauss, Gary. "Casual Clothes by Intense Design: Jhane Barnes Wields Software to Weave Menswear Empire." *USA Today* (August 10, 2000): 1B.

A.T.P.

G.H. Bass and Company

Today, G.H. Bass is the largest seller of men's and women's casual shoes in the United States. When George Henry Bass started the company in 1876, he created a reputation which endured for more than a century. He constructed durable footwear in the finest shoemaking tradition. Among the devotees of craftsmanship was Charles Lindbergh, who wore Bass aviation boots on his first trans-Atlantic flight in 1927.

The company had existed for sixty years before it introduced its signature style, the Weejun, in 1936. College and high school students avidly wore the style, and they gave it the nickname "penny loafer" for the pennies they put in the slit at the vamp of the shoe. In the 1960s and 1980s, the style experienced skyrocketing sales, and it has remained a popular style since its introduction.

Since its purchase by Phillip-Van Heusen Corporation in 1982, the com-

pany has maintained its tradition of producing classic, casual footwear including moccasins, bucks, and Weejuns. It has enjoyed recent success with its clogs and sandals. Its three flagship stores in Paramus, New Jersey; Skokie, Illinois; and Atlanta, Georgia; sell shoes, apparel, and accessories.

Website: http://www.ghbass.com

REFERENCES

"Bass to Test Apparel Line." *Footwear News* 48 (May 25, 1992): 20.
Schneider-Levy, Barbara. "New Tricks for Old Bass: G.H. Bass Is Updating Its Product and Appealing to a New Generation of Consumers." *Footwear News* 53 (January 27, 1997): 18.
———. "Oldies but Goodies." *Footwear News* 51 (July 31, 1995): 40.

A.T.P.

Geoffrey Beene

B. August 30, 1927

Birthplace: Haynesville, Louisiana

Awards: National Cotton Council Award, 1964, 1969
Coty American Fashion Critics Award, 1964, 1966, 1968, 1974, 1975, 1977, 1981, 1982
Neiman Marcus Award, 1965
Ethel Traphagen Award, 1966
Council of Fashion Designers of America Award, 1986, 1987, 1989
Council of Fashion Designers of America, Lifetime Achievement Award, 1988

Geoffrey Beene graduated from high school in Haynesville, Louisiana, when he was sixteen. In 1943 he enrolled in Tulane University to study medicine but soon found himself sketching dress designs in his Gray's Anatomy text. Realizing that medicine was not his true calling, Beene moved to Los Angeles in 1946, where he enrolled at the University of Southern California and worked as a display assistant at I. Magnin department store. While at I. Magnin, Beene continued sketching his design ideas and was encouraged by the store president to pursue a career in fashion design. In 1947 Beene moved to New York to study fashion at the Traphagen School. One year later, in 1948, he decided to move to Paris to study at the Chambre Syndicale d'Haute Couture and the Academie Julien. In Paris, Beene worked as an apprentice tailor for Molyneux from 1948 to 1950 before moving back to New York. After he returned to New York, Beene worked for a series of fashion companies including Mildred O'Quinn, Samuel Win-

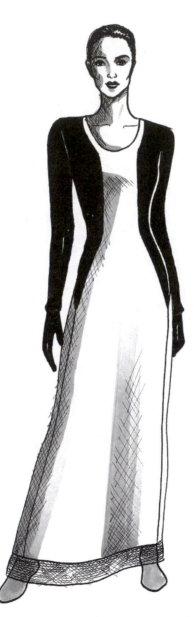

Geoffrey Beene: Beene's body conscious designs are typically characterized by geometric lines and architectural shapes.

ston, and Harmony between 1950 and 1958 before landing a position as a designer at Teal Traina in 1958. Beene remained at Traina until he founded his own house in 1963.

Beene's first fashion show in 1964 met with critical acclaim. His designs were original, not interpretations of current trends. When other designers in the 1960s were showing "space-age" fashions, Beene was showing sequined football jersey evening dresses. By 1970 Beene's whimsical, elaborate fashions were applauded by the fashion press and coveted by women; however, a review which appeared in the *New Yorker* in 1972 changed the entire direction of Beene's work. According to the *New Yorker*, Beene was "indulging fancifully in styles that women have never dreamed of simply because they have no earthly use for them" (Cocks, p. 97). This one review made Beene change his entire approach to design; he would now emphasize structure and function, not embellishment, in his designs.

This new approach to design led Beene to explore texture, pattern, and construction. He began to experiment with fabrics that were not typically found in couture fashions. Beene combined fleece, denim, mattress ticking, Hudson Bay blankets, and industrial zippers with lace, satin, and wool for evening wear, suits, and coats. He was also one of the few couture designers to experiment with synthetic fabrics. Beene executes his unusual fabrications into sensuous architectural structures which conceal, reveal, and envelop the body, often creating trompe l'oeil illusions, but always permitting movement.

Many designers rely on bridge lines and licensing agreements to support their couture business financially. Over the course of his career, Beene has attempted to introduce two secondary lines, Mr. Beene and Beene Bag, both of which failed. Beene was not able to translate his unusual fabrications and constructions into lines that could be manufactured inexpensively. However, Beene has been very successful with licensing, especially in menswear. He has licenses with Phillips-VanHeusen for men's dress shirts; Randa for men's neckwear; Hampshire Designers, Inc., for sweaters; Lanier for men's tailored clothing, sports coats, dress slacks, and suits; and Bedford Capital Financial, Inc., for men's fragrances Grey Flannel and Bowling Green and women's fragrance Chance. He also has various other licensing agreements for shoes, bags, hosiery, eyeglasses, loungewear, bedding, and towels.

Geoffrey Beene is not like any other American designer. He does not follow fashion trends; in fact, he verbalizes his dislike for designers who create fads and for patrons who follow them. Beene, unlike Ralph Lauren and Calvin Klein, does not promote a lifestyle image. Beene is the rebel of the American fashion industry, something which earns him both punishment and praise. Beene has repeatedly renounced the ritual of the twice-yearly fashion show, occasionally opting to present his new collections on

dress forms instead of runway models. In 1983 a dispute with John Fairchild caused Beene to be banned from all Fairchild publications (*Women's Wear Daily, W, Daily News Record*). Not a single Fairchild fashion editor attended or reviewed any of his fashion shows until 2000. Coincidentally, shortly following that show, Beene announced it would be his last fashion show, ever. He decided he was bored with traditional fashion show presentations, and he will present future collections either on video or over the Internet.

Many consider Beene to be the greatest American designer. He has received more Coty awards than any other designer, as well as a lifetime achievement award from the Council of Fashion Designers of America. In June 2000, Beene was among the first eight designers (Calvin Klein, Ralph Lauren, Bill Blass, Rudi Gernreich, Halston, Claire McCardell, and Norman Norell) to be inducted into the Fashion Center Walk of Fame, a new walkway of plaques in New York honoring American fashion designers. Fashion rebel or hero, Beene provides the shape of modern, wearable, distinctly American clothing. *See also*: Edward Molyneux; Ralph Lauren; Calvin Klein; Bill Blass; Rudi Gernreich; Halston; Claire McCardell; Norman Norell.

REFERENCES

Bellafante, Gina. "The Poetics of Style." *Time* 151 (February 2, 1998): 68–70.

Cocks, Jay. Geoffrey Beene's Amazing Grace." *Time* 132 (October 10, 1988): 95–97.

Cullerton, Brenda. *Geoffrey Beene*. New York: Harry Abrams, 1995.

Milbank, Caroline Rennolds. *Couture: The Great Designers*. New York: Stewart, Tabori, and Chang, 1985.

———. *New York Fashion: The Evolution of American Style*. New York: Harry N. Abrams, 1989.

Wilson, Eric. "Beene Walks Walk and Talks Some Talk." *Women's Wear Daily* (June 7, 2000): 18.

A. K.

❧❦

Henri Bendel

See The Limited, Inc.

❧❦

Benetton

The Benetton siblings, Luciano, Giuliana, Gilberto, and Carlo, grew up in a small town in postwar Italy with bombers flying overhead. While

working at a fabric store in the 1960s, Luciano Benetton delivered, by bicycle, colorful sweaters hand knit by his sister, Giuliana, to local patrons. The unusual patterns and bright colors of Giuliana's designs were diametrically opposed to the traditional, muted English sweaters that were typically worn. The popularity of Giuliana's sweaters inspired Luciano to open the first Benetton store in 1968 in Belluno, Italy, followed by a second store in Paris in 1969. The remaining Benetton siblings, Gilberto and Carlo, soon joined Luciano, the business director, and Giuliana, the chief designer, to launch the Benetton fashion empire.

The unique, high-quality, moderately priced knitwear products designed by Giuliana rapidly saturated the European market. In 1979 Benetton decided to expand outside of Europe and opened its first store in the United States in New York. Benetton established a fashion empire through a unique global system of independent retailers. The Benetton system creates a partnership-franchise arrangement whereby the retailer provides the operating capital for the store, fixtures, and merchandise and agrees to stock their store exclusively with Benetton merchandise. In return, Benetton provides the marketing and advertising for all 7,000 stores.

Benetton, along with companies such as Esprit, came to epitomize 1980s fashions. The brightly colored, patterned knitwear captured the active lifestyle of the 1980s youth market and the energy of New Wave music. The fashions were comfortable and affordable, and they crossed social classes. However, Benetton wanted to sell more than fashion; they wanted to sell social awareness. In 1981 Benetton launched their first socially oriented advertising campaign, "All the colors of the world." The advertisements, which embraced diversity, featured models from multiple races, celebrating the United Colors of Benetton. The advertisements, designed by Oliveiero Toscani, incited national debate and propelled Benetton to the forefront of the fashion industry. Successive advertising campaigns continued to espouse the Benettons' views on increasingly sensitive social issues such as terrorism, race, AIDS, and the death sentence, but they rarely featured any of Benetton's products. The advertisements generated controversy and were frequently banned. As the popularity of Benetton's products waned, many questioned whether the advertisements were simply a publicity gimmick to keep the Benetton name in the public eye. The dwindling sales experienced by many Benetton retailers in the United States even resulted in lawsuits by store licensees against Benetton for failure to provide the marketing and advertising required by the franchise agreement.

Throughout the 1990s, Benetton struggled to reposition itself in the U.S. fashion community. At its peak in the 1980s, 700 Benetton stores operated in the United States, but by 1992 only 300 remained, creating annual operating losses of approximately $10–$15 million. In the United States, the Benetton label suffered from a narrow product line with an outdated image and could not compete with hip, trendy retailers such as The Limited and

The Gap. One fashion writer even commented, "They're not fun or buzzy in the way that Gap is. It's about as much of a retail experience as McDonald's is a culinary one" (Mills). To regain market share and profits in the United States, Benetton signed a deal with Sears, Roebuck and Company to launch the line Benetton USA in 1999. The line, which would be manufactured by Sears from designs created by Benetton, was expected to generate $100 million for Benetton during the first year and boost the image of both Benetton and Sears. However, after the Benetton death row advertising campaign resulted in lawsuits in Missouri and picketing by victim rights groups in Texas, Sears canceled the Benetton deal.

By 1995 the Benetton family, through their Edizione Holding Company, realized only about 40 percent of their revenues from apparel. While the popularity, and profitability, of the Benetton label declined, the Benetton family continued to expand their operations through other business acquisitions. Benetton now operates Albatros (whirlpool baths), Enervit (sports drinks), Ecoflam (gas burners), E Group (olive oil and coffee), Autogrill (a fast-food chain), Nordica (ski equipment), Prince (tennis rackets), Ektelon (racquetball equipment), Langert (golf equipment), Kastle (skis and bikes), Asolo (mountaineering boots), and Rollerblade and Killer Loop (snowboards). They also hold half ownership in Euromercato supermarkets.

Benetton is a unique design and retail group. They are the largest clothing manufacturer in Europe and the world's largest consumer of wool for apparel production. At its peak in the 1980s, the Benetton name appeared not only on casual wear for men, women, and children but also on sunglasses, watches, bags, shoes, gloves, hats, jewelry, and even car parts. By 1999 over 7,000 Benetton stores were operating in over 120 countries. In addition to its licensed retail operations, Benetton retails its apparel through Colors, a combination magazine and catalog that provides an outlet for Benetton to transmit its social beliefs. Despite the criticism surrounding Benetton's advertising campaigns, Benetton does invest in society; they give scholarships to young dancers, operate an art school in Treviso, Italy, and support young entrepreneurs through Edizione's Twenty-one Investments. *See* also: Esprit.

Website: http://www.benetton.com

REFERENCES

Levine, Joshua. "Even When You Fall, You Learn a Lot." *Forbes* 157 (March 11, 1996): 58–60.

Mills, Dominic. "Mills On . . . Benetton" *Campaign* 29 (February 11, 2000).

O'Leary, Noreen. "Benetton's True Colors." *Adweek* 33 (August 24, 1992): 26–32.

Waterstone, Tim. "Benetton—The Family, the Business and the Brand." *Management Today* (April 1999): 48.

 A. K.

Bes-Ben

See Benjamin Benedict Green-Field.

Manolo Blahnik

B. 1942

Birthplace: Canary Islands

Awards: CFDA Special Award, Accessory Design, 1987, 1989
Fashion Council of America Award, 1988, 1991
British Fashion Council Award, 1991
Balenciaga Award, 1991
American Leather Award, 1991
Antonio Lopez Award (Hispanic Institute), 1991

Some women admit to having more than 100 pairs of his provocative pumps. They are "as good as sex, and they last longer," says fashion chameleon, Madonna, one of the most devoted (and famous) fans of his fabled footwear (O'Koeffe, p. 156). Manolo Blahnik is to the late twentieth century shoe what Godiva is to chocolates . . . he creates delicious confections for women's feet.

If it is true, as some say, that to learn about a woman's personality, one should study her feet, it is no wonder that women covet his creations. Not only are his shoes said to transform the appearance of the leg by elongating its look, but the materials used in the making of his ultra-feminine and sexy shoes are always witty and surprising. Blahnik, who takes his inspiration from Madeleine Vionnet, Salvatore Ferragamo, and Roger Vivier, became interested in shoes at an early age. His mother was an avid collector of lavish pairs made of brocade, satin, lace, and other fabrics which inspired Blahnik in his later work.

Blahnik studied international law at the University of Geneva, in accordance with his father's wishes. Later he turned to architecture and literature, intending to become a set designer. He then moved to Paris, where he studied art and continued to compile a portfolio of costume and set designs for the theater. When *Vogue* editor Diana Vreeland saw his work, she immediately recognized his talent and encouraged him to concentrate on shoes.

During the early 1970s originality in fashion was paramount. Blahnik moved to London, where new materials were being used to create wacky

footwear—shiny leather, appliqués, clunky stacked heels, futuristic shapes and colors were all the rage, and Blahnik was in step with the moment, so much so that Ossie Clark, then London's hottest designer, asked Blahnik to create a line of shoes for his company. He opened his first shop, Zapata, in 1973, and it quickly became a popular stop for fashionable Londoners. Elio Fiorucci, Milan's then reigning avant-garde fashion king, commissioned Blahnik to create colorful plastic sandals, or *jellies*, which were sold in Fiorucci stores worldwide. In the 1980s Blahnik turned his attention to designing more sophisticated shoes which reflected elegance and desirability, attracting the attention of the world's best-dressed women.

Blahnik's shoes go through approximately fifty processes before they are hand finished in Italy at his factory. Admitting to having "little tricks," Blahnik participates in production himself, working with great care to craft and finish his flattering slippers. From the beginning of his career, both the shoemaker and his shoes have enjoyed media attention. Photographing them is a pleasure; the vivid colors, the jeweled details, the trims of marabou and mink, the ribbon-tied ankles—all of these glamorous, yet refined, touches make his shoes instantly recognizable. Designers, including Yves Saint Laurent, Emanuel Ungaro, and Bill Blass, commission him to design shoes for their runway shows. Blahnik's elegant looks and lively personality have served him well. *See* also: Madeleine Vionnet; Salvatore Ferragamo; Roger Vivier; Ossie Clark; Elio Fiorucci; Yves Saint Laurent, Emanuel Ungaro; Bill Blass.

REFERENCES

Gan, Stephen. *Fashion 2000—Designers at the Turn of the Millennium*. New York: Universe Publishing, 1997.
McDowell, Colin. *Manolo Blahnik*. New York: Harper Collins, 2000.
O'Keeffe, Linda. *Shoes: A Celebration of Pumps, Sandals, Slippers & More*. New York: Workman Publishing, 1996.

S. B.

❧❧

Bill Blass

B. June 22, 1922

Birthplace: Fort Wayne, Indiana

Awards: Coty American Fashion Critics "Winnie" Award, 1961, 1963, 1970
　　　　Gold Coast Award, Chicago, 1965
　　　　National Cotton Council Award, New York, 1966
　　　　Coty American Fashion Critics, Menswear Award, 1968
　　　　Neiman Marcus Award, Dallas, 1969

Coty American Fashion Critics, Hall of Fame Award, 1970
Coty American Fashion Critics, Special Citations, 1971, 1982, 1983
Point Council Award, 1971
Martha Award, New York, 1974
Honorary Doctorate, Rhode Island School of Design, 1977
Ayres Look Award, 1978
Gentlemen's Quarterly Manstyle Award, New York, 1979
Cutty Sark Hall of Fame Award, 1979
Council of Fashion Designers of America Award, 1986

William Ralph Blass, a Midwestern native, knew at an early age exactly what he wanted to be when he grew up. As a child, Blass's favorite pasttime was going to the movies where he could escape the desolation of the Great Depression by immersing himself in the glamor and sophistication of Hollywood starlets. Blass attended the Parsons School of Design in New York City after high school, where he often sold his drawings to Seventh Avenue designers.

The first job Blass landed after college was as a sketch artist for New York sportswear designer David Crystal in 1940. Blass's fashion career was delayed by the onset of World War II; Blass served as a sergeant in the United States Army from 1941 to 1944. When his term of service was over, Blass took a position as a designer at Anna Miller and Company, Ltd., which later merged with Maurice Rentner in 1958. By the mid-1960s Blass had positioned himself as the head designer, vice president, and partner of the company. In 1968 Blass bought out the other partners and renamed the company Bill Blass, Inc.

Blass's signature style was all about sophistication. He gathered inspiration from museums, books, opera, and the ballet. His love for sketching enabled him to translate this inspiration into designs which captured the essence of the American woman. He mixed texture, color, and pattern to create refined looks. Blass's eye for detail was carried throughout his collections. Blass launched several different lines including Blassport in 1972 (currently Bill Blass Sport), House of Blass in 1971, Bill Blass Jeans in 1997, and Bill Blass Dress, Bill Blass Evening, and Bill Blass USA in 1995 to provide women with clothing for all facets of their lives. Blass's products are merchandised in the finest retail department stores, including Saks Fifth Avenue, Macy's, Burdines, and Lord and Taylor, and in various specialty stores across the United States. In 1996 Blass opened his first freestanding store in Singapore through the Singapore distribution company FB Benjamin Fashions.

Blass, referred to as the "Genius of Licensing," holds over forty agreements that total over three million dollars in revenue. One of his most unusual licensing agreements occurred in the 1960s when he briefly licensed his name to chocolates. Blass maintains licensing agreements with several

different companies, while at the same time maintaining control over the product design. Blass's current licensing agreements include Augustus Clothiers for Bill Blass USA; Pennsylvania House for furniture; Spring Industries, Inc., for the Bill Blass Home collection; Five Star for fragrance lines; Rose Cloak and Suit Company for coats; He-Ro Group for Bill Blass Knit Dress and Bill Blass Evening; Mallory and Church Corporation for hosiery; Krementz and Company for jewelry; Basha Scarves for women's scarves; OAS Industries for Bill Blass Swimwear; and Zaralo for suits.

After years of doing what he knows best, the American designer announced his retirement in 1999 after he suffered a minor stroke at the age of seventy-six. Blass still plays a creative role in the company, but he turned over the management responsibilities to the Resource Club. Blass will always be remembered for the sophisticated fashions he created for woman. Woman such as Barbara Bush, Angelica Huston, Nancy Reagan, Mary Tyler Moore, and Barbara Streisand all turned to Blass when they needed graceful, timeless fashions. His reputation for designing classical clothing earned him the title of "Dean of American Fashion Designers."

REFERENCES

Martin, Richard, ed. *Contemporary Fashion*. New York: St. James Press, 1995.
Milbank, Caroline Rennolds. *New York Fashion: The Evolution of American Style*. New York: Harry N. Abrahams, 1989.
Pagoda, Dianne. "Bill Blass and He-Ro: Reshaping the Deal." *Women's Wear Daily* 161 (February 26, 1991).
Perschetz, Lois, ed. *W. The Designing Life*. New York: Clarkson N. Potter, Inc. 1987.

<div align="right">*N. S.*</div>

Body Glove International

Award: Diving Hall of Fame and the Pioneers of Surfing, 1990

Body Glove was founded by identical twins Bob and Bill Miestrell. The brothers were born in Missouri, two of seven children. Both boys loved the water and were taught to swim by their older brother, Joe, a local lifeguard. By the time the boys were fourteen, they had become avid swimmers and explorers and soon became interested in deep-sea diving. They were obsessed with creating a diving helmet to be used for exploring the local lakes. Their first invention consisted of a five-gallon vegetable can with padding on the cut edge with a glass front sealed with tar. They tested their inven-

tion in the swimming pool: one boy would sit on the bottom of the pool with the helmet on while the other pumped air into the helmet with a tire pump. There were a few complications, but the results did not stop their exploring minds. They took the helmet to a local lake, submerged it under fifteen feet of water and explored the unknown.

In 1944 the family moved to Manhattan Beach, California, where the boys attended Redondo Union High School and El Segundo High School where they were active in swimming and football. Still obsessed with developing a diving helmet, the boys purchased a genuine diving helmet from a local shop. The adventurous boys tested the helmet in up to twenty feet of water for durability, functionality, and safety. After spending several hours experimenting with the helmet in cold, polluted waters, the brothers determined that the helmet needed some improvements. However, more important, they needed something to wear in the freezing cold waters.

After graduation the boys worked briefly as lifeguards before being drafted into the army. When they returned from service they resumed their pursuit of inventing a diving suit. First, they researched and tested fabrics that would withstand ocean temperatures. The brothers selected neoprene, a material used to insulate refrigerators, to fabricate their first diving suit in 1953. Their Thermocline wet suit, which was used only for exploring at the time, later became the standard wardrobe for surfing. As the wet suit became popular, the Miestrell bothers realized the name did not fit the suit. The brothers hired consultant Duke Boyd to help them select a name for their product. The name Boyd created was Body Glove, because the suits "fit like a glove."

The Miestrells' new suit caught the attention of friend Bev Morgan who owned a local sports shop, Dive N' Surf. Morgan was also a lifeguard and inventor, who had just closed a deal with a local surfboard designer, Hap Jacobs. Morgan offered the brothers a third share of her business if they would design surfboards for her store. The brothers agreed, and four years later, the revenues the business generated from the sale of their surfboards allowed the brothers to buy the Dive N' Surf outright from Morgan in 1957. In 1955 Bob Miestrell enrolled in the Underwater Instructors Certification course, which provided him with the training he needed to open two other companies: Dive N' Surf Marine Photography and Undersea Graphics. The companies are involved in the exploration of oceans.

Body Glove's prominence in the surfing industry in the 1980s caught the attention of Robin Piccone of Piccone Apparel, Inc. Body Glove, through a licensing agreement with Piccone Apparel, finally launched their first line of swimwear and active wear. The line contained the signature neoprene fabric the Miestrell brothers had experimented with years earlier for diving suits and created an entirely new look for swimwear, the "wet suit" look. This new look, which featured style details typically found only in diving

suits, immediately became the hottest, sexiest look for swimwear in the 1980s and complimented the fitness craze that was sweeping the United States.

In 1991 Body Glove created a sportswear division for men's, young men's, women's, and junior active wear targeted to the urban contemporary customer. The line was licensed by Panaj Distribution, Inc. In that same year, Body Glove produced a line of intimate apparel in cotton and Lycra spandex blends under a licensing agreement with Wundies, Inc. The product line, which included underwear, boxers, and teddies, was available in department and specialty stores.

Body Glove displays their main product lines on their website and at trade shows and sponsored events around the world. Body Glove now consists of five divisions: a wet suit division, a surf division, a sporting goods division, a footwear division, and an electronics division. The products offered by these divisions include men's, women's, and children's wet suits, gloves, hoods, watches, bags, wallets, hats, t-shirts, water performance shoes, neoprene pager cases, radio suits, and an award-winning neoprene cellular phone case licensed through GoNeo. Body Glove continues to sell products, such as diving equipment, surfboards, and beach apparel, through their Dive N' Surf shops in Redondo Beach, Del Amo Fashion Center in Torrance, and Dana Point, California. There are also stores in Hong Kong and Thailand under the Body Glove International name.

Over the last decade, the Body Glove label has not retained the same mass market appeal that launched the company to the forefront of the swimwear industry in the 1980s. However, the Body Glove and the Dive N' Surf shops continue to be prominent in the diving and surfboarding communities. Both brothers are currently involved in the business, as are their children. The Miestrell brothers still love the water and continue to explore the ocean.

Website: http://www.bodyglove.com

REFERENCES

"Body Glove Seeks an Urban Following." *Women's Wear Daily* 161 (June 3, 1991).
Gordon, Maryellen. "Neoprene Takes Body Glove into Next Generation." *Sporting Goods Business* 21 (September 1988): 68(2).
Monget, Karyn. "Body Glove Gets Intimate." *Women's Wear Daily* 162 (July 11, 1991).
Tedeschi, Mark. "Body Glove International." *Sporting Goods Business* 33 (January 22, 2000).

N. S.

Hugo Boss Fashions, Inc.

In 1923 Siegfried Boss and his son-in-law, Eugen Holly, opened a manufacturing facility in Germany specializing in uniforms. Boss and Holly discontinued their uniform line in 1948 and developed men's and children's lines. In 1972 Boss's grandsons, Jochen and Owe Holly, purchased the family-owned shares of the company. Even though the brothers' experience in the clothing industry was minimal, their degrees in economics and business prepared them for their new positions. The Holly brothers divided the responsibilities of the business; Jochen Holly managed the production and administration duties, and Owe handled the marketing.

The Hugo Boss suit evolved as a strong power suit, usually double breasted, accompanied by pleated trousers. Each season the shoulder and lapel lines were slightly varied, and the suit was refabricated. The design modifications were based upon the latest style trends, but they always retained their comfort. The brothers relied on technicians each season to transform the basic suit until 1989, when they hired Baldessarini, an Austrian designer.

Hugo Boss has been successful in satisfying their customers partly because of their sampling process. Each season the company offers buyers 140 different samples. Hugo Boss continued striving to meet customer demands by adding additional lines to the Hugo Boss label. In 1981 a line of men's shirts was added to complement the existing suit line. A sportswear division was added in 1984 to provide customers with active wear outside of work. By 1994 the Hugo Boss label consisted of three separate labels which addressed all their customers lifestyle needs: Hugo Boss for casual, Boss Hugo Boss for career, and Baldessarini Hugo Boss for the confident man. The lines were sold in several countries, including the United States, and were displayed in department stores such as Barneys New York, Bloomingdale's, Bergdorf Goodman, and Jacobson's. The Hugo Boss lines are not just merchandised in department and specialty stores but are also sold in franchised mono-brand stores around the world, including Hong Kong, Taiwan, Singapore, and South Korea. The company also formed subsidiaries in Paris under Hugo Boss SARL, in Italy under Hugo Boss Italian, and Tokyo under Hugo Boss Japan.

Hugo Boss produces their garments in its three factories while selectively pursuing licensing agreements. Licensed products include leather accessories to Charmant Inc., footwear and accessories to MH Shoes and Accessories, Boss Hugo Boss Bodywear to Schiesser AG of Radolfzell, fragrance to Procter and Gamble and Revlon, and Hugo Eyewear to Carrera eyewear. In 1989 Hugo Boss purchased Joseph and Feiss (previously Phillips-Van Heusen), a tailored suit manufacturer located in Cleveland, Ohio. In 1996

Hugo Boss also purchased its Swiss shirt manufacturer, Della Croce-Besazio.

Hugo Boss has employed many different channels for advertising products including sponsorships, television, print ads, and special events. The first activity they sponsored was Formula One auto racing. The company felt that associating their name with such an exciting sport would provide them with a compelling, powerful image. Hugo Boss also sponsored golf star Bernhard Inager, who represented the more classical, debonair side of Hugo Boss. Perhaps the biggest boost to Hugo Boss's profile came through the 1980s television show *Miami Vice*. The Hugo Boss sports coats worn by actor Don Johnson launched a revolution in menswear. Suddenly men everywhere were abandoning their dress shirts and ties and wearing t-shirts with their sports jackets. In 1995 Hugo Boss provided financial support to the Solomon R. Guggenheim Foundation for exhibitions and educational programs for the museum. Hugo Boss attire was also exposed through print advertising in such classic men's magazines as *GQ*.

Classic. Masculine. Powerful. These are all terms that come to mind when looking at a Hugo Boss suit. Hugo Boss has carefully cultivated a lifestyle image associated with influence, strength, and privilege. Their products are selectively distributed at high-end retail establishments and company-franchised boutiques in the United States, Belgium, the Netherlands, Scandinavia, England, Italy, Japan, Spain, Portugal, Taiwan, and Korea. The combination of promotional activities and distribution strategies has helped make Hugo Boss the largest menswear company in Germany.

Website: http://www.hugoboss.com

REFERENCES

Deeny, Godfrey. "Say Holys Seek to Regain Control of Hugo Boss AG." *Daily News Record* 21 (November 1, 1991): 2.
———. "The World According to Boss." *Daily News Record* 21 (April 1, 1991): 14.
Weisman, Katherine. "Hugo Boss: Big Plans in Women's." *Women's Wear Daily* (March 31, 1999): 2.

N. S.

❧❧❧

Brioni

There is no Mr. Brioni, and there never has been. In 1945 two partners, Gaetane Savini and Nazareno Fonticoli, opened a tailor shop in Rome and named it after a resort island in the Adriatic Sea, where the wealthy frolicked. The two craftsmen became known for creating handmade suits of

exceptional quality at a time when nothing similar was available anywhere but on London's Savile Row.

In the early 1950s, Brioni Roman Style, the full name of the salon, began to make a name for itself by initiating a new Italian phenomenon: runway presentations of Italian menswear for the press and important American retailers. In 1955 *Life* magazine hailed the firm for its first-ever men's fashion show, held in Florence, calling attention to "such startling innovations as matching ensembles and brass-button overcoats" (Spindler, p. 22). The company's use of novelty fabrics, such as silk shantung, in colors not previously found in men's apparel, appealed particularly to American buyers.

Soon Brioni caught the attention of well-dressed men around the world, including Hollywood movie stars, who had seen Frederico Fellini's 1959 movie masterpiece *La Dolce Vita* and wanted a part of the lifestyle it portrayed. Rock Hudson, Anthony Quinn, Clark Gable, Richard Burton, and Sidney Poitier all found their way to Brioni for the impeccably tailored, quintessentially Italian suit, sleek and elegant with tapered shoulders and a fitted waist. That same year, Savini and Fonticoli branched out beyond their tailoring operations into a ready-to-wear business and began selling to stores outside of Italy.

A Brioni suit is the product of 186 different stages of production and inspections with 42 intermediate and final pressing stages. While approximately five hours are required to make a standard suit, it takes eighteen hours to make a Brioni suit. According to the company, 50 percent of the time is spent on hand sewing the garment, and 80 percent of the process is done by hand. The company's dedication to quality and elegance begins with the best wools, cashmeres, and linens and continues with expert cutting by master tailors, who cut each suit individually. Details include buttonholes, hand stitched with silk thread, extra pockets, and special features that keep one's shirt from creasing. With such attention to every facet of production, it is no wonder that Brioni once had difficulty finding qualified tailors. Thus, the company set up its own private school in 1978, offering five-year programs to qualified students. This school, located in the town of Penne, home of the Brioni factory, not only guarantees employment upon completion, but also encourages and preserves the heritage of the region.

Over its years of international fame, Brioni has had a part in many memorable moments. Nelson Mandela wore a light gray worsted Brioni suit to celebrate the first anniversary of his election. Actor Pierce Brosnan, who portrayed the world's most famous secret agent in a series of 007 films during the 1990s, wears only Brioni when he appears as James Bond. The company has published several successful books on Brioni style. And, with its expansion into knitwear, outerwear, leather goods, and loungewear, Brioni opened freestanding sportswear stores in Aspen, Colorado, and Beverly Hills, California, in the year 2000, the first of its kind, although the

company already operates several full-line stores in New York City and Italy.

Today, the Brioni Group owns several luxury goods companies, including Burini, maker of fine shirts; Sabri, Brioni's only licensee, specializing in handmade neckwear; and Sforza, maker of high-quality leather garments. The Brioni label in a garment affirms it was made by the preeminent producer of tailored menswear.

Website: http://www.brioni.it

REFERENCES

McCormick, Bernard. "Bonding with Brioni." *Gold Coast Magazine* (January 1999).

McInerney, Jay, Nick Foulkes, Neil Norman, and Nick Sullivan. *Dressed to Kill: James Bond—The Suited Hero*. Paris: Flammarion, 1996.

Sartoria: Brioni. *Italia Magazine* 96 (May 1998).

Spindler, Amy. "Brioni's One and Only Style." *Daily News Record* 22(2) (June 22, 1992).

"A Stitch in Time." *Forbes* 156 (July 31, 1996): 96.

S. B.

Brooks Brothers

Brooks Brothers, one of America's oldest retailers, is known for its classic, sometimes staid, styling. Harry Sands Brooks founded Brooks Clothing Company in 1818 and passed it to his sons who renamed it Brooks Brothers in 1854. The company was one of the first to offer men's ready-to-wear clothing. Before the introduction of ready-to-wear garments, men had to wait days, sometimes weeks, for their custom-made clothing. Brooks Brothers offered premade suits, which was especially appealing to sailors who did not spend much time in port. In 1849 Gold Rush prospectors often purchased ready-made garments from Brooks Brothers before heading west.

The company also manufactured other types of ready-to-wear clothing. For over 100 years, the company supplied the U.S. military with uniforms. Even Civil War generals wore Brooks Brothers uniforms.

In addition to being a pioneer of ready-to-wear garments, Brooks Brothers invented and popularized many of the classic styles in men's fashion. In 1830 it introduced the first seersucker suit, which featured a lightweight puckered cotton that was far more comfortable than other fabrics in warm weather. In 1890 the company began to offer jackets, trousers, and beachwear made from a plaid fabric adapted from the madras cloth of India. In 1896 Brooks Brothers became the first American company to make a button down collar shirt, which was adapted from the polo shirt. The collar

was buttoned-down to keep it from flapping in the wind during polo matches. The shirt quickly became one of the company's best-selling items and a staple for men.

During the twentieth century, Brooks Brothers brought more innovation to men's fashion. In 1904 it adapted the wool sweaters made by the residents of the Shetland Islands and introduced the Shetland sweaters to the United States. Also, Brooks Brothers introduced an American version of the English camel-hair polo coat in 1910. The company helped revolutionize menswear by offering one of the first wash-and-wear shirts in 1953. The new fabric, called BrooksWear, was a blend of Dacron and polyester. The shirts were so popular that the company also offered suits and sportswear made from the fabric.

Brooks Brothers is synonymous with the Ivy League style, including khakis and a navy blazer. The look was completed with a repp tie, which was styled after British club ties. Brooks Brothers Americanized the tie by reversing the direction of the stripes. The Ivy League style, first popularized in the 1920s, continued to be worn for the remainder of the century. This style, along with other Brooks Brothers fashions, enjoyed renewed popularity during the preppy revival of the 1980s.

Women began wearing their husbands' and fathers' Brooks Brothers clothing long before the company began selling women's garments in the 1940s. Shetland sweaters were among the first women's-wear offerings. In 1976 the company opened a women's department in its New York store, where it sold feminine versions of the popular men's styles.

In 1988 a company with a long history as a British fashion institution, Marks and Spencer PLC, purchased the company. Michael Mark founded the company in 1884 and took on Tom Spencer as a partner in 1894. The company went public in 1926 and opened a flagship store on Oxford Street in London in 1930. By the 1960s, the company was known for mass producing well-constructed clothes which were as fashionable as the haute couture garments featured on Parisian runways. Trend-conscious pop stars of the sixties, such as the Rolling Stones, often purchased suits from the store.

In 1999 the company operated almost 700 stores in thirty countries including 190 Brooks Brothers stores in the United States and Asia. In addition to retailing, the company owns manufacturing facilities. It produces ties from its facility in New York City and shirts from the Garland Shirt Company in Garland, North Carolina. By 2000, Marks and Spencer was liquidating some of its less profitable divisions, but it retained and expanded the successful Brooks Brothers division.

Website: http://www.brooksbrothers.com

REFERENCES

Faircloth, Anne. "Brooks Brothers Dresses Down." *Fortune* 138, (September 7, 1998): 44.

Palmieri, Jean E. "Brooks Brothers Luxury Men's Collection on Track." *Daily News Record* 28 (May 11, 1998): 3.

Powell, Polly, and Lucy Peel. *50s and 60s Style*. Secaucus, N.J.: Chartwell Books, 1998.

A.T.P.

‧❧‧

Lane Bryant

See The Limited, Inc.

‧❧‧

Dana Buchman

B: 1987

Birthplace: Dallas, Texas

Award: Dallas Designer Sportswear Award, 1991

Dana Buchman was named vice president of design for the Buchman division of Liz Claiborne, Inc., in 1987. This signature collection was created for working women who wanted fashionable dress but were concerned about professionalism and comfort. In 1989 Karen Harman was brought on as vice president of design and codesigner for the Buchman division and, in 1990, Gail Cook was made president of the Buchman division. Together, these three women drew upon their everyday lives to create a line of fashionable, functional pieces targeted to the working woman.

The immediate success of the signature line lead Buchman to create a petite division in 1990 and a plus-size division in 1994 to appeal to a broader audience and gain more representation in the marketplace. Buchman was the first bridge designer to develop a woman's sportswear plus-size division. That same year Buchman opened her first boutique in New York which displayed her signature and petite lines and provided an opportunity for ordering her plus-size line. The boutique focused on customer service by offering alterations and special events geared toward their customers.

Buchman developed a secondary line in 1995 to provide a broader range of the American women's workforce with the wardrobes they needed at a lower price point. The line, Dana B. and Karen, was named after Dana Buchman and her codesigner, Karen Harman. The line offered women a relaxed, but still professional, look and was available in stores such as Neiman Marcus, Nordstrom, and Saks Fifth Avenue.

The Buchman division used various avenues to advertise their lines. They regularly advertised in such magazines as *Harper's Bazaar, Vogue,* and *W*

and utilized outdoor and co-op advertising venues. Buchman and Harman were also known for their occasional in-store appearances which helped them stay in tune with the needs of their customers. Another promotional tool used for marketing was the film *Women in Motion*, which depicts the process behind the creation of the 1997 Buchman line. The promotional film was shown in theaters and in retail stores. The Buchman line was further brought to prominence when such notable personalities as Tipper Gore and Hillary Rodham Clinton were seen sporting Buchman ensembles in the early nineties.

Buchman continued to expand into other product lines including a fragrance in 1995, a sunglass line licensed by Bausch and Lomb in 1998, and small leather goods and handbags. The Dana Buchman bridge lines and accessories were available in departments stores or in Dana Buchman's freestanding stores. Buchman, like Ellen Tracy, designs with real women in mind. Her collections are fashionable, yet always professional, designed to meet the demands of the rapidly increasing market segment of professional women. *See also*: Ellen Tracy.

REFERENCES

D'Innocenzio, Anne. "Buchman's Case for Casual." *Women's Wear Daily* 171 (February 21, 1996): 38.

Ozzard, Janet. "Dana Buchman's Media Makeover." *Women's Wear Daily* 172 (December 20, 1996): 8.

Perman, Stacy. "Dana Buchman Does Her Take on Plus Sizes." *Women's Wear Daily* 166 (November 10, 1993): 19.

White, Constance. "Dana Buchman: A Slow and Steady Rise." *Women's Wear Daily* 165 (February 10, 1993): 54.

N. S.

Bugle Boy

Awards: World Trade Hall of Fame

Mow Chao Wei came to the United States in 1949 when he was thirteen. His family fled Shanghai just before the city fell to Communist rule. They settled in New York City, and he became William C. Mow. In 1967 Mow completed his doctorate in electrical engineering at Purdue University, and two years later he founded Macrodata, a company which developed and tested computer microchip technologies. Mow's successful venture captured the attention of investors, and Mow sold control of his company to a Milwaukee-based conglomerate. In 1976 the company filed a lawsuit against Mow, alleging wrongdoings, accusations which would take him twelve years to clear. When Mow left Macrodata in 1976 the noncompe-

tition clause in his contract prevented him from pursuing a career in the electronics field. Mow's new business enterprise would be in the apparel industry. In 1976 Mow founded Dragon International to import clothing from Asian manufacturers for American wholesalers; however, the high financial risk and relatively low margins associated with importing prompted Mow to close his business.

In 1977 Mow made a second attempt at founding an apparel business, Buckaroo International. The new company would produce casual clothing for young men under the label Bugle Boy. Even though Mow knew very little about the apparel industry, he felt that if he could design electronic components he could design, manufacture, and market pants. Despite the immediate success he achieved in the electronics field, Mow struggled to launch his new start-up. Mow's inexperience with the apparel industry resulted in several near fatal mistakes for his fledgling company, such as a product line that was too diverse, price points that were too high, and products that were introduced out of season. By 1981 Mow's assets were nearly wiped out, and the bank was canceling his line of credit. To save his company, Mow promoted Vincent Nesi, a merchandiser, to president of the company in charge of sales and merchandising, dropped the collection of expensive men's clothing, and converted the company to an item line manufacturer of moderately priced pants. After two years of struggling, the new strategy paid off, and one of the biggest fads of the 1980s, parachute pants, was launched. The tremendous success of this single item revolutionized young men's fashions, propelled the Bugle Boy label to the forefront of young men's fashions, and seemingly secured Mow's place in the apparel industry. However, when the fad passed, Bugle Boy was left with piles of nylon, and no new trendy product to replace the obsolete parachute pants. As Bugle Boy struggled to launch new, hot trends, the company decided to refocus its marketing strategy. Instead of risking the success of the company on the ability to launch fads, it would focus on building brand loyalty among consumers by producing a quality product, at a moderate price, with fashion forward styling.

This new strategy proved successful, and the tremendous popularity of the original Bugle Boy line allowed Mow to diversify Bugle Boy into other product lines and licensing agreements to provide a comprehensive line of coordinating products for men, women, boys, girls, toddlers, and infants. Throughout the late 1980s and early 1990s, new Bugle Boy labels were launched, including Bugle Boy Co., Bugle Boy Classics, Bugle Boy for Her, and Gold Crest. The 1993 purchase of Ilio, Inc., added the women's labels Ilio by Bugle Boy, Row One, Cossette, In Place, and Coastline. These new labels target primarily men between twenty-six and fifty-four and the women's casual Friday niche. Bugle Boy also signed licensing agreements with Hampton Industries to produce men's and boy's loungewear; Merjo Enterprises to produce caps, hats, bags, and backpacks; Superba to produce men's neckwear; Keepers to produce socks; Van Mar, Inc., to produce

women's intimate apparel; and several other companies to produce watches, footwear, underwear, sunglasses, belts, prescription eyewear, and small leather goods.

The Bugle Boy label provides casual wear with attitude. Bugle Boy garments are injected with small doses of the latest fashion and lifestyle trends to meet the demands of fashion-conscious young men and women. Bugle Boy jeans and washed-twill cargo pants have become part of the standard teen and young men's uniform. Bugle Boy is one of the largest privately held apparel companies in the United States, with sales regularly grossing around $500 million. The Bugle Boy line of products is carried in over 7,000 department and specialty stores; however, to maintain their brand identity, the products are not sold to discounters. The Bugle Boy label continues to provide a solid core of fashionable, comfortable, affordable separates for men, women, and children geared toward the American lifestyle.

REFERENCES

Barrier, Michael. "From Riches to Rags and Riches." *Nation's Business* 79 (January 1991): 34–36.
Spevack, Rachel. "Bugle Boy's Men's Division." *Daily News Record* 21 (February 26, 1991): 4.
———. "Bugle Boy's Nesi to Focus on Building Women's Lines." *Women's Wear Daily* 168 (December 7, 1994): 23.
———. "Mow to Acquire Nesi's Stock in Bugle Boy Industries." *Daily News Record* 25 (August 29, 1995): 2–4.

A. K.

Bulgari

B. 1857

D. 1932

Birthplace: Greece

Born in Greece in 1857, Sotirio Bulgari, armed with his skills as a silversmith, came to Naples in 1881 and opened a small shop where he engraved precious objects. He moved to Rome four years later and opened a shop on the Via Sistina, eventually moving his business to the Via Condotti, the same street on which its modern headquarters is located today. Sons Giorgio and Costantino gradually took over the business in the 1920s, first continuing their artful engraving and then turning to the production of modern jewelry.

Bulgari's success is due largely to the introduction of a new aesthetic into modern jewelry. In place of the so called French-style setting, characterized by a diamond surrounded with other precious stones, which had dominated since the 1700s, Bulgari used round, colored stones set in handmade gold bezels on thick gold chain necklaces. By studying and integrating both Etruscan and Renaissance motifs, such as cameo intaglios and cabochons, in new and modern ways, the Bulgari brothers introduced center stones of violet, pink, and yellow. These bold designs virtually transformed the look of twentieth-century jewelry.

In the 1950s, Bulgari was the first to substitute yellow gold for platinum and the first to put semiprecious cabochons into fine jewelry. In addition, the use of antique coins and architectural shapes, rather than shapes found in nature, was a complete departure from the prevailing style of the preceding 200 years.

Bulgari is the only house of jewelry to have achieved a worldwide reputation after World War II, and it has become the third largest jeweler in the world, surpassed only by Cartier and Tiffany and Company. During the 1970s Bulgari expanded internationally, opening stores in New York, Paris, Monte Carlo, and Geneva. In 1977 the now classic Bulgari-Bulgari watch was created. The company, like its competitors, has expanded its offerings through licensing agreements with Rosenthal for crystal and tableware and with Luxottica for eyewear. In addition, Bulgari offers its own fragrance collection. Today, run by the fourth generation of Bulgari family members, it has approximately eighty locations throughout Europe, Asia, and the United States. *See also*: Cartier, Tiffany and Company.

Website: http://www.bulgari.com

REFERENCES

Bulgari. Available from http://www.bulgari.it.html. Accessed October 8, 2000.

Snowman, A. Kenneth, ed. *The Master Jewelers.* New York: Harry N. Abrams, 1990.

S. B.

❦

Thomas Burberry

B. 1835

D. 1926

Birthplace: Dorking, Surrey, England

When Thomas Burberry opened his drapery business, T. Burberry and Sons, in 1856, he could not have fathomed the impact he would have on

men's outerwear and clothing in general. In the 1870s he invented gabardine, a revolutionary fabric which rain could not penetrate, yet was cool and wrinkle resistant. This fabric became invaluable for sportswear as active leisure pursuits became popular in the 1890s. Burberry's gabardine trenchcoat, made for the British military during World War I, evolved into a timeless style worn by civilian men and women for the remainder of the century.

By 1891 Thomas Burberry had established a wholesale business in London. He named his coat made from gabardine the "Gabardinee," but the term never stuck. Devotees, such as Edward VII, called it "The Burberry," and that name was registered as a trademark in 1909. The tan, red, and black plaid used in Burberry garments is trademarked as well. In 1910 Burberry expanded into women's wear and opened a Paris branch.

Activewear like the "Walking Burberry," a smock with raglan sleeves, became the specialty of the business. Hunters and fishermen welcomed the protective yet comfortable clothing. The coats became essential to drivers who needed protection from wind and dust in their open-air cars during the early days of motoring. South Pole explorers Ernest Shackleton, Roald Amundsen, and Robert Scott wore Burberry's overalls and used his gabardine for their tents.

Despite the popularity of Burberry's activewear, the trenchcoat would be the company's legacy. From its introduction during World War I, the functional and stylish coat attained popular acclaim. Stars have appeared in films such as *Today We Live* (1933), *Patton* (1970), *Kramer vs. Kramer* (1979), and *Wall Street* (1987) wearing the distinctive coat. The classic style has changed little since its introduction.

Until the 1990s, Burberry's image remained tied to the trenchcoat. The company had been purchased by a British mail-order business, Great Universal Stores (GUS). The company expanded into international markets, but GUS allowed each country to expand the brand as it chose. Italy fabricated men's suits, Switzerland made watches, and Korea produced whiskey. Even Great Britain marketed a line of Burberry's Fine Foods including biscuits, marmalade, preserves, chutney, and tea complete with plaid lids. Because each country developed the brand differently, it did not have a cohesive image.

In 1997 Rose Marie Bravo, Burberry's chief executive, and Roberto Menichetti, the design director, began revamping the company. First, they changed the name to Burberry. Then they modernized the look of the clothing while retaining its classic British character. While coats remained the main emphasis of the company, Burberry upgraded its line of men's suits, put more focus on its women's wear, and launched a golf collection. The company entered into licensing agreements with Cluett Designer Group for dress shirts; Hart, Schaffner & Marx for clothing; Franco Fratelli for belts; Grosse for jewelry; Olmetto for neckwear; and Safilo for sunglasses. In

addition, Burberry produced Thomas Burberry, a line for young men and women from 1988 to 1997.

Also, the company looked to expand its retail presence. It opened its first U.S. store in 1978, and by 1997 it had twenty-five shops in the United States and more than fifty stores worldwide. In the late 1990s, Burberry's planned to open in-store shops, a move that would coordinate with its effort to cultivate a designer image. The company did not expect to see the success of its image overhaul until 2002.

REFERENCES

Fallon, James. "Burberrys' Next Generation." *Daily News Record* 26 (November 26, 1996): 3.

Goldstein, Lauren. "Dressing Up an Old Brand." *Fortune* 138 (November 8, 1998): 154.

Schiro, Anne-Marie. "Unstuffing Burberry's." *Chicago Tribune* (January 7, 1999): S5, 11.

A.T.P.

C

❧❧❧

Callot Soeurs

Callot Soeurs was formed by three sisters: Marie Callot Gerber, Marthe Callot Bertrand, and Regina Callot Chantrelle. They formed the house in 1895 after Madame Gerber, the oldest of the sisters, closed her lace shop. The women acquired their affinity for lace, a consistent element in their designs, from their mother, a lace maker. Their appreciation for design was most likely inspired by their father, a design instructor and artist.

As the head designer, Madame Gerber quickly made a name for the house by fashioning shirtwaists and lingerie accented with delicate lace and ribbon. By the time the sisters moved to a larger space on avenue Matignon in 1914, they had expanded their design expertise. In addition to ultrafeminine lingerie and day clothes, they became renowned for period gowns and Asian-inspired clothing.

The period gowns were contemporary versions of eighteenth-century gowns. The garments, which featured tightly corseted, pointed waists with wide hoop skirts, were usually created from pastel-colored tulle. These unusual dresses found devotees during the 1910s and 1920s.

The most influential and popular of their designs were the *robes phéniciennes*, as their Asian-inspired styles were known. Sometimes Asian elements, such as dragons embroidered onto a 1920s beaded chemise, were part of the decoration. Other times, the Oriental influence was incorporated into the structure of the garment. Madame Gerber introduced the kimono sleeve into Western dress effecting one of the most significant sleeve innovations in twentieth-century fashion design.

The sisters' ability to adapt Asian motifs into Western garments and their fine workmanship set standards for the couturiers who followed them. Ma-

dame Gerber's son, Pierre Gerber, took over the business in 1928. He tried to uphold his mother's standards and trademark styles, which prevented the house from producing cutting-edge designs during the 1930s. Despite this, the house enjoyed financial success and loyal customers until it was absorbed into Calvet in 1937.

REFERENCES

Callan, Georgina O'Hara. *The Thames and Hudson Dictionary of Fashion and Fashion Designers.* New York: Thames and Hudson, 1998.
Kirk, Betty. *Madeleine Vionnet.* San Francisco: Chronicle Books, 1999.
Milbank, Caroline Rennolds. *Couture: The Great Designers.* New York: Stewart, Tabori and Chang, 1985.

A.T.P.

Pierre Cardin

B. July 2, 1922

Birthplace: San Andrea da Barbara, Italy

Awards: Sunday Times International Fashion Award (London), 1963
De d'Or Award, 1977, 1979, 1982
Chevalier de la Legion d' Honneur, 1983
Fashion Oscar, Paris, 1985
Golden Orchid Award for Maxim's, 1985
Foundation for Garment & Apparel Advancement Award, Tokyo, 1988
Grand Officer, Order of Merit, Italy, 1988
Honorary Ambassador to UNESCO, 1991

Pierre Cardin was born in Italy but spent most of his childhood in France. The Cardins knew their son was destined to be a designer; his interest in costume design and architecture was evident at an early age. Cardin's parents supported his interest in design by enrolling him in architectural studies at the school of Saint Etienne in France. By the time Cardin was fourteen, he was working as an apprentice for Manby, a local tailor. Anxious to start his career, the seventeen-year-old Cardin was on his way to Paris when World War II erupted and he was enlisted. After the war, Cardin returned to Paris, anxious to launch his career in fashion. Cardin landed a series of positions with prominent couturiers, including Madame Paquin, Elsa Schiaparelli, Jean Cocteau, and Christian Bérard, which helped mold his design skills. He also spent four years at Christian Dior, from 1946 to 1950, designing coats and suits.

In 1950 Cardin established the House of Cardin. His first collection, presented in 1951, featured sculptured suits and coats in heavy weight wool with exaggerated details and geometric shapes. These style characteristics continued to be prevalent in Cardin's future collections, in garments such as in his barrel coat with oversized roll collar in 1955 and in his balloon dresses in 1959. In 1957 Cardin was presented with a unique opportunity. He was invited to teach at the Bunka Fukusoi design school in Japan. His association with the school allowed him to be the first designer to form business relations with the Japanese market. When Cardin returned to Paris, he designed his first ready-to-wear collection which debuted in 1959 in Paris department store Printemps. Cardin was the first couturier to break tradition and design ready-to-wear clothing. This distinction earned him expulsion from the Chambre Syndicale. Cardin was reinstated to the Chambre Syndicale a few years later, after other couturiers began to see the financial benefits of providing ready-to-wear lines.

The sixties were full of freedom and experimentation for Cardin. His combined interest in space and technology fueled his futuristic collections. Cardin's use of man-made materials, such as vinyl, moldings, and paper constructed into fitted silhouettes with cutout details and geometric patterns, defined him as a fashion innovator. Cardin again broke the haute couture tradition in 1960 by designing a men's ready-to-wear collection. The collection consisted of slim, French cut suits with narrow shoulders, high armholes, and a fitted waist, paired with tapered pants. The European suits were not immediately popular in America; however, when the Beatles appeared on Ed Sullivan's television show in knockoff versions of the same suit, a new men's fashion craze was born. Cardin's next venture was a line of children's wear in 1966. Cardin even opened a children's shop on the Rue du Faugourg Saint-Honoré in Paris for the collection.

As the space age–inspired 1960s drew to a close, Cardin's designs reflected a new direction. The designs became more refined in the 1970s. His collections incorporated drapey fabrics, pleating, quilting, and asymmetrical design lines in either the hemline or neckline. His bold use of pattern was still apparent but more subtle. Cardin reached back to his sixties heritage for space-age influence in the early 1990s. His couture line again showed futuristic characteristics reflecting a return to his interest in science and technology. In 1992 Cardin debuted Paris by Cardin, his first new line in the United States in thirty years. Cardin suffered an unfortunate loss in 1993 when Andre Oliver, a designer, retailer, and friend of Cardin's, passed away in Paris. Oliver was instrumental in the development of Cardin's men's and women's couture and ready-to-wear collections.

Cardin began to expand his business globally in the late 1970s. First, Cardin's licensee Gruppo GFT entered into a joint venture with Tianjin Jin Tak Garment Company, a suit factory, to produce garments under the

Pierre Cardin label. In 1983 Cardin became the first French designer to retail his line in the Soviet Union. Cardin also opened several outlet stores in India in 1996 under the name Pierre Cardin Fashions, Pvt. Ltd.

Pierre Cardin may be best known around the world for his numerous fragrances. His first fragrance, Geste, was introduced in 1958. Cardin signed a licensing agreement with Jacqueline Cochran, a division of America Cyanamid, in 1970 to introduce his first men's scent, Escape, which he followed with the fragrance Pierre Cardin. The fragrances were in high demand, and Cochran began distributing the fragrances to the mass market. Ultimately, this widespread distribution to moderate and budget retailers damaged the brand's identity and Cardin's name. Cardin was unable to regain control over his product, and name, until the license expired in 1991. The license was reassigned to Tsumura International, Inc., who also held the license for Cardin's fragrances Pierre Cardin pour Monsieur, Bleu Marine de Cardin, and Rose Cardin. The fragrances were initially launched with a limited distribution in Europe but were later expanded to the United States. Cardin continued to expand his fragrance lines between 1992 and 1995 adding the men's scents Enigme, Insatiable, and Pierre Cardin Sportif, which were carried in moderate department stores such as J.C. Penney's and the French hypermarket Carrefour.

Cardin was a genius when it came to promoting his name. He licensed his name to a wide array of products including chocolate, pens, cigarettes, frying pans, alarm clocks, mineral water, cassette tapes, car-seat covers, and more. He has accumulated over 900 licenses worldwide, a feat to which no other designer even comes close. Cardin is the first couture designer to engage in such an exhaustive campaign to exploit his name. Cardin has over thirty licenses for apparel products including shoes, lingerie, blouses, neckwear, leather goods, belts, accessories, suits, and pants for men and women. His licensees include some of the largest manufacturers in the world such as Hart, Schaffner & Marx, Intercontinental Branded Apparel, Harbor Footwear Group, Vestra, Burma Bibas, Coronet, Appel Corporation, and Salant Corporation.

In addition to apparel and accessories, Cardin designed a collection of furniture which was produced in his French factory in 1970. The furniture line was designed to create an atmosphere for his clothing line. This line was relaunched in 2000 in collaboration with Daniel You. Another unique opportunity was presented to Cardin in 1988. He entered the restaurant business with the well-known French restaurant Maxim's de Paris (now Maxim's Restaurant). The complex held more than 125 guests in the L'Omnibus Restaurant and another 225 guests in the moderately priced bistro Super Club. Maxim's is now located around the world in areas such as Rio, Brussels, Peking, Monte Carlo, Sydney, and New York.

Pierre Cardin is probably the wealthiest haute couture designer, realizing over $2.5 billion a year through his various product lines. His name ap-

pears on more than 800 different products in over 100 countries. He has accomplished this not just with his ingenious brand licensing, but also by being a fashion innovator and entrepreneur. Early in his career he recognized both the financial and marketing benefits of incorporating ready-to-wear and licensed products into the offerings of his couture house. He is one of the few couture designers ever to finance solely his own couture operation. His acute business sense and design abilities have allowed his couture line to retain its cachet, despite the widespread distribution of his licensed products to moderate retailers. *See also*: Paquin; Elsa Schiaparelli; Christian Dior.

Website: http://www.pierrecardin.com

REFERENCES

Gellers, Stan. "The Big Brand Era." *Daily News Record* 25 (January 18, 1995): S30.

Milbank, Caroline Rennolds. *New York Fashion: The Evolution of American Style.* New York: Harry N. Abrams, 1989.

Murray, Maggie Pexton. *Changing Styles in Fashion: Who, What, Why.* New York: Fairchild Publications, 1989.

N. S.

Carolee

B. 1972

Birthplace: Greenwich, Connecticut

Award: National Woman Business Owner of the Year, 1999

Carol Friedlander, founder, president, and chief executive officer of Carolee Designs, has succeeded literally in building a business from the ground up. Friedlander's jewelry line was originally produced in her home before she launched her collection nationwide in 1985. The costume jewelry line she produces contains signature elements such as synthetic pearls that are so finely crafted as to appear genuine. Friedlander creates this illusion through a lost-wax casting process she employs in the production of each piece, a process which results in the look of fine jewelry.

The Carolee line was launched to the forefront of the costume jewelry industry when Friedlander designed a collection in 1987 based on jewels from the Duchess of Windsor's collection. This collection brought Carolee to a new prominence in the public eye and allowed her to open her first boutique, located in Short Hill, New Jersey, in 1988. Friedlander's success continued to grow throughout the early 1990s as she focused her attention

on publicity for her company. One of Friedlander promotions was a joint venture with Estée Lauder USA called custom color consultation. The promotion was held at Bloomingdale's in New York City at the Estée Lauder counter with consultants from both Carolee and Estée Lauder. Consultants worked together to advise customers on techniques for selecting cosmetics and accessories that complement each other. The success of this promotion lead to new, exciting opportunities for Friedlander to expand her business, including entering into a licensing agreement with Ralph Lauren for a line of Polo jewelry to be launched in spring 1995.

Another turning point in Friedlander's career came in 1996 when she attended a Sotheby's auction. At the auction she purchased a collection of Jacqueline Kennedy Onassis's jewelry for $81,000. From this collection, she created a seventeen-piece Carolee collection which virtually replicated the original pieces. After a special unveiling at the New York Bloomingdale's flagship store, the collection was distributed to other Bloomingdale's stores across the country. This special collection also inspired Friedlander to expand into fine jewelry. Her new fine jewelry collection includes such materials as freshwater pearls, sterling silver, gold, and hematite.

Friedlander's company is located in her hometown of Greenwich, Connecticut, with factories in Providence, Rhode Island, and Greenwich, Connecticut. Friedlander produces new collections four times a year which can be purchased at department and specialty stores worldwide. She has also added new product lines to her company including handbags, belts, and small leather goods which are produced by Koret of California. *See also*: Estée Lauder; Ralph Lauren.

REFERENCES

Hessen, Wendy. "Jackie O Pearls to Launch Carolee Line at Bloomingdale's." *Women's Wear Daily* 172 (August 29, 1996): 10.
Milbank, Caroline Rennolds. *New York Fashion: The Evolution of American Style.* New York: Harry N. Abrams, 1989.
Newman, Jill. "Carolee and Lauder: Getting Together." *Women's Wear Daily* 163 (May 8, 1992): 10.
Pofeldt, Elaine. "The Self-made Women." *Success* 44 (June 1997): 37.

N. S.

Cartier

B. 1819

D. 1904

Birthplace: Paris, France

Almost from the moment Louis-François Cartier took over the shop of his former employer in 1847, he attracted prosperous clients by selling jewelry and art objects which he purchased from numerous manufacturers. He opened several more locations over the years, but the Cartier name became even better known when, in 1899, son Alfred and grandson Louis opened a new shop at 13 Rue de la Paix in Paris, which was, at that time, the heart of the haute couture and jewelry district. Louis, in fact, married Andree Worth, granddaughter of Charles Frederick Worth, the "Father of Haute Couture," that very same year. To this day, it is still Cartier's primary location.

The fame of Cartier continued to grow, especially when the company started to restore, redesign, and create custom pieces for the aristocrats of Europe. For the coronation of Edward the VII, so many orders were received from London that the London branch was opened the same year, 1902, and eventually managed by grandson Jacques, who remained as director there for the rest of his life. In 1909 grandson Pierre opened the New York branch on 5th Avenue. Although the Cartier shops were located in only three cities until the 1960s, the business stretched throughout the world. From Saint Petersburg to Moscow, from Bombay to Kashmir, the House of Cartier offered the rich and powerful the most superb quality and design in watches, brooches, rings, bracelets, necklaces, and objets d'art.

Many new styles of jewelry came from the Cartier workshops. Among their best-known innovations are the *broche de décolleté* (dress clip or clasp), first shown at the 1925 Paris Exhibition; their convertible jewels, such as the brooch that turns into a pendant and the headband that converts to two bracelets; diamond "curls," individually mounted and attached to one's hair or eyebrow; and beautiful objects (cigarette cases, perfume bottles, desk clocks, powder boxes, and so on) inspired by ancient motifs from Egyptian amulets, Japanese scrolls, Chinese carvings, and Islamic miniatures.

The Cartier style was also differentiated by a nontraditional approach to design, such as the famous panther-skin ornamentation, which became the house symbol; the brilliant use of color (emeralds, mother of pearl, coral, lapis lazuli); and the introduction of platinum, the precious metal which Louis Cartier described as "the embroidery of jewelry" due to its ability to retain strength even when a very thin gauge is used. Evidence of its flexibility can be seen in the light and lacy effects for which their delicate pieces are known.

Still coveted today are the fine watches Cartier is known for, among which is the Tank, a modern simple rectangle with gold bars on each side, and the Santos-Dumont, a sleek and flat square which is both timeless and functional. Perhaps Cartier's most enduring contribution to wristwatch

style is the *boucle deployante* or folding buckle, introduced in 1910 and currently used in many contemporary timepieces.

The Maison Cartier was owned by family members until 1962, when great grandson Claude sold the New York branch and, within a few years, the Paris and London branches. In 1972 the company was reunited by its new owners, and in 1973 a new mass-produced line of articles known as *Les Must de Cartier* was introduced through *Must* boutiques throughout the world. Today, Cartier Monde is renowned for its writing instruments, handbags, perfumes, and scarves, as well as timeless gems of extraordinary quality. *See also*: Charles Frederick Worth.

Website: http://www.cartier.com

REFERENCES

Rudoe, Judy. *Cartier: 1900–1939*. New York: Harry N. Abrams, 1997.
Snowman, A. Kenneth, ed. *The Master Jewelers*. New York: Harry N. Abrams, 1990.

S. B.

<center>❧❦</center>

Oleg Cassini

B. April 11, 1913

Birthplace: Paris, France

Awards: Mostra della Moda, Turin, 1934
 Honorary Doctor of Fine Arts, International College of Fine Arts, Miami, Florida, 1989

Oleg Cassini-Loiewski grew up in Saint Petersburg, Russia. He was born into nobility (his father held the title of count); his grandfather served the czar as minister to China and later to the United States; and his father was the secretary of the Russian Embassy. After the Russian Revolution, the Cassini family relocated in Florence, Italy. It was in Florence that Cassini was exposed to fashion through his mother who opened a dress shop, the Maison de Couture. As a child Cassini enjoyed the leisurely life of nobility, learning to ride, fence, play tennis, and play the piano. He also developed a talent for designing costumes for masquerade parties. Between 1931 and 1934, Cassini attended the University of Florence, while selling his first creations in his mother's dress shop. After his studies, Cassini received an apprenticeship with the Parisian designer Jean Patou.

In 1936 Cassini immigrated to the United States. Because the Italian currency restriction allowed him to take only $100 out of Italy, by the time

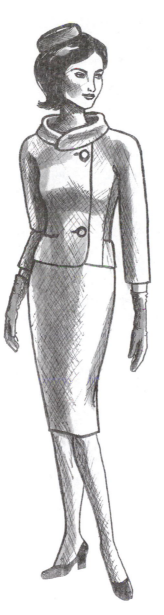

Oleg Cassini: The classic tailored suit and pillbox hat were the trademarks of the sophisticated look Cassini created for Jacqueline Kennedy.

he arrived in New York all he had was $25, a tennis racquet, and a dinner jacket. Poverty was a new experience for the count and surviving in Depression-era New York was difficult. To make money, Cassini played in tennis tournaments along the East Coast, which allowed him to mingle with the elite. He tried to retain a position as a fashion designer, working for Jo Copeland in 1936, William Bass in 1937, and James Rotherberg in 1938 and 1939, but he never achieved any measure of success.

Cassini's entrée to the fashion arena finally came through the movie industry. Cassini signed a seven-year contract with Paramount and worked for other studios, and he designed wardrobes for some of the most glamorous stars including Veronica Lake, Grace Kelly, Marilyn Monroe, Gene Tierney, and Natalie Wood. In 1942 Cassini, now a U.S. citizen, postponed his design career to serve his newly adopted country in World War II. After the war, Cassini found investors to provide him with the finances to found his own business in 1950. His first collection was so popular with U.S. buyers that he wrote enough orders to pay back his investors and become sole owner of Oleg Cassini, Inc.

By 1960 Cassini was a well-known, well-respected American designer, and as a longtime friend of John F. Kennedy, he was granted the much-coveted position as Jacqueline Kennedy's official designer. Jacqueline Kennedy had always been dressed by the finest couturiers in Paris, but now, as First Lady, she felt it was important to promote American fashions and American fashion designers. Cassini consulted with Jacqueline Kennedy on fabrics, colors, and silhouettes to determine the best garments for all her social appearances. He purchased only the best fabrics from Europe for her creations. This new position demanded so much of his time that he had to devote a separate workroom to her wardrobe. To ensure proper fit, Cassini housed three dress forms and employed a fit model with the first lady's body measurements. Cassini was also in charge of accessorizing each outfit, either by designing the pieces himself or by arranging for them to be made.

Together, Cassini and Jacqueline Kennedy created many memorable garments which captured the essence of 1960s femininity and the imagination of the American public. The "Kennedy look" created by Cassini featured boxy jackets with slim skirts for day, long strapless fitted dresses for evening, and her personal favorite, a two-piece ensemble consisting of a fitted dress and short jacket with a detachable Russian sable collar. Each ensemble was always completed by Cassini's original creation, Kennedy's signature pillbox hat. All of Cassini's designs for the first lady were simple and sophisticated. The combination of Cassini's elegant designs and Kennedy's grace brought worldwide attention to the American fashion industry.

In 1963 Cassini introduced his first menswear collection. Cassini's men's collection broke from the traditional white dress shirt and introduced col-

ored dress shirts paired with traditional three-piece suits. During the 1970s, Cassini designed a line of tennis clothes for Munsingwear and a line of swimwear for WaterClothes.

Cassini's popularity waned after his association with Jacqueline Kennedy ended, and he began transitioning from designer lines to licensed products. He introduced dresses under the Dress Emporio Oleg Cassini label licensed to He Ro Group, Ltd., and the Cassini Dress Studio label licensed to Dress Industries. Cassini licensed outerwear under the Oleg Cassini Couture label, active wear under the Oleg Cassini Actis label, and sleepwear under the Cassini Intimates label. He also entered into a licensing agreement with Aspects Handbag Company to produce day and evening handbags and launched a fragrance, A Love That Never Ends.

Cassini also continued to expand his men's business through licensing agreements. He licensed dress and sport shirts to Boonshaft, Inc., then to Burma Bibas, and finally to the Wilk Shirt Corporation. In 1996 Cassini signed a licensing agreement with the Chicago-based Gingiss Formalwear to design a line of tuxedos and formal-wear accessories. This line would become one of Cassini's most popular licenses, providing stylish, yet moderately priced formal wear to over forty retail stores and 200 franchises.

Cassini, who was once known as the White House "Secretary of Style" for his role in the creation of the Kennedy-era Camelot, is now known primarily for licensing. His name appears on a wide range of products including men's and women's moderately priced fashions, ties, luggage, children's wear, makeup, shoes, and umbrellas. In the 1960s, Cassini dressed the woman who was the closest thing that America has ever had to royalty. Today he lends the cachet of his name to fashions for middle-class America. *See also*: Jean Patou.

Website: http://ww.olegcassini.com

REFERENCES

Milbank, Caroline Rennolds. *New York Fashion: The Evolution of American Style.* New York: Harry N. Abrans, 1989.
"Oleg Cassini Licenses Gingiss for Formalwear." *Daily News Record* 26 (August 1, 1996): 4.
Pogoda, Dianne M. "Oleg Cassini Heads Formal Daytime." *Women's Wear Daily* 162 (October 22, 1991): 24.

N. S

Jean-Charles de Castelbajac

B. November 28, 1949
Birthplace: Casablanca, Morocco

Awards: Centre Georges Pompidou, Paris, 1978
 Forum Design, Linz, Austria, 1980
 Laforêt Museum, Belgium, 1984

Castelbajac began designing for his mother's apparel manufacturing company, Ko and Co., when he was only eighteen. He introduced his first line for the company in 1968. Soon thereafter, he worked as a design assistant at Pierre d'Alby.

After starting his own label in 1970, Castelbajac quickly became known for taking everyday materials, such as gauze, terrycloth, and blankets, and transforming them into garments. He soon shifted to creating wearable art, which peaked in popularity during the early 1980s. At that time, many people turned to art-inspired clothing as a form of conspicuous consumption. By working with intense color and architectural shapes, he designed garments which were playful and outspoken without being flashy.

Garments like his sleeping-bag coat, blanket coat, and clear plastic jacket filled with colored feathers cemented his reputation in outerwear. Also known for his sportswear and jeans wear, he outfitted such fashion-forward musicians as Elton John, Rod Stewart, and the Talking Heads. The U.S. Olympic gymnastic team wore his designs during the 1984 events in Los Angeles.

In addition to designing for his own label, Castelbajac has worked for Carel Shoes, Jesus Jeans, Julie Latour, Levi Strauss, Max Mara, and Les Createur, a design group including Issey Miyake and Emmanuelle Khanh. From 1994 to 1996, he designed the ready-to-wear collections of André Courrèges. He has licensed his name to two fragrances: Premier de Jean-Charles in 1982 followed by a men's scent. His other licenses include chocolates, home furnishings, jewelry, and shoes. *See also*: Levi Strauss; Issey Miyake; André Courrèges.

REFERENCES

"Castelbajac Doing Courrèges RTW Collection." *Women's Wear Daily* 166 (September 2, 1993): 7.
George, Leslie. "Fashion Institute of Technology's Castelbajac Exhibit: Celebrating his U.S. Muse." *Women's Wear Daily* (February 7, 1986).
Martin, Richard, ed. *Contemporary Fashion*. New York: St. James Press, 1995.

A.T.P.

❧❧

Catalina

Award: Los Angeles Chamber of Commerce Golden 44 Award, 1979

Catalina, a leading swimwear and active-wear company, originated as a manufacturer of underwear and sweaters under the name of Bentz Knitting

Mills. As the company grew, it underwent several name changes. From Bentz Knitting Mills, the company became Pacific Knitting Mills in 1912; after that, they became Catalina Knitting Mills in 1928 and finally Catalina in 1955. Catalina launched its first wool knitted swimwear collection in 1912. The company employed Annette Kellerman, an Australian swim star, as a spokesperson to launch their functional, comfortable one-piece suit. Throughout the 1920s, as swimming and sun tanning became popular pastimes and bathing-beauty contests began to be held on the boardwalk, Catalina expanded their swimwear production, always keeping in mind fashion plus function.

The 1930s and 1940s brought new excitement to the swimwear industry: the invention of Lastex, a rubber-cored thread, known for giving stretch to fabric and providing shaping and support. Catalina, one of the first to use this new thread in the production of their swimwear fabrics, first employed the new elastic thread in men's swim trunks, which were sometimes referred to as having "Lastex Appeal."

Catalina was clever when it came to marketing their product lines. The proximity of the company to Hollywood allowed Catalina to draw upon star power to help popularize their lines. Catalina's association with Warner Brothers costume designer Orry Kelly and makeup artist Perc Westmore helped them gain access to such stars as Ronald Reagan and Marilyn Monroe as models for their swimwear. Other designers also supported the Catalina label, including Elizabeth Stewart, Gustave Tassell, Frank Smith, and John Norman.

Catalina promoted their swimwear line in the 1940s through beauty pageants. The first pageant was the Miss America Pageant held in Atlantic City. Catalina became the sole supplier of the flying-fish logo suits for the competition. Although Catalina ended its exclusive agreement with the Miss America Pageant in 1950, it continued to promote its swimwear through the Miss USA, Miss Teen USA, and Miss Universe pageants. Catalina was responsible for founding all of these pageants and was exclusively affiliated with them until 1993.

In 1975 Catalina was purchased by Kayser-Roth which sold the company to Taren Holdings Incorporated in 1989. Taren Holdings declared bankruptcy in 1993 and sold Catalina to Authentic Fitness Corporation. Catalina now consists of six product lines: children's swimwear, junior swimwear, misses swimwear, misses sportswear, men's swimwear, and men's sportswear. Catalina's main operations are based in Los Angeles, with the manufacturing based in Utah for the swimwear division and in the Far East for the sportswear division. For nine decades, Catalina has "shaped" the swimwear industry. From the one-piece, skirted, wool bathing suits of the 1910s and 1920s, to the first two-piece swimsuits of the 1930s and 1940s, to the tiniest bikinis of today, Catalina has been an important design force in the swimwear industry. Catalina has retained its

prominence in the swimwear industry through glamorous promotional events and well-engineered swimwear which always considers fashion plus function.

REFERENCES

Lencek, Lena, and Gideon Bosker. *Making Waves: Swimsuits and the Undressing of America.* San Francisco: Chronicle Books, 1989.
Martin, Richard, and Harold Koda. *Splash! A History of Swimwear.* New York: Rizzoli, 1990.

N. S.

Nino (Antonio) Cerruti

B. 1930

Birthplace: Biella, Italy

Awards: Bath Museum of Costume Award, 1978
 Cutty Sark Award, 1982, 1988
 Pitti Uomo Award, 1986

It has been said by many who have known him that Nino Cerruti is more businessman than designer, more manager than creative talent, more realist than innovator. But there is one area in which all agree: he is, indeed, a visionary. From the moment he took control at age twenty of his family's textile firm (founded in 1881), he foresaw what integrated operations would do for the business, and, as a result of his tremendous success, was eventually copied by many other companies. Today he rules an operation that begins in the Cerruti Brothers mills, continues with clothing design and production, and expands into fragrances and accessories, all of which are packaged and presented via sophisticated advertising and promotion. Voila! Vertical integration.

Viewed as a fashion revolutionary early in his career, Cerruti introduced his first men's ready-to-wear line, Hitman, in 1957. In 1967, he showed unisex clothing and, also that year, opened his boutique in Paris, Cerruti 1881. Ultimately, he became best known for cultivated refinement and sophistication in menswear, the result of his devotion to excellence in tailoring and his love of richly textured fabrics, and for his successful fragrances, manufactured by Elizabeth Arden.

Cerruti knew the value of publicity. He cleverly cultivated the business of actors and movie studios. Orson Welles, Jean-Paul Belmondo, and Mi-

chael Caine were among those who frequented his Right Bank boutique, known for its fine workmanship. Throughout the 1970s, he created film wardrobes for such actors as Yves Montand and Alain Delon. One of Cerruti's most enduring contributions to men's fashion has been the designs he created for the male stars in *Miami Vice*, the revolutionary television show of the late 1980s, which showed American men that it is acceptable to dress in brightly colored suits with t-shirts, unconstructed blazers, and sportswear in pastel shades. He went on to design costumes for Jack Nicholson's character in *The Witches of Eastwick* (1987); for *Philadelphia* (1993), the groundbreaking drama starring Tom Hanks; for Richard Gere in *Pretty Woman* (1990); and for Oliver Stone's film *Wall Street* (1987), among others.

Nino Cerruti's influence has been felt in all areas of the international fashion industry. His famous protégé Giorgio Armani learned all about fabrics and manufacturing during his six years with the company, enjoying, along with his former boss, much of the praise that resulted from Cerruti's forays into film. Cerruti has continuously displayed the ability to combine the artistic with the logical, the traditional with the modern, and the historic with the technological—all of which has enabled him to maintain the success he enjoys today. Throughout his career, he has demonstrated, perhaps, the most important ingredient of all—good taste. *See also*: Giorgio Armani.

Website: http://www.cerruti.net

REFERENCES

Agins, Teri. *The End of Fashion: The Mass Marketing of the Clothing Business.* New York: William Morrow, 1999.

The Fashion Book. London: Phaidon Press, 1998.

Kurz, Yutta. "Cerruti Celebrates Le Festival de Cannes." *Student Internship Report #8.* International Academy of Design and Technology, Chicago, IL (May 1997).

S. B

Gabrielle Bonheur "Coco" Chanel

B. 1883

D. 1971

Birthplace: Samur, France

Awards: Neiman Marcus Award, 1957
London Sunday Times International Fashion Award, 1963

Born in a poorhouse and raised in an orphanage, Gabrielle Chanel was, as a pauper, forced to wear clothing which set her apart from the rest of the young ladies in her convent school. And that is why, explains psychoanalyst Claude Delay-Tubiana, a friend of hers during the last years of her life, "she put all women in a uniform . . . her revenge" (Fire, p. 137).

When Gabrielle turned twenty years of age she was placed, by the school she had attended as a seamstress, in a shop which served wealthy customers. Desiring to become a singer, she often performed at a local music hall where her limited repertoire included a song entitled "Qui Qu'a Vu Coco" from which came her nickname—Coco. One of the patrons of the hall, a wealthy infantryman named Etienne Balsan, became her lover. He invited her to live with him at his estate in the horse-breeding area of France, where she became an accomplished horsewoman, well known for her mannish mode of dress and her disdain for the era's frilly, overly ornamented fashions. Since she was a small, slender woman, masculine attire suited her much better than the opulent Belle Epoque clothing which celebrated the voluptuous figure.

At twenty-six (1909), Chanel opened her first shop in Paris—a hat shop—which promptly became so successful that she moved to the Rue Cambon (1910) where the House of Chanel is located today. In the summer of 1913, a new lover, a rich Englishman named Boy Capel, set her up in a shop in the fashionable resort of Deauville, where she began adding sporty knitwear to her line. These pieces offered relaxed style and required no corsets. Soon after, she opened an even larger shop in Biarritz, in Southwestern France, which attracted wealthy Spanish customers. She had somehow tapped in to a new kind of chic . . . a complete departure from the elaborate designs of Paul Poiret, the reigning king of couture.

Sadly, Capel, said to have been the greatest love of her life, was killed in a car accident, and Chanel, strong willed and independent as she was, needed the attention and devotion of a man. Her relationship with Grand Duke Dimitri Pavlovich, a nephew of the czar, began in 1920 and led her to develop an interest in Russian-inspired tunics and enormous gems, characteristic of the Romanov jewels presented to her by Pavlovich, many of which she used as models for her opulent costume jewelry designs. The duke also introduced her to the son of the czar's own perfumer, with whom she developed her first perfume, Chanel No. 5, packaged in a bottle so elemental and sleek that it could be compared in its simplicity to her "little black dress," also conceived in the 1920s. Today, Chanel No. 5 is the top-selling perfume in France and England and among the top five in Germany and the United States, with yearly sales at approximately 10 million bottles a year.

Chanel was, by this time, socializing with the greatest artists of the era, including Salvador Dalí, Pablo Picasso, Jean Cocteau, and Igor Stravinsky, as well as Winston Churchill, whom she met through her new companion,

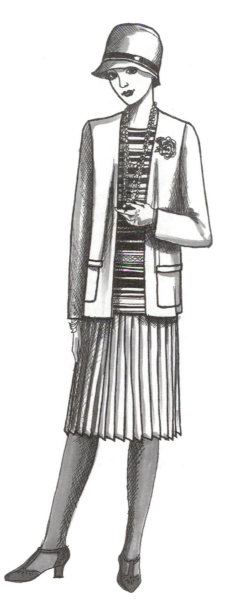

Gabrielle "Coco" Chanel: Chanel's unstructured jackets and skirts in wool jersey provided the new, modern woman of the 1920s with a comfortable ensemble to complement her active lifestyle.

the duke of Westminster, the man Chanel hoped would become her husband. He married, however, an English socialite.

In the 1930s, Horst's famous photographs of Chanel captured her extraordinary looks and signature style—the tanned complexion, the red lips, the stacked bracelets, piled-on necklaces, and the cigarette. Even the appearance of Paris's newest darling, designer Elsa Schiaparelli, did not keep Chanel's business from flourishing. In 1939, when France declared war on Germany, Chanel closed her couture house and began an affair with a German diplomat, thought by many to be a German spy. Chanel's activities during the war years were less than honorable. It has been reported that she tried to gain control of the perfumery, which had been producing her fragrances for many years, by taking advantage of the fact that the owners were Jewish and not allowed to own a business under the Nazi regime. Because of her connections to the Germans, she was exiled to Switzerland following World War II and spent nine unhappy years there, but she was able to travel to Paris on occasion.

In 1954, at the age of seventy, Chanel staged a brief comeback, relaunching her formulaic suit with its two-pocket cardigan jacket, pearl buttons, and braided trim, her quilted handbag, and her black toe pumps. Throughout her design career, she endorsed neatness and perfection in everything from clothing to coiffure, with comfort and proper fit her obsessions. The only deviation from her dedication to tidiness was the cascade of necklaces, both real and fake, she piled on with abandon.

Mademoiselle Gabrielle "Coco" Chanel died in her suite at the Ritz Hotel, in Paris, in 1971. The first choice for her successor was Yves Saint Laurent, who was unavailable. Her two assistants, Yvonne Dudel and Jean Cazaubon, took over the company. The house stagnated for over a decade until 1983 when Karl Lagerfeld was hired as head designer for Chanel. Determined to present clothing right for the moment, but ever mindful of those magical "Cocoesque" elements, Lagerfeld uses the ingredients that are essentially Chanel—the pearls, the gold chains, the white camilla—and gives these classics a new and spirited look.

Today, although the House of Chanel has approximately 150 couture clients, its ready-to-wear line is the mainstay of its clothing sales; there are well over 100 Chanel boutiques around the world. In 1993 the company reintroduced a collection of precious jewelry, with most of the pieces based on the designs from Mademoiselle's 1932 exhibition, *Bijoux de Diamants*. As for its scarves, belts, cosmetics, sunglasses, and so on, the House of Chanel refuses licensing agreements of any kind and maintains control over all divisions of the company. In fact, Chanel is one of the only fashion houses to have its own perfume factory. The current owners and directors insist on sole control of all products that bear its respected label, determined to maintain the image for which the Chanel name is known. Today, the house is owned by the Wertheimer family and is the only one of the

larger couture houses to remain in private hands. *See also*: Karl Lagerfeld; Elsa Schiaparelli.

Website: http://www.chanel.com

REFERENCES

Collins, Amy Fine. "Haute Coco." *Vanity Fair* 57 (June 1994): 132.

Edelman, Amy Holman. *The Little Black Dress*. New York: Simon & Schuster, 1997.

Lynam, Ruth, ed. *Couture*. Garden City N.Y.: Doubleday, 1972.

Mackrell, Alice. *Coco Chanel*. New York: Holmes & Meier, 1992.

Madsen, Axel. *Chanel: A Woman of Her Own*. New York: Henry Holt, 1990.

Tapert, Annette, and Diana Edkins. *The Power of Style*. New York: Crown Publishers, 1994.

S. B.

Chloé

Jacques Lenoir and Gaby Aghion envisioned a deluxe, ready-to-wear house which would epitomize modern, wearable femininity when they opened Chloé in 1952. The timing was perfect; five years after the introduction of the constrictive, corseted New Look, more functional clothing was part of the future of fashion. Throughout its history, femininity has been the unchanging factor in Chloé's identity.

Although Chloé has hosted several designers over its lifetime, its most prominent designer was Karl Lagerfeld. He joined the house in 1963 as one of four designers. By the early 1970s he overcame Graziella Fontana, the last of the other three designers, to become chief designer.

Lagerfeld's designs brought the house to its peak of popularity and influence during the late 1960s and 1970s. He designed upscale versions of hippie clothes. His swirling gypsy slip dresses, skirts, and blouses gained immediate devotees. Although he left the house in 1983, when he returned in 1992 he resumed where he had left off. His updated, hippie-inspired slip dresses crafted from nostalgic 1970s prints were immensely popular during the flower-child resurgence of the early 1990s. He stopped designing for the house in 1997.

When Martine Sitbon began designing for Chloé in 1987 she took the house in a new direction by focusing on feminizing masculine tailored suits. She transformed the suits by adding delicate chiffon and silks as blouses, pants, and skirts. Her frilled collars and low-cut necklines emphasized the bust. In 1991 she left the house to create her own line.

In 1997 Stella McCartney, Paul McCartney's daughter, took over the designing helm. She trained at Central St. Martin, Savile Row, and Chris-

tian LaCroix before starting her own line, and she gave up that line to design for Chloé. Her first lines added romantic touches, including antique lace and glass buttons, to modern tailoring.

The house has entered into few licensing agreements, concentrating on the successful fragrances Chloé and Narcisse. Dunhill Holdings PLC acquired Chloé in 1985. Vendome, the luxury conglomerate which also owns Cartier, Mont Blanc, Alfred Dunhill, and Piaget, purchased the company in 1993. *See also*: Karl Lagerfeld; Christian Lacroix.

REFERENCES

Conti, Samantha. "This May Be Lagerfeld's Last Season with Chloé." *Women's Wear Daily* 172 (December 3, 1996): 2.
"Lagerfeld Backs Bid by Biderman." *Women's Wear Daily* (October 17, 1983).
Mower, S. "Keeping up with Karl." *Harper's Bazaar* (January 1993): 82–83.
 A.T.P.

Ossie Clark

B. June 9, 1942
D. August 6, 1996
Birthplace: Liverpool, England

In the late 1960s and early 1970s, when London's Chelsea neighborhood was the center of world chic, one designer was at the center of that world. Ossie Clark, along with his wife, Celia Birtwell, famous for her tuned-in textiles with psychodelic prints, helped define the moment.

Born into a working-class family, Clark took courses at a technical college and studied art at a local college. He ultimately attended London's Royal College of Art on a scholarship and graduated with honors. Clark's clothing designs quickly attracted the attention of some of the most memorable personalities of the moment. He is probably best known for designing the costumes of rocker Mick Jagger, lead singer for the Rolling Stones, and for Dave Gilmour of Pink Floyd. Clark's most notable creation was probably the iconoclastic snakeskin suit he designed for the companion of Stones guitarist Keith Richards, singer Marianne Faithfull; every fan knew she and her girlfriend, Anita Pallenberg, took turns wearing the treasured garment.

Clark, who loved fabric, used everything from his wife's painted chiffons and satins in his 1930s style gowns to painted paper dresses, resulting in a kind of whimsical, yet glamorous look, which the public loved. His ethereal creations were often shown in unconventional settings, like London's Chel-

sea Town Hall, on dancing and twirling models. Each piece had a secret pocket, just big enough for some money and a key, his special trademark. In the early 1970s Clark called upon a talented new shoe designer, Manolo Blahnik, who had just arrived in London and asked him to design a line of shoes exclusively for his company.

Personal difficulties, along with changing aesthetics and values, resulted in a declining demand for Clark's creations, but many of his customers, like Bianca Jagger, remained faithful to him throughout his life. He and his wife were immortalized by their friend, famed artist David Hockney, in the well-known painting, *Mr. & Mrs. Clark and Percy*, which hangs today in Chicago's Art Institute. *See also*: Manolo Blahnik.

REFERENCES

The Fashion Book. London: Phaidon Press, 1998.
Martin, Richard, ed. *Contemporary Fashion*. New York: St. James Press, 1995.

S. B.

Cole of California

Award: Los Angeles Chamber of Commerce Golden 44 Award, 1979

Cole of California was founded by Fred Cole, a former actor at Universal Studios. Cole's family wanted him to join their underwear manufacturing operation, West Coast Knitting Mills; however, Cole found underwear design uninspiring and decided to produce swimwear instead. Cole's attitude toward swimwear design was not typical for the time. While most swimwear designers of the 1920s and 1930s were concerned with designing functional swimwear, Cole was interested in designing fashionable swimwear.

Cole's first swimsuit design was dubbed the "prohibition suit" because it was considered quite revealing for the time. Despite its scandalous reputation, the suit was extremely popular, and it became known as the first true fashion swimsuit. Cole's designs were inspired by exposure to the glamor of Hollywood. He translated the allure of Hollywood into swimwear for glamorous movie stars and for ordinary women who wanted to look and feel glamorous.

The first designer for Cole's label was Margit Fellegi, a costume design student from the School of the Art Institute of Chicago. Fellegi had already built a reputation for herself as "*the* swimwear designer for Hollywood" when she came to work for Cole in 1932. Fellegi had developed a "Matletex process," which allowed cotton fabric to be shirred on elastic thread.

This process allowed Fellegi to manipulate the style lines of her swimsuit designs without sacrificing a close fit. Fellegi's combination of distinct patterns, vibrant colors, and unusual design lines caught the eye of both film stars and average women.

Fellegi became even more popular in 1964 when she designed the "scandal suit" collection by Cole of California. The "peek-a-boo suits" consisted of variations on black leotards which selectively exposed certain areas of the body with cutouts of elastic mesh. Fellegi's new elastic mesh provided shaping and support while, at the same time, creating a transparent, sexy look. To promote the new suit line, Cole launched an advertising campaign with a provocative photograph of actress Joan MacGowan mouthing the words, "Isn't it time somebody created an absolutely wild scandal for nice girls?"

Anne Cole, the daughter of Fred Cole, began designing for Cole of California in 1982 and launched a signature collection under her own name. Anne Cole's collection was distinguished by an innovative use of fabrics. Her 1986 collection, inspired by fashions from the 1960s, was fabricated in vinyl and metallic swimwear fabrics. When the collection was photographed for the swimsuit edition for *Life* magazine, it exposed Cole's line to viewers all across America. In 1994 Anne Cole launched her Anne Cole Locker collection which featured functional swimwear and active wear for working out. The line was also labeled as Faux Fitness in association with its parent company, Authentic Fitness Corporation. Authentic Fitness Corporation purchased Cole of California from Taren Holdings in 1993. Taren Holdings, which also sold Catalina to Authentic Fitness Corporation, purchased Cole of California from Kayser-Roth in 1989.

Over the past seven decades, Cole of California has expanded its product lines to include offerings under the Cole, Sandcastle, Anne Cole, Adrienne Vittadini, Hot Coles for juniors, and Juice for juniors labels. Each label is made in one of the company's nine plants in Utah. The collections are sold in department stores or specialty stores across the country. Fred Cole, credited for transforming his family's underwear business into an amazing swimwear company, will be remembered for his racy, glamorous, fashionable suits. He brought fashion into swimwear, making the average women feel elegant while sunbathing on the beach or by the pool.

REFERENCES

Lencek, Lena, and Gideon Bosker. *Making Waves: Swimsuits and the Undressing of America*. San Francisco: Chronicle Books, 1989.
Martin, Richard, and Harold Koda. *Splash! A History of Swimwear*. New York: Rizzoli, 1990.

N. S.

Kenneth Cole Productions Inc.

B. 1982

Birthplace: New York City, New York

Kenneth Cole was born and raised in Brooklyn, New York, where he was exposed to shoemaking by his father whose El Greco ladies shoe manufacturing business produced Candies shoes. At twenty-two Cole realized he wanted to venture in the world of law rather than shoes and planned to attend New York University of Law but decided to delay his decision when an important employee of his father's company left. The vacant position in his father's business gave Cole the opportunity to sketch his own shoe collection, which he called Earthpadilles. Cole incorporated natural materials, such as colorful twine for the heel, into his shoe collection. His design philosophy was to mix nature with fashion to achieve refinement. He continued designing for his father's company for the next six years, while learning every aspect of the shoe business.

In 1982, at the age of twenty-eight, Cole took his $200,000 savings and invested it in his own footwear line which he produced out of an upper-east side Manhattan apartment. His goal was to develop a collection for the New York market. Cole's limited financial resources provided challenges in both manufacturing and introducing his new line. To save money on manufacturing, Cole traveled to Italy where he could produce his samples more economically than in New York. To introduce his line to buyers, Cole had planned to borrow a friend's forty-foot trailer to park in midtown Manhattan; however, permits to park a trailer in Manhattan were given only to motion picture companies and utility services. This small obstacle did not stop Cole, who quickly changed his company's name from Kenneth Cole, Inc., to Kenneth Cole Productions, Inc., to represent his business as a motion picture company. He also turned this potential problem into a creative marketing strategy and shot a film entitled *The Birth of a Shoe Company*, which helped him sell 40,000 pairs of shoes in two and a half days.

The first brand Cole introduced was Kenneth Cole, a line of women's shoes and boots. The structural details comprised laces, pointy toes, and kicked-in heels, all made of stonewashed denim. After the success of his women's line, Cole introduced his first men's collection in 1983. In 1987 Cole launched another women's label, Unlisted, which was created for a moderate customer looking for quality plus reasonable price. In addition to shoes, the Unlisted line included accessories such as purses and wallets.

The early 1990s were very exciting and successful for Cole. He launched a catalogue business, opened seventeen Kenneth Cole freestanding stores in the United States, opened fourteen concept shops in Federated department stores, and launched a bridal shoe collection and a new shoe line called Reaction. By 1997 Cole had expanded his business to the international market, opening two freestanding stores, one in Amsterdam and the other in Singapore, as well as signing an agreement with Dickenson Concepts, Ltd., of Hong Kong to wholesale and retail his products in Asia.

In 1996 Cole ventured into menswear through a licensing agreement with Hartmarx's Intercontinental Branded Apparel Division. This agreement enabled Cole to produce two lines, one which was sold in better specialty stores and another which was sold primarily in department stores. The Hartmarx division produced and marketed contemporary tailored garments such as sports coats, top coats, suits, tailored shirts, and pants under the Kenneth Cole and Kenneth Cole New York labels. A men's moderately priced sportswear line was also introduced under the Reaction label through a licensing agreement with Gruppo Covarra.

Currently, Cole is the president and chief executive officer of Kenneth Cole Productions. His business has diversified from his original women's footwear line to include women's and men's footwear, women's and men's apparel, leather handbags, and accessories. In addition to Hartmarx and Gruppo, he holds licensing agreements with Cluett Designer Group (dress shirts), Bedford Sportswear (leather outerwear), Paul Davril, Inc. (fabric outerwear and sportswear), Host Apparel Group (underwear, loungewear, and robes), Brookville Corporation (neckwear), and Swank (men's belts and jewelry).

Cole consistently designs and produces quality footwear and accessories which reflect and complement the latest trends in fashion. However, his success in the footwear industry can be attributed as much to his creative vision as a designer as to his creative strategies in marketing. Cole's distinctive and often cynical ads, which he writes himself, reflect his philosophy toward fashion. According to Cole, "We may not change the world, but we hope to be an accessory (Block)."

Website: http://www.kennethcole.com

REFERENCES

Block, Toddi Gutner. "Patricide?" *Forbes* 156 (November 20, 1995): 190.
"Kenneth Cole Earnings." *Daily News Record* 28 (March 2, 1998): 12.

N. S.

Comme des Garçons

B. 1942

Birthplace: Tokyo, Japan

Awards: Mainichi Newspaper Fashion Award, 1983, 1988
 Fashion Group Night of the Stars, 1986
 Centre Georges Pompidou Exhibition: Mode et Photo, Comme des Gar-
 çons, 1986
 Chevalier de l'Ordre des Arts et des Lettres, 1993

Her contemporaries are Issey Miyake and Yohji Yamamoto, and, like their designers, her designs emerge from the fabric: the texture, the weave, and the natural imperfections. She considers it her job to question convention, and to take risks. Rei Kawakubo and her label, Comme des Garçons, became synonomous with all that is avant-garde and innovative in fashion, from the moment she presented her first women's clothing line in Tokyo in 1975 and then in Paris in 1981.

She did not intend to become a fashion designer. After majoring in art at Tokyo's Keio University, Kawakubo worked first for a company which produced man-made fibers for use in clothing and then as an independent photo stylist. After several years she grew tired of the unimaginative clothing with which she worked. By combining her interest in complex and imperfect fabrics with her original ideas regarding structure and form, Kawakubo began to create clothing based on the shapes of traditional Japanese clothing but intended to challenge fashion norms and, thereby, the wearer. Referred to as "rag-picker clothing" and "post nuclear chic," her clothing integrates the rips, holes, and shredding found in the crumpled clothing of street people into layered and wrapped body enclosures, producing startling anti-fashion fashion. At first, her designs appear to be confusing, as they lack the symmetry one expects from clothing, but, after further examination, it becomes clear that each garment is beautifully made, highly imaginative, and definitely unlike anything that has been done before. She continuously questions fashion's conventions with her unlikely investigations.

In 1994 Kawakubo surprised the fashion world with her first use of color, which was vibrant and dazzling. A shocking departure from the 101 shades of black which had previously dominated every one of her collections, it was a triumph. Of course, surprises have always been part of her repertoire. In 1992 she gave her assistant of eight years, Junya Watanabe, his own label under the Comme des Garçons name; since then, she has continued to encourage him as his international reputation has grown.

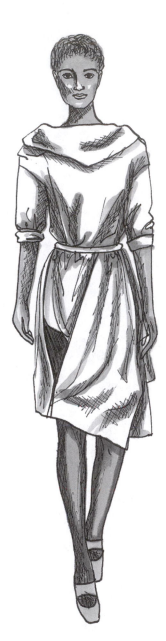

Comme des Garçons: Rei Kawakubo, an avant-garde fashion innovator, explores structure and form based upon traditional Japanese clothing forms to create layered, wrapped body enclosures.

She was hailed by *Vogue* (December 1999) as making "one of the most beautiful statements on the Paris runway. Ever!" Her spring 2000 collection was charged with color; some of the pieces were dyed to turn contrasting shades. Said Kawakubo of the spring show, "The concept was *force*—to instill a sense of pushing the limits of what is beauty." That is pretty much what she has always done. *See also*: Issey Miyake; Yohji Yamamoto.

REFERENCES

Gan, Stephen. *Visionaire's Fashion 2000—Designers at the Turn of the Millennium.* New York: Universe Publishing, 1997.

Grand, France. *Comme des Garçons.* New York: Universe Publishing, 1998.

Kawakubo, Rei. *Comme des Garçons.* Japan: Chikuma Shobo, 1987.

Martin, Richard. *Three Women: Madeleine Vionnet, Claire McCardell and Rei Kawakubo.* New York: Fashion Institute of Technology, 1987.

S. B.

Converse

The origin of Converse shoes dates back to 1908 when Marquis M. Converse established the Converse Rubber Company in Malden, Massachusetts. The small company began producing shoes in 1909. In the last ninety years, the company has grown to become the largest U.S. manufacturer of footwear.

Converse made its mark on the footwear industry when it introduced the canvas All Star® basketball shoe in 1917. Through the endorsement of Basketball Hall of Famer Charles "Chuck" H. Taylor, the shoe captured a majority of the basketball shoe market. As the first athletic shoe endorser, Taylor became a salesperson for the company in 1921. He traveled the country promoting the shoes and conducting basketball clinics for coaches. His signature was added to the ankle patch of the shoe in 1923, and the shoe style became known as the Chuck Taylor® All Star®.

As one of the most popular shoes of all time, over 550 million pairs of the Chuck Taylor® All Star® have been sold. Until the 1970s, when leather supplanted canvas on the basketball court, the shoe retained between 70 and 80 percent of the basketball shoe market. The Chuck Taylor® All Star® continued to be popular as a fashion shoe, and it continues to attract devotees eighty years after its introduction. During the 1970s, Converse developed new, high-performance leather shoes and acquired new endorsers. Following in the tradition of Chuck Taylor, NBA basketball players Larry

Bird, Julius "Dr. J" Erving, and Dennis Rodman have endorsed Converse basketball shoes.

The company has experienced numerous ownership changes since Converse sold it to the Stone family in 1933. Converse became a public company traded on NASDAQ in 1983, and 1994 marked the first year that the company's stock was traded on the New York Stock Exchange under the trading symbol CVE. In 1999 Apollo Investment Fund owned 65 percent of the company.

As Converse grew, it acquired other companies including Tyer Rubber company in 1961 and the Hodgman brand of sporting goods in 1964. Its most notable acquisition was the footwear division of B.F. Goodrich Company in 1972. With the Goodrich purchase, Converse acquired the Jack Purcell® sneaker, a leading tennis shoe since its introduction in 1935. Characterized by simple lines and a blue toe, this shoe was named after the famous badminton player of the 1920s and 1930s who helped design it.

In the 1990s, the company marketed products in more than ninety countries. Its current basketball shoes feature the REACT™ shock absorber. It also markets cross-training, children's, and leisure shoes. In addition, it licenses sports apparel and operates approximately thirty retail stores.

Website: http://www.converse.com

REFERENCES

Horrigan, Kevin. "A Star Is Gone: Converse Departs Taking Our Memories with It." *St. Louis Post-Dispatch* (January 28, 2001): B3.
Sinclair, Tom. "Shoe Business." *Entertainment Weekly* (March 19, 1999): 105.
Weir, Tom. "20th Century: This Day in Sports." *USA Today* (June 24, 1999): 3C.

A.T.P.

෧෨෪෧

Victor Costa

B. December 17, 1935

Birthplace: Houston, Texas

Awards: May Company American Design Award, 1967
Stix, Baer and Fuller Golden Fashion Award, 1975
Wild Basin Award from the State of Texas, 1979, 1982
Dallas Fashion Award, 1980, 1987, 1991
American Printed Fabrics Council Tommy Award, 1983, 1984, 1988, 1989
University of Houston Distinguished Alumni Award, 1990
Fashion Group of San Antonio, Night of the Stars Award, 1991

Houston-based designer Victor Costa, often referred to as the "king of knockoffs" or the "king of Copycats," blossomed at an early age. He discovered his talent for designing and sketching clothes at the age of nine when he found himself designing paper-doll outfits for his friends. Costa continued designing and sketching into his early teens, focusing on bridal wear and creating his first sample garments.

After high school, at age seventeen, Costa enrolled in the Fashion Design Department at Pratt Institute in Brooklyn, New York, for one year, and then transferred to the University of Houston. In 1954, still in his early twenties, Costa traveled to Paris to attend L' Ecole de la Chambre Syndicale de la Couture Parisienne. After his training, in 1958, Costa moved to New York to begin his career in fashion. He began working his way into the industry by selling his European-inspired sketches to established designers such as Oleg Cassini, Ceil Chapman, and others. Costa's first design jobs were with bridal designers Murray Hamberger, from 1959 to 1961, and Pandora, from 1962 to 1965. His experiences with these firms, combined with his talent for recalling every detail of garments presented on the runway, enabled him to gain a position with Suzy Perette. Costa worked for Perette, copying European designs and translating them for the American market from 1965 to 1973.

Shortly after his work with Suzy Perette, Costa designed his first collection and sold over 1,000 pieces to Bloomingdale's. A few years later, in Dallas, Texas, Costa partnered with Robert Licht, a former employee of Suzy Perette, to form Victor Costa, Inc. Costa designed a signature bridge line consisting of special occasion wear, cocktail dresses, and suits. His inspiration for his lines came from visiting the European haute couture and prêt-a-porter fashion shows. Costa, known for having a pictorial memory and a swift hand for sketching, made a name for himself by reinterpreting and refabricating the European couture collections for the bridge and better markets. Costa, who produced his collection in Dallas, oversaw all facets of the production even training employees with the necessary skills for sewing his clothing. His garments were distributed to more than 450 specialty and department stores including Bloomingdale's, Bergdorf Goodman, Nordstrom, and Lord and Taylor.

In 1989 Costa opened his first Victor Costa Boutique in Highland Park Village in Dallas. The freestanding store carried his Victor Costa, Victor Costa Taille (suits), Victor Costa Bridal, and accessory lines. The boutique offered Costa's special customers a chance to view his lines five times a year. Costa dresses both the very young and the very mature. The typical Costa client is fit and wealthy and attends numerous social functions.

Costa's business peaked in 1990 with retail sales of $50 million at

which point he was designing for six divisions: a signature bridge line, a bridal line, a girls' line, an accessories line, a leisure at-home line, and a suit division, Tailleur. He was also designing a dress and suit line for Christian Dior's American market. In 1993 Costa further expanded his product offerings by creating a new, lower price point line, Victor Costa Boutique, to meet the increased demand in the better special occasion dressing market. Another expansion came in 1994, when Costa entered into a licensing agreement with retailer J.C. Penney to produce a collection of holiday evening suits under the label Victor Costa Romantica. Unfortunately, Costa's new additions were short lived. In 1994 Costa declared personal bankruptcy and filed for Chapter 7 bankruptcy for his business in 1995. There has been a great deal of speculation as to the cause of Costa's personal and professional bankruptcy; contributing factors include a 1993 sexual harassment lawsuit against Costa, employee thefts, and the damage to his reputation from designing a line for J.C. Penney. After seventeen years of business, and having accounts with such prestigious stores as Saks Fifth Avenue, Marshall Field's, Neiman Marcus, Bergdorf Goodman, Harvey Nickols in London, and Holt Renfrew in Toronto, Costa closed his doors. Costa's reaction to the closing was, "Every time one door has closed, a window has opened" and "I hope to embark on an exciting new stage in my career and return to my true love—designing" (Williamson).

Costa followed his own advice and signed with a multiple-line sales firm called A.S. A.S. was responsible for showing Costa's collection in regional markets including Dallas, Los Angeles, and Atlanta. Costa's true reason for designing was to create beautiful clothing for women for social functions. He wanted his customers to feel confident and fashionable. His talent to interpret European couture fashions into successful bridge-priced social attire was unique. Costa, like many designers before him, started his business by redesigning Paris originals; however, unlike most designers, Costa never tried to conceal this practice, nor did he ever stop it. *See also*: Oleg Cassini; Christian Dior.

REFERENCES

Milbank, Caroline Rennolds. *New York Fashion: The Evolution of American Style.* New York: Harry N. Abrams, 1989.
Williamson, Rusty. "Social Occasion: Victor Costa Takes Secondary Route." *Women's Wear Daily* 165 (January 26, 1993): 10.
———. "Victor Costa Files Chapter 7." *Women's Wear Daily* 169 (May 8, 1995): 1.

N. S.

André Courrèges

B. March 9, 1923

Birthplace: Pau, Pyrénées Atlantiques, France

Award: Couture Award, London, 1964

André Courrèges was studying architecture at the Ecole des Pont et Chaussées when he realized his true calling was fashion. In 1945 Courrèges moved to Paris to study the art of fashion from master couturier Cristóbal Balenciaga. After years of refining his techniques under the guidance of Balenciaga, Courrèges left Balenciaga in 1961 to open his own house. The first line from the new House of Courrèges echoed Balenciaga: classic, tailored silhouettes in wool and tweed. By the mid-1960s, however, Courrèges had revolutionized haute couture by showing miniskirts, see-through dresses, and cosmonaut suits paired with vinyl boots.

Courrèges's designs, based on geometric forms, reflected his early architectural training. The tailoring skills he developed under Balenciaga were applied to details such as hip yokes, welt seams, patch pockets, and top stitching to create simple, functional clothing which complemented the new, modern 1960s woman. Courrèges's collections were in complete contrast to the corseted and padded variations on the "New Look," which had continued into the 1960s. The Courrèges woman worn flat-heeled boots, not stiletto heels; trousers with tunics, not strapless dresses with full skirts and crinolines; and helmets, not pillbox hats with veiling. Courrèges's new feminine ideal was based on men's clothing. He believed men's clothing was practical and logical and could provide women with a functional wardrobe. In 1965, after his first couture collection, Courrèges sold his house to L'Oreal. After two years, he purchased his house back from L'Oreal, returned to designing, and launched his Prototype couture line in 1967 and his Couture Future ready-to-wear line in 1969.

The 1970s were a period of both expansion and decline for Courrèges. In the early 1970s, Courrèges launched a line of men's ready-to-wear and designed uniforms for the 1972 Olympic Games in Munich and flight attendant uniforms. He also developed several fragrances, including Empreinte, Courrèges Homme, Eau de Courrèges, Courrèges Blue, Sweet Courrèges, and Generation Courrèges. During the late 1970s and early 1980s, Courrèges also signed several licensing agreements for lines of leather goods, scarves, ties, shoes, hosiery, lingerie, gloves, sunglasses, watches, home linens, towels, children's wear, active sportswear, and table wear. However, the once innovative designer who had captured the essence

André Courrèges: Fashion or science fiction? The fashions of the space-age 1960s are epitomized by this Courrèges ensemble which came complete with helmet and boots.

of the 1960s space-age movement did not embrace the new ethnic styles popularized by the 1970s hippie movement, and his prominence as a fashion leader diminished. Courrèges retired in 1993 to pursue painting and sculpting and installed Jean-Charles de Castelbajac as designer for the House of Courrèges. *See also*: Cristóbal Balenciaga; Jean-Charles de Castelbajac.

REFERENCES

Milbank, Caroline Rennolds. *Couture: The Great Designers.* New York: Stewart, Tabori and Chang, 1985.
Schiro, Anne-Marie. "60s Revival Is Official: Courrèges Is Back." *New York Times* 140 (February 17, 1991): 66.

A. K.

D

Lilly Daché

B. 1904

D. December 31, 1989

Birthplace: Beigles, France

Awards: Neiman-Marcus Award, 1940
Coty American Fashion Critics' Special Award, 1943

Lilly Daché was born in 1904 in Beigles, France, the daughter of a farmer. At fourteen, she dropped out of high school and apprenticed in her aunt's millinery shop. One year later, she apprenticed to Reboux, one of the most exclusive milliners in Paris. In 1924 Daché immigrated to the United States where she lived the classic American rags-to-riches fairy tale.

Daché's first position in America was as a designer for Darlington's in Philadelphia. However, she soon moved to New York to work in millinery sales for Macy's, where she was fired for her poor English. Daché's next position, also in millinery sales, was for the Bonnet Shop, the store which held the key to her future. In 1924, after only a few months at the Bonnet Shop, Daché bought the store from the owner.

Daché, a strong, dramatic woman, worked diligently to establish herself as one of the top milliners in New York. The height of her career was during the Great Depression and World War II when her outrageous designs could enliven a woman's otherwise difficult life. She popularized draped turbans, molded brims, half hats, and snoods or hairnets. Her imaginative designs landed her contracts with Travis Banton to design hats for

Hollywood movies starring Joan Crawford, Marlene Dietrich, Carmen Miranda, and Betty Grable in the 1940s.

In 1949 Daché began to expand her business to include other product lines such as dresses, coats, and accessories. She also introduced the fragrances Drifting and Dashing. In the mid-1950s she expanded her millinery lines to include two ready-to-wear labels: Mlle. Lilly and Dachéttes. She also discovered Halston in Chicago and persuaded him to work for her in New York, where he was soon named codesigner, and allowed him to show his own collection alongside Daché's.

During the late 1950s social norms were relaxing. A woman no longer had to don a hat to be considered properly dressed. Daché again expanded her business, this time by opening a beauty salon and by adding cosmetics to her product offerings. However, Daché's heart was not in this new venture. The woman, who at the height of her career produced 9,000 hats per year, closed her doors in 1968. *See also*: Halston.

REFERENCES

Ginsburg, Madeleine. *The Hat: Trends and Traditions.* Hauppauge, N.Y.: Barrons Educational Series, 1990.

McDowell, Colin. *Hats: Status, Style and Glamour.* New York: Thames and Hudson, 1997.

A. K.

Oscar de la Renta

B. July 22, 1932

Birthplace: Santo Domingo, Dominican Republic

Awards: Coty American Fashion Critics Award, 1967, 1973
Coty Return Award, 1968
Neiman Marcus Award, 1968
Golden Tiberius Award, 1969
American Printed Fabric Council "Tommy" Award, 1971
Caballera of the Order of Juan Pablo Duarte, 1972
Gran Comandante of the Order of Cristóbal Colon, Dominican Republic, 1972
Fragrance Foundation Award, 1978
Crystal Star Award for Design Excellence, 1990

Oscar de la Renta was raised in a middle class family with his mother, father, and seven sisters. At seventeen, de la Renta's father sent him to Madrid to study painting. By 1950, de la Renta, inspired by the fine art work he was exposed to, returned to the Dominican Republic to study art

at the National School of Art in Santo Domingo. After two years of studies, de la Renta returned to Spain in 1953 to study at the Academic de San Fernando in Madrid. While in school, de la Renta was exposed to fashion design, and utilized his training as a fine artist to obtain work as an illustrator. In 1955 de la Renta concluded his studies at the Academia de San Fernando, continued to work as a freelance illustrator for Cristobal Balenciaga, Carolina Herrera, Ollero and others until he landed a position with Antonio Castillo at Lanvin in 1961.

By the time de la Renta was thirty, he was living in New York City. From 1963 to 1965, he worked on the Elizabeth Arden couture and ready-to-wear collections. In 1965 he accepted a position, and a partnership, with designer Jane Derby. De la Renta and Gerald Shaw bought Jane Derby from Shaw's father and renamed the company Oscar de la Renta, Ltd. In 1973 de la Renta became the head designer and chief executive officer of Oscar de la Renta, Ltd.

De la Renta is primarily known for his evening ensembles. His use of fabrics, such as his drapey chiffons, rich brocades, plush velvets, crisp taffetas, and jeweled, embroidered fabrics, create romantic, feminine garments. De la Renta adorns his designs with his signature ruffled details on necklines and cuffs. The designer also popularized the Gypsy- and Russian-inspired apparel that dominated the 1970s fashions.

Oscar de la Renta designs under three main labels: Oscar de la Renta Studio, Oscar de la Renta Signature, and Oscar de la Renta Couture. He also designs a bridge line of dresses and sportswear through Apparel Group International and the couture and ready-to-wear collections for the Balmain French couture house. De la Renta also launched three perfumes: Oscar de la Renta in 1977, Ruffles in 1983, and Volupte in 1993.

In 1990 de la Renta experienced something most American designers never do—he was given the opportunity to show his ready-to-wear collection in Paris. The first American designer ever afforded this opportunity, he is also the first American, and one of the few non-Parisians, to ever be appointed head designer of a Paris couture house. *See also*: Jeanne Lanvin.

REFERENCES

Brady, James. "In Step with Oscar de la Renta." *Parade Magazine* (July 25, 1999): 12.

Doyle, Kevin. "Oscar Sews up Couture, RTW Deal at Balmain." *Women's Wear Daily* 164 (November 17, 1992): 1.

Milbank, Caroline Rennolds. *New York Fashion: The Evolution of American Style.* New York: Harry N. Abrams, 1989.

Morris, Bernadine, and Barbara Walz. *The Fashion Makers.* New York: Random House, 1978.

Perchetz, Lois, ed. *W, The Designing Life.* New York: Clarkson N. Potter, Inc. 1987.

N. S.

Sonia Delaunay

B. November 14, 1885

D. December 5, 1979

Birthplace: Gradzihsk, Ukraine

Award: Légion d'Honneur, 1975

Sonia Delaunay, born Sophie Stern, moved to Paris in 1905 to study art at the Academie de la Palette. At the turn of the twentieth century, Delaunay, with her husband Robert, was at the forefront of a new artistic movement, Orphism, an early form of abstract painting. Delaunay's interest in collage inspired her to combine fine and applied arts and to experiment with color and texture combinations in fabric designs. The tubular silhouette of women's fashions in the teens and twenties provided the perfect canvas for Delaunay to experiment with geometric shapes, electrified colors, textural variations, and formal and informal balance—all combined in a single garment. The motifs and colors enveloped the body, and her clothing became a moving painting.

Delaunay began experimenting with apparel design as early as 1913, but it was the Russian Revolution of 1917 that forced her entrance into the apparel business. The Delaunays had supplemented their income as artists by renting out their apartments in Russia, which were now nationalized under communism. To support her family, Delaunay opened Casa Sonia in Madrid, Spain, where they were living during World War I, to sell clothing and accessories. In 1921 she closed her store and returned to Paris where she designed for private clients as well as couturiers such as Jacques Doucet, Gabrielle Bonheur "Coco" Chanel, and Jacques Heim.

In 1923 a Lyons silk manufacturer commissioned textile designs from Delaunay, and she opened her own textile workshop, L'atelier Simultane, in 1924 to produce her designs. She began experimenting with embroidery and developed the *point du jour* or *point populaire* stitch, which was done with wool or silk thread in gradient colors mixed with black and white. Delaunay's textile designs brought drama to the simple silhouettes of the 1920s; however, the color combinations and motifs were lost in the structural details and bias draping of 1930s apparel, which broke the plane of the fabric, interrupting the textile design. By 1933 Delaunay was designing very few textiles for apparel.

Over her lifetime, Delaunay painted; designed clothing, fabrics, carpets, dishware, posters, automobiles, playing cards, and home furnishings; and created the first neon sculpture. She designed costumes for Serge Diaghilev for the Ballets Russes production of *Cleopatre* in London in 1918 and

costumes for the Barcelona Opera Company for *Aida* and *Amneris* in 1920. After the 1930s, Delaunay slowly stopped designing and began mounting exhibits of her and her husband's art in museums and galleries throughout the world to document their impact on the art of the twentieth century.

REFERENCES

Baron, Stanley, and Jacques Damase. *Sonia Delaunay: The Life of an Artist.* New York: Harry N. Abrams, 1995.
Buckberrough, Sherry. "*Delaunay Design: Aesthetics, Immigration and the New Woman.*" College Art 51 (1995): 54.
Damase, Jacques, and Sonia Delaunay. *Sonia Delaunay: Fashion and Fabrics.* New York: Thames and Hudson, 1997.
Galloway, David. "Robert and Sonia Delaunay." Art News 97 (1998): 144

A. K.

Delia's

Christopher Edgar and Steve Kahn founded the direct marketing company Delia's in 1993 with $200,000 in a Brooklyn apartment. When Edgar and Kahn launched their new company, they were targeting college-age women in the northeastern United States. However, the product assortment featured in their catalog proved to be of more interest to teenage sisters of these coeds. In response, Edgar and Kahn broadened their customer profile to include the newly emerging teen market, and within six years grew their business to $113 million in sales.

Delia's is a direct marketer of branded and private label casual wear and accessories targeted to Generation Y girls and young women between the ages of ten and twenty-four. The catalog features apparel, swimwear, intimate apparel, shoes, accessories, candy, posters, books, CDs, tattoos, and novelty home accessories from brands such as Free People by Urban Outfitters, Roxy by Quicksilver, 26 Redsugar, Greed Girl, and Dollhouse, as well as private label products made exclusively for Delia's. The styles are fun and funky. They have attitude, drawing inspiration from teen lifestyle trends such as skateboarding, biking, and snowboarding as well as music and movies.

Delia's was one of the first companies to cater to Generation Y and collect demographic data on their purchasing habits. Generation Y comprises approximately 55 million girls in the United States. Of that group, over 4.8 million of them have requested catalogs, and 1.5 million have purchased products. This massive "house list" has allowed Delia's to collect demographic information on an age group with no previous purchasing history. The information they collect allows them to fine-tune their product

offerings and marketing concepts to capture and hold the attention of the teen market.

In addition to the original Delia's catalog, Edgar and Kahn have expanded their holdings to include other catalogs and retail store ventures which appeal to the teen market. Catalog additions include Storybook Heirloom and dot dot dash, for the preteen market; Contents, for Generation Y home furnishings; and Droog, for Generation Y boys' and young men's apparel and accessories. They have added three retail operations: TSI Soccer Corp., the largest retailer of soccer apparel and equipment for boys and girls; Jeans County; and Screeem. In addition to the Delia's factory outlets, the first full-priced Delia's retail store was opened in 1999.

Edgar and Kahn also expanded their operations into the very heart of teen existence: the World Wide Web. Over 22.3 million teen and college-age students regularly access the Internet. To reach this audience, Edgar and Kahn purchased gURL.com and launched iTurf, both community websites which provide gateways to websites of interest to teens, allow teens to interact in chat rooms, and enable them to shop online. The Delia's, Droog, and TSI Soccer websites were all expanded to allow the online sale of their products.

Since Edgar and Kahn took Delia's public in 1996, Delia's has continued to expand both its operations and market share. The demographic data collected by Delia's has provided the company with unique insight into the previously untapped teen market. The combination of hip catalog presentations and Internet resources has allowed Delia's to dominate the teen market.

Website: http://www.delias.com

REFERENCES

Carr, Debra. "E-Male." *Footwear News* (December 6, 1999): 48.

Krol, Carol. "Delia's: Christopher Edgar." *Advertising Age* (June 28, 1999): S26.

Parr, Karen. "New Catalogs Target Gen Y." *Women's Wear Daily* 174 (July 24, 1997): 12.

Redecker, Cynthia. "Delia's Opens First Retail Unit." *Women's Wear Daily* (February 25, 1999): 11.

Ryan, Thomas. "Delia's Internet IPO Seeks to Raise $45 Million." *Women's Wear Daily* (January 27, 1999): 10.

———. "Delia's Reaches Accord to Buy Screeem, Jean Country Chains." *Women's Wear Daily* 175 (June 3, 1998): 21.

A. K.

Louis dell'Olio

See Anne Klein.

Christian Dior

B. January 21, 1905

D. October 24, 1957

Birthplace: Granville, France

Awards: Neiman Marcus Award, Dallas, 1947
Remise de la Legion d'Honneur, 1950
Parsons School of Design Distinguished Achievement Award, New York, 1956
Sports Illustrated Designer of the Year Award, 1963
Schiffi Lace and Embroidery Institute Award, 1963
Chevalier de la Legion d'Honneur, 1979
Dé d'Or, 1983, 1989, 1990
Christian Dior et le Cinéma, Cinémathèque, Paris, 1983
Dessíns de Dior, Musée des Arts de la Mode, Paris, 1987
Fashion Industry Foundation Award, 1990
Christian Dior, the Magic of Fashion, Powerhouse Museum, Sydney, Australia, 1994
Christian Dior, Metropolitan Museum of Art, New York, 1996.

Christian Dior, one of the world's most famous fashion designers and the creator of the luxurious and elegant New Look, grew up in the privileged household of his well-to-do parents. His early years were spent in his birthplace on the Normandy coast; when he was five, the family moved to Paris. Acquiring an appreciation for art at a young age, Dior enjoyed roaming through art museums and touring the architecture of Paris. He gave up his aspirations in architecture to follow his mother's wishes and attend the Ecole des Sciences Politiques in 1923.

After serving in the military, an obligatory duty of all French men, Dior returned to Paris and opened an art gallery with a friend, Jacques Bonjean, in 1927. Christian Bérard, Jean Cocteau, and Salvador Dalí were among the avant-garde painters whose art was featured in the gallery. The economic downturn caused by the U.S. stock market crash in October 1929 resulted in the failure of the art gallery.

Over the next few years, misfortune beset the Dior family. Dior's father faced bankruptcy and his mother died. Mental illness afflicted his brother, and in 1934, Dior himself contracted tuberculosis. After a year of recuperation, he returned to Paris. His roommate, Jean Ozenne, a designer, encouraged Dior to create fashion sketches. Soon he began supplying sketches to Mme. Agnes, the milliner, and Robert Piguet. Also, he wrote the weekly fashion page for *Le Figaro*.

At the age of thirty-three, Dior began his career as a fashion designer

Christian Dior: When Christian Dior presented his sculpted, padded New Look in 1947, the fashionable silhouette virtually changed overnight. His "new look" emphasized and exaggerated the feminine hourglass shape.

when Robert Piguet hired him as assistant designer. It was 1938 and World War II would soon call Dior away from designing to serve in the military. Upon France's defeat in 1940, Dior was discharged from the service and went to live with his father and sister in Callian. When he returned to Paris in 1941, Piguet had replaced him. Soon he found employment with Lucien Lelong.

In 1946 Marcel Boussac, a French textile millionaire, approached Dior with an offer; Boussac wanted him to resurrect the couture house Gaston et Philippe. The normally reserved Dior boldly asked him to back the House of Dior instead. Impressed by the capable and respectful designer, the wealthy textile giant wisely invested $500,000 in the venture.

From the very first collection introduced for spring 1947, the house was a success. Dior named the collection Corolle after the flower shapes that inspired him. The garments, with their wide, sumptuous skirts resembled upturned flowers. Slender shoulders, a nipped waist, and emphasized, lifted breasts completed the silhouette.

This feminine look was a stark contrast to the masculine look popular during the war. For much of the 1940s, women wore broad, padded shoulders and slim skirts in response to cloth rationing and their new, more assertive role in society. Dior's "New Look," as it was called by *Harper's Bazaar* editor Carmel Snow, was revered and controversial. Many women loved the new lavish, ladylike designs; they were tired of the utilitarian look of the war years. Critics condemned the extravagant use of fabric and believed that the New Look set back the advances made by women during the war. How could women allow themselves to be reduced to mere corseted pretty things, they asked.

Although Dior is often cited as the sole originator of this silhouette, other designers had come out with a similar silhouette before the war. In effect, the war postponed the emergence of the New Look. Designers such as Cristóbal Balenciaga, Jacques Fath, and Charles James introduced similar looks at the same time as Dior. What made Dior different was that he was using the silhouette for day wear. One of his most famous designs was Le Bar, a day suit from the 1947 collection which epitomized the New Look with its fitted waist, padded peplum, and voluminous skirt.

Dior's reputation and acclaim for popularizing the New Look led to his dictatorship of styles for the next ten years. He was able to introduce a new silhouette twice a year, dramatically speeding up the rate of fashion change. He forced women to purchase new wardrobes more rapidly than in the past, spurring on the trendy nature of fashion during the latter half of the century.

One almost needs a scorecard to keep up with Dior's changing silhouettes. For example, his spring 1948 collection entitled Zig-Zag featured asymmetry, and his autumn 1949 collection used bloused tops to give dresses a two-piece look. The Long Line of 1951 employed princess seams and elevated waists.

By 1954 the silhouette changes had become more dramatic. The autumn H-Line dropped the waist to the hip. The very next season, Dior introduced the A-Line, which suspended the dress from the shoulder and gradually flared from there. For the autumn 1955 Y-Line, Dior reversed the A-Line, placed the emphasis on the shoulders, and tapered the silhouette into slim skirts. Dior's last two lines in 1957, which presented softer waists, showed a clear movement away from the New Look.

Despite the changes in silhouette, Dior always produced finely tailored garments made from the most luxurious fabrics. Critics and customers raved about each new collection, effectively keeping Dior on the fashion throne until 1957 when he died of a heart attack. Yves Saint Laurent, who had served as Dior's first and only design assistant, took over the designing helm.

Three years after joining Dior, Saint Laurent introduced his first collection for spring/summer 1958. Named the Trapeze Line, it received critical acclaim. Dior's personally chosen heir seemed to be a success, but his next collection, the Arc Line, was not as well received. His spring/summer 1959 Long Line won approval from both clients and critics. In 1960 the young designer introduced the Beat Look, complete with a fur-trimmed, leather jacket. This youth-oriented look did little to impress the upper-class matrons who constituted Dior's loyal clientele.

Since Saint Laurent's ideas of haute couture did not match those of Dior's clients, his days at the house were numbered. Shortly after the introduction of the Beat Look, Saint Laurent was called into military service. Marc Bohan, the designer for the company's London branch since 1958, was brought in to replace Saint Laurent. His first collection, the Slim Look, earned kudos.

Bohan was born in Paris on August 22, 1926, and he studied art and philosophy at the Lycée Lakanal Sceaux from 1940 to 1944. He acquired his first designing job with Robert Piguet in 1945. In 1951 he designed for Edward Molyneux, and in 1952 for Madeleine de Rauche. He opened his own house in 1953, but he showed only one collection owing to a lack of financing. The next year he was appointed head couture designer at Jean Patou. Briefly, in 1958, he moved to New York to design coats for Originala before accepting the London design position at Dior.

Bohan's approach appealed to Dior's clients; it featured classic femininity, sumptuous fabrics, and flattering fit. He was able to blend the youthfulness of the 1960s, the womanly form of the Dior client, and the elegance of the Dior reputation. He became known for his evening wear, and he maintained the house's standing for nearly thirty years. After leaving Dior, he began designing for Norman Hartnell, where he presented his first collection in 1991.

In 1989 Gianfranco Ferre took over the design position from Bohan. Ferre was born in Italy in 1945, and he studied architecture. Early in his career he designed furniture, gold jewelry, and accessories. In 1974 he

started his own design label, which he continued during the seven years he designed for Dior. He is known for the architectural quality of his clothes. In 1996 he left Dior to concentrate on his own label.

Following Ferre's departure, John Galliano, then designer for Givenchy, was offered and accepted the design position. Born Juan Carlos in Gibraltar in 1960, Galliano studied fabric design at East London College. His graduation from St. Martin's School of Art in 1984 led to his own ready-to-wear business. His reputation for grandeur and theatrics is evident in the lines he has created for Dior. Bernard Arnault, chairman of Christian Dior SA, has deemed Galliano's work for Dior a success (Martha and Koda, p. 10).

The House of Dior would not have flourished as well over the years without expanding into other products and markets. Dior himself realized the importance of a complete look; without the proper shoes, gloves, and hat, the New Look could not be achieved. Almost immediately after introducing his first collection, he began entering into licensing agreements for accessories. In 1948, when negotiating a license for hosiery, Dior insisted on receiving a percentage of the sales instead of the customary flat fee. This arrangement soon became the norm in the fashion industry.

Dior first entered into ready-to-wear clothing in 1948 when he established Christian Dior–New York to cater to the U.S. market. Stores such as Bergdorf Goodman in New York and Marshall Field's in Chicago negotiated for the exclusive rights to sell Dior's designs in those cities. In 1967 the company introduced Miss Dior, its ready-to-wear label, and in 1973 it launched a ready-to-wear fur collection.

The peak of licensing activity came in the 1980s, when the company held licenses with 200 companies. Over its history, Christian Dior has held licenses for baby clothes (launched in 1967), bedsheets, coats, corsetry, costume jewelry, furs (introduced in 1948), knitwear, lingerie, men's formal wear, menswear (Christian Dior Monsieur, launched in 1970), scarves, shoes (introduced in 1953), sleepwear, stockings, and suits. During the 1990s, the company bought back many licenses or allowed them to lapse in an effort to regain control over its couture image. For years, goods of varying quality sold at a myriad of price points had inundated the market and marred Dior's reputation of refinement, elegance, and quality. In 1996 the house decided to continue only a few of its licenses, including Bestform for foundations, Carrera for eyewear, Henkel and Grosse for jewelry, Carol Hochman for intimate apparel, and Pennaco for hosiery. By the late 1990s, the company was well on its way to reestablishing its couture image.

In 1948 Dior started Christian Dior Perfumes to market the fragrance Miss Dior, which he named for his sister, Catherine. This initiated a string of successful perfumes including Diorama launched in 1949, Eau Fraîche in 1953, Diorissimo in 1956, Diorling in 1963, Diorella in 1972, Dioressence in 1979, Poison in 1985, Tendre Poison and Dune in 1991, Dolce

Vita in 1996, and Lily in 1999. The company relaunched Miss Dior in 1993. In 1966 the company introduced its first men's fragrance, Eau Sauvage. It was followed by Eau Sauvage Extrême in 1984, Fahrenheit in 1988, and Dune pour Homme in 1998.

In addition to fragrances, Christian Dior Perfumes markets cosmetics. It made its first entry into cosmetics in 1955, when it launched lipsticks; 1969 marked the first full line of Christian Dior cosmetics. The house sold Christian Dior Perfumes in 1972, and like Christian Dior SA, it is now owned by parent company Moët Hennessy Louis Vuitton. (LVMH).

Christian Dior SA operates more than fifty-seven stores worldwide. The flagship store is located on Avenue Montaigne in Paris. In 1998 the company began adding new stores, including ones in Orange County, California, and Costa Mesa, California, and it began remodeling its other stores to harmonize with the image of the flagship store. In 1998 it launched an Internet site which offers information about the house, fashions, fragrances, and cosmetics. Christian Dior has proven itself to be one of the most influential fashion houses of the twentieth century and will continue to have an impact on the fashions of the twenty-first century. *See also*: Cristóbal Balenciaga; Jacques Fath; Charles James; Yves St. Laurent; Edward Molyneux; Hubert de Givenchy; Louis Vuitton.

Website: http://www/dior.com

REFERENCES

DeMarly, Diana. *The Great Designers: Christian Dior*. New York: Holmes and Meier, 1990.

Martin, Richard, and Harold Koda. *Christian Dior*. New York: Metropolitan Museum of Art, 1996.

Pocha, Marie-France. *Universe of Fashion: Dior*, translated by Jane Brenton. New York: Universe Publishing, 1996.

A.T.P

Doc Martens (R. Griggs & Co.)

Dr. Klaus Maertens of Munich, Germany, who created an air-cushioned, soled boot from a truck tire in 1945 after breaking his foot skiing, could never have imagined the fashion statement his boots would one day make. Dr. Herbert Funck, an engineer, helped Maertens perfect his boot in 1947 for commercial production in Germany. The hard-wearing utility boot with a Goodyear welted sole, which resists oil, fat, acid, petrol, and alkali, was transformed in 1960 into Doc Martens (or DM's) through a licensing agreement with R. Griggs & Co. of England.

Since its inception, the company has gone through many incarnations.

The symbolic association of Doc Martins began in the late 1960s when they were adopted by an early British skinhead group and became known as the "bovver boot." As part of the skinhead uniform, DM's became associated with aggressive urban males who advocated crushing the establishment. For over a decade DM's were associated exclusively with violence and extreme bigotry; they were considered a "boxing glove for the feet."

In the 1980s, Doc Martens were born again and became a universal fashion accessory. DM's became popular with college students, both male and female, and were adopted as part of the traditional jeans and t-shirt uniform. New Wave musicians, such as Cyndi Lauper, popularized the pairing of DM's with lacy skirts, providing a contrast between feminine and masculine symbols, a fashion that was disseminated through MTV. The once tough Doc Martens were now being made in floral and polka-dot patterns or with lace inserts in trendy, fashion colors. Simultaneously, Doc Martens while still being worn by skinheads and were also being adopted by gays and lesbians as symbols of strength to blur gender distinctions. The 1990s brought one more rebirth to Doc Martens when they became associated with the Grunge music movement in Seattle.

Doc Martens, once available only at English punk stores such as Red or Dead, are available at Kinney and Nordstrom. In addition to manufacturing 150 footwear styles in 3,000 versions for men, women, and children, Griggs manufactures a product line which includes sportswear such as jeans, t-shirts, leather jackets, and dresses. Once considered extremist or reactionary, Doc Martens have entered the collective consciousness, becoming the Levis of boots, paving the way for other utility boot manufacturers such as Skechers, Timberland, RedBack, and Simple to enter the fashion arena. *See also*: Skechers.

Website: http://www.drmartens.com

REFERENCES

Darwent, Charles. "Fashion Fascism and Dear Old Doc." *Management Today* (April 1992): 50–54.
Fallon, James. "The Doc Is In." *Footwear News* 49 (May 31, 1993): 24–26.
Morais, Richard. "What's up, Doc?" *Forbes* 155 (1995): 42.
Witt, Debra. "Alternative Nation: Reacting to the Choice of a New Generation." *Footwear News* 49 (July 19, 1993): 23.

A. K.

E

Florence Eiseman

B. 1899

D. January 8, 1988

Birthplace: Unknown

Awards: Neiman Marcus Award, 1955
 Gimbel's Fashion Award, 1971
 I. Magnin's Great American Award, 1974

Florence Eisman never intended to be a designer, much less one of the most influential children's designers of the twentieth century. She studied stenography before she married Laurence Eiseman and settled into motherhood. After the birth of her sons, she taught herself to sew and began making clothes for her boys and other children in the neighborhood.

In 1945, to supplement the family's income, Laurence took Florence's organdy pinafores to Marshall Field's. Impressed by the dresses, Field's placed a $3,000 order for Eiseman's clothes, and her business was born. During the early years of the business, Eiseman worked from her Milwaukee home and employed women to do piecework from their homes. A few years later she moved the business to a factory and eventually added additional designers. She retained ultimate control over all designs until her death.

Eiseman's design philosophy revolved around the needs of the child. Unlike other children's wear designers of the 1940s and 1950s, she believed that children were individuals and should not be dressed like miniature

adults. Therefore she ignored adult fashion fads and crafted uniquely young clothes instead.

Unimpressed by the somber, muted colors of most children's clothes, she used bright, primary colors in her own designs, often taking inspiration from the modern art she collected. Using the finest quality fabrics, she designed simple garments with clean lines which were often accented with hand-sewn embroidery and appliqués.

She tried to make children comfortable by carefully placing seams, eliminating tight waistbands, and removing encumbering ruffles and flounces. She debuted the trapeze shape and empire waist for children prior to their prevalence in adult fashion. Also, she popularized one-piece garments including the That's All, which replaced the traditional toddler's shirt and overalls. She introduced knits at moderate prices for everyday use.

Eiseman introduced a number of innovations which improved the longevity of children's clothes. By designing adjustable buttons and deep hems into her garments, Eiseman increased the useful life span of the clothes, which made them more affordable. One of Eiseman's designers, Gloria Nelson, invented the "add-a-hem" which allowed one to drop a hem by pulling a thread, thereby extending the use of a garment.

To expand her business, Eiseman signed licensing agreements with Dan River Mills and Simplicity patterns. From 1967 to 1976 she produced women's swimsuits. In 1984 she added a couture line to regain the high-quality, hand-sewn garments that she had made in the early years of the business. Since Eiseman's death, despite declaring bankruptcy in 1999, the company continues to uphold her philosophy of high-quality clothes designed specially for children.

Website: http://www.florenceeiseman.com

REFERENCES

Buck, Genevieve. "Florence Eiseman." *Chicago Tribune* (February 9, 1976).

Florence Eiseman Retrospective: Forty Years of Children's Fashions. Milwaukee: Milwaukee Art Museum, 1985.

Hajewski, Doris. "Its Finances in Tatters, Clothier Florence Eiseman Liquidates, Bankruptcy Ends 54 Years of Elegance." *Milwaukee Journal Sentinel* (October 30, 1999).

A.T.P

Perry Ellis

B. 1940

D. May 1986

Birthplace: Portsmouth, Virginia

Awards: Neiman Marcus Award, 1979
 Winnie, Coty, 1979
 Women's Apparel, Coty, 1981, 1983, 1984
 Menswear, Coty, 1983
 Coty Hall of Fame, 1984
 MAGIC Menswear Hall of Fame, 1993

Perry Ellis received his bachelor's degree in business administration from the College of William and Mary in 1961, after which he enlisted in the U.S. Coast Guard and served in President John F. Kennedy's White House honor guard. When Ellis completed his term of service, he enrolled at the New York University School of Retailing and earned his master's degree. In 1963 Ellis returned to Virginia to work as a buyer at Miller and Rhodes. Rarely satisfied with the apparel available at market, Ellis felt the designs did not meet the needs of the Miller and Rhodes customer. Ellis frequently sketched out ideas for redesigning the apparel, and he returned to the showrooms with directions for the designers to modify their original designs. Ellis left Miller and Rhodes to become design director for John Meyer in Norwich, New York, in 1968. Six years later, Ellis accepted a position which, one day, would allow him to revolutionize casual clothing for men and women.

In 1974 Ellis became the vice president of merchandising for the Vera Companies, a division of Manhattan Industries, where, in 1976, he traded in his administrative office for a design studio and created his first women's collection under the Portfolio label. The line was a huge success and Ellis was given his own label, Perry Ellis Sportswear, by Manhattan Industries in 1978. The demand for Ellis's name led him to found Perry Ellis International in 1978 as a vehicle for licensing his name to produce other product lines in addition to those for Manhattan Industries.

Ellis's designs were youthful and fresh. He wanted to design clothing which was "friendly," such as comfortable shirts, oversized sweaters, unconstructed knitwear, and baggy trousers. Many of his designs contained masculine lines which were gracefully adapted for a woman's figure. Ellis became known for classic American sportswear designs which combined unusual proportions, unique textures, unconventional colors, and distinct patterns. His designs were both sophisticated and fun at the same time. In

Perry Ellis: Perry Ellis became famous for his comfortable, casual women's sports-
wear. However, it was Marc Jacobs who made the Ellis label infamous when he
presented his grunge collection in 1993.

1980 Ellis applied his unique approach to sportswear design to menswear, and he virtually revolutionized the industry overnight. Ellis was the first designer to create truly casual clothing for men, long before the popularity of casual Fridays or business casual. The sportswear Ellis created for men bridged the gap between business suits and blue jeans.

Perry Ellis died from AIDS-related illnesses in 1986. At the time of his death, Ellis had been designing for four labels in each of the men's and women's divisions: Perry Ellis Signature Collection, Perry Ellis Portfolio, Perry Ellis Sportswear, and Perry Ellis America. After Ellis's death, his long-time companion and business partner, Robert L. McDonald, continued to run Perry Ellis International until he also died from AIDS-related illnesses in 1990. Under McDonald's direction, Brian Bubb was appointed the menswear designer and Patricia Pastor the women's wear designer; however, the collections floundered, with no real sense of design direction. In 1988 McDonald replaced both Bubb and Pastor with Roger Forsythe and Marc Jacobs, respectively. Jacobs was able to generate excitement in the women's collections by bringing notoriety to the company and returning a sense of fun to the line. However, in 1993, Jacobs went too far. His now infamous grunge collection resulted in his dismissal from Ellis. The collection, a complete departure from the classic Ellis look, was canceled before it went into production. In 1991 Forsythe too died from AIDS-related illnesses, and he was replaced by his assistant, Andrew Corrigan.

The design direction at Perry Ellis International had been highly unstable since Ellis's death, especially in the women's lines. The lack of a unifying design direction resulted in the canceling and relaunching of the women's lines. In 1988 the Salant Corporation acquired Perry Ellis licenses through its takeover of Manhattan Industries. In 1989 Salant returned its license for the women's designer collection to Perry Ellis International and discontinued the Portfolio collection. By 1992 Salant had returned all its women's licenses to Perry Ellis International. However, Salant retained its licenses for all the Perry Ellis menswear labels including the Perry Ellis Signature Collection, the Perry Ellis Sportswear Collection, the Perry Ellis boys' collection, and Perry Ellis sport shirts, neckwear, belts, and suspenders. Perry Ellis International wanted to continue the women's lines to provide a prestigious profile for the house which would support its other licensing initiatives. In 1991 Perry Ellis International reinstated the Portfolio collection and continued to revamp the Perry Ellis America collection, redefining its image and relaunching it (again) in 1992.

Claudia Thomas, a longtime friend of Ellis and McDonald, who was appointed chief executive officer of Perry Ellis International in 1990, was faced with several difficult questions: How do you reconcile fashion and business? How do you merge designer prestige with mass marketing? How do you provide one design direction to over twenty different licensees in over thirty different product categories? Thomas was accountable for the

financial success of the company to the Perry Ellis trust, which was created for Ellis's young daughter when he died, and to the Salant Corporation.

First, to provide a unified direction for all the Perry Ellis licensees, Thomas created the Perry Ellis Design Studio in 1992. The studio consisted of a twelve-person design team headed by Julio Espada and Richard Haines. The design studio would be responsible for reviewing the designs of all licensees to ensure consistent direction and continuity. The design studio also coordinated product advertising. Second, Thomas made the controversial decision to discontinue the women's business in 1993. Because the Perry Ellis women's designer line posted large annual losses, Thomas opted to discontinue all the women's lines, including Portfolio and America, and focus on the men's lines and the licensing agreements.

Throughout the 1990s, Perry Ellis International became a licensing giant. The Perry Ellis name appears on sleepwear by Host, cuff links and studs by David Donahue, Inc., underwear by Jockey International and later by Ithaca Industries, socks by Trimfit and later by Gold Toe Hosiery, gloves and hats by the Glove Source, outwear by Europe Craft, loungewear and active wear by Davco Industries, small leather goods by Westport Corporation, tuxedos by Lord West Formalwear, belts by Aimee Lynn Accessories, belts by Gold Tone, scarves by V. Fraas, Inc., handbags by Premier Designer, loungewear by Aris, hats by Hat Source, footwear by Geoffrey Allen, watches and clocks by Genender International, and home furnishings by Crown Crafts, Inc. In the 1980s, the name Perry Ellis stood for comfortable, classic, American fashions; by the 1990s, the name stood for massproduced products that had little to do with fashion trends.

Despite Thomas's restructuring, Perry Ellis International still languished. In 1994 Thomas was replaced by Max Garelick. To restore prestige to the label, Garelick made reinstating the women's lines his first priority and began looking for a licensee. The proliferation of product licenses had kept the Perry Ellis name alive; however, it remained to be seen if the once powerful fashion leader retained enough prestige to reenter the women's market. The Perry Ellis fragrance line, originally licensed to Sanofi Beaute, Inc., but sold to Parlux Fragrances, Inc., in 1994, helped provide cachet to the ailing label. In addition to continuing the existing women's scent 360 Degrees and Perry Ellis for Men, Parlux introduced Perry Ellis America, 360 Degrees for men, and Perry Ellis Reserve (a scent distributed solely to tuxedo shops)—all in 1996. In 1994 Perry Ellis International signed a licensing agreement with the upscale menswear company Hart, Schaffner & Marx to produce lines of tailored clothing under the Perry Ellis men's labels.

By 1998 total retail sales for Perry Ellis were estimated at $900 million, which were generated by thirty-nine different product categories distributed in sixty different countries. As Perry Ellis International continued to search

for a women's wear licensee, Salant, who had filed for Chapter 11 in 1990, found itself filing for Chapter 11 again in 1998. This time, Salant's debt could not be restructured, and the Perry Ellis men's licenses changed hands for a third time. In 1999 Supreme International Corporation bought the Perry Ellis licenses from Salant and agreed to pay the estate of Perry Ellis $75 million for Perry Ellis International. Ultimately, this transaction provided the Perry Ellis labels with the capital they needed to mount a full-scale return to the fashion arena.

Supreme International, a company which has been publicly held since 1993, consists of the labels Natural Issue, Munsingwear, Ping, PNB Nation, Crossings, Penguin Sport, Pro Player, Andrew Fezza, and Grand Slam, as well as the Perry Ellis, John Henry, and Manhattan labels which were acquired from Salant. In 1999 Supreme International voted to change the corporation name to Perry Ellis International. Supreme International, now Perry Ellis International, installed Kristina Salminien as head designer for the women's lines and Jerry Kaye as head designer for the men's lines in 1999. Their first lines debuted to eagerly awaiting audiences in 2000. The initial response to the lines was strong; the designers had captured the "classics with a twist" style which had launched Perry Ellis over two decades ago. Over the next several years, Perry Ellis International plans to transform the Perry Ellis label into a lifestyle brand that will compete with Ralph Lauren and Calvin Klein.

Perry Ellis had always envisioned his company becoming a licensing entity that provided well-designed, well-made products to a broad audience. Few companies survive the death of their founders. In the fourteen years since Ellis's death, several designers and corporations have tried and failed to carry on the Ellis legacy. The challenge now remains with the newly formed Perry Ellis International to return honor to the labels created by the man celebrated as the quintessential American designer. *See also*: Marc Jacobs; Ralph Lauren; Calvin Klein.

Website: http://www.perryellis.com

REFERENCES

Berman, Phyllis. "Grunge Is out, Licensing Is In." *Forbes* 153 (May 23, 1994): 45–47.
Cardona, Mercedes. "Perry Ellis Strives to Refashion Itself under New Owner." *Advertising Age* (October 11, 1999): 24.
D'Innocenzio, Anne. "A Perry Ellis Revival." *Women's Wear Daily* (December 23, 1999): 1.
Parola, Robert. "At Ellis: Discord on Design and Direction." *Daily News Record* 22 (July 24, 1992): 1–5.
Perchetz, Lois, ed. *W, The Designing Life*. New York: Clarkson N. Potter, Inc., 1987.

White, Constance. "Duffy, Jacobs Recreate Portfolio." *Women's Wear Daily* 161
 (February 6, 1991): 8–10.
———. "Ellis Collection Ends; Jacobs off on His Own." *Women's Wear Daily* 165
 (February 17, 1993): 1–2.

A. K.

Esprit

In 1964 Susie Russell picked up hitchhiker Doug Tompkins, a hopeful
Olympic skier. Four years later, the Plain Jane Dress Company was born
out of the back of their station wagon. Plain Jane was cofounded by the
Tompkinses and Jane Tise in 1968 to wholesale simple, 1940s-inspired
dresses under the premise of "real clothes for real people." In 1970 the
company was incorporated as Esprit de Corp, and in 1975 the Tompkinses
bought out Tise to become the sole owners.

Esprit epitomizes the California lifestyle with bold colors and casual sep-
arates which can be worn for both work and play. During the reign of the
late 1970s and 1980s power suits and slinky dresses, Esprit emphasized
youthful vitality, launching a worldwide sportswear revolution. Esprit pro-
moted a lifestyle, not just a fashion trend and used innovative advertising
concepts to reinforce their image. "Be informed. Be involved. Make a dif-
ference" is the corporate mission statement which guides the direction of
Esprit. Esprit's catalogues regularly feature employees and customers, in-
stead of fashion models. The catalogue also provides a forum to promote
public awareness of social issues, including a message in 1987 that urged
public awareness of AIDS. The environmental concerns of the 1990s in-
spired Esprit to launch a new line, Ecollection, in 1992 which used organic
fabrics and environmentally friendly manufacturing techniques. The 1999
"I am Esprit" on-line campaign encouraged women to post scanned photos
of themselves with an essay, "Why I am Esprit," to promote the individ-
uality and inner beauty of all women around the world.

Since its inception, Esprit has continued to expand into new lines and
licensing agreements for bath and bed lines, accessories, and men's and
children's apparel. The Esprit Kids line was launched in 1981. Next, Esprit
signed a licensing agreement with a German optical company, Optyl, for
eyewear in 1987. In 1994 Esprit was granted a license from Dr. Seuss to
produce apparel, sleepwear, footwear, and accessories for children and
adults. Esprit added a swimwear line in 1997 through a licensing agreement
which allowed Beach Patrol, Inc., to design Esprit swimwear and sports-
wear. Esprit also signed a licensing agreement with DKNY in 1998 to de-
sign DKNY girls' and boys' apparel.

During the mid-1980s, Esprit encountered financial and management dif-
ficulties. The decision to open outlet stores put Esprit in direct competition
with large, private-label retailers, such as The Gap and The Limited. Esprit
did not have the resources to support the expansion, and by the time they
had restructured the company, they had missed major fashion trends and
lost a large share of the junior market. By 1987 the Tompkinses were also
disagreeing on the direction of the company, and their personal relationship
deteriorated. The Tompkinses divorced, and Susie bought the company
from Doug in 1990. During the last decade, Esprit has struggled to redefine
its market niche. It has remained a mainstay of the children's market, but
it has not been able to regain its former status in the junior market. In
1998 Esprit launched its on-line store, providing interactive shopping and
promoting their social beliefs to a new generation of customers. *See also*:
Donna Karan; The Gap, Inc.; The Limited, Inc.

Website: http://www.esprit.com

REFERENCES

Tompkins, Douglas. *Esprit: The Comprehensive Design Principle*. New York: Nip-
 pon Books, 1995.
White, Constance. "Susie Tompkins: Crossing a New Bridge." *Women's Wear
 Daily* 165 (March 10, 1993): 8.

A. K.

F

Max Factor

B. 1872

D. 1938

Birthplace: Lóolź, Poland

Max Factor's career began in Russia, where he owned a hair-goods shop, served as a cosmetician to the royal court in Saint Petersburg, and worked as chief makeup artist for the Moscow Theatre. He came to the United States in 1904 and operated a beauty products concession at the Saint Louis World's Fair. Intrigued by the emerging motion picture industry, he moved to Los Angeles in 1908 and opened a store that sold theater cosmetics to stage actors. At that same time he founded Max Factor and Company.

The shiny, thick, unattractive greasepaint of early movie actors prompted Factor to create Supreme Greasepaint in 1914. This flexible greasepaint, which was packaged in a tube, was the first makeup ever designed specifically for motion pictures. He marketed the enormously successful greasepaint along with his eyeshadows and pencils.

Factor's name soon became synonymous with the makeup of the stylish Hollywood actresses of the 1910s, 1920s, and 1930s. He advised stars such as Theda Bara, Clara Bow, Jean Harlow, Greta Garbo, Judy Garland, and Rita Hayworth and helped them create their signature looks. During these years women relied on movie stars for makeup styles, and Factor's influence on the general public was significant.

His impact was so strong that he changed women's belief that makeup was for actresses only. He was credited with popularizing the word

"makeup" in everyday language. His opinion that makeup shades should complement a woman's natural features, a concept he called color harmony, helped popularized the everyday use of makeup.

Realizing the company's potential, Factor began marketing products to everyday women. In 1920 he developed a mass-market color cosmetic line called Society Makeup. He provided leaflets filled with makeup application tips demonstrated by stars such as Bette Davis, Myrna Loy, and Ginger Rogers.

Ever the innovator, Max Factor and later his son, Max Factor, Jr., developed many products that have become staples of the cosmetics industry. He introduced lip gloss in 1930, Pan-Cake Make-up in 1937, Pan-stik Make-up for television in 1948, a cover-up stick in 1954, and the first "waterproof" makeup in 1971. In the late 1990s, stick foundation and lip gloss experienced a resurgence of popularity.

Max Factor and Company's current owner, Proctor and Gamble, purchased the company from Revlon in 1991. Proctor and Gamble also owns two of Max Factor's competitors, Cover Girl and Oil of Olay. During the 1990s Max Factor's marketing returned to its Hollywood roots. In an effort to reglamorize its image, the company cross-promoted Max Factor products with the movies *Titanic* (1997) and *A Midsummer's Night Dream* (1999); and its European and Asian ads featured Madonna.

Website: http://www.maxfactor.com

REFERENCES

Brookman, Faye. "The Big Three Battle Anew for More Space and Share." *Women's Wear Daily* 171 (June 14, 1996): 56.
"Max Factor." *Economist* 339 (June 15, 1996): 82.
Tannen, Mary. "The Man Who Made the Faces Up." *New York Times Magazine* 175 (December 29, 1996): 6.

A.T.P.

Fashion Fair Cosmetics

Fashion Fair Cosmetics is one of the leading companies that focuses on cosmetics for women of color. Its products are sold in stores in the United States, the Carribean, Africa, and Europe. The company offers over 350 products specially formulated for black skin.

Fashion Fair Cosmetics is a division of Johnson Publishing Company, the largest black-owned publishing company in the world. John H. Johnson started the publishing company in 1942 with a $500 loan against his mother's furniture. The success of the company's first publication, *Negro*

Digest, encouraged Johnson to produce *Ebony* and *Jet*, which are two of the most widely read black publications today.

In 1958 Johnson's wife, Eunice, began Fashion Fair, the world's largest traveling fashion show. The show, an outgrowth of *Ebony* magazine, has raised millions of dollars for charity. The models featured in the fashion show found it difficult to find shades of makeup that matched their skin tones. Unlike whites, who have only ten complexion colors, blacks have as many as thirty-six variations of skin tone. At that time, few cosmetics companies offered products for blacks. Eunice Johnson and her husband decided to solve this problem by launching their own cosmetics line, Fashion Fair Cosmetics.

The Johnsons started cautiously by offering makeup kits through *Ebony* and *Jet* magazines. The mail-order kits were immensely popular, and readers purchased 100,000 of them in six months. John H. Johnson persuaded Marshall Field's to carry the line in its cosmetics department, and within a year, the product was offered in 125 finer stores. In 1992 the company launched the Ebone line, which is sold in drugstores and discount chains. Currently, Fashion Fair products are sold in more than 2,000 stores. The products are marketed through images of sophisticated, elegant models and workshops which are available at the Fashion Fair counters.

Fashion Fair created products specifically for the special needs of women of color. The formulations of the products are effective on skin that is oily, sensitive, and scars easily. Since 1984 many of the products are offered in regular and fragrance-free formulations. The products include skin treatment, foundation, fragrances, and eye, blush, lip, and nail colors. Because of the variety of tones in the products, Asian, Hispanic, and Caucasian women can also use them. Supreme Beauty Products is Johnson Publishing Company's hair-care division, which was launched in 1960. It sells women's products under the brand name Raveen, and its men's products are sold under the name Duke.

At a time when black women were ignored by traditional cosmetic companies, Fashion Fair Cosmetics responded by producing high-quality products which embraced the beauty of black skin. It helped redefine and validate black complexions as elegant and beautiful.

Website: http://www.fashionfaircosmetics.com

REFERENCES

Belcove, Julie L. "Fashion Fair Widens Sights." *Women's Wear Daily* 166 (October 1, 1993): 5.

Edelson, Sharon. "Beauty Takes New Roads to New Readers." *Women's Wear Daily* 164 (August 14, 1992): 1.

Gordon, MaryEllen. "Cosmetics Firms Make Major Bid for Ethnic Groups." *Women's Wear Daily* 162 (August 9, 1991): 1.

 A.T.P.

Jacques Fath

B. September 12, 1912

D. November 13, 1954

Birthplace: Lafitte, France

Award: Neiman Marcus Award, 1949

Jacques Fath was destined to be a couturier—his great grandmother had been a dressmaker to the Empress Eugénie—but his path to fulfilling his destiny was not a direct one. Fath considered pursuing a career as either an actor or businessman, and he studied bookkeeping and law at the Commercial Institute in Vincennes, France. However, Fath's true love was fashion, and in 1937 he and one fitter produced his first collection, a mere twenty pieces. The eruption of World War II forced Fath to close his fledgling business and enlist in the military; however, after the war, Fath returned to France and reopened his house. Despite the erratic start, the House of Fath ultimately grew to be one of the largest couture houses, with ventures in France and the United States and employing 600 people at the height of its operations.

The collections Fath designed were feminine, sexy, and glamorous. His designs glorified the female form with fitted bodices, décolletage necklines, wasp waists, and full hips. He employed decorative details such as cascades of drapery and arrays of pleats to further emphasis the hourglass figure. Fath was just as influential and popular as his contemporaries Christian Dior and Cristóbal Balenciaga; however, his name is relatively unknown today despite his having made a unique contribution to the fashion industry. In 1948 Fath established a relationship with the American ready-to-wear manufacturer Joseph Halpert to produce a line of Fath's designs which Fath himself reinterpreted for mass-market production. Such an arrangement was virtually unheard of in the couture industry, and many French designers were appalled by it. Many of Fath's peers criticized him for this arrangement; however, it helped Fath combat knockoff design, control how his designs would be interpreted, and make money. This unprecedented arrangement paved the way for future designers to engage in what would eventually be known as licensing agreements, which have become crucial to the profitability of couture houses today.

After Fath died in 1954, his wife continued the business until 1957. For the next thirty-five years the House of Fath was dormant. In 1992 the women's ready-to-wear line was relaunched under the direction of Tom VanLingen, a Dutch designer, and in 1995 the couture line was also briefly reinstated. Elena Nazaroff replaced VanLingen in 1997, however, she re-

mained only for one year. Finally, in 1998, Octavio Pizarro joined the House of Fath as the head designer. *See also*: Christian Dior; Cristóbal Balenciaga.

REFERENCES

Deeny, Godfrey. "Fath RTW to Return to Runways in March." *Women's Wear Daily* 162 (October 30, 1991): 13.
———. "Paris Scene: A Revival of the House That Jacques Built." *Women's Wear Daily* 163 (February 26, 1992): 32.
Milbank, Caroline Rennolds. *Couture: The Great Designers*. New York: Stewart, Tabori and Chang, 1985.
Weisman, Katherine. "The Renewal of Jacques Fath." *Women's Wear Daily* 169 (May 25, 1995): 11.
Wilson, Eric. "Fath Dismisses RTW Designer Elena Nazaroff." *Women's Wear Daily* 174 (November 24, 1997): 9.

A. K.

Fendi

See Karl Lagerfeld.

Louis Féraud

B. February 13, 1921
D. February 11, 2000
Birthplace: Arles, France
Awards: Dé d' Or, 1978, 1984
 Légion d'Honneur

As a young boy growing up in France, Louis Féraud aspired to be a baker; however, he went to school to become an electrician. Ultimately, neither of these fields would prove to be Féraud's true calling. Féraud moved to Cannes in 1948 to write, paint, and pursue the "good life" after serving in the French underground during World War II. While living in Cannes, Féraud's interests shifted to fashion design, and in 1953 he met French sex-kitten Brigette Bardot. Féraud designed simple dresses, unlike the sculpted silhouettes of Christian Dior, which captured the spirit of the youth movement embodied by Bardot. In 1955 Féraud officially opened his

couture house in Cannes, as well as several boutiques along the French Riveria.

Over the course of his career, Féraud continually diversified his business. In addition to introducing a line of ready-to-wear clothing in 1962, he expanded into the perfume business launching Justine in 1965, Corrida in 1975, and Fer for men in 1982. Féraud held a licensing agreement with Avon from 1980 to 1992 to produce Fantasque, Jour de Féraud/Vivage, Cote d'Azur, and Féraud pour Homme which made him an affordable status symbol for the middle class. Féraud introduced a line of menswear in 1975, which is currently licensed to Gruppo Covarra SA de CV Mexico, and holds licenses for home textiles, accessories, leather goods, and lingerie. Féraud also designed apparel for over eighty films, including many of Bardot's.

Known as the "man who loves women," Féraud designs glamorous, luxurious, and seductive clothing without forsaking comfort. The allure of his clothing was never more apparent than in the 1980s when he designed clothing for the television shows *Dynasty* and *Dallas*. These two shows were the epitome of 1980s business practices, moral standards, and fashion trends. Women were portrayed as strong and sexy, and the bold, seductive designs of Féraud complemented these roles. In 1987 Féraud's daughter Dominique (Kiki), who trained at the Ecole de la Chambre Syndicale de la Haute Couture, began making contributions to Féraud's collections. Féraud retired in 1996 to return to painting and writing and passed on the reins to Kiki, who produced her first full collection in 1997. *See also*: Nolan Miller.

REFERENCES

"Louis Féraud." Fashion live website available from http://www.worldmedia.fr/fashion/.
"Louis Féraud: Le Chic." *Vogue* (April 1986).
Smithers, T.S. "Fast Times with Louis Féraud." *Women's Wear Daily* (October 20, 1986).

A. K.

Salvatore Ferragamo

B. 1898

D. August 7, 1960

Birthplace: Bonito, Italy

Awards: Neiman Marcus Award, 1947
 Salvatore Ferragamo Retrospective, Florence, Italy, 1985

Footwear News Hall of Fame Award, 1988
The Art of the Shoe Retrospective, Los Angeles, 1992

In 1998 the Ferragamo family celebrated the 100th anniversary of its founder's birth, delighted at the fact that the Ferragamo company of today is a fully diversified luxury fashion house, producing everything from handsome ties and scarves to elegant coats and handbags. But as family members proudly admit, it was the shoemaking skill, amazing creativity, and tremendous determination of founder Salvatore Ferragamo that built the dynasty which exists today.

As the story goes, nine-year-old Salvatore, not wanting his sister to suffer the shame of being without white shoes for her first communion, made the shoes himself, of cardboard and other materials borrowed from the local cobbler. The eleventh of fourteen children, born to poor farmers, he left for America when he was fifteen to make his name as a shoemaker, after having studied the craft in Naples. In the United States he studied shoemaking and mass production and became extremely knowledgeable about the technical aspects of manufacturing. He was not content simply to design shoes which were exquisite and adored; he was determined to create shoes which were comfortable as well. His enrollment at the University of Southern California in anatomy was a blessing not only to Ferragamo but to women in general—he later invented a metal arch support, which he used in every one of his shoes, to provide both beauty and function for his customers.

In 1924 Ferragamo opened a chic shoe store in Los Angeles called the Hollywood Boot Shop. When his shoes started turning up on the feet of many famous customers including Gloria Swanson, Greta Garbo, and Marlene Dietrich, both Cecil B. DeMille and D.W. Griffith commissioned him to create shoes for their silent movies. Even after his return to Italy in 1927, Hollywood kept calling. He created Carmen Miranda's mirrored platforms in 1935, beaded satin mules for Judy Garland in 1938, and continued to receive private commissions from many celebrities and notables, as diverse as the Duchess of Windsor and Eva Perón.

Salvatore Ferragamo's inventions include the wedge heel (1936), the platform (1938), and the "invisible" shoe (1947). Challenged by the rationing of leather during World War II, he used such unconventional fabrics as raffia, cork, braided packing string, tree bark, and nylon fishing line to create some of the wittiest, most fanciful shoes of the twentieth century, many of which are reintroduced and reinterpreted each season. At the time of his death, he had registered 350 patents and created over 20,000 shoe styles, including sandals adorned with 18 karat gold bells and chains, which sold for $1,000 in 1956. Many of his inspirations and adventures are discussed in his autobiography, *Shoemaker of Dreams*, first published in 1957.

Today the Ferragamo children and grandchildren continue the family

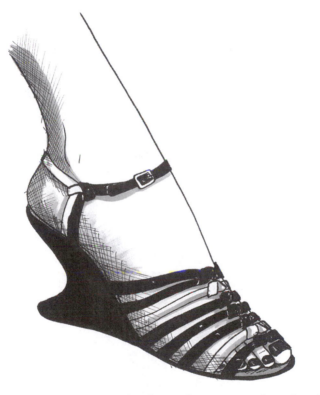

Salvatore Ferragamo: Ferragamo, who designed exquisite and comfortable shoes, patented several of his designs. Two of his most noted designs were for the wedge heel in 1936 and the platform heel in 1938.

tradition of innovation and perfection. Son Ferruccio is the chief executive officer of the company, and sons Leonardo and Massimo oversee operations. All aspects of production are closely controlled. Only very recently have any licenses been granted. After Ferragamo's 1996 acquisition of Emanuel Ungaro S.A., the Luxotica Group agreed, in 1997, to the production of two new eyewear collections, under the Ferragamo and Ungaro names. In the same year Ferragamo teamed with Bulgari to form Ferragamo Perfumes and Ungaro Perfumes. *See also*: Emanuel Ungaro.

Website: http://www.salvatoreferragamo.it

REFERENCES

Ferragamo, Salvatore. *Shoemaker of Dreams*. London: George G. Harrap, 1972.
O'Keeffe, Linda. *Shoes: A Celebration of Pumps, Sandals, Slippers & More*. New York: Workman Publishing, 1996.
Watson, Linda. *Vogue: Twentieth-Century Fashion*. London: Carlton Books, 2000.

S. B.

Elio Fiorucci

B. 1935

Birthplace: Milan, Italy

Award: La Jolla Museum of Art, *Italian Re-Evolution*, 1982

Elio Fiorucci was the very first designer/entrepreneur to recognize and implement what is today the driving force behind so many of the fashion world's greatest successes: the total retail concept. In the late 1960s, however, his ideas were considered outrageous and even subversive by many adults, who cringed at the very mention of his name. For teenagers, however, he was pure inspiration.

Shopping for clothes at a Fiorucci boutique in Milan, London, Tokyo, Rio de Janeiro, Hong Kong, Chicago, or anywhere else was the ultimate in stimulation. Every Fiorucci shop was not only filled with the newest items, including clothing by Ossie Clark and Zandra Rhodes, woven bags from Morocco, and fluorescent plastic shoes or *jellies*, produced by Manolo Blahnik, but was designed and decorated somewhat like a circus set, with employees encouraged to dress in carefree costume. Employment opportunities at a Fiorucci shop were advertised as "auditions," and securing a job was equivalent to winning membership in an exclusive club.

While Mary Quant was defining the "swinging 60s" with her miniskirt and other youth-oriented looks in London, it was Fiorucci in Milan, who took the shoe store he inherited from his father and expanded to include

the latest looks in clothing, accessories, makeup, and blue jeans. He is credited with inventing the concept of designer denim, a direction which continued with Gloria Vanderbilt, Calvin Klein, and virtually every other designer who recognized the value of the label. By the 1970s, when Fiorucci opened his first store in America, New Yorkers like Bianca Jagger and Diana Ross were clamoring for his Buffalo '70 jeans—skin tight and not available in any size over 10.

The popularity of Fiorucci shops declined in the 1980s, although the company continued licensing its name in various men's, women's, children's, and nonapparel categories through the early 1990s. A virtual visionary, Elio Fiorucci pushed aside the parameters of what was considered acceptable and offered young people a fun and funky, all-encompassing shopping experience. From his hot pink plastic rainwear to the chunky cherubs on his whimsical sunglasses, Fiorucci's timely and innovative concepts set the tone for the balance of twentieth-century retailing. *See also*: Ossie Clark; Zandra Rhodes; Manolo Balhnik; Mary Quant; Gloria Vanderbilt; Calvin Klein.

Website: http://www.fiorucci.com

REFERENCES

Martin, Richard, ed. *Contemporary Fashion*. New York St. James Press, 1995.
The Fashion Book. London: Phaidon Press, 1998.

S. B.

Anne Fogarty

B. February 2, 1919

D. January 15, 1980

Birthplace: Pittsburgh, Pennsylvania

Awards: Coty American Fashion Critics' Award, 1951
 Bonwit Teller, 1951
 Neiman Marcus Fashion Award, 1952
 International Silk Association Award, 1955
 Cotton Fashion Council Award, 1957
 American Express Fashion Award, 1962

Fogarty attended Allegheny College and studied drama at the Carnegie Institute of Technology. She moved to New York in 1947 to pursue acting and became a fit model and fashion stylist. In 1948 she began designing for Youth Guild, a fashion company specializing in clothes for teenagers and then worked for Margot Dresses, Inc., from 1950 to 1957.

Her first designs featured her most acclaimed style, the paper-doll silhouette, which was a junior's version of the New Look. This silhouette featured a tight-fitting bodice with a cinched waist and an expansive crinoline petticoat under a full skirt. Tailored to the junior's market, these styles were inexpensive and created from casual fabrics with few trims. Her styles were often imitated by other junior's clothing makers.

In 1962 she established her own business and expanded into misses sizes and separates. Her design work during the 1960s emphasized a new style which combined an empire waistline with a scooped neckline, small puffed sleeves, and a long, narrow skirt. Some of her lines included A.F. Boutique, Clothes Circuit, and Collector's Items. In the 1970s she stopped designing.

In her 1959 book *Wife-Dressing*, Fogarty expressed her design philosophy. In her view, women should look feminine and constrained, thus a girdle was necessary at all times. As an advocate of femininity, she explained that women should dress for their husbands. Her sentiments echo the ideals of the 1950s, an era which called for women to shun the workplace and embrace the roles of wife and mother.

REFERENCES

"Anne Fogarty Dies; Took Several Awards." *Women's Wear Daily* (January 16, 1980).

Connikie, Yvonne. *Fashions of the Decade: The 1960s*. New York: Facts on File, 1990.

Gold, Annalee. *75 Years of Fashion*. New York: Fairchild Publications, 1975.

<div align="right">*A.T.P.*</div>

Tom Ford

See Gucci.

Mariano Fortuny (y Madrazo)

B. 1871

D. May 2, 1949

Birthplace: Granada, Spain

Awards: *A Remembrance of Mariano Fortuny*, Los Angeles County Museum, 1967–1968

Mariano Fortuny (1871–1949), Musée Historique des Tissus, Lyons; Brighton Museum, Fashion Institute of Technology; and Art Institute of Chicago; 1980–1982.

Fortuny was born into a family of artists, so it is no surprise that his work focused on the artistic element of fashion. Although his talents and interests were broad, spanning from lighting design and inventions to sculpture and photography, he was a painter foremost. In addition to traditional painting, he created textile designs using painting techniques.

This painter was an unlikely fashion designer. He disliked the trendiness and commercialism of fashion, preferring the natural form to the corseted contortion in vogue during the 1900s. Theater introduced Fortuny to fashion. His first creation, "Knossos scarves," were made in 1906 for the first performance at the theater he designed for music patroness Comtesse Bearn. These simple silk scarves, which were decorated with geometric patterns, wrapped around the dancers and became unique with each individual dancer's movements. Fortuny continued making the scarves until the 1930s. The success of the scarves piqued his interest in textile production.

Fortuny's most enduring and groundbreaking design was the "Delphos gown," created in 1907 and patented in 1909. Although the dress was cut simply, the elastic quality of the pleated silk produced a sinuous silhouette that harkened back to ancient Greece. First worn by Fortuny's wife, this soft, uncorseted dress was dramatically different from the tailored, highly structured fashions of the era. It became popular as a tea dress, an informal daytime garment. He produced variations of the dress; some had short sleeves, while others had long ones. One version had a peplum. Each dress was finished with small glass beads to weigh down the lightweight fabric.

From the pleated fabrics he created trousers, horizontally and vertically pleated dresses, and dresses with stenciled designs, in addition to the Delphos gown. Also, he worked with velvet. From this fabric he created fashionable dresses and cloaks as well as home furnishings.

Fortuny's pleating and dying methods became his trademark. He patented his pleating method, in which each pleat was formed by hand and set with heat. To retain the pleats, each garment was twisted into a small coil. He created deep, luxuriously hued fabrics by layering colors of natural dyes. Also, he mastered numerous textile dying techniques including aquatint printing, photographic printing, and stenciling. Preferring to create designs with dyes, he avoided embroidery and woven designs. The Middle East, Asia, Ancient Greece, and Venice inspired his designs.

For years Fortuny shunned the commercial nature of the fashion world, selling his creations only from his store in Venice. Eventually he authorized the houses of Babani and Poiret in Paris to sell his clothes. Finally, he opened a store in Paris in 1912, which sold clothing and home furnishings. With the efforts of Elsie MacNeill, who would later become Contessa

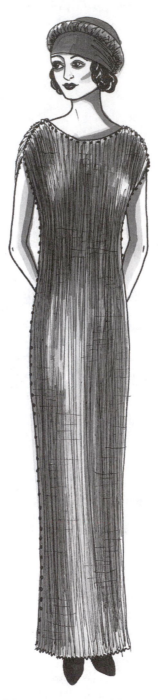

Mariano Fortuny: The "Delphos gown," created by Fortuny in 1907, was a distinct departure from the elaborate, restrictive tea gowns typically worn by society women. The sinuous gowns skimmed the uncorseted body with a sea of silky pleats in a style reminiscent of ancient Greece.

Gozzi, a Fortuny store opened in New York City in 1929. She played an invaluable role for Fortuny by creating her own Fortuny-approved designs from the fabrics and eventually overseeing the fabric-production facilities. She continued to produce garments and fabrics after his death until the early 1980s.

Fortuny's impact on fashion endured beyond his life. He foreshadowed the uncorseting of women in the 1920s, and he reawakened interest in the natural form. His slinky Delphos gown was repeated by designers for the remainder of the century.

REFERENCES

De Osma, Guillermo. *Fortuny: Mariano Fortuny, His Life and Work.* New York: Rizzoli, 1985.
Martin, Richard, ed. *Contemporary Fashion.* New York: St. James Press, 1995.
Milbank, Caroline Rennolds. *Couture: The Great Designers.* New York: Stewart, Tabori and Chang, 1985.

A.T.P.

Fox Brothers' Tailoring

See Harold C. Fox.

Harold C. Fox

B. 1910

D. July 28, 1996

Birthplace: Unknown

The zoot suit is the most innovative men's garment of the twentieth century. Its knee-length jacket featured exaggerated padded shoulders, and the voluminous, high-waisted pants narrowed to a pegged ankle. When the zoot suit emerged during the 1940s, it was a radical departure from typical men's suits which had changed little in nearly a century.

Although the origins of the zoot suit are unclear, several sources attribute the suit's invention to Harold C. Fox, a Chicago tailor. At the least, Fox outfitted musicians such as Duke Ellington, Count Basie, and Louis Armstrong, who helped popularize the style. Fox was the leader of the Jimmy Dale Orchestra when he took over the his family's tailoring business in

1941. He reputedly traded suits for musical arrangements made by the popular jazz musicians who frequently played in Chicago and sported the extreme style. In addition to jazz musicians, urban blacks and Latinos were the primary wearers of the style.

The zoot suit was regarded as fashionable by some and as rebellious and unpatriotic by others. Its popularity coincided with World War II. Rationing during the war led to clothing restrictions for U.S. citizens. To some people, the copious amounts of fabric required to construct a zoot suit constituted open defiance of the American war effort. In California, animosity between Latino "zoot suiters" and U.S. servicemen erupted in a fight known as the Zoot Suit Riots in June 1943. Racial prejudice lay beneath the servicemen's outrage over the fashion, since the garment was worn primarily by blacks and Latinos.

The initial fad of zoot suits was short lived, but the 1990s witnessed a resurgence in the popularity of swing dancing and the zoot suit. In an effort to embody the spirit of the 1940s, many dancers dressed in vintage clothing which helped bring back the zoot suit. Soon, the fad expanded to dressier occasions such as high school proms. Several tailors throughout the country began offering custom-made zoot suits. Fox, who died in 1996, continued wearing the fashion throughout his life and was buried in a lavender one.

REFERENCES

Eig, Jonathan. "The Mad Haberdasher." *Chicago* 45 (December 1996): 61–64.
Samek, Susan. *The Well-Suited Man.* Chicago: Chicago Historical Society, April 12, 1994–October 3, 1994.
Taubeneck, Anne. "Dressing the Part: Those Zoot Suits Are Really Killer-Diller." *Chicago Tribune* (July 16, 2000): 7.

A.T.P.

Frederick's of Hollywood

Frederick's of Hollywood originated as a New York mail-order company which specialized in intimate apparel. Frederick Mellinger, called "Mr. Frederick," began the business in 1946. He opened his first store on Hollywood Boulevard to take advantage of the glitz and glamor that surrounded movie stars.

Much of Frederick's initial success can be attributed to Mellinger's inclusion of black lingerie. This European-style lingerie was quite a departure from the standard white undergarments worn by most American women. Frederick's lingerie was designed from a man's perspective, producing a man's ideal of women's undergarments. Frederick's draws female custom-

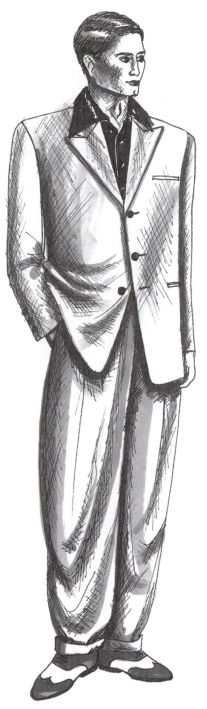

Harold Fox: The most innovative and outrageous men's fashion of the twentieth century, the zoot suit was characterized by a knee-length jacket with exaggerated padded shoulders and voluminous, high-waisted pants with pegged ankles.

ers, male customers buying lingerie for women, and cross-dressing men, attracted by the anonymity of mail order and the availability of larger sizes.

Over the years Frederick's has popularized many lingerie innovations including one of the first push-up bras in 1948, front-hook bras, and bras with shoulder pads. All of the company's undergarments worked together to create the firm yet feminine silhouette of the 1950s. By providing this important infrastructure in a fashionable way, the company became a household name if only in the bedroom. Frederick's experienced a resurgence of recognition in the 1980s when MTV stars, including Madonna and Cyndi Lauper, wore underwear as outerwear. One of the company's most notable products during this decade was the bustier, an often strapless, tight-fitting top worn instead of a brassiere or as outerwear. It continues to be one of the few companies that carries an extensive line of the garment.

The late 1990s brought many changes to the time-honored company. Knightbridge Capital acquired Frederick's in 1997. During that same year, the company launched its highly successful website. For over fifty years Frederick's relied on its long-standing image of overtly sexy lingerie modeled by bold, brash pinup girls. When Terry Patterson took over as the company's first female chief executive officer in 1998, she began updating the company's image. Aiming to offer lingerie from a woman's perspective, Patterson gave the models and lingerie a softer, more natural look. Also, she consolidated the catalog and the more than 200 stores of retail operation into one harmonious entity. In the process, the stores were remodeled to fit the company's new image. As it embarked upon the new millennium, Frederick's poised itself to take advantage of the less-closeted attitudes about prevailing undergarments.

Website: http://www.fredericks.com

REFERENCES

Monget, Karyn. "Perfumes to Panties: Linda LoRe Appointed CEO of Frederick's." *Women's Wear Daily* (June 21, 1999): 1.
"Patterson Freshens Up Frederick's." *Women's Wear Daily* 175 (September 28, 1998): 10.
Wedlan Candace A. "Frederick's of Hollywood Wants to Be the Pillar of Panties." *Grand Rapids Press* (September 10, 2000).

A.T.P.

Carol Friedlander

See Carolee.

֍

Fubu

Daymond John entered the fashion industry by selling tie-top hats on the street corners of Queens, New York, in the early 1990s. The immediate popularity of his hats lead John to assemble a team of his neighborhood friends to form the company FUBU. The idea behind FUBU (For Us by Us) was simple: "The consumer is making clothes for the consumer." With this philosophy guiding the FUBU team, Daymond John, Keith Perrin, Carl Brown, J. Alexander Martin, and designer Kiki Peterson affixed the FUBU name on oversized t-shirts, hooded sweatshirts, baseball caps, and baggy jeans to create the new uniform of the hip-hop generation.

In 1993 John, then a waiter at a Red Lobster restaurant, decided to risk everything on his upstart company and took out a second mortgage on his home in Hollis, Queens, to convert his basement into a manufacturing and distribution center. The gamble paid off. Retailers, in both inner cities and suburbia, were developing urban sportswear departments, and by 1995 department store chains such as J.C. Penney, May, Macy's, and Federated were looking for new labels to attract the African-American hip-hop market. What stunned the retailers, however, was the demand for FUBU products outside of this niche market. Teens everywhere wanted to dress like the Fugees, Wu-Tang Clan, and LL Cool J, and the FUBU label rapidly made the transition from niche brand to mainstream.

The increasing demand by consumers for urban sportswear resulted in the rapid ascent of many new companies, most of which were plagued by distribution problems associated with high-volume demand. Even early hip-hop pioneers such as Karl Kani suffered when his manufacturing and distribution operations could not sustain the ever-increasing demand. FUBU, which is operated under the Samsung Corporation, developed a limited distribution strategy to maintain demand and delivery. FUBU also focused on marketing strategy, drawing on friends such as LL Cool J to endorse their line and secure their market share through a carefully cultivated brand identity.

After securing their position in the urban sportswear market, FUBU began expanding its operations by developing new product lines and creating licensing agreements. Through licensing agreements with Pietrafesa and Phillips-VanHeusen, FUBU expanded into tailored clothing, dress shirts, and neckwear which are carried at prestigious establishments such as Brooks Brothers and Nordstrom. They hold several licensing agreements for women's and men's accessories, loungewear, footwear, and underwear, and they partnered with the National Basketball Association in 1999 to create a line of team-associated apparel. FUBU also developed a retail division with plans to open forty-five stores in various international locations

Fubu: Oversized t-shirts, jackets, and jeans, prominently emblazoned with logos, typify FUBU's hip hop–inspired fashions.

by 2005. As a result of their apparel lines, licensing agreements, marketing strategies, and limited distribution, the FUBU label continues to be the leading company in the urban apparel market. *See also*: Karl Kani.

Website: http://www1.fubu.com

REFERENCES

Cole, Patrick. "FUBU's Ultra-hip Clothing Hops from Niche to Mainstream." *Chicago Tribune* (June 20, 1999): 5.

Hunter, Karen. "FUBU Challenges Rivals in Urban Apparel Industry." *Knight-Ridder/Tribune Business News* (November 11, 1996): 8, 9.

Perez, Anabelle. "Urban Development." *Sporting Goods Business* 30 (June 23, 1997): 35–40.

Romero, Elena. "FUBU Gets Ball Rolling with NBA License." *Daily News Record* (January 25, 1999): 14.

———. "FUBU Licenses P-VH." *Daily News Record* (August 13, 1999): 33.

A. K.

G

John Galliano

See Christian Dior; Hubert de Givenchy.

The Gap, Inc.

Awards: Advertising Age's Marketer of the Year, 1997
 Gold Medal Winner, National Retail Federation, 1997

In the late 1960s, lifestyles in America were changing rapidly. Society was becoming more relaxed, people had more leisure time to spend on recreational activities, social roles for women were changing, and the hippy movement was questioning societal norms with open protest and blatant disregard for the establishment. It was an era marked by constant disagreement among the generations and the birth of a new, casual dress uniform: t-shirts and jeans.

Concurrently, Don Fisher and his wife, Doris, were looking for a new business opportunity. The high demand, and high-profit margin for Levi's prompted them to open a store in San Francisco to sell Levi's and records. The name of the store would be PAD for "pants and discs." Shortly before opening the store, the couple attended a party where a discussion ensued on the new concept of the generation gap. Doris Fisher, who was not completely happy with the PAD name, thought perhaps that Generation Gap

might be an appropriate name for a jeans store. The name seemed too long though, so it was shortened, and in 1969 The Gap was born.

The Fishers' timing was perfect for entering the jeans market. The fashion silhouette had just changed from tapered pants to bell bottoms, and people everywhere were restocking their wardrobes. The competition for the jeans market was fierce; everybody was selling Levi's. The key to Don Fisher's success was aggressively to monitor and replenish his inventory. He wanted to always be in stock, so that customers would not need to look elsewhere. The Gap established a reputation for always having every size, and it developed a loyal following.

The Gap continued to expand throughout the 1970s. In 1974 Fisher decided to add private-label merchandise to the product mix. By 1976 The Gap carried fourteen private labels in 200 stores when the unthinkable happened: the bottom dropped out of Levi's. The Federal Trade Commission ruled that Levi Strauss and Company could not set prices. Soon, stores everywhere were dropping the retail price for Levi's, and Fisher was forced to do the same, at the sacrifice of his profit margins. If The Gap had not already expanded into private-label goods, and had not developed such a loyal following through their inventory strategy, The Gap would have had to close.

The popularity of The Gap sparked an idea with Fisher: why not take the company public? In 1976 The Gap successfully launched an IPO, and the stock traded with moderate demand, and sustained moderate profits, for the next several years. However, Fisher saw signs of trouble ahead. By 1980 only 35 percent of The Gap sales revenues were generated by Levi's. The private-label product lines were popular, but the merchandise was not distinctive; it did not have a niche. The Gap was a basic discount retail chain with no brand image, trying to compete at a time when all retailers were expanding into private-label goods. Fisher realized that he did not fully have the background to shift The Gap from a retailer to a brand. To grow his business, Fisher brought in Mickey Drexler.

Mickey Drexler was born and raised in the Bronx. While in high school Drexler frequently accompanied his father, a button and textile buyer for a coat manufacturer, into the garment district of New York City. After high school, Drexler earned his bachelor's degree in business from the State University of New York at Buffalo, which he followed with an MBA from Boston University in 1968. Drexler worked his way through a series of positions at the retailing giants Bloomingdale's, Macy's, and Abraham & Straus, developing a reputation for ingenious merchandising strategies. In 1980 he was named president of the women's clothing chain Ann Taylor and completely revitalized it. Fisher was impressed by Drexler's accomplishments and hired him in 1983 to invigorate The Gap.

Drexler's first step was to discontinue all the private labels except one: The Gap line. He assembled a new design team, established high standards

for quality, and renovated all the stores. It was Drexler's merchandising expertise that created the clean Gap image. All the stores were remodeled with wood floors, clean white walls, tables with neatly folded stacks of shirts, and a back wall with jeans stacked in columns from floor to ceiling. Drexler also decided to focus on the basics: jeans and t-shirts in as many colors, styles, and sizes as each store could stock. Success followed. Stock values rose. Profit margins grew. The Gap was on top. The Gap revolutionized the concept of the specialty store; they became a brand as well as a retailer.

The immense success of The Gap allowed The Gap, Inc., to expand, both within The Gap store offerings, and by adding new divisions to the corporation. In 1983 Fisher bought the small retail chain Banana Republic. The merchandise carried in Banana Republic was inspired by such movies as *Indiana Jones* (1981) and *Out of Africa* (1985). The division generated strong sales and profits until the popularity of the "safari look" waned in the late 1980s. Fisher and Drexler began work immediately to do for Banana Republic what they had done for The Gap. They created a new image, based upon sophisticated, upscale career separates which embraced trends without looking trendy. The store interiors were remodeled, and the mosquito netting was ripped down and replaced by sleek, European-inspired wood and metal fixtures. In 1986 Drexler, unable to find basic, moderately priced clothing for his son, launched GapKids, creating the first new Gap division. The following year, The Gap opened its first store outside of the United States, in London. The Gap attempted to add shoes in 1992, but met with little success and closed the division in 1994. Also in 1994, The Gap debuted its first fragrance. With steady growth occurring in The Gap, Fisher and Drexler looked for the next challenge. Since Banana Republic provided an upscale division for The Gap, they decided to develop a budget division. There was a distinct growth in discount retail sector with companies such as Target and Wal-Mart providing budget merchandise. However, Drexler and Fisher asked, "Does bargain shopping have to be dreary?" "Does the quality have to be inferior?" The answer came in 1994 with Old Navy. Old Navy provided a fun alternative to the typical budget-price retailer. These open, bright stores resembled a warehouse with exposed pipes and concrete floors. Refrigerators were used to display the merchandise. The Old Navy product line stuck with simple basics which could be produced inexpensively without sacrificing quality. Old Navy made it chic to bargain shop, even for those who could afford designer labels.

While Drexler and Fisher focused on building Banana Republic and Old Navy, The Gap began to suffer. In 1991 Vogue magazine featured super-models in Gap jeans and t-shirts. By the mid-1990s, everyone was copying The Gap, from store design to merchandising strategies to product development. The basics that The Gap carried could be found in J.C. Penney,

Ralph Lauren, and Wal-Mart. In 1992 The Gap's stock prices dropped 50 percent. Store sales began to decline, experiencing only a 5 percent sales growth in 1993, a 1 percent growth in 1994, and finally sales went flat in 1995 with no increase. Suddenly the golden child of the retail industry was the subject of ridicule for failing to stay ahead of the competition. Wall Street dubbed The Gap "mature," indicating it had saturated the marketplace and would no longer continue to experience growth. In 1996 Drexler was shocked by the appearance of The Gap stores. The interiors were run down, and the clothing resembled Calvin Klein's unisex, heroin chic look. Radical change was required to reposition The Gap.

Drexler immediately transformed both the advertising and product design departments and brought in new staff. He returned the product focus to The Gap basics: khaki pants, jeans, woven shirts, and t-shirts. Every product that is generated by the design department must be "ordinary, understated, unpretentious and familiar" (Munk, p. 70), because that is what The Gap is—everyday, basic American clothes. The competition is tough for this basic market; everyone from Levi's to Ralph Lauren to J Crew to Abercrombie & Fitch is selling the same core product. What The Gap is able to do, better than their competition, is develop innovative marketing campaigns to create a "cool" image for their products. In 1997 The Gap made a triumphant return to television advertising, resurrecting the "Fall into the Gap" campaign which first appeared in 1974. The Gap drew upon a diverse range of performers, including LL Cool J, Lena Horne, and Luscious Jackson, to sing their signature tune on television and appear in print ads. The concept was simple—one person singing against a white background—and consistent with The Gap's philosophy that less is more, whether it is in advertising, store design, or product development. The campaign was a success, and The Gap posted a 6 percent increase in sales in 1997. Determined to keep The Gap in the forefront of basic fashions, The Gap began to conduct advance planning for its merchandising, advertising, and product development strategies. The Gap decided in 1997 that 1998 would be "the year of the khaki." The concept was promoted throughout all facets of The Gap corporation. The design team generated hundreds of color and style variations, the merchandising team generated window display concepts, the sales clerk were dressed exclusively in khakis (they could buy them for $10), and the advertising department launched the Khakis Swing, Khakis Rock, Khakis Groove, and Khakis A-Go-Go campaigns. When the products hit the stores, the advertising and merchandising strategies created a "must have" phenomenon.

The Gap's other strength is their product availability. Drexler, who became chief executive officer of The Gap in 1995, believes that The Gap's inventory strategy should be modeled after supermarkets. "If you go to the supermarket, you would expect to find milk. I don't know why apparel stores should be any different" (Munk, p. 68). Unlike most retail stores,

which try to carry as little back stock as possible, The Gap stores carry a high inventory and pride themselves on always being in stock. Drexler has transformed The Gap into a staple, just like Coca-Cola, McDonald's, and Gillette. He believes that it should be as easy to purchase a Gap t-shirt as it is to purchase a Coke. This strategy seems to be working. In 1998 Americans spent an average of $700 per capita on clothing, and $23 of that was spent at The Gap.

The Gap, Inc., encompasses five divisions—The Gap, GapKids, Baby Gap, Banana Republic, and Old Navy—each is targeted to a different customer base. The Gap, Inc., grows, on average, between 15 and 20 percent every year, opening a new store almost every day. Under Drexler, The Gap, Inc., has grown to over 2,000 stores located in the United States, Japan, England, France, and Germany. The combined annual sales volume for all The Gap, Inc., divisions in 1999 was $9.05 billion. The phenomenal success experienced by The Gap, Inc., is due to the integration of merchandising, marketing, and product development strategies that never lose sight of the target customer. See Also: Levi Strauss, Ralph Lauren, The Limited, Inc.

Website: http://gapinc.com

REFERENCES

Cuneo, Alice. "The Gap." *Advertising Age* 68 (December 15, 1997): 1.
Mitchell, R. "The Gap: Can the Nation's Hottest Retailer Stay on Top?" *Business Week* (March 1992): 58–64.
Munk, Nina. "Gap Gets It." *Fortune* 138 (August 3, 1998): 68–74.
Reda, Susan. "Donald G. Fisher." *Stores* 79 (1997): 139.

A. K.

Jean-Paul Gaultier

B. April 24, 1952
Birthplace: Arcueil, France
Award: Fashion Oscar Award, 1987

Even in his forties Jean-Paul Gaultier was described as an enfant terrible, a moniker he earned when his began his fashion career in the 1970s. As a designer he embraced an unconventional sense of gender and sensuality. He revised the feminine ideal to include the qualities of strength, power, and authority. To the stereotype of masculinity he added the ideas of sensuality, femininity, and narcissism. This gender redefinition in his designs has become the most enduring characteristic of his work.

Gaultier showed his first collection when he was only thirteen. The small

Jean-Paul Gaultier: As the unrefuted enfant terrible of fashion, Gaultier designs glamorous, theatrical fashions which embrace an unconventional sense of gender and sensuality.

audience consisted of his mother and grandmother. He was often inspired by his grandmother, the person who taught him about makeup and hairdressing. He attended the Ecole Communale, the College d'Enseignement, and the Lycée d'Arcueil, but he preferred to skip school and work on his designs.

In 1972 Gaultier was hired as an assistant to Pierre Cardin. He worked at a number of other companies including Jean Patou before returning to Cardin. Following his departure from Cardin the second time, he became a stylist in the Philippines.

In 1976 he unveiled his first collection after setting up his own company with two school friends, Francis Menuge and Donard Potard. After financing collections for a few seasons, they found themselves $12,000 in debt. In 1979 the debt prompted them to sign a licensing deal with a Japanese company, Kashiyama to finance Gaultier's first thematic collection, which was based on the James Bond character. By 1981 he had acquired additional financial support from the Italian companies Gibo and Equator.

Gaultier's main influence on fashion occurred in the 1980s. His glamorous, theatrical designs appealed to the excess and conspicuous consumption of the decade. From his 1983 slashed and layered look to his chiffon dungarees, he elevated the styles he found on the streets and put them on the designer runway. During this decade he resurrected the conical, pointed breasts of the 1950s and created exaggerated examples for the costumes of Madonna's Blonde Ambition tour. Also, he played with the gender roles by introducing men's skirts and popularizing the corset as outerwear.

Gaultier's most accepted designs were menswear for men and women. He reworked classic suits, fitting the jackets to produce hourglass shapes. To further stylize the designs he elongated the shoulder lines and added metal tips to the collars.

Although the 1980s marked Gaultier's height of popularity, it was not until 1996 that he presented his first couture collection. He aimed to keep his designs accessible to the street kids who inspired it by creating JPG, a diffusion line, and licensing such items as furniture, jeans, jewelry, and perfumes. His first fragrance was appropriately packaged in a bottle shaped like a corseted female torso. Shiseido produced this self-titled scent. In 1999 he introduced Fragile perfume, which was packaged in an innovative snow globe bottle.

During the late 1990s many previously independent designers found their companies stagnating. They sold shares of their businesses to larger luxury goods companies to attain enough money to expand their enterprises. In 1999 Gaultier-brand products were earning $390 million a year. By 2000 Gaultier felt that the company could not achieve further growth without additional financial backing. In an effort to alleviate the lack of funds, he sold 35 percent of the company to Hermès. *See also*: Pierre Cardin; Jean Patou; Hermès.

Website: http://www.gaultier.com

REFERENCES

Carnegy, Vicky. *Fashions of the Decade: The 1980s.* New York: Facts on File, 1990.

Conti, Samantha. "Selling Out in Order to Survive." *Women's Wear Daily* 179 (January 3, 2000): 8.

Spindler, Amy. "Jean-Paul Gaultier: France's Homeboy." *Daily News Record* 21 (July 22, 1991): 22.

A.T.P.

Rudi Gernreich

B. 1922

D. April 21, 1985

Birthplace: Vienna, Austria

Awards: Coty Award, 1960, 1963, 1966, 1967
 Knitted Textile Association Crystal Ball Award, 1975
 CFDA Special Tribute, 1985

Long before December 1, 1967, when he became the first American designer to appear on the cover of *Time*, colleagues from the worlds of art and fashion had hailed him as a super star. Rudi Gernreich has been referred to as a visionary, a prophet, a clairvoyant, and an innovator who changed the shape of fashion. His ingenious and imaginative designs foretold all that clothing would be about in the future—fun, freedom, and sex. His 1965 invention—the soft, unstructured "no bra" bra—was probably the most important garment introduced during the second half of the twentieth century. His new concept, which he began to formulate in 1970, called "unisex," was a reflection of his uncanny ability to foresee what was to come. Although his topless swimsuit may have outraged the America of the 1960s, it enshrined him as *the* guru and the most influential social message carrier of fashion's next forty years.

One-time film-maker (*Crackers*, 1970), a cofounder of the first revolutionary gay rights organization (the Mattachine Society), and the creator of "the total look," achieved by extending the wild Op Art patterns on his clothes to the shoes and stockings, Gernreich began his career in New York in 1949, with a coat and suit manufacturer who dismissed him within months for his unsatisfactory designs. Having moved to Los Angeles from Vienna with his mother in 1938, he naturally retained images from his childhood and later used them as inspiration for his designs, such as his topless swimsuit which, supposedly, was based on a children's bathing suit popular in Vienna during the 1930s.

Gernreich was trained in modern dance, and he danced professionally for several years. The use of tights and leotards in his body-conscious clothes reflected his belief that clothing should celebrate freedom of movement, a radical concept that contrasted strongly with the prevailing idea that fine clothing should be rigidly constructed. These were just a few of the Gernreich influences that began fashion's new relationship with stretch and comfort.

In 1952 Gernreich 's cotton dresses were shown in Jax, a hip shop in Los Angeles, where they sold out in a day. In the late 1950s, he was the first to shorten the skirt, followed immediately by André Courrèges, Emilio Pucci, and Mary Quant. By the 1960s his career was booming, resulting largely from the huge success of his knitwear, produced in conjunction with Harmon Knitwear and Westwood Knitting Mills. Gernreich was the first to use transparency in clothing, inserting clear vinyl panels in mini dresses and swimsuits. His experimentation with synthetic fabrics, including a molded dress, is now acknowledged as the prelude to today's use of high-tech fabrics. His 1974 thong and Y-front underwear for women were later popularized in the 1980s (the latter by Calvin Klein), as was his tube dress, reinvented by Donna Karan in the 1990s.

After his forays into gourmet food and furniture design, he began work on his final fashion statement—the pubikini—his perfectly cut and fitted triangle of fabric, intended to break the last taboo in the revolution of women's liberation. His colorful, uninhibited, and audacious designs are considered by many as indisputable evidence that Gernreich was indeed the most farsighted designer of the century. *See also*: André Courrèges; Emilio Pucci; Mary Quant; Calvin Klein; Donna Karan.

REFERENCES

Horyn, Cathy. "The Shock Heard Round the World." *Vanity Fair* (May 1998): 122.

Milbank, Caroline Rennolds. *New York Fashion: The Evolution of American Style*. New York: Harry N. Abrams, 1989.

Moffitt, Peggy, and William Claxton. *The Rudi Gernreich Book*. New York: Rizzoli, 1991.

S. B.

Hubert (James Taffin) de Givenchy

B. February 20, 1927

Birthplace: Beauvais, France

Awards: Oscar, Wardrobe Design, *Sabrina* (1954)
 Oscar, Wardrobe Design, *Breakfast at Tiffany's* (1960)
 Dé d'Or Award (Golden Thimble), 1982, 1978
 Chicago Fashion Award, Chicago Historical Society, 1995

Hubert de Givenchy's imagination was inspired by his grandfather, a former director of the renowned Manufacture de Beauvais and the Manufacture des Gobelins tapestry works, and his grandmother's collection of fine textiles. Givenchy viewed his first couture garments at the age of ten when he attended the Pavillon d' Elégance at the 1937 Paris Exposition. From that moment, Givenchy knew that he wanted to be a couturier; however, his family disapproved. At his family's request, Givenchy attended college, intending to pursue a career in law, but he found himself drawn to fabrics and fashion periodicals.

Givenchy moved to Paris after World War II and entered the Ecole des Beaux-Arts. While pursuing a formal education in fashion, he apprenticed at the House of Fath. Givenchy also worked briefly at two of the top couture establishments in Paris, the House of Piguet—which was known for a young, dramatic, yet simple style—and the House of Lelong—which had a reputation for conservative, distinguished, high-quality clothing. Next, Givenchy took a position under Elsa Schiaparelli, one of the most creative and unconventional designers in Paris, where he designed her youthful boutique clothes. This position gave him creative control and the opportunity to cultivate relationships with couture customers.

Givenchy's first collection, shown in February 1952, was an immediate success. This collection introduced simple, functional, and youthful separates and dresses in complete contrast to Christian Dior's rigid, corseted, and padded styles. His clothes were modern and fresh. The success of his first collection allowed Givenchy to meet his longtime idol, Cristóbal Balenciaga. Balenciaga, who became Givenchy's mentor and friend, helped him refine his designs. Givenchy derived his design philosophy from Balenciaga: "Keep it simple. Eliminate everything that interferes with the line." Givenchy continued to refine his designs, placing more emphasis on shape. By 1957 his experimentation had resulted in a new fashion silhouette, the chemise or sack silhouette, the first major style change since the hourglass silhouette of Dior's New Look in 1947. The sack dress was widely adapted by all women for its style and comfort.

Givenchy's designs are characterized by bright colors, unusual textures, and architectural shapes. He sculpted his creations from crisp silk gazar, soft cut velvets, and heavy cloque textured silks. Givenchy's design combined both elegance and playfulness, with subtle, whimsical details and accents such as feathers or fringe. His collections contained easy to wear, mix and match pieces for day and evening which were both stylish and practical.

Hubert de Givenchy: Through experimentation with line, shape, and form, Givenchy pioneered the new sack silhouette for women in 1957. The silhouette marked the first major departure from Christian Dior's New Look of 1947.

Givenchy's client list has included such distinctive and elegant women as Jacqueline Kennedy Onassis, Wallis Warfield Simpson, and Princess Grace of Monaco; however, he is probably best known for his relationship with film star Audrey Hepburn. Hepburn came to epitomize the spirited, classic, and glamorous clothing designed by Givenchy. Givenchy and Hepburn first met when he was hired to design her wardrobe for the movie *Sabrina*. The two immediately became friends. The youthful energy exuded by Hepburn became the inspiration for many of Givenchy's designs; she even served as the inspiration for his perfume L'Interdit. The fashions designed by Givenchy and the youthful chic of Hepburn define both the fashion ideal of the 1960s and the new ideal for feminine beauty. Givenchy continued to design wardrobes for other Hepburn films such as *Funny Face* and *Breakfast at Tiffany's*, in addition to her personal wardrobe.

The 1960s were difficult times for many couture houses. Changing economic conditions reduced the number of clients who could afford to pay couture prices. The new youth market was not interested in conservative fashions which required numerous fittings. Many couture houses began exploring options in ready-to-wear clothing and licensing to expand their marketplace and profits. Givenchy introduced his first line of ready-to-wear apparel, Givenchy Nouvelle Boutique, in 1968. The line contained trendy, chic fashions targeted to the youth market, at substainially less than haute couture prices.

Givenchy also developed other product lines and entered into licensing agreements. The Givenchy name appeared on products such as cosmetics, fragrances, eyeglasses, furs, men's shirts, and home furnishings. He licensed two jewelry lines, Givenchy Bijoux and Nouvelle Classics, both manufactured by Victoria Creations in New York, and a hosiery line licensed by Esmark Inc. He licensed a line of handbags and small leather goods to Koret, which concluded in 1994 and was returned to in-house design staff. These licensing agreements not only were lucrative, but also allowed Givenchy to offer men and women the complete "Givenchy look." Other unique opportunities were also presented to the couturier from outside the fashion industry. Givenchy designed a 1979 model of the Lincoln Continental Mark V, interiors for the Singapore and Brussels Hiltons hotels, the Indosuez Nagoya Bank in Tokyo, and porcelain for Limoges.

Givenchy was a master at incorporating the latest fashion trends into designs that did not look too trendy. He moderated his unusual combinations of color, texture, and line with his own inherent sense of good taste and sophistication. Many consider Givenchy to be one of the last true couturiers. Givenchy has subltly and consistently directed fashion trends since the opening of his house in 1952. With the fall 1995 haute couture collection, Givenchy completed his seven-year contract with Moët Hennessy–Louis Vuitton (LVMH), the company which bought his couture house from him in 1988, and he retired from the fashion industry.

After Givenchy's retirement, the flamboyant John Galliano was named by LVMH as the new head couturier at the House of Givenchy. The appointment of the British newcomer and ready-to-wear designer was considered controversial. His wildlife style and theatrical designs were in complete contrast to the Givenchy style. LVMH hoped Galliano would update and revitalize the image of Givenchy, but would the ready-to-wear designer measure up to French standards?

John Galliano, born Juan Carlos in Gibraltar in 1960, grew up in the working-class suburbs of London. Galliano studied design at the St. Martin's School of Art and graduated in 1983. The collection he produced for his graduation was so impressive that it was purchased immediately by Brown's, one of London's fashionable shops. This early success provided Galliano with the impetus to found his own ready-to-wear business, and in 1991 he launched his first collection in Paris. However, his wild lifestyle and artistic temperament often delayed his production schedule, earned him a reputation for being difficult to work with, and cost him the support of many of his financial backers. Drawing on historic costume research and cultural groups, Galliano's ready-to-wear collections are dynamic and glamorous. He is the master of the slinky bias-cut dress. His first couture collection for Givenchy (spring 1996) was received with mixed reviews. While paying homage to Givenchy's style, the collection was sparse, only fifty pieces, and lacked the strong themes and grandeur of French couture. Galliano designed two collections for the House of Givenchy before being appointed head designer at the House of Dior (also owned by LVMH).

Alexander McQueen was signed to Givenchy in 1996 to replace Galliano, and he produced his first couture collection for the house for the spring 1997 season. McQueen, another British newcomer and ready-to-wear designer has been noted for his post-punk designs which are sexy, dark, and energetic. He often has been criticized for using car crashes and attacks as inspiration for producing his angry, edgy designs. His work is the epitome of British design, and it stands in complete opposition to the quiet elegance of the House of Givenchy.

Born in 1970 on London's East End, McQueen is the son of a cabdriver. He apprenticed on Savile Row as a pattern cutter for tailors Anderson & Sheppard and Gieves & Hawkes. Next, McQueen assisted Kohji Tatsuno in London and Romeo Gigli in Milan. This work helped him win a scholarship to the St. Martin's College of Art and Design where he graduated in 1991 and his senior collection garnered him attention from fashion critics. He founded his own label in 1992 and produced shocking and raw women's ready-to-wear clothing. He launched his first men's and footwear collections in spring 1996. Also, in 1996, he received the British Designer of the Year award.

McQueen's first collection for Givenchy was not received with rave reviews. It contained several strong pieces, yet lacked maturity. Underneath

the glitz and glamor however, was superbly constructed clothing. In 1998
LVMH resigned McQueen to a three-year contract which will end with the
fall 2001 ready-to-wear season. With each collection McQueen continues
to refine the Givenchy image. His work is becoming more fluid and elegant,
with a purity of line and an emphasis on geometric shapes which show
innovative details and impeccable tailoring. He has re-created the Givenchy
woman combining good, clean Parisian couture with a tough chic image.
See also: Jacques Fath; Elsa Schiaparelli; Christian Dior; Cristóbal Balen-
ciaga; Louis Vuitton.

Website: http://www.givenchy.com

REFERENCES

Collins, Amy Fine. "When Hubert Met Audrey." *Vanity Fair* (December 1995):
 278–95.
Drake, Alicia. "Will It Sizzle?" *Women's Wear Daily* 173 (January 16, 1997): 6–
 9.
Duffy, Martha. "The New Kid in Town." *Time* 147 (1996): 64.
Kanellopoulos, Anddreas. "Thank You, Hubert de Givenchy." *Next Fashion* (Win-
 ter 1996): 94–99.
Lender, Heidi. "Monumental Hubert." *Women's Wear Daily* 164 (November 10,
 1992): 11.
Milbank, Caroline Rennolds. *Couture: The Great Designers.* New York: Stewart,
 Tabori and Chang, 1985.
Mulvagh, Jane. *Vogue History of 20th Century Fashion.* New York: Viking, 1988.
"Paris: Givenchy to Galliano." *Europe* 350 (October 1995): 381.

A. K.

❧❧

Gottex

Award: Dallas Fashion Award for Swimwear, 1994

Gottex was created in 1956 by Armin and Leah Gottilieb, a family-
owned business, originally based in Tel Aviv, Israel. The owners' daughters,
Miriam and Judith, were involved in the business; Miriam selected fabrics
and acted as head designer, and her husband, Stephen Ruzow, was vice
chairman. The Gottiliebs' other daughter, Judith, managed the company's
operations. In the 1990s 80 percent of the company was purchased by
Africa Israel, making them a partner, following the death of Armin and
Leah Gottilieb. Miriam Ruzow was promoted to president and kept the
position of head designer.

Miriam received her training in Paris where she studied fashion design.
Her first interest was in designing lingerie, but her mother persuaded her

to design swimwear for the family business. Miriam's creative ideas and technical knowledge made Gottex successful with the use of innovative fabrics, surface embellishments, and, most important, the fit. Some of the fabrics include complicated prints inspired by Pucci prints, beaded surfaces, and an abundance amount of lycra for encompassing the body. The quality of the fabric and construction contribute to the look and fit of the garments. Gottex's signature styles contain one-piece and two-piece suits, fitted lycra skirts with coordinated tops, and various styles of matching cover-ups.

Gottex also carries a line called Viewpoint, a contemporary, moderately priced swimwear collection; Gottex for Kids Swimwear; and other products such as sun-care products, sheets, and towels. Gottex also has a license agreement with Eur-Eyes, Ltd., which produces their sunglass line. In addition, Miriam introduced her new lingerie collection in Europe in 1995.

This family-owned business has been a leader in swimwear for years and still is with its exquisite, innovative fabrics made of vibrant colors and flattering silhouettes. In the fashion industry, the name Gottex is synonymous with quality and fashion.

Website: http://www.gottex.com

REFERENCES

"Gotta Have Gottex." *Connoisseur* 21 (June 1988): 98.
Mansfield, S. "Gottex's Miriam Ruzow." *Vogue* 181 (June 1995): 53.
"Swimwear: Gottex." *Women's Wear Daily* 168 (September 26, 1994): 18.
White, Constance. "Miriam Ruzow Keeps the Sun in Focus at Gottex." *Women's Wear Daily* 157 (February 22, 1989): S10.

N. S.

Benjamin Benedict Green-Field

B. 1897

D. December 13, 1988

Birthplace: Chicago, Illinois

Benjamin Green-Field was born in Chicago, Illinois. The death of Green-Field's father, when Benjamin was three, necessitated his mother, Ida Helen Green-Field, to open a hat shop to support her four children. Green-Field dropped out of high school to apprentice in the millinery trade, and soon after he opened his own business, Bes-Ben, a partnership with his sister, Bessie Green-Field, in the late 1920s.

Green-Field's early work was typical of late 1920s and early 1930s headwear, and his shop on fashionable Michigan Avenue was relatively un-

known. However, in 1941, Green-Field accidentally developed a design concept that created a worldwide following for his work. As legend recounts, Green-Field saw a woman walking her Dalmatians down Michigan Avenue. On a whim, he made a hat topped with miniature Dalmatians and placed it in his store window for sale. Soon, he was flooded with requests to create hats for patrons featuring the likenesses of their pets and other whimsical creatures.

Over the next three decades, Green-Field became known as the "Mad Hatter" for his conversation-piece designs. His whimsical designs featured leather lobsters, dice, jeweled bees, clocks, and other objects he collected on his travels to Cuba, Paris, Hong Kong, and other exotic locations. During the World War II rationing restrictions, he incorporated nonrationed materials, such as kitchen utensils, scrub clothes, feather dusters, napkin rings, tea strainers, and clothespins, into his designs. Green-Field was also commissioned for a number of special headwear pieces including a hat for the 1944 Democratic National Convention, a hat adorned with razor blades for Hedda Hopper to wear to the opening of her film *The Razor's Edge* in 1946, and a headpiece for the queen of Belgium for the Brussels 1958 World's Fair. As hat popularity declined in the 1960s, Green-Field added decorative pillows to his business, but he elected to close his shop and retire in 1978.

REFERENCE

Papers of Benjamin Benedict Green-Field. Archives. Chicago Historical Society.

A. K.

❧

Madame Grès (Germaine Barton)

B. November 30, 1903

D. November 24, 1993

Birthplace: Paris, France

Awards: Chevalier de la Légion d'Honneur, 1947
 Dé d'Or Award, 1976
 New York University Creative Leadership in the Arts Award, 1978

Germaine Emilie Krebs, who to most of the world was known as Alix Grès, grew up in a middle-class Parisian family where she studied music, dancing, and art. Grès was primarily interested in sculpture, an unacceptable career for a lady, so she applied her interests in art to "sculpting" dress designs. A family friend who owned a fashion house encouraged Grès to enter

Alix Grès: The elegant fashions of Madame Grès demonstrate her mastery of fabric manipulation. The designs, which contain between twenty and seventy yards of fabric, are cut and draped into works of art inspired by her travels to exotic destinations.

the fashion business, and in 1930 she became an apprentice at Premet, a couture house, where she acquired skills in sketching, cutting, and sewing.

In between her travels to exotic places, such as North Africa and Egypt, Grès utilized her design talents by working on toiles (copies of couture designs) for buyers. The combination of remarkable cutting and draping skills and unique sources of inspiration prepared Grès for designing her first collection. In 1934 Grès acquired a partner and opened her doors for business under the name Alix Barton.

Her first collection consisted of day wear, cape and skirt ensembles, and evening wear, using draping techniques to pleat bias-cut fabrics into complex designs. It was her third collection, in which she introduced silk jersey in neoclassical style evening gowns, which made her famous. This was the first time that anyone had ever incorporated silk jersey into evening wear. Her gowns made such an impact on the industry that jerseys were often referred to as "Alix jerseys." Grès continued to instill inspiration from her travels in her designs; in 1935 her "Arabian gown" featured an ornamental harem-pant style trouser skirt in grape angora jersey. The success of her couture house continued to escalate, but unfortunately, in 1940, the impact of World War II forced her to close her doors.

Grès left Paris with her daughter for several years but returned after the war to reestablish her business. Upon her return to Paris, she opened a new couture house under her name, Maison Grès, which she solely financed. Her new venture was highly successful, and her work continued to reflect her unique design aesthetic. She designed day-time tailored suits fabricated in wools and leathers, and exquisite gowns using her signature bright brocades, failles, jerseys, taffetas, silk satins, and organdes. Each design was a piece of art, a masterful manipulation of between twenty and seventy yards of fabric, which were sculpted to enhance the figure, or conceal flaws, and transform each individual client's personality.

In 1958 Grès was sent to India by the Ford Foundation to study textiles. Again, her travels inspired her, this time not only in the design of sari-like gowns and Nehru jackets, but also in fragrances. She launched her first perfume in 1958: Choda, which was later renamed Cabochard (pig headed). Grès continued to develop perfumes throughout her career, launching Grès pour Homme (1965), Qui pro Quo (1976), Eau de Grès (1980), Alix (1981), Gre v'Nonsieu (1982), and Cabotine de Grès (1990), as well as a special, limited edition of their perfume in celebration of their twentieth anniversary. Grès also designed accessories for Cartier in 1977, as well as lines of scarves, ties, and sunglasses for other companies, and she launched her first collection of ready-to-wear clothing in 1981.

Ultimately, her business proved to be financially unstable, and it was purchased by investor Bernard Tapie. The house of Maison Grès also suffered financially under Tapie, and it was sold again, this time to Estorel, a French group. Estorel declared bankruptcy in 1987 and sold the house to

a Japanese investment firm, Yagi. Although Grès continued on as designer until her retirement in 1990, she never received any royalties for her work. Grès died three years after her retirement at her home Château de la Condamine on November 24, 1993.

Madame Grès, known as the "grande dame of haute couture," contributed fifty years of her extraordinary talents to the world of fashion by focusing on the fabric and the body as one. A perfectionist, she was not concerned with the functionality of dress, rather in sculpting fabric into exquisite pieces of art.

REFERENCES

Cooper, Arlene. "How Madame Grès Sculpts with Fabric." *Threads* (April/May 1987): 50.

Godfrey, Deeny. "The Strange, Secret Death of Madame Grès." *Women's Wear Daily* 168 (December 14, 1994): 1 (3).

Milbank, Caroline Rennolds. *Couture: The Great Designers*. New York: Stewart, Tabori and Chang 1985.

N. S.

Gucci

B. 1881

D. 1953

Birthplace: Florence, Italy

Awards: Future Best New Designer, Tom Ford, VH-1 Fashion Awards, 1995
 CFDA International Designer of the Year Award, Tom Ford, 1996
 International Designer of the Year, Tom Ford, Fashion Editors Club, Japan, 1996
 Designer of the Year, Tom Ford, VH-1/Vogue Fashion Awards, 1996, 1997, 1998, 1999
 European Company of the Year, European Business Press Federation, 1998
 Style Icon Award, Tom Ford, ELLE, 1999
 Commitment to Life Award, AIDS Project Los Angeles, 1999

The House of Gucci was for years a thriving business, known for its beautiful saddles and fine leather goods, the most famous of which were its quietly understated loafers and handbags. Well known as international status symbols, the famous bit-and-stirrup hardware and double G's have adorned shoes and bags since the company's beginnings, when all pieces were lovingly designed and assembled by founder Guccio Gucci and his brotherhood of Florentine artisans who first came together in 1921.

Passed down from father to sons, the company flourished and began its worldwide expansion, opening the first U.S. store in New York in 1953, followed by shops in London, Paris, the Far East, and so on. When family leader Rodolfo Gucci died in 1983, however, the business suffered tragic setbacks which began when the various branches of the family began fighting, and worsened as the company image started to plummet, largely as a result of the continued licensing of literally thousands of inferior products— from key chains to drinking glasses—most bearing the red-and-green-striped bands that had become part of the Gucci trademark.

In 1989 Maurizio Gucci, son of Rodolfo, became chief executive officer and the largest shareholder in the family, owning 50 percent of Gucci shares. The other family members had sold their 50 percent of the company to an international investment firm, Investcorp. Rodolfo's brother, Aldo, and his sons blamed not only Maurizio, but also his clever attorney, Domenico de Sole (who later became president and chief executive officer of Gucci Group), for the internal chaos the company was experiencing. Maurizio, determined to restore the Gucci name, unwittingly sent the entire business into a downward spiral by refusing to continue the myriad of ill-advised licensing agreements. His decision brought about a serious cash-flow crisis which forced most of the designers to leave the company. Ultimately Maurizio also sold his share of Gucci to Investcorp.

At what appeared to be the final hour, a young designer named Tom Ford entered the spotlight, poised to alter the course of modern fashion. Ford had joined Gucci in 1990, after leaving his position as design director for Perry Ellis at the urging of Gucci's new creative director, Dawn Mello, who had left her post as president of Bergdorf Goodman to save the failing brand. On the edge of bankruptcy, having lost $30 million in one year alone, Investcorp was desperately trying to sell Gucci, but there were no takers, and by 1994 it looked as if the company would be liquidated. Tom Ford, who was then designing all eleven product lines, magically reinvented Gucci style and changed fashion history with a witty and wonderful mix of tradition and modern innovation. It appeared that Ford had single-handedly transformed Gucci overnight.

Ford was named the new creative director, and his 1995 men's and women's collections were acclaimed by style watchers everywhere and embraced by trendsetters from Madonna to Goldie Hawn. In just a few seasons, he helped turn the fading company into the hottest name in international fashion, increasing sales so dramatically that Investcorp was able to take Gucci public. Lucrative licensing agreements with Zamasport, Ermengildo Zegna, and other Italian manufacturers were also put in place. In 1997, for example, Gucci Timepieces was created when Gucci Group NV acquired Severin Montres, a Gucci licensee for twenty-three years and one of the world's largest manufacturers and distributors of watches. In 1999 Gucci completed its acquisition of Yves Saint Laurent Couture, Sanofi

Beaute, and Sergio Rossi, and plans for the acquisition of Boucheron International, the prestigious jewelry and perfume giant, were well under way.

What did Ford do at the end of the century's final decade that was so right for the moment? It is clear that he has a brilliant understanding of popular culture; his revival of the double G logo, banished from all Gucci goods shortly before he took his place as head designer, was a stroke of genius. By resurrecting the famous status symbol and reframing it as an icon for the 1990s and beyond (the G's now appear on all Gucci products, in every form from rhinestone to gold), he demonstrated shrewd marketing know-how and a clear understanding of the prevailing zeitgeist.

Gloss, glamor, and daring experimentation characterize everything Ford designs, and the pieces fly out of Gucci's more than 150 stores, from Milan to Tokyo. Many of his hard-edged creations (mile-high stilettos, metallic jackets, and leather hip huggers, for example) are a reflection of today's urban life which, as Ford has said, is becoming tougher. Whatever his take on modern fashion is and where it is going, he and president/CEO Domenico de Sole have turned Gucci into a billion-dollar international luxury goods company with customers clamoring for more of anything bearing those globally glorified G's. *See also*: Yves Saint Laurent.

Website: http://www.gucci.com

REFERENCES

Burrough, Bryan. "Gucci and Goliath." *Vanity Fair* 94 (8) (July 1999).
Forden, Sara Gay. *The House of Gucci: A Sensational Story of Murder, Madness, Glamour and Greed*. New York: HarperCollins, 2000.
McKnight, Gerald. *Gucci: A House Divided*. New York: Donald Fine, 1987.
Shnayerson, Michael. "The Ford That Drives Gucci." *Vanity Fair* 136 (10) (March 1998).

S. B.

H

༺❧༻

Halston (Roy Halston Frowick)

B. April 23, 1932

D. March 26, 1990

Birthplace: Des Moines, Iowa

Awards: Coty American Fashion Critics Award, 1962, 1969, 1971, 1972, 1974
 Halston Retrospective, Fashion Institute of Technology, New York City,
 New York, 1991

Halston's presence seemed larger than life. From the time he left Evansville, Indiana, where he grew up, he radiated an aura of glamor. He became known for his millinery designs in the 1950s and 1960s, his elegant streamlined women's clothes in the 1970s, and an extensive array of licensed goods in the 1980s. But Halston was more than a designer; he cultivated personal relationships with his celebrity clients, a strategy which made him into a star. By hanging out at Studio 57 and throwing his own outrageous parties, Halston appeared in the society and gossip columns as often as in fashion magazines.

Halston's beginnings barely hinted at his future success. He was the middle child of a Des Moines, Iowa, family. His family moved around the Midwest during his youth, ending up in Evansville when he was eleven. After enrolling in Indiana University for a semester in 1952, he moved to Chicago where he began designing almost immediately.

While attending a night course at the Art Institute, he worked as a fashion merchandiser at Carson Pirie Scott. Soon he met André Basil, a hairdresser who owned a prestigious salon at the Ambassador Hotel. Although

Halston: Halston captured the decadence of 1970s nightlife with fluid dresses in narrow, elongated silhouettes which seductively skimmed the body.

Basil was twenty-five years older than Halston, the two moved in together. Basil set up a display of Halston's hats in his salon. When Basil opened his Boulevard Salon at 900 North Michigan Avenue, he devoted half of the space to Halston's hats. By 1959 their personal relationship had eroded, and Halston moved to New York upon accepting a design position with Lily Daché.

His move to New York opened new opportunities. Later in 1959 he began designing hats for Bergdorf Goodman, and within two years his name began appearing on the hats. He acquired many notable clients including Rita Hayworth, Marlene Dietrich, Diana Vreeland, Mrs. William (Babe) Paley, and Mrs. Henry Ford II. Many of his designs bordered on the fantastic; he used mirrors, fringe, jewels, and flowers to decorate hoods, bonnets, coifs, and helmets. His innovative scarf hat was a much-copied design of the 1960s, and Jacqueline Kennedy made his pillbox hat famous.

It was only a matter of time before Halston would expand into clothing. Bergdorf Goodman offered him an opportunity to design clothes in 1966, and his first ready-to-wear collection was sold in the Halston boutique at the store. This arrangement was short lived. He left Bergdorf Goodman in 1967, and it closed the boutique upon his departure.

Halston wasted no time in developing his own business venture. In 1968 he created a corporation, Halston, Ltd., to sell hats. It capitalized on different markets by offering lower-priced, mass-market hats sold through better department stores as well as more expensive, made-to-order hats sold at Bonwit Teller and Neiman Marcus. By the end of the year, he had introduced a ready-to-wear collection. The garments featured simple construction and few closures. The pajama skirt and wrap dress were the most popular pieces.

During the early 1970s, Halston made his mark on the ready-to-wear scene. Although he already had a small in-store boutique at Bloomingdale's, he opened his own women's boutique in 1972. The first two floors featured ready-to-wear clothing at two different price points, and the third floor offered custom-made garments. That same year he teamed with Ben Shaw to start Halston Originals, a successful ready-to-wear manufacturing venture with a product which was sold in high-end department stores.

In his fall collection of 1972, he introduced model #704, a simple shirtwaist dress made from ultrasuede, a fabric which would become synonymous with Halston. This washable, wrinkleless, durable dress sold 78,000 copies. It was initially offered at $185, but demand elevated the price to $360. Taking advantage of the success of this dress, Halston made ultrasuede a fixture in his collections, and he signed licensing agreements for a variety of ultrasuede goods including handbags, shoes, boots, belts, and bed covers.

In 1973 Norton Simon purchased all of Halston's companies, his trademark, and his exclusive design services for approximately $12 million. The

ownership of the company changed five times before being purchased by Revlon in 1986. Halston continued as the chief designer for the company until 1984. His drug-abuse problem had caused increasingly erratic behavior which led to his firing.

Halston had been part of the party scene since he moved to Chicago in the 1950s. When disco emerged in the 1970s he found himself in the middle of it. He frequented the hottest clubs, socialized with celebrities, embraced the most popular drugs, and designed clothes that were in tune with the streamlined decadence of the era. He created some of his most memorable designs during the 1970s. When he introduced his halter dress in 1974, it became a staple on the dance floor. Also, he was known for his caftans, cashmere sweater sets, shirtwaist dresses, strapless dresses, and asymmetrical necklines. All of his designs were simple and unconstructed. He usually worked in solid colors and soft knitwear. His narrow, elongated silhouettes skimmed over the body and flattered young and old figures alike. Halston's trademark sunglasses, worn both day and night, completed the look.

Halston did not limit himself to designing fashion. During the 1970s he developed uniforms for Braniff flight attendants, Girl Scout troop leaders, American athletes in the PanAm Games, and the 1976 Winter Olympics team. He continued designing dancewear for Martha Graham even after he stopped designing for Halston.

Halston's reputation as a designer to the elite of the 1970s was dramatically transformed in the 1980s when J.C. Penney purchased the rights to the Halston III line in 1982. Unwilling to be associated with a mass-market retailer, Bergdorf Goodman dropped the main Halston line. Although the deal with J.C. Penney undermined the upscale image of Halston, the clothes received positive reviews and high sales. The in-store boutiques featuring women's sportswear and dress lines opened in the fall of 1983. During the next two years, menswear, furnishings, and children's wear were added.

The perfume Halston was another of the company's lucrative undertakings. Within two years of being introduced in 1975, Halston was the second biggest selling scent in history. The teardrop-shaped bottle was the creation of jewelry designer Elsa Peretti. By the 1980s, the perfume had lost its cachet due to excessive licensing of the Halston name and indiscriminate distribution.

Halston's name graced a wide variety of goods spanning disparate price points. The goods ranged from ultrasuede luggage by Hartmann to scarves by Daniel La Foret. For example, the company signed licensing agreements for cosmetics and the men's fragrances 1–12 and Z-14. The Halston name appeared on loungewear, sportswear, beachwear, menswear, sleepwear, and underwear.

Accessories constituted another profitable type of licensed goods. Kayser Roth manufactured hosiery, A.C. Bang produced gloves and furs, and Bausch and Lomb offered eyeglass frames. Belts, wallets, hats, wigs, and

shoes were produced by various licensees. Consumers could buy Halston towels and sheets by Fieldcrest, Halston patterns by McCall's, and Halston rugs by Karstan. In 1977 Halston himself formed a company that worked with H.B. Accessories to produce handbags and leather goods.

Halston's life was cut short; he was diagnosed with AIDS in 1988, and he passed away two years later. In 1990 Revlon closed Halston Enterprises, Inc. Halston International, which owned the Halston trademark for all products except cosmetics and fragrances, remained. In 1997 the company relaunched the brand with Halston Lifestyle, a moderate line. By 1999 while Halston Lifestyle was being phased out, three additional lines were added: Halston was a bridge line, Halston Designer offered less expensive designer clothes, and Halston Signature featured the most expensive garments. Bergdorf Goodman, Neiman Marcus, and Saks Fifth Avenue carried the lines. At the same time, the company expanded its licensees which numbered more than twenty by 2000. The popularity of 1970s fashion and the timeless quality of Halston's designs have restored the legacy and endurance of the Halston name. *See also*: Lily Daché.

REFERENCES

Gaines, Steven. *Simply Halston: The Untold Story*. New York: Putnam, 1991.
Gross, Elaine, and Fred Rottman. *Halston: An American Original*. New York: Harper Collins, 1999.
Milbank, Caroline Rennolds. *New York Fashion: The Evolution of American Style*. New York: Harry N. Abrams, 1989.

A.T.P.

Miriam Haskell

B. 1899

D. 1981

Birthplace: Tell City, Indiana

For connoiseurs of costume jewelry, Miriam Haskell's pieces are among the most coveted. Made of the finest faux pearls, brass filagree, and handmade glass beads, her designs were beautifully intricate and perfectly executed.

Haskell began her career in the early 1920s as the manager of a stylish boutique in New York's McAlpin Hotel. Reportedly inspired by Chanel's innovative imitations, as well as her exposure to the chic items sold in the hotel shop, she founded her own company in the mid-1920s, creating original pieces that were an immediate success. She acquired a huge and fash-

ionable following, including celebrities such as the great Flo Ziegfeld, for whom she designed spectacular "jewels." By the 1930s, Haskell became so well known that she was able to open a shop on Fifth Avenue and establish the Miriam Haskell Company to wholesale her designs which were renowned for their uncompromising beauty.

Haskell was well known for her versatile pieces, among which is a convertible necklace that can be worn as a lariat with floral endings, a long rope with a double floral clasp, or a short multilayered necklace with two separate floral pins; her imaginative color choices which included combinations of tan, mustard, and orange or black, turquoise, and coral; and her natural themes, ranging from shells to butterflies to birds.

As did many American costume jewelers, Haskell opened her factory in Providence, Rhode Island, which remains a center for U.S. costume jewelry production to this day. It was in Providence that she worked to create the unique "antique Russian gold" finish that characterized most of her jewelry. Haskell is said to have worked with the same French companies Chanel used, such as Gripoix and Rousselet, to create the special stones that made her pieces so handsome.

When Miriam Haskell retired in the early 1950s, she turned the company over to her brother, Joseph. Since then, it has changed hands several times, most recently in 1990, when Frank Fialkoff became the new owner, dedicating himself to maintaining the Haskell reputation for excellence in design. Still made by hand, quality costume jewelry bearing the Haskell name appears in retail stores throughout the country. However, there is no doubt among collectors that the truly elegant and classic pieces are the ones originally developed by the talented perfectionist herself. *See also*: Gabrielle Bonheur "Coco" Chanel.

REFERENCES

Ball, Joanne Dubbs. *Costume Jewelers—the Golden Age of Design*. West Chester, Pa.: Schiffer, 1997.
Klein, Mim. *A Look at Three Great Costume Jewelry Houses: Monet, Trifari, Haskell*. West Chester Pa.: Schiffer, 1988.

 S. B.

Edith Head

B. 1897

D. October 26, 1981

Birthplace: San Bernardino, California

Awards: Academy Award for Costume Design: *The Heiress* (1949), *All About Eve*
(1950), *Samson and Delilah* (1950), *A Place in the Sun* (1951), *Roman
Holiday* (1953), *Sabrina* (1954), *The Facts of Life* (1960) *The Sting*,
1973
Motion Picture and Television Fund, Tribute to Edith Head, 1998

From 1938 to 1967, Edith Head ruled at Paramount Studios, working
on more than 1,000 movies, winning eight Academy Awards, and being
nominated thirty-five times. She is Hollywood's most successful costume
designer, if not the most popular.

In 1923 she answered a *Los Angeles Times* ad for a sketch artist, and
although her portfolio was composed of other people's designs she had
"borrowed" from a local art school, she impressed Howard Greer, then
the head of Paramount Studio's costume department. Working with both
Greer and another new addition to Paramount, Travis Banton, the young
Edith Head learned from the best. Her first film, *She Done Him Wrong*
(1933), starred Mae West. Their collaboration was a tremendous success,
and years later, when Mae West was cast with Raquel Welch in *Myra
Breckenridge* (1970), she asked that Edith Head be brought in from Uni-
versal Studios, where she was then working, to dress West for the film.

Her next, and perhaps most enduring, alliance was with actress Barbara
Stanwyck, for whom she created gorgeous costumes and a sexy image.
Beginning with *Interns Can't Take Money* (1937) and continuing with *The
Lady Eve* (1941) and *Double Indemnity* (1944), their professional rela-
tionship and great friendship resulted in tremendous recognition for both,
as Head transformed Stanwyck from an unglamorous actress to a woman
of beauty and style, primarily by dressing her in clothing that hid her figure
flaws.

That ability to "mother" actresses, to listen to their fears and to advise
them, is what made superstars, such as Grace Kelly, Bette Davis, and Lor-
etta Young, revere her. Her difficulties came when actresses, such as Audrey
Hepburn, made clear their desires to work with other costume designers.
It was Head's seemingly guiltless ability to accept the Academy Award for
Sabrina (1954), without even acknowledging the efforts of Hubert de Gi-
venchy, and to take credit for his *Sabrina* neckline (the bateau neck with
a tie at each shoulder), even when it became clear that the famous dress
was not her idea. It is for this and other similar incidents that many in
Hollywood do not remember her kindly. However, no one denies her amaz-
ing ability to keep pace with the fashion zeitgeist. While most famous cos-
tumers are remembered for designs of a certain period, her garments never
looked dated. Alfred Hitchcock was among those who admired her ability
to advance his plots by dressing his characters so appropriately.

Perhaps her most influential dress is the one Elizabeth Taylor wore in *A
Place in the Sun* (1951). It was so popular that it was reproduced and sold,
bearing Edith Head's label, in department stores all over the United States.

The famous strapless confection, with its layers of tulle and fabric violets, was worn by thousands of prom goers and high school graduates that year.

Head was popular with the public. She appeared on television talk shows and published two books: *The Dress Doctor* (1959), which landed on the best-seller list, and *How to Dress for Success* (1967). Head's last movie was Carl Reiner's *Dead Men Don't Wear Plaid*, released in 1982, just after her death. From her first creations to her final ones, Edith Head earned her reputation as the "director's designer." *See also*: Hubert de Givenchy.

REFERENCES

Collins, Amy Fine. "Anything for Oscar." *Vanity Fair* (March 1998): 230.
Head, Edith. *The Dress Doctor*. Boston: Little, Brown, 1959.

S. B.

Joan and David Helpern, Inc.

See Joan and David.

Hermès

It is a legendary name among family businesses and is currently overseen with the same love and eye for impeccable quality by its fifth-generation chairman, Jean-Louis Dumas-Hermès. The saga began with beautifully handcrafted harnesses and saddles, made by founder Thierry and his son Emile-Charles, who catered to the wealthy carriage trade. When grandson Emile-Maurice saw that the invention of the automobile could mean extinction for the company, he expanded into travel accessories, silk scarves, and jewelry. Emile-Maurice is also known for introducing zippers to France in 1922. He promptly put them in leather jackets, the very first of which was immediately snapped up by the Prince of Wales.

The family tradition has continued for over 160 years, with Hermès craftsmen using the same tools and specialized techniques of those before them. These makers of saddles, boots, luggage, and silver, along with product managers and developers, often travel together to remote areas of India, Mexico, the Amazon, and Africa to learn the techniques of artisans who still practice age-old crafts, such as complicated embroidery and unusual metalworking. The Hermès team then brings these techniques back to the Paris and Pantin workrooms, using their newfound knowledge to stay far ahead of competitors.

Hermès: Of all the luxurious leather, silk, and cashmere accessories designed by Hermès, the item they are most noted for is the "Kelly" bag, popularized in the 1950s by Princess Grace Kelly of Monaco.

Among their best-known, most coveted luxury items are sumptuous leather goods, including boots, belts, and briefcases, stunning silk scarves, opulent cashmere shawls and blankets, and the famous Kelly bag, first introduced in the 1930s but named in 1956 for the Princess of Monaco, Grace Kelly. There is currently an eighteen-month wait for a Kelly bag, which can range in price from $5,000 to $13,000.

Hermès currently produces menswear, designed by Veronique Nichanian since 1988, and women's ready-to-wear, designed since 1998 by Martin Margiela. Margiela, one of the Antwerp Six, a group of young Belgian designers including Ann Demeulemeester and Dries Van Noten, was originally known for his participation in the deconstructionist movement of the early 1990s. This avant-garde movement, in part a reaction to the excessive fashions of the 1980s, endorsed the philosophy that clothing should be looked at from the inside out; thus linings were used on the outsides of garments, surged seams might become part of a garment's design, the sleeves of a jacket might not match. Originally an assistant to Jean-Paul Gaultier, Margiela was at first rejected by fashion's mainstream, but ultimately he was recruited by Hermès to modernize its image.

All items bearing the Hermès name are manufactured by the company itself—no licenses have been granted in order to maintain perfection. Hermès also makes its own fine watches, creates its own fragrances, and manufactures its own hand-painted porcelain dinnerware. Although Hermès went public in 1993, 80 percent of the shares are still controlled by relatives. Today there are over 150 Hermès stores around the world. As of this writing, Hermès owns 35 percent of Jean-Paul Gaultier's business, as well. *See also*: Jean-Paul Gaultier.

REFERENCES

Jackson, Jennifer. "Shhh! Hermes' Deepest Secrets." *Harper's Bazaar* (September 1998): 234.

Rafferty, Jean Bond. "The Height of Luxury." *Town & Country* 176 (8) (May 2000).

S. B.

Tommy Hilfiger

B. 1952

Birthplace: Elmira, New York

Awards: Menswear Designer of the Year, CFDA, 1995
From Catwalk to Sidewalk, VH1 Fashion and Music Awards, 1995

FiFi, men's fragrance award, 1996
Designer of the Year, Parsons School of Design, 1998

Normally when we talk about the big three, we are referring to Ford, General Motors, and Chrysler. There is, however, another big three: Ralph Lauren, Calvin Klein, and Tommy Hilfiger. Together, they form the triumvirate that dominates the menswear industry.

Tommy Hilfiger was one of nine siblings born into a middle-class family in Elmira, New York. After high school, Hilfiger began his career in the fashion industry with $150 and twenty pairs of jeans which he sold out of the back of his car. This self-taught designer had opened ten specialty stores, People's Place, across upstate New York by the time he was twenty-six. In 1979 he sold his stores and moved to New York City to pursue a career in fashion design. Hilfiger launched his own label through a licensing agreement with Murjani International; however, he terminated his agreement with Murjani, which was suffering financially, and went in search of a new backer.

Hilfiger found Silas Chou, a private-label contractor. Instead of creating a licensing agreement, the two decided to form a partnership. Hilfiger contributed the design direction, and Chou contributed the manufacturing connections that would allow them to produce Ralph Lauren–quality products at slightly lower prices. Chou and Hilfiger also brought former Ralph Lauren executives Lawrence Stoll and Joel Horowitz into the partnership, and in 1984 the Tommy Hilfiger Corporation was born. The first collection was launched with a series of exaggerated advertisements, including a Times Square billboard advertisement in which Tommy Hilfiger declared himself "one of America's top four designers."

Tommy Hilfiger is often considered a re-designer. He interprets the American spirit into a line of clothing which captures the red, white, and blue dream of America in comfortable sportswear. Over the next decade, Hilfiger fought with Calvin Klein and Ralph Lauren for the same customer base: predominantly middle-class, white males between the ages of twenty-five and forty-five. His all-American sportswear classics were popular, but not greatly different from his competitors'.

Then, in 1994, rapper Snoop Doggy Dog appeared on *Saturday Night Live* wearing a Tommy Hilfiger shirt. Sales suddenly skyrocketed, and Hilfiger became the first designer to dress both jocks and homeboys. Realizing the potential profitability from tapping into the black urban rap subculture, Hilfiger reevaluated his line and adapted his designs to the oversized silhouettes favored by the rap music factions. Hilfiger also realized the importance of the status symbol to this group and emblazoned his name prominently across all his designs. There was no doubt whether a garment was a Hilfiger.

As the Hilfiger label gained prominence, the Tommy Hilfiger Corpora-

tion expanded its product offerings through a series of licensing agreements to position itself as a lifestyle brand. The Tommy Hilfiger Corporation became a relentless marketing engine to convert Hilfiger's followers into life-sized Tommy dolls. Hilfiger launched new apparel and accessory lines to dress his dolls from head to toe for all occasions. Under the labels Tommy by Tommy Hilfiger; Tommy Jeans; White, Red, Blue; Crest; Flag; and Hilfiger Athletics, the Tommy Hilfiger Corporation built on its men's casual clothes and better sportswear business to offer new lines of sportswear, tailored apparel, bridge suits, jeans, and athletic wear for men, women, and children, as well as an exclusive custom design line for musicians. Hilfiger licensed accessories such as shoes, handbags, belts, neckwear, dress shirts, swimwear, eyewear, sleepwear, underwear, intimate apparel, watches, socks, and jewelry to provide the complete Hilfiger look for men, women, and children. The Hilfiger Corporation also added the fragrances Tommy (for men), Tommy Girl, and Freedom to their offerings and expanded into home bedding and linen collections. Hilfiger maintains control over the design, marketing, advertising, and distribution of all licensed products through collaboration with each manufacturer to ensure a cohesive brand image and to maintain quality.

In 1992 the Tommy Hilfiger Corporation offered stock through an IPO at $15 per share. Fueled by the trend toward casual dress, in 1995, the stock hit a record high of $47. However, by 2000, the stock had plunged to $9 per share, and the corporation posted its first quarterly loss since going public. What was happening to Tommy? Many started to question whether Hilfiger had lost sight of his core audience, or if in his quest to become a lifestyle brand he had oversaturated the market by applying his not so subtle label to too many products. Did the world need Tommy shampoo, moisturizer, and hair gel? Was the Hilfiger cachet gone?

By the mid-1990s several other brands had gained prominence in the men's sportswear market. Hilfiger was now competing with urban sportswear designers such as FUBU and Karl Kani and specialty retailers such as Abercrombie & Fitch and American Eagle for market share. Hilfiger needed to refocus his designs, redefine his product line, and update his image. Season after season the products demonstrated only the slightest style variations, diluting the demand. How many red, white, and blue striped sweatshirts did one person need? In 1997 Hilfiger began "operation clean-up" to redefine his men's sportswear into two marketing segments: Flag and Crest. The Flag label would continue to be marketed to the young, statusconscious customer with the Hilfiger logos prominently displayed, while the Crest label would be marketed to a slightly older, more understated customer with subtle logo and branding treatments. Hilfiger also dropped his signature collection, which was unprofitable, and released the Hilfiger retail store exclusive Blue Label collection for department store distribution. Throughout the late 1990s, Hilfiger struggled to gain entry into the

women's sportswear market with several failed attempts to launch sportswear and career collections, and he has since decided to postpone any further ventures until he can more clearly define his target customer.

When you think of Ralph Lauren, you conjure an image of old money. When you think of Calvin Klein, you conjure an image of sultry seduction. When you think of Tommy Hilfiger, you conjure an image of small-town, mainstream America, but with a slight urban twist. Despite recent troubles in the marketplace, Tommy Hilfiger's sales exceed $1 billion a year. His celebrated red, white, and blue logo, symbolizing the All-American spirit, is available in over 10,000 department and specialty stores across the United States, Canada, Mexico, Central and South America, Europe, Japan, and the Far East. His products transcend race, age, and lifestyles; they appeal to college students, lawyers, rappers, and jocks. *See also*: Ralph Lauren; Calvin Klein.

Website: http://www.tommy.com

REFERENCES

Borden, Mark. "Why Tommy Hilfiger Tanked." *Fortune* 141 (May 29, 2000): 52.
Curan, Catherine. "Hilfiger: Retailing Keys Creativity." *Daily News Record* 26 (May 29, 1996): S16.
Doebele, Justin. "A Brand Is Born." *Forbes* 157 (February 26, 1996): 65–67.
Duffy, Martha. "H Stands for Hilfiger." *Time* 148 (September 16, 1996): 66.
Lohrer, Robert. "Tommy Segments Core Sportswear Business." *Daily News Record* 27 (August 4, 1997).
Mitchell, Alan. "Why Top Brands Thrive on 'Down to Earth' Modesty." *Marketing Week* 23 (September 14, 2000): 38.
Parr, Karen. "The Image Makers." *Women's Wear Daily* 172 (October 31, 1996): S16.
Rice, Tommy. "Hilfiger's Bipartisan Fashions Are Hot." *Fortune* 132 (October 30, 1995): 32.
Welsh, Alice. "The Return of the Logo." *Women's Wear Daily* 168 (August 3, 1994): 8–10.

A. K.

Hobé et Cie

For generations, the Hobé family has continued the tradition started in 1887 by founder Jacques Hobé, who believed that costume jewelry could be manufactured with the same care and attention to detail as fine jewelry. Making use of the newest manufacturing techniques, Hobé designed and produced magnificent costume jewels in France and passed along his pas-

sion to his son, William, who eventually brought the business to New York in the 1930s.

Believing that clothing and jewelry were reflections of the time period during which they appeared, William Hobé studied historic costume and became renowned for his knowledge and ability to reinterpret historical designs into modern pieces. The results dazzled Hollywood, and he created jewelry, costumes, and set designs for many films. Because he believed, as did his father, that beautiful jewelry should be enjoyed not only by the wealthy, Hobé pieces were available through retailers as well.

Using components such as sterling silver and nonprecious metals, Hobé creations feature intricate workmanship and beautiful semiprecious and faux stones. The patented designs include brooches, handbags, and hair accessories, as well as necklaces, earrings, and bracelets—all meticulously executed.

There are currently over 1,200 styles in the Hobé line, each of which makes use of the special finishes and techniques that have immortalized the Hobé name. Among the family's discoveries is the formula for magnificent faux pearls from Majorca, known for their amazing luster. William's nephew, James Hobé is also credited with the invention of the detachable pearl enhancer which he developed in the 1980s, and which has become a staple in many a jewelry wardrobe.

REFERENCES

Ball, Joanne Dubbs. *Costume Jewelers—the Golden Age of Design*. West Chester, Pa.: Schiffer, 1997.

Rezazadeh, Fred. *Costume Jewelry: A Practical Handbook and Value Guide*. Paducah, Ky.: Collector Books, 1998.

 S. B.

I

Izod

See René Lacoste.

J

Marc Jacobs

B. April 9, 1963

Birthplace: New York City, New York

Awards: Perry Ellis Golden Thimble Award, 1984
 Chester Weinberg Gold Thimble Award, 1984
 Best Student of the Year, Parsons, 1984
 Council of Fashion Designers of America, Perry Ellis Award for New Fashion Talent, 1987
 Council of Fashion Designers of America, Womenswear Designer of the Year, 1993
 Council of Fashion Designers of America, Womenswear Designer of the Year, 1997
 Women's Designer of the Year, VH1, 1998
 Council of Fashion Designers of America, Accessory Designer of the Year, 1999

Marc Jacobs graduated in 1981 from the New York High School of Art and Design. After graduation, he immediately enrolled in Parsons School of Design to pursue his dream of becoming a fashion designer. While at Parsons, Jacobs designed a collection of sweaters for Charivari, where he was working as a stock boy, which won him Parson's Perry Ellis Golden Thimble Award. After graduation in 1984, Jacobs began designing for Ruben Thomas, Inc. In 1986 Jacobs decided to strike out on his own, and he launched his own line. His sophisticated, playful designs garnered praise from the fashion press and brought him to the attention of Perry Ellis executives.

In 1988 Jacobs was named vice president of women's designs at Perry Ellis, and his business partner, Robert Duffy, was named president of women's wear. At twenty-five years of age, Jacobs not only was designing the Perry Ellis women's collections, but also was overseeing the design and production of twenty-five women's product licenses. Jacobs rose to the challenge, revitalizing the women's collections with his energy and passion. Only one year later, in 1989, Jacobs was named head designer for Perry Ellis. For the next three years, Jacobs combined imagination and sophistication in the Perry Ellis lines. Jacobs, who had become known for classic sportswear, deviated from his standard repertoire with the 1993 Perry Ellis women's collection and launched a trend for which he would become infamous: grunge. The collection featured little flower print dresses layered with plaid shirts and paired with Birkenstocks. While some applauded the collection, many were appalled at the prospect of paying $1,500 for clothing that looked as if it came from the thrift store. Perry Ellis executives agreed, immediately fired Jacobs, and canceled the production of the line.

Jacobs staged his triumphant return to the fashion arena in 1994 with the launching of his own line. The collection received rave reviews from the press and sizeable orders from retailers. Jacobs and partner Duffy nurtured their shoestring operations, even cutting samples on their shared desk, until Jacobs's work caught the attention of Moët Hennessy—Louis Vuitton (LVMH). LVMH provided financing for the fledgling company and named Jacobs as the artistic director at LVMH where he developed the first ready-to-wear line for LVMH. Jacobs also assumed consulting positions with Iceberg in Italy and Renown Look in Japan. After the successful introduction of the Jacobs designer collection, Jacobs launched a secondary line in 1995: Marc Jacobs Look. Although successful in Japan, the collection was not well received in the United States and was canceled.

During the late 1990s Jacobs signed several licensing agreements including licenses for fine jewelry with Charles Turi, scarves with V. Fraas, handbags with Austin Designs, sunglasses with Colors in Optics, hats with Patricia Underwood, and furs and outerwear with Birger-Christensen. Jacobs's future plans for his company include leather goods, eyewear, fragrance, and men's ready-to-wear collections. He also plans to reenter the women's bridge market with a new women's secondary line targeted to the business casual market in 2001.

Marc Jacobs is at the forefront of talented young, American designers. He designs beautiful, wearable, classic sportswear in luxurious fabrics, playful prints, and rich colors. He draws inspiration for his creations from music, street fashions, and historic costume. Unlike other designers, Jacobs designs only two collections a year, instead of the standard four to six, a strategy to keep demand ahead of supply and ensure that each collection is eagerly anticipated by both consumers and the fashion press. *See also*: Perry Ellis; Louis Vuitton.

REFERENCES

Berman, Phyllis. "Grunge Is Out, Licensing Is In." *Forbes* 153 (May 23, 1994): 45–47.

Infantino, Vivian. "On the Marc." *Footwear News* 50 (November 28, 1994): S16–19.

MacDonald, Laurie. "Marc Jacobs to Start Own Firm." *Footwear News* 49 (February 22, 1993): 4–6.

Poster, Caryl. "Jacobs' Ladder: Climbing to the Top." *Footwear News* 47 (June 3, 1991): S20–22.

Socha, Miles. "Jacobs's Ladder: Marc's Ready to Climb." *Women's Wear Daily* (January 18, 2000): 24.

Weil, Jenny. "Marc Jacobs Finally Signs on LVMH's Dotted Line." *Women's Wear Daily* 171 (January 9, 1996): 2–4.

White, Constance. "Jacobs Hopes New Venture Is On-line by June." *Women's Wear Daily* 165 (February 18, 1993): 3.

A. K.

Charles (Wilson Brega) James

B. July 18, 1906

D. September 23, 1978

Birthplace: Sandhurst, England

Awards: Coty American Fashion Critics Award, 1950, 1954
Neiman Marcus Award, Dallas, 1953
Woolens and Worsteds of America Industry Award, 1962
The Genius of Charles James, Brooklyn Museum and Art Institute of Chicago, 1982–1983
Charles James, Architect of Fashion, Fashion Institute of Technology, New York, 1993

Charles James's designs can be described as a seamless union of art, architecture, engineering, and fashion. Although he was not prolific (he created a mere 200 designs over his entire career), his garments influenced decades of fashion design. He was known for his ball gowns, and one could draft an extensive list of his most recognizable designs. For example, his "Clover-leaf," a gown which consists of a four-petalled skirt which fluidly erupts from a tiny corseted bodice, has been featured in numerous publications and collected by museums. Other noteworthy designs include the "Taxi," "Figure 8," and "Ribbon."

James used color and garment structure to attain his signature look. His

use of color was innovative and masterful. One of his techniques involved layering different colored chiffons to achieve depth of color. As for garment structure, James engineered garments to create highly sculpted clothing which was comfortable to wear.

Unfortunately James's personal and professional life was never as glamorous or successful as his designs. Born in England to an American mother and English father, he was expelled from Harrow School. He attended the University of Bordeaux for a short time. He moved to Chicago in 1924 where he worked in an architectural design department and at the *Herald Examiner* newspaper.

James entered into design in 1926 as a milliner under the name Charles Boucheron. He opened three shops in Chicago before moving to New York in 1928 where he started another shop. During the 1930s he moved among London, Paris, and New York designing under various names including his own.

During this period either his ventures went bankrupt or his difficult personality eroded his working relationships, sabotaging the business. He developed a paranoia of people plagiarizing his work. His suspicions that his business associates were trying to steal or misuse his designs led James to initiate numerous lawsuits for piracy and breach of contract. He spent more of his life in litigation and conflicts over his designs than designing.

He often clashed with his collaborators. For example, he designed for Elizabeth Arden until 1945, when personal conflict between the two ended the business relationship after James had completed only one collection. Similarly, a collaboration with Halston in the 1970s ended in personal conflict after one collection.

His relationship with customers was equally tumultuous. Often, he would fail to deliver a dress, or he would borrow back a dress and give it to another client. Women paid a premium for his exclusive designs, only to have him sell them to be mass produced. Certainly James is known today for his design genius rather than his business acumen or rapport with clients.

Repeatedly, James entered into relationships to produce ready-to-wear clothing. As early as the mid-1930s, he sold original pieces to Marshall Field's, Lord and Taylor, and Saks Fifth Avenue. From the originals, the retailers would produce copies. His 1955 venture with Samuel Winston to manufacture a line of clothes ended in a lawsuit. During the 1950s he designed lines of children's wear and maternity clothes. In 1962 he designed a ready-to-wear line for Korvettes.

James retired from couture in 1958 and spent much of the 1960s lecturing. He continued to embroil himself in lawsuits long after his retirement. After years of drug abuse, he died of pneumonia at the Chelsea Hotel in 1978. *See also*: Halston.

REFERENCES

Coleman, Elizabeth Ann. *The Genius of Charles James*. New York: Holt, Rinehart, and Winston, 1982.
Martin, Richard. *The Universe of Fashion: Charles James*. New York: Universe Publishing, 1999.
Milbank, Caroline Rennolds. *Couture: The Great Designers*. New York: Stewart, Tabori and Chang, 1985.

<div align="right">A.T.P.</div>

Jantzen, Inc.

Awards: Woolknit Award for Men's Sweater Design (six times)

Jantzen, Inc. evolved from the Portland Knitting Mills, located in Portland, Oregon, a company owned by John A. Zehntbauer, Roy C. Zehntbauer, and Carl C. Jantzen. The mill produced knit items such as sweaters, socks, and gloves which were retailed out of the factory. In 1913 Jantzen, the mills knitwear designer, experimented with a sweater cuff machine and invented the first rib-stitched swimsuit. Jantzen's new invention provided stretch, shape, and comfort for the wearer, allowing them not only to sunbathe but also to swim.

Jantzen's first suit, referred to as the "California style," was a one-piece, sleeveless, fitted top connected to long shorts. The suit unisex, was available in a range of sizes, colors, and striped patterns for every member of the family. The elasticized suit was so popular that it was even sold in Mexico and Canada, making this the first apparel product produced in conjunction with countries outside the United States. The notoriety Portland Knitting Mills experienced as a result of Jantzen's new fabric prompted the company to change its name to Jantzen Knitting Mills in 1918 and then finally to Jantzen, Inc., in 1949.

In the 1940s, a new thread called Lastex was invented. Its rubber-cored thread enabled manufacturers to create clingy silhouettes in their swimwear lines. Jantzen used the fabric to create a group of men's and women's foundation separates. The line included mix and match tops and bottoms in a variety of solids and prints. The success of this line allowed Jantzen to separate the company into two divisions: men's and women's.

Jantzen incorporated Hollywood celebrities, public awareness events, and professional athletes into their promotion activities and advertising campaigns. Jantzen's first endorsement came when swimming legend Johnny Weissmuller appeared in the 1924 Olympic Games in a Jantzen tank suit. Beginning in the 1950s, Jantzen became the first apparel company

regularly to sponsor athletes and to use athletes in product endorsements. Jantzen also sponsored "Learn to Swim" and "Clean Water" campaigns used for educating swimmers on health and safety regulations in swimming pools. Other advertising campaigns featured celebrities such as Marilyn Monroe, James Garner, and Loretta Young.

The growing health movement of the late 1970s and early 1980s brought new competitors to the swim and athletic wear arena. Companies such as Nike and Reebok were expanding to offer apparel items; reducing Jantzen's marketshare. As a result, Jantzen narrowed its target market and opted to eliminate its men's separates and swimwear division and focus solely on the women's division. The increased competition also forced Jantzen to seek additional financial resources. In 1979 Jantzen was acquired by Blue Bell, Inc., who, in turn, sold Jantzen to VF Corporation in 1986.

In 1992 Jantzen opened its first boutique to provide a year-round accessibility of their product lines. One year later, they expanded the companies offering to include a line of beach volleyball athletic apparel. By the late 1990s, Jantzen had opened over 400 in-store shops and boutiques in over 100 countries. Jantzen also developed two licensing agreements in 1995. The first licensing agreement was with Nike. Jantzen was hired to produce a line of women's and men's competitive swimwear and activewear under the Nike label. The merchandise was sold in sporting goods stores across the United States, Canada, and the Caribbean. H.H. Cutler Company, a division of VP Corporation, also signed an agreement with Jantzen to design a line of children's apparel.

In 1923 Jantzen incorporated a red diving girl logo into all of their swim apparel. Over time, many artists have been selected to transform the figure of the diving girl into the ideal body type for each era. Jantzen swimwear has mirrored those changes in ideals of beauty, providing fashionable, sporty swimwear for over seven decades. *See also*: Nike.

Website: http://www.jantzen.com

REFERENCES

Lencek, Lena, and Gideon Bosker. *Making Waves: Swimsuits and the Undressing of America*. San Francisco: Chronicle Books, 1989.

Martin, Richard, and Harold Koda. *Splash! A History of Swimwear*. New York: Rizzoli, 1990.

Spector, Robert. "Jantzen sticks a Toe in Retailing." *Women's Wear Daily* 164 (September 23, 1992): S14.

N. S.

Joan and David

Awards: American Fashion Critics Coty Award, 1978
 Footwear New Designer of the Year Award, 1986
 Cutty Sark Award, 1986
 Fashion Footwear Association of New York Award, 1990
 Michelangelo Award, 1993
 Women's Achievement Award Girl Scout Council of Greater New York,
 1995
 Financial Women's Association Entrepreneurial Award, 1996
 The Michael Awards for the Fashion Industry—First Award for Footwear
 Design, 1996
 The Athena Award, Hunter College, New York, 1997
 The Shattered Ceiling Award, Atlanta Women's Fund, 1997

Joan and David, a subsidiary of Joan and David Helpern, Inc., is owned by Joan and David Helpern. Joan and David's first success as retailers came in 1948 when they operated leased shoe departments in department and specialty stores. In 1977, guided by Joan's design philosophy that women should have stylish shoes that are both comfortable and classic, the company launched the Joan and David label in their stores and supplied other retail operations with their line.

Joan Helpern, who earned a Ph.D. at Harvard University in child psychology and is the mother of two, is the designer for Joan and David. She works entirely by instinct, having received no formal training in the business. Joan's unexpected role as a designer began when she realized that she needed fashionable yet comfortable shoes to meet the demands of her busy lifestyle, and she was inspired to design a flat, oxford-style shoe. From that simple shoe, Joan began to design a wide assortment of styles to fit the varying personalities of the Joan and David customer.

The success of Joan and David's footwear designs can be contributed to their merchandising strategies. No two stores carry exactly the same merchandise. They also believe in the limited edition, which helps to keep their product lines unique. With the success of their footwear, Joan and David expanded into other product lines including men's footwear, handbags, belts and small leather goods, umbrellas, scarves, jewelry, hats, and socks. They also brought their unique combination of simple silhouettes, textures, and colors to women's apparel lines. The Joan and David, Joan and David Too, and Joan and David Couture lines can be found in over eighty retail stores across the United States, Europe, and Asia.

Joan and David's practical design philosophy has influenced the shoe industry and the way in which customers buy shoes. That stylish, yet prac-

tical shoe is available for those concerned with comfort and quality. Joan and David have succeeded in focusing on the wants and needs of footwear and apparel in today's fast-paced society.

REFERENCES

Joan and David, Company Report, 1999.
Milbank, Caroline Rennolds. *New York Fashion: The Evolution of American Style.* New York: Harry N. Abrams, 1989.

N. S.

Jockey International

Jockey International is one of the leading men's underwear brands in the United States, the United Kingdom, Australia, Germany, the Phillippines, and South Africa. The company's products are sold in more than 120 countries throughout the world. Jockey, which originated as S.T. Cooper and Sons, a hosiery company in Saint Joseph, Michigan, was founded in 1876 by Samuel T. Cooper who wanted to improve the comfort of the socks worn by lumberjacks.

Shortly after Cooper's death in 1893, his sons moved the company to Kenosha, Wisconsin, where it is headquartered today. The new manufacturing facility produced hosiery under the Black Cat brand, which quickly acquired a reputation for high quality. Seven years later, the company expanded its product line with White Cat underwear. By 1902 rapid growth necessitated the construction of a second factory just to manufacture the underwear.

Jockey introduced its first major clothing innovation, the Kenosha Klosed Krotch, in 1909. This unique, diagonal-shaped crotch design replaced the bulky drop seat found in union suits, the most common type of men's underwear at the time. In 1934 the company developed a new men's undergarment which transformed the company and men's fashion. This new garment, the Jockey brief, was styled after a skimpy men's swimsuit. It was designed to serve as underwear and as an athletic supporter. This new style revolutionized men's underwear by allowing freer movement and support for activity. To maximize the athletic association of the briefs, Jockey used Babe Ruth, Ty Cobb, Red Grange, and Jim Palmer to promote its products. Initially other companies dismissed the brief, but its almost immediate popularity forced those companies to create their own versions of the comfortable style.

During the 1940s and 1950s, the company pioneered the idea of fashion underwear by marketing prints. This idea was unusual, since most people

regarded underwear to be a "private" item. In 1959 Jockey introduced the first men's bikini brief, which became extremely popular in the 1970s. The company introduced its first full line of women's underwear, Jockey for Her, in 1982. In 1998, although it continued manufacturing and marketing women's underwear, the company dropped the "for Her" part of the brand name and integrated the men's and women's lines.

In addition to manufacturing its own brand, Jockey held numerous licensing agreements. During the 1990s, the company held agreements with Tommy Hilfiger, Jerzees, and Liz Claiborne to manufacture and market underwear. It also held licensing agreements for active wear, sleepwear, and socks for Jacques Moret, Host Apparel, and Gold Toe, respectively. By 1999 the company operated fifteen factories in the United States, Canada, Mexico, and Costa Rica.

Website: http://www.jockey.com

REFERENCES

Friedman, Arthur. "Liz Claiborne, Jockey Sign Pact for Innerwear." *Women's Wear Daily* 175 (September 24, 1998): 4.
Lloyd, Brenda. "Jerzees Labeled for Undercover Action." *Daily News Record* 27 (June 30, 1997): 12.
Monget, Karyn. "When a Slight Change Makes a Big Difference." *Women's Wear Daily* 175 (March 30, 1998): 13.

A.T.P.

❧❧

Joe Boxer Corporation

Awards: Woolmark Award, 1991
 Marty Award, 1991
 Absolute Golden Shears Award, 1992
 MIRA Award, 1992
 Earnie Award for Children's Design Excellence, 1994, 1995

In 1985 Nicholas Graham, a native of Canada, used $1,000 to start a novelty tie business. The business developed into Joe Boxer after Graham created a line of men's boxer shorts featuring whimsical designs, most notably the glow-in-the-dark boxers that debuted in 1988. The company thrived in the 1980s, a decade that saw underwear evolve into outerwear. During the next decade, the company added several product lines: men's loungewear and sleepwear in 1990; JOE BOXER Girlfriend! sleepwear and loungewear in 1992; JOE BOXER Kids! underwear and sleepwear in 1992 with the addition of infants and toddlers sleepwear in 1996; JOE BOXER Girlfriend! underwear in 1996; and, also in 1996, CLEAN FRESH UN-

DERWEAR™, simple, white, cotton underwear. In an effort to expand its lines further, Joe Boxer has licensed its name to create JOE BOXER Home! by Martex/WestPoint, JOE BOXER Time! by Timex Corporation, JOE BOXER Jeans by DJ Industries, and activewear for men and boys.

Since its inception, the company has sought unique, innovative ways to market its products. It has taken the innovative approach to an extreme to distinguish the company's marketing from the overcrowded arena of marketing that characterized the 1990s. To differentiate the brand, the company adopted the distinctive bright yellow smiley face with red tongue, called "Lickey Logo," in 1993.

The company's playful logo is its most conventional form of marketing. To launch the JOE BOXER Home! collection, the company decorated the JOE BOXER Suite at the Triton Hotel in San Francisco with its home products. In 1994 it celebrated Virgin Airways' first flight from London to San Francisco with an in-flight underwear fashion show. Joe Boxer's award-winning "Zipper" billboard first graced Times Square in 1995, and it displayed e-mail messages sent to the billboard's website. In 1998 the company introduced Undo-Vendo™ a vending machine that dispenses underwear.

Website: http://www.joeboxer.com

REFERENCES

Cuneo, Alice Z. "Joe Boxer: Nick Graham." *Advertising Age* 70 (June 28, 1999): S36

Ezersky, Lauren. "Lunch with Lauren, Shadow Boxers." *Paper Magazine* (July 1999).

Wolfe, David B. "Boomer Humor." *American Demographics Magazine* 20 (July 1998): S36.

A.T.P.

John P. John

B. March 14, 1906

D. June 25, 1993

Birthplace: Munich, Germany

Awards: Coty American Fashion Critics Award, 1943
Neiman Marcus Award, 1950
Millinery Institute of America Award, 1956

John P. John, born John (Hans) Piocelle Harberger, immigrated to the United States and worked initially as a dressmaker for Mme. Laurel in

1926, before forming a partnership with Frederic Hirst in 1929 to establish the millinery label John-Frederics. The John and Hirst partnership continued until 1948 when John independently formed Mr. John, Inc.

John was one of the most prominent milliners working in New York in the 1930s. His spirited, chic designs garnered him attention from Hollywood where he worked with costume designers including Gilbert Adrian, Walter Plunkett, and Cecil Beaton. His headwear designs for *Gone with the Wind* (1939) popularized bonnets, picture hats, and the snood and brought glamor and romance to women's wartime fashions. The movies allowed John's designs to be seen by thousands, launching headwear trends across the United States and in Paris. John's work was regularly featured on the cover of *Vogue* magazine during the 1940s and 1950s. Unlike other milliners who layered flowers, feathers, and netting to create frothy designs, John relied on pure shape and form for effect. The sculptural style of John's designs complemented the carefully molded, corseted, and padded silhouette of Dior's New Look.

At the peak of his career, John employed 150 people and produced 16,000 hats per year. In addition to the Mr. John label, John continued to design under the John-Frederics label, and produced millinery under the labels Fredoras, Charmers, Sweet Young Things, and Mr. Fred. He also expanded to produce lines of gloves, stockings, hair nets, scarves, stoles, and Golden Arrow cologne for men. John closed his millinery business in 1970 but continued to design for private clients, developing a line of clothing that was later carried at I. Magnin. *See also*: Gilbert Adrian; Walter Plunkett.

REFERENCES

Ginsburg, Madeleine. *The Hat: Trends and Traditions*. Hauppauge, N.Y.: Barrons Educational Series, 1990.

McDowell, Colin. *Hats: Status, Style and Glamour*. New York: Thames and Hudson, 1997.

A. K.

❧ ❧

Betsey Johnson

B. August 10, 1942

Birthplace: Wethersfield, Connecticut

Awards: Mademoiselle Merit Award, 1970
 Coty American Fashion Critics' "Winnie," 1971
 American Printed Fabrics Council Tommy Award, 1971, 1990

As a girl, Betsey Johnson dreamed of becoming a dancer and began sewing dance costumes to pay for her lessons. She attended Syracuse University where she graduated magna cum laude and Phi Beta Kappa in 1964, with a major in illustration and a minor in drama. During her final year of college Johnson won a contest to become *Mademoiselle* magazine's guest fabric editor. In this position, Johnson reviewed hundreds of fabrics and took the samples home to sew her own clothes. Coworkers admired Johnson's unique creations and began ordering from her.

In 1965 Johnson was introduced to Paul Young, a British retailer opening Paraphernalia boutiques in the United States. The store catered to the flower-power fashions of the 1960s, carrying designs by Mary Quant and Emmanuelle Khan. Johnson was hired as head designer, and she launched her first collection. In 1969 Johnson left Paraphernalia to open a boutique, Betsey, Bunky, & Nini, with two of her friends. Johnson's affordable, whimsical collections established her as the leader of the youth-oriented anti–Seventh Avenue movement of the late 1960s. Her signature style included t-shirt dresses, ballerina skirts, and clear vinyl "kit" dresses with paste-on stars, fish, and numbers which let wearers design their own look.

Johnson worked for numerous companies in the 1970s which expanded her design abilities. From 1970 to 1974 she designed award-winning fabrics and junior sportswear for Alley Cat; in 1971 and 1975 she designed for Butterick Patterns; and in 1974 and 1975 she designed for Gant. The birth of her daughter, in 1975 inspired Johnson to design maternity and children's wear. From 1974 to 1975 she designed for Jeannette Maternities, and from 1974 to 1977 she designed a line of children's clothes for Shutterbug. Johnson also founded three different companies in the 1970s: Star Ferry by Betsey Johnson and Michael Miles (1975–1977), Tric-Trac (1974–1976), and B.J. Vines (1978).

Finally, in July 1979, Betsey Johnson, Inc., was formed to produce sportswear, body wear, and dresses in vinyls and stretch fabrics which appealed to the new punk movement. Her business thrived in the 1980s, and she was offered numerous lucrative licensing agreements, all of which she rejected. Johnson was not interested in relinquishing control of any aspect of the design process. In 1996 the "Madwoman of Seventh Avenue," who was known for offering extreme street styles and had rejected the Seventh Avenue establishment, launched Ultra, a designer-priced collection. The Ultra line, which also includes a fragrance, is co-designed by Johnson's daughter Lulu, whose conservative style brings refinement to the line and balances Johnson's inherent whimsy. *See also*: Mary Quant.

Website: http://www.betseyjohnson.com

REFERENCES

Benatar, Giselle. "Betsey Johnson Just Wants to Have Fun." *Mademoiselle* 99 (February 1993): 130–39.

"Betsey Johnson." *Current Biography* (January 1994): 29–32.
"Betsey Johnson's Soho Space." *Women's Wear Daily* (May 7, 1998): 8.
Goodman, Wendy. "Earth to Betsey." *Harper's Bazaar* (August 1996): 190–210.

<div align="right">*A. K.*</div>

<div align="center">❦❧</div>

Alexander Julian

B. February 8, 1948

Birthplace: Chapel Hill, North Carolina

Awards: Coty American Fashion Critics Award, 1977, 1979, 1980, 1983, 1984
 Cutty Sark Award 1980, 1985, 1988
 Cutty Sark Achievement Award, 1988
 Men's Woolknit Design Award, 1981
 Council of Fashion Designers of America Award, 1982
 Major Collection, Pinnacle Design Achievement Award, 1998
 Forrest L. Dimmick Award for Excellence in Color Marketing, Color
 Marketing Group, 1998

 Alexander Julian's interest in fashion peaked at any early age. As a child he was intrigued by the fabric sample books in his father's apparel store, the Clothing Cupboard, and he began designing fabrics, shirts, and jackets in his early adolescence. By sixteen, Julian was managing the Clothing Cupboard and attending trade shows with his father, where he received first-hand exposure to the apparel and retail industries. After high school, Julian enrolled at the University of North Carolina, where he majored in English since the university did not offer a major in design. In 1969, at the age of twenty-one, Julian struck out on his own and opened his own store, Alexander's Ambition, in Chapel Hill, which he operated until 1975. In 1975 Julian decided to leave Chapel Hill for New York City, and he founded the Alexander Julian Company, showing his first collection that same year. The collection was well received, and two years later, Julian became the youngest designer to win the Coty American Fashion Critics Award.

 Alexander Julian, a pioneer in men's fashions, foresaw the shift to casual dressing that now dominates men's business attire, and he was one of the first designers to introduce interchangeable separates for men, transforming business jackets into sports coats paired with dress shirts without ties. Perhaps even more revolutionary are the colors Julian has brought to men's fashions. Julian broke from the traditional neutral color scheme that had always dominated men's fashions to design with a rich palette when he introduced his moderately priced, aptly named, Colours line in 1981. The line revolutionized men's dressing and immediately made Alexander Julian

a household name. Over the next decade Julian expanded his business to add a women's wear line in 1983, Colours by Alexander Julian for boys in 1984, Watercolors swimwear in 1984, Alexander Julian couture in 1988, and Coloursport in 1994.

In 1985 Julian made his first foray into designing for the home furnishings industry. Julian applied his artistic flair for combining colors and patterns in menswear designs to home furnishing designs. He adopted leather and tortoise shell buttons for draw pulls, converted argyles into veneer inlays, and transformed plaids into carpet and rug designs. His color and pattern combinations created unique room accents. Since entering the home furnishings market, Julian has signed licensing agreements for bedding, rugs, carpeting, lamps, mattresses, decorative art, wall coverings, paint, window treatments, laminate flooring, kitchen cabinets, countertops, decorative pillows, throws, lines of furniture, upholstery, and fabrics under the Alexander Julian Home Colours labels. Some of the most prestigious home furnishing manufacturers have forged relationships with Julian, including Universal Furniture, Lifestyles Furnishings, Dan River, Pillowtex, Couristan, Asia Minor, Robert Abbey, Spring Air, Capel, Soicher-Marin Fine Art, Lowe's, Home Innovations, BenchCraft, Sunworthy, and Hampshire Mills. Julian's home furnishing designs have become so popular that the sale of these products is virtually equal to the sale of his menswear products.

The three primary Alexander Julian labels—Colours by Alexander Julian, Coloursport, and Alexander Julian—are all produced through a series of licensing agreements currently held by Windsong, American Trouser, Inc., and Pincus Brothers Maxwell. Julian also licenses his name to Fashion Neckwear, Swank, William Barry, Host Apparel, Pico Manufacturing Sales Corporation, Shalom and Company, Paul Lavitt Mills, Mallory and Church Corporation, Lifeguard Apparel, Paul Sebastian, J. Pietrfesa, Mel Howard Accessories, Marchon/Marcolin Eyewear, Leshner, and others for a variety of apparel-related products. Julian's name currently appears on such products as neckwear, belts, small leather goods, men's and boy's outerwear, robes and pajamas, men's and boy's underwear, headwear, gloves, handkerchiefs, men's hosiery, men's and women's fragrances, formal-wear accessories, eyewear, luggage, and towels.

Alexander Julian is known for creating timeless, affordable designs for real life. His brings a unique color and pattern aesthetic to casual, comfortable clothing for men. Julian has over twenty active licensees covering such a diverse range of products that one observer noted that, "If Alexander Julian could design the air, he would" (Orenstein, p. 28). Despite his success, Julian still maintains an active relationship with his hometown of Chapel Hill and the state of North Carolina. He designed the uniforms for the Charlotte Hornets basketball team in 1988, designed the stadium seating for the Charlotte Knights baseball team in 1990, and designed uniforms for University of North Carolina Tar Heels basketball team. He comanages

Julian's College Shop (formerly the Clothing Cupboard) with his sister Missy.

REFERENCES

Gellers, Stan. "Designers Add New Rules to Dress Code Book." *Daily News Record* 21 (July 15, 1991): 14–17.

Maycumber, S. Gray. "The Fabric Is the Core of the Fashion." *Daily News Record* 24 (February 24, 1994): 8.

———. "Fearless Color by Alexander Julian Award." *Daily News Record* (November 30, 1998): 14.

Orenstein, Alison. "Alexander Julian: Color Conscious." *Home Furnishing Network* 70 (May 27, 1996): 28.

Spevack, Rachel. "Alexander Julian: On His Own at Last." *Daily News Record* 21 (January 30, 1991): 8–11.

A. K.

K

Norma Kamali

B. June 27, 1945

Birthplace: New York City, New York

Award: Coty American Fashion Critics Award, 1981, 1982, 1983
Council of Fashion Designers of America Award, 1982, 1985
Ernie Award, 1983
Fashion Institute of Design and Merchandising Award, 1984
CFDA Award, Innovative Use of Video in Presentation and Promotion of Fashion, 1984
6th Annual Interiors Award, 1985
Fashion Group Award, 1986
American Success Award, Fashion Institute of Technology, 1989
Fashion Outreach Style Award, 1995

Norma Kamali grew up on the upper east-side of Manhattan, New York. As a child, Kamali was interested in becoming a painter to express her inner self. Later, the rather shy Kamali found another way to express herself: experimenting with unique fabric combinations in her dress. From 1961 to 1964 Kamali attended the Fashion Institute of Technology where she received her bachelor's in fashion illustration. After college, Kamali worked for one year as a freelance fashion illustrator. Because she wanted to travel to gain a broader exposure to fashion, she worked as a clerk for Northwest Orient Airlines from 1966 to 1967.

In 1967 Kamali decided to launch her own business, Kamali Fashion Imports, for which she designed and imported garments sold out of her basement. One of Kamali's first designs, t-shirts with rhinestone studs,

snakeskin, appliqués, or leather, received recognition in several magazine editorials which generated a large volume of consumer demand. In 1974 Kamali relocated her business to Madison Avenue where she continued to create unique designs with innovative fabrics and silhouettes. She designed a line of parachute clothing from real silk parachutes and developed a coat from a sleeping bag that is now part of the costume collection at the Metropolitan Museum. The recognition she received from these collections also provided her with the opportunity to create original costumes for the Emerald City in Sydney Lumet's film *The Wiz* (1978).

Kamali's experimentation with swimwear fabric in 1978 resulted in the "pull bikini," a revealing, drawstring, two-piece suit. The suit was modeled by Christie Brinkley for the cover of *Cosmopolitan* magazine. The pull bikini received international recognition and pushed Kamali to the forefront of the swimwear business. The increase in demand for her designs led Kamali to open a second operation, OMO (On My Own), in 1978 on West 56th Street.

Kamali introduced her first ready-to-wear collection in 1981, a fleece-based collection of sweatshirts embellished with interesting decorative details. This collection, licensed to Jones Apparel Group, was her first venture into licensing. In 1982 she signed another licensing agreement with Renown to distribute her designs in Japan and the Orient. This new expansion allowed Kamali to open world headquarters in 1983 on West 56th Street with administrative offices, a showroom, and a design studio.

Kamali continued to add licensing agreements to her operation. She signed Empire Shield Group for her children's sportswear line in 1982, Vittorio Ricci for her bags and footwear in 1983–1984, and Stetson for her headwear collection in 1985. In 1985 Kamali added a signature fragrance collection for both men and women and an accessory line licensed to Raymon Ridless. An OMO home collection was created in 1988, which consisted of furniture, fabrics, and home fragrances. In 1992 Kamali joined forces with Italian shoe manufacturer Andrea Carrano to produce and distribute footwear and, at the same time, added Colors in Optics for eyewear and sunglasses.

In the early nineties, Kamali focused on expanding her swimwear collection, using pinup advertising boards. In addition, an OMO athletic wear collection licensed to Weekend Exercise Company was developed to match women's active lifestyles. In 1993 Norma Kamali launched a casual wear line called 1.800.8Kamali, which included polyester jersey items that could be mixed and matched for a year round wardrobe. Accompanied with the collection was a sack bag large enough to carry the entire collection for weekend traveling.

Continuing with her clever use of advertising, in 1996 Kamali presented her fall collection on the Internet. She used a virtual reality experience to broadcast simultaneously a worldwide exhibition. Kamali also used the

Internet to expand into direct marketing in 1998 with "Shop like a Celebrity." This enabled customers to view photos and videos of all her collections, and to work with personal shoppers to select garments for delivery to their office or home.

Today, Kamali still continues successfully to mix unusual fabrics with interesting silhouettes. Kamali contributes her creativity to new technologies that promote invention in fashion. Kamali's lines are carried in boutiques as well as in major department stores, including Bloomingdale's, Neiman Marcus, and I. Magnum. Her Shop like a Celebrity service is very successful in satisfying her clients, providing them with a much-needed convenience in the hectic lifestyle of today's women.

Website: http://www.normakamalicollection.com

REFERENCES

Milbank, Caroline Rennolds. *New York Fashion: The Evolution of American Style.* New York: Harry N. Abrams, 1989.

Milbank, Caroline Rennolds. *Couture: The Great Designers.* New York: Stewart, Tabori and Chang, 1985.

Norma Kamali, Company Report.

White, Constance. "Rediscovery of Norma Kamali." *Women's Wear Daily* 164 (October 21, 1992): 24.

N. S.

Karl Kani

B. 1969

Birthplace: Brooklyn, New York

Awards: Entrepreneur of the Year, *Inc.* Magazine, 1995
 Company of the Year, *Black Enterprise*, 1996

When Carl Williams (Karl Kani) started selling his designs to his friends in Brooklyn he could not have imagined the cross-cultural impact he would have on fashion. Kani's street-inspired fashions transcend the African-American, urban, hip-hop niche. They have been widely adopted by white suburban teens who want to be part of big city culture. Suburban malls and national retailer's such as Merry Go Round, Coda, Macy's, Nordstroms, Dayton Hudson, and Marshall Field's prominently display Kani as an attestation to their fashion-forward direction.

Carl Williams worked as a newspaper carrier while he was growing up in the Brooklyn projects. The shirts and pants he designed for himself and his friends were sewn by a local tailor, and he placed mail-order ads for

his designs in rap magazines. As Kani's business grew, the cost of manufacturing in New York forced him to relocate to Los Angeles in 1988 to open Seasons, an apparel store, and establish production facilities in South Central Los Angeles. Business was slow, but Kani's designs came to the attention of Cross Colours, a subsidiary of Threads 4 Life, who funded the full-scale launch of the Karl Kani label in 1990. Kani's association with Cross Colours was plagued by manufacturing and distribution problems which delayed shipments to retailers. In 1993 Kani ended his three-year relationship with Cross Colours to found his own company, Karl Kani Infinity.

Kani originally debuted on the fashion scene pioneering hip-hop baggy jeans and oversized tops. As his twenty-something customer base aged, Kani developed new lines of fashion-conscious clothing aimed at young professionals. He also expanded into athletic wear, couture, big and tall, and women's casual wear. The manufacturing problems that affected Kani's early career prompted him to sign licensing agreements rather than produce his own collections. Beginning with the fall 2000 collection, Neema Clothing, Ltd., holds the licenses to manufacture and market the Kani line (tailored), the Karl Kani Black Label (sportswear), and the Karl Kani line (business casual). Kani retains creative control over all the lines he licenses including footwear lines for both Skechers and Summit Footwear, a boys' line for Siegfried and Parzifal, leather apparel for G-III, and an underwear line for Checkmate. He will also be adding fragrance, eyewear, neckwear, socks, girls', infants' and home furnishing licenses throughout 2000.

The fact that Karl Kani operates the twenty-fifth largest African American–owned business in America is a testament to his ability to combine street-smart fashions with marketing genius. Kani draws on the celebrity cachet of his friends in the National Basketball Association, including Charles Barkley and Magic Johnson, and rap artists, such as Snoop Doggy Dog, Puff Daddy, and Heavy D, to endorse his products. As the market for street wear grows, Kani will have to continue to distinguish his designs in the highly competitive arena which he created. *See also*: Skechers

Website: http://www.karlkani.com

REFERENCES

McAllister, Robert. "Kani Can Do." *Footwear News* 51 (January 16, 1995): S5.
Muhammad, Tariq. "From Here to Infinity: Karl Kani." *Black Enterprise* 26 (June 1996): 140–46.
Romero, Elena. "Urban Sportswear Pioneer Karl Kani Celebrates 10 Years." *Daily News Record* (February 15, 1999): 26.
Welsh, Alice. "Kani Gets into Shape for Casual." *Women's Wear Daily* 169 (May 18, 1995): 7.

A. K.

❦

Donna Karan

B. October 2, 1948

Birthplace: Forest Hills, New York

Awards: Coty American Fashion Critics "Winnie," 1977, 1981, 1984, 1985
CFDA, Best Designer, 1985, 1986, 1990, 1992, 1997
Fashion Footwear Association of New York Award, 1988
CFDA, Best Men's Designer, 1991
Woolmark Award, 1992

Donna Karan grew up Donna Faske in Forest Hills, New York, and seemed destined from the beginning to be in the fashion industry: her father was a tailor and her mother was a sales representative and showroom model. After high school Karan moved to New York City to attend Parson's School of Design and landed an internship at Anne Klein in 1967. However, Karan's dream job became a nightmare when she was fired after nine months. At nineteen, Karan brought a youthful enthusiasm to her position as Klein's assistant or "head pin-picker-upper," but she lacked the maturity to work in a high-pressure position for such a meticulous woman. Fortunately, Karan was able to obtain a position under Patti Cappalli at Addenda, where she diligently worked for the next year and a half to learn all aspects of the apparel industry.

Karan returned to Anne Klein in 1968 determined to be successful. In 1971 her determination paid off when she became associate designer at Klein. The young designer worshipped Klein and became her right hand. When Klein died in 1974, a devastated Karan was appointed head designer and, with Assistant Designer Louis dell'Olio, carried on the Klein tradition. Karan, with dell'Olio, prepared to take the fashion community by storm, virtually reinventing women's fashions. Together the duo launched the Anne Klein II line in 1982 targeted toward working women, which was soon to become Karan's niche.

In 1984 Karan left Anne Klein, and with the backing of the Japanese conglomerate Takiyho, launched her own company. Karan's timing was perfect. Women were entering upper-level management positions in record numbers and were in need of a new uniform. The collections Karan designed combined comfort and functionality. The mix and match pieces built on basic black and were versatile enough to go from day to evening. Karan paired her signature body suits with wrap skirts and tailored jackets in silhouettes which flattered the figure and concealed imperfections. The looks were professional yet sexy, corporate but not masculine. Her collections broke sales records in department stores across the country.

As Karan's business grew, she developed new product lines and added licensing agreements. She launched her swimwear line in 1986, intimate apparel in 1992, and children's wear in 1992. Karan signed licensing agreements with Hanes for hosiery and Erwin Pearl for jewelry. The Donna Karan Beauty Company was formed in 1992 to develop fragrances and cosmetics. However, despite all her success, when Karan decided to launch a menswear line in 1991, her announcement was met with skepticism. No one was sure whether men would want to buy clothing designed by a woman, but her golden touch continued and the line was a success.

The American fashion industry has traditionally been viewed as an old boys' club, in which Karan was often considered a trespasser. Her designs, which revolutionized the working woman's wardrobe, earned her comparisons between herself and Coco Chanel. Her design philosophy is simple— she merely asks herself "what do I need?" and designs it. Karan has her finger on the pulse of the American woman and has a unique ability to interpret her every need and mood with her designs. *See also*: Anne Klein.

Website: http://www.donnakaran.com

REFERENCES

Lubow, Arthur. "The Mega Mom and Pop Shop." *New Yorker* (November 7, 1994): 124–35.

Perchetz, Lois, ed. *W, The Designing Life*. New York: Clarkson N. Potter, Inc. 1987.

Rudolph, Barbara. "Donna Inc." *Time* 140 (December 21, 1992): 54–58.

Steele, Valerie. *Women of Fashion: Twentieth Century Designers*. New York: Rizzoli, 1991.

A. K.

Rei Kawakudo

See Comme des Garçons.

Patrick Kelly

B. 1955

D. January 1, 1990

Birthplace: Vicksburg, Mississippi

Whimsy and playfulness characterize Patrick Kelly's designs. He was known for his sexy spandex dresses with bold, theatrical embellishments. By decorating his designs with mismatched buttons, black baby dolls, rhinestones, and exaggerated frills, he created lighthearted designs that captured the spirit of the 1980s.

Kelly created a persona for himself, and many of the facts about his life are difficult to distinguish from the image he created. Many saw him as a fun, spirited character attired in oversize overalls and bright "Paris" caps, but his beginnings were a bit more ordinary. He attended Jackson State University on an art scholarship but dropped out. He owned a vintage clothing shop in Atlanta, and later moved to New York where he attended the Parsons School of Design.

The designer first set foot in Paris in 1981. The one-way ticket to the city, which would become his adopted home, was provided by his model friend, Pat Cleveland. He began his design career by sewing designs in his hotel room and selling them on the Boulevard Saint-Germain. After partnering with Bjorn Amelan in 1985, he became a sensation in Paris. At his first show that year, Bergdorf Goodman was among the purchasers of Kelly's designs. The next year he freelanced as a sportswear designer for Benetton.

1987 was a watershed year for the designer. He opened his first boutique in Paris and introduced his first couture collection. In July of that year he sold the worldwide rights to his women's ready-to-wear to Warnaco. The next year, the Chambre Syndicale honored the designer by admitting him as the first American designer in the organization.

Kelly's bright career was cut short. He showed his last and much lauded collection in 1989. Some of the featured dresses were embroidered by Lesage while others were embellished by an image of the Eiffel Tower created in rhinestones. The designer's failing health owing to AIDS forced him to enter the hospital shortly after his last collection, and he died a few months later.

REFERENCES

George, Leslie. "Patrick Kelly: An American in Paris." *Women's Wear Daily* 155 (January 15, 1988).
Martin, Richard, ed. *Contemporary Fashion*. New York: St. James Press, 1995.
Voight, Rebecca. "Remembering Patrick Kelly: American Whimsy in Paris." *Women's Wear Daily* 159 (January 3, 1990): 28

A.T.P.

Barry Kieselstein-Cord

B. November 6, 1948
Birthplace: New York City, New York

Awards: Hollywood Radio and Television Society Award, 1965
 Art Directors Club of New York Award, 1967
 Illustrators Society of New York Award, 1969
 Coty American Fashion Critics Award, Jewelry Design, 1979
 Council of Fashion Designers of America, Excellence in Design, 1981
 Coty American Fashion Critics Award, Excellence in Women's Wear Design, New York, 1984

"I am not influenced by fashion, preferring to be an influencer," stated Barry Kieselstein-Cord, son of an architect and an illustrator, who is known for his contemporary designs in jewelry, belts, handbags, and other "sculptures for the body" (Martin, p. 221).

After studying at the Parsons School of Design, New York University, and the American Craft Institute, Kieselstein-Cord worked in the advertising business for several years before starting his jewelry company in his walk-up apartment in 1972, but he claims he knew that he was destined to be an artist at an early age. His fascination with ornamentation, particularly from the past, led him to early explorations in carving, painting, and, ultimately, metalwork. In the early 1970s, his pieces were introduced at George Jensen and quickly attracted the attention of those who recognized the sophisticated cultural elements of his creations.

Kieselstein-Cord is best known for his understated, hand-crafted, and somewhat whimsical motifs, which demonstrate the divergent interests of the designer. He is attracted to both the old and the new, the spiritual and the technological, the simple and the elaborate. These contradictions are all evident in his designs.

From his crocodiles and bears to his scarabs and serpents, the use of green gold, the rich matte finishes, and the unique textural elements all combine in dynamic, yet subdued, pieces, appreciated by collectors including Giorgio Armani, Oprah Winfrey, and Steven Spielberg.

Aside from jewelry, belts buckles, and pocketbooks, he designs furniture, lamps, tabletop items, and humidors. His name also appears on scarves, ties, and eyewear, all of which are produced under licensing agreements. Kieselstein-Cord's creations are included in the collections of New York's Metropolitan Museum of Art and the Louvre in Paris. In 1980 he won a copyright infringement case against a jeweler who had reproduced one of his belt buckles; it was determined by the court that the item was a piece of art rather than simply a belt buckle—a significant precedent-setting decision. Considered a highly respected artist, he is greatly appreciated for his revival of the jewelers art in the United States.

Website: http://www.kieselsteincord.com

REFERENCES

Goodman, Wendy. "Challenging the Gold Standard." *Harper's Bazaar* (January 1995): 64.

Phelps, Nicole. "Design for Living: Barry Kieselstein-Cord Is the New Designer in Residence at His Historic East Side Townhouse." *W* (March 1998): 260.
Stegemeyer, Anne. *Who's Who in Fashion*. New York: Fairchild Publications, 1996.

S. B.

◈◈◈

Anne Klein (Hannah Golofsky)

B. 1923

D. March 19, 1974

Birthplace: New York City, New York

Awards: Mademoiselle Merit Award, 1954
 Coty American Fashion Critics Award, 1955, 1969
 Neiman Marcus Award, 1959, 1969
 Lord and Taylor Award, 1964
 National Cotton Council Award, 1965

In 1948 Anne Klein and first husband, Ben Klein, formed Junior Sophisticates, which completely transformed the clothing styles, choices, and attitudes of young American women. Anne Klein will forever be remembered as the designer who revolutionized the junior market, doing away with the traditional little-girl clothing that featured button-and-bow detailing, and addressing the primary need of this important group—the desire to look more stylish, more polished, and, above all, more grown up.

Klein, who was destined to move American sportswear to center stage, was only fifteen years old when she got her first job on Seventh Avenue. After working as a freelance sketcher, she joined a New York manufacturer, Varden Petites, and then worked at Maurice Rentner for several years, before founding Junior Sophisticates. Her blazers, pleated skirts, and jackets, which were offered at prices ranging from $50 to $90 and made in regular and petite sizes, presented sophisticated options, not only to young women but to smaller women who previously had had few choices.

In the 1950s Klein worked with sheath dresses, tunics, and pea coats, creating interesting adaptations that appealed to modern young women by reflecting their lifestyles, all at reasonable prices. In the 1960s she began working on the concept of combining her sporty shapes with her other pieces—hence the idea of building a wardrobe by mixing separates which can be worn for both day and evening. Her concept was not only groundbreaking, but wonderfully practical as well, and her designs reflected much the same fashion philosophy as that of Claire McCardell—clothing should be versatile, comfortable, flattering, and timeless. Her work with Mallory Leathers during the same time period resulted in smart coats and separates and established leather as an accepted fabric in the ready-to-wear market.

In 1968 Klein and second husband opened Anne Klein and Company and Anne Klein Studio. The designer continued to emphasize the importance of interchangeable clothing and coordinated wardrobes. Her classic blouses, kilts, jumpsuits, trousers, and easy wrap coats all reflected the new 1970s preference for unstructured silhouettes. Her collections were showcased in areas of major department stores, designated as Anne Klein Corners, marking the beginning of the in-store designer boutique, so much a part of modern merchandising. In addition, Anne Klein believed in a total look; thus she designed and licensed jewelry to Swank, gloves to Isotoner, scarves to Vera, sunglasses to Riviera, furs to Goldin-Feldman, as well as shoes, rainwear, and umbrellas, all of which went with her clothing. By 1972 Anne Klein's astrological sign, the lion, had become her recognized logo. The following year she was one of only five American designers invited to Paris to show her line at the Palace of Versailles, along with Halston, Bill Blass, Oscar de la Renta, and Stephen Burrows.

At her untimely death in 1974, her ideas were more popular than ever. Her young assistant, Donna Karan, was named head designer and soon brought in her close friend from Parson's School of Design, Louis dell'Olio. Together they worked as codesigners for the company, at first turning out both casual and dressy separates such as suede jeans and soft silk shirts. They continued to use more luxurious fabrics like cashmere, wool crepe, and charmeuse in their boldly shaped garments, and the company became known for high-quality fashions. In 1982 the Anne Klein II line was introduced and featured many of the same pieces in less expensive fabrics. In 1984, when Donna Karan left to launch her own collection, which debuted in 1985, Dell'Olio continued the Anne Klein tradition of creating simple and wearable sportswear for many successful years. When he resigned in 1993, Richard Tyler, an Australian designer who had recently been awarded the CFDA New Talent Award, agreed to join the company as design director.

Tyler had become well known in the 1970s for attracting touring rock-and-roll stars, including Cher, Elton John, and Alice Cooper, to his Melbourne shop where he created unique costumes for each of them. In 1978, when Rod Stewart asked Tyler to come to Los Angeles to design costumes for his "Blondes Have More Fun" tour, Tyler enjoyed the city so much that he eventually moved there and started a menswear company, at the urging of his wife/partner, Lisa Trafficante. Tyler specialized in impeccably tailored, fashion-forward men's suits, complete with silk linings and hand-tailored details. Eventually he incorporated women's clothing as well, using the same beautiful construction and finishing. Within a few years, Tyler became one the hottest designers in Los Angeles, and he took his line to New York in 1992 where he was warmly welcomed and immediately approached by Anne Klein and Company.

The relationship was short. Although, during his year with Anne Klein,

store orders increased dramatically, so did the prices. This, coupled with a variety of other difficulties, resulted in the end of Tyler's tenure with the company. Since Tyler's departure in 1994, Anne Klein and Company has employed several design directors, including Patrick Robinson, and most recently the design team of Ken Kaufman and Isaac Franco.

Unfortunately, by the year 2000, only the A-Line division of the company, a lower end line launched in 1994 and aimed at a younger customer, remained. Nevertheless, students of modern fashion will always remember Anne Klein, in the words of *New York Times* writer Judith Cummings, for "elevating sportswear looks to the level of high style." *See also*: Donna Karan; Claire McCardell; Halston; Bill Blass; Oscar de la Renta.

REFERENCES

Cummings, Judith. "Anne Klein." *New York Times* (March 20, 1974).
Ewing, Elizabeth. *History of 20th Century Fashion*. New York: Charles Scribner's Sons, 1974.
Martin, Richard, ed. *The St. James Fashion Encyclopedia: A Survey of Style from 1945 to the Present*. Detroit: Visible Ink Press, 1996.
Milbank, Caroline Rennolds. *New York Fashion: The Evolution of American Style*. New York: Harry N. Abrams, 1989.
Mulvagh, Jane. *Vogue History of 20th Century Fashion*. New York: Viking, 1988.

S. B.

Calvin Klein

B. November 19, 1942

Birthplace: Bronx, New York

Awards: Coty American Fashion Critics Award, 1973, 1975, 1984
Bath Museum of Costume Dress of the Year, 1980
Council of Fashion Designers of America Award, 1993, 1999

Sex sells, and Calvin Klein knows it. Throughout his career he has created functional, mainstream clothing, but his true contribution to fashion has been his ability to capitalize on sensuality and sexuality in his marketing. By creating an image of provocative sexuality, he has been able to build a multibillion-dollar fashion empire.

Klein attended the New York High School of Art and Design in the 1950s and the Fashion Institute of Technology from 1959 to 1962. Upon graduating, he worked as an assistant designer at Dan Millstein in New York, leaving to pursue freelance design in 1964. In 1967 he partnered with his school friend Barry Schwartz to form Calvin Klein Company. He

founded the company to produce coats and suits in the contemporary price range. Quickly, he found a niche among younger women, who found couture clothes to be too expensive and matronly for their taste. His adaptations of masculine pea coats and pants were quite popular. In 1969 one of his coats appeared on the cover of *Vogue*.

In the 1970s, he established a reputation for simple clothes crafted from luxury fabrics, and he has maintained this formula throughout his design career. He focused on basic shapes and styles, like tank tops, blazers, trousers, and skirts made from "couture fabrics" like cashmere, suede, silk, and linen. Preferring neutrals, his favorite color choices were creams, beiges, and grays. Also, he liked the monochromatic look and developed entire wardrobes comprising of interrelated pieces in a single color.

Although Klein created simple, minimal designs, he viewed them as being complex. He felt that the attitude of the wearer brought out an individuality in the clothes; how she chose to wear them affected the image she projected. He focused on this idea of dynamism and individuality when creating a design, paying special attention to the way the clothing moved on the body. This focus on movement created a sensual quality to his clothes.

Klein continued to focus on sensuality and sexuality in the 1980s and 1990s by centering his ad campaigns on provocative images. In 1980 Klein aired a television advertisement for his jeans featuring a teenage Brooke Shields. In the spots, which were directed by Richard Avedon, Shields strikes suggestive poses and asks, "Want to know what comes between me and my Calvins? Nothing." Although the ads are mild by today's standards, at they time they were shocking, and many stations canceled the commercials.

Klein continued to mount sexually provocative ad campaigns. In 1982 he hired Bruce Weber to photograph Calvin Klein's men's underwear. He photographed the muscular models from below with an emphasis on the bulge in the underpants. The result was an unprecedented erotic portrayal of men in advertising. In 1983 Klein's ads for man-style cotton underwear for women implied group sex. His ads for the 1985 launch of Obsession perfume featured naked models. A 1995 ad campaign for cK Calvin Klein Jeans was criticized for bordering on child pornography, and a 1999 billboard featured half-naked children wearing Calvin Klein's underwear. Although all of these ads generated criticism, they also generated publicity that helped popularize Klein's designs.

Through the 1980s and 1990s, Klein continued to rely on basic styles, minimal aesthetics, and comfortable dressing. His designs included such essentials as pantsuits, sweater sets, chemise dresses, and pea coats. His skin-tight interpretation of jeans contributed to the popularity of designer jeans during the early 1980s, a trend that characterized the conspicuous

consumption of the period. His cK line of the 1990s targeted a younger market of Generation Xers with more casual clothes and a less refined look.

Klein launched several successful fragrances in the 1980s and 1990s. He introduced Obsession in 1985, and sold $50 million of the fragrance in the first year. Following the success of Obsession, he launched Eternity in 1988, Escape in 1991, and cK One, a unisex fragrance, in 1994. The timing of cK One seemed to be perfect; it was very successful and spawned many imitators.

In the 1990s, most of the company's revenues came from licensing, with Warnaco producing most of Klein's apparel. Jeans, underwear, and fragrances generated the largest revenue, but the company also licensed footwear, watches, and eyewear. In addition, Klein licensed almost thirty retail stores in locations around the world. The company reorganized in 1991, but in the spring of 1992 it nearly folded when it was unable to buy a block of bonds that came up for redemption. David Geffen bailed out Klein by purchasing the bonds for $30 million. By the start of the new century the company's financial health was renewed, making $5.4 billion in global retail sales in 1998.

Website: http://www.ckjeans.com

REFERENCES

Gaines, Steven, and Sharon Churcher. *Obsession: The Lives and Times of Calvin Klein*. New York: Avon Books, 1995.

Herald, Jacqueline. *Fashions of the Decade: The 1970s*. New York: Facts on File, 1992.

Klensch, Elsa. "Calvin Klein: An Anti-materialist Turns 30 and Waits to Go Co-op." *Women's Wear Daily* 178 (September 13, 1999): 405.

A.T.P.

Michael Kors (Karl Anderson)

B. August 1959

Birthplace: Long Island New York

Awards: Dupont's American Original Award, 1981
 Council of Fashion Designers of America Womenswear Designer of the Year, 1999

Michael Kors designs great American sportswear. He began his professional career in 1978 as a salesperson/designer at Lothar's, a once famous New York boutique. Recognizing the value of the hands-on training he

was enjoying there, he left Fashion Institute of Technology after one semester, preferring to spend more time at Lothar's, sketching outfits and having samples made for display in the store's windows. Celebrities and fashionistas who shopped there were disarmed by Kors' charming personality and willingness to escort them right into their dressing rooms, discussing their outfits and pinning up their hems.

His mother, a former Revlon model, had originally thought Michael would go into show business. As a child, he appeared in several television commercials on behalf of products including Charmin paper goods and Lucky Charms cereal. But, by the age of ten, Michael was also selling clothes out of his basement, a sure sign to Mrs. Kors that her son was not destined for the stage, but rather for fame in the fashion world.

In 1981 Kors brought a small collection of sportswear to Bergdorf Goodman, where buyers quickly recognized the appeal of his casual approach to chic clothes: Kors makes luxury simple. Today, he continues to use a sophisticated blend of beautiful shapes and lush fabrics like cashmere, kidskin, and charmeuse. Kors takes his inspiration from Halston, the designer who changed the way American women dressed by exalting American style and panache during the 1970s, and Coco Chanel, who also challenged the way women dressed. Kors believes that comfort in clothing should be a requirement, not an added benefit, and that dressing can be easy and elegant simultaneously.

Of course, Kors's career has not been without setbacks. In 1993 his company went bankrupt owing to a flawed licensing agreement with another company. However, his admirers remained faithful, and he remained true to his fashion philosophy: timelessness is the essence of fine clothing. Certainly that is why Bernard Arnault, renowned financier of fashion and owner of Moët Hennessey–Louis Vuitton, the luxury goods conglomerate, took notice and hired Kors in 1997 to modernize the image of his French luxury label Celine. Arnault was so happy with the results, he purchased a portion of Kors's own company, which produces the Michael Kors signature collection and KORS, the bridge line. This kind of alliance was one of several forged at the end of the twentieth century—young American designers were hired by venerable European fashion houses to introduce the American concept of sporty elegance to European women.

Michael Kors, despite his fame, still enjoys chatting with his customers, whether he is making a guest appearance in a department store or appearing at Celine in Paris, a fact that greatly pleases his boss/partner Bernard Arnault. The days young Michael spent at Lothar's apparently served him well—that and the indisputable statement he has made many times: "I just love clothes!" *See also*: Halston; Gabrielle Bonheur "Coco" Chanel; Louis Vuitton.

REFERENCES

Betts, Katherine. "King Kors." *Vogue* (August 1999): 224.
Gross, Michael. "Of Kors." *New York* 25 (March 9 1992): 20.
Sessums, Kevin. "Kors, of Course." *Vanity Fair* (September 2000): 358.

S. B.

L

René Lacoste

B. July 2, 1904

D. October 12, 1996

Birthplace: France

Awards: Design Award, 1984
 Innovation Award, 1988
 Global Recognition Trophy by the American Cotton Institute, 1995
 Meryl Award in Sportswear, 1997

After seeing what tennis players wear today, it is hard to believe they once wore button-down shirts and white flannel pants. One tennis player with a knack for innovation transformed the clothing of the sport as well as men's sportswear. René Lacoste had a notable tennis career. As the number-one ranked player in the world in 1926 and 1927, he won three French Opens, two Wimbledons, and two U.S. Opens. His tenacious playing style earned him the nickname "Le Crocodile." His drive for success on the courts developed into a passion to refine and improve the sport.

Teaming up with the owner of France's largest knitwear company, André Gillier, Lacoste established a clothing manufacturing company in 1933. The company produced Lacoste's design for a tennis shirt with a crocodile logo. Radically different from the typical starched, long-sleeved tennis shirt, Lacoste's design was far more functional. It was crafted from a lightweight, knit fabric, which was cooler and allowed more freedom of movement. The shirt featured other innovations such as short sleeves, a ribbed collar, and longer shirttails. These many advantages made it one of the first pieces of

performance sportswear. The crocodile emblem over the left breast made it the first sportswear with the logo on the outside of the garment.

Lacoste's popularity propelled the early sales of the shirt. During World War II the company halted production, but by the early 1950s, it had begun exporting to Italy and the United States. David Crystal, Inc., imported the shirts in the United States and sold them under the Jack Izod label. During the next decade, Lacoste's shirt remained a specialty product. Its $8 price tag, expensive for a sport shirt at the time, limited the number of retailers willing to sell the product. By the early 1970s, only Bloomingdale's, Brooks Brothers, and pro shops were carrying the line in the United States. This exclusivity lent to the shirt's reputation and prestige.

The shirt achieved its ultimate popularity during the preppy look of the 1970s. General Mills acquired the U.S. manufacturing license in 1970, and by the 1980s it began manufacturing the shirts in the Far East to increase profits. Also, it began making the shirts from a synthetic fabric instead of the traditional cotton. These changes eroded brand loyalty.

Other marketing decisions impacted Lacoste's reputation as well. Between 1978 and 1990, the company signed manufacturing and distribution licenses in more than seven countries including Brazil, Thailand, and Mexico. This move reduced the company's control of product quality. During the same period, dozens of other companies, including Ralph Lauren, Sears, Roebuck and Company, and L.L. Bean, began producing their own versions of the shirt. By the early 1990s, the Lacoste brand was being sold in discount stores, and it had lost its prestige.

During the 1990s, the company worked to rebuild its reputation. In 1992 Lacoste regained control of its U.S., Canadian, and Caribbean licenses and consolidated them under Denvanlay. This allowed the company to ensure production of quality products. Also, it revised its marketing plan, using trunk shows, runway shows, and advertisements in fashion magazines to reestablish its reputation of prestige and exclusivity. By 1997 retailers such as Bloomingdale's, Neiman Marcus, Saks, and golf pro shops were carrying the product again.

As the company evolved, so did its products. After World War II it added a women's line, and in 1959 it offered a range for children. In 1951 the company began to produce the shirt in a variety of colors in addition to its standard white. The company added track suits in 1966, sport bags in 1981, and athletic and deck shoes starting in 1985. René Lacoste's other tennis innovations such as string dampers and the first steel racket led to the 1989 partnership of Dunlop France, Sumitomo Rubber Industries, and Lacoste to develop and distribute technical tennis and golf product lines.

In addition, the company licensed its name to several products. In 1968 it began its long relationship with Jean Patou when it licensed Lacoste Eau de Toilette. Jean Patou also produced the fragrances Land in 1991 and Sport and Booster in 1994. Other licensing agreements include L'AMY for

optical frames signed in 1981, Pentland for leisure shoes in 1991, and Roventa-Henex and Vimont for watches in 1993.

Lacoste opened its first boutique in 1981 in Paris. During the 1990s it opened boutiques in Bombay, New Delhi, Madras, Mexico, Morocco, Palm Beach, Russia, and Madison Avenue in New York. In 1996 it unveiled its Internet site. Through Lacoste's nearly seventy-year history, it has evolved from one man's attempt to improve tennis, to a status symbol during the age of conspicuous consumption, to an overexposed and over-licensed logo in the late 1980s. Finally it has been reborn as a status symbol. *See also*: Ralph Lauren; Sears Roebuck and Company.

Website: http://www.lacoste.fr

REFERENCES

Jenkins, Maureen. "Brands That Ruled the 80s Try to Regain Cachet." *Chicago Sun-Times* (December 8, 1996).

O'Connell, Vanessa, and Suzanne Vranica. "What to Do with a Brand Gone Bland." *Wall Street Journal* (December 14, 2000): B14

Torkells, Erik. "Classic: Lacoste Benefit Analysis." *Fortune* 142 (October 2, 2000): 308

A.T.P.

Christian Lacroix

B. May 16, 1951

Birthplace: Arles, France

Awards: Dé d'Or Award (Golden Thimble), 1986, 1988
 Council of Fashion Designers of America Award, 1987

Christian Marie Marc Lacroix never intended to be a fashion designer. He studied art history at Paul Valery University, in Montpellier, and museum studies at the Sorbonne, in Paris, from 1973 to 1976 where he wrote his dissertation on seventeenth-century costume. However, his love of costume drew Lacroix into the world of fashion instead of museum curatorship.

Lacroix first entered the fashion realm as a freelance fashion sketcher in 1976. Two years later, in 1978, he landed an apprenticeship with Hermès, and in 1980, he became a design assistant to Guy Paulin. From this position Lacroix caught the attention of the House of Patou. The House of Patou, established in 1914, was in desperate need of new life. In 1981 Lacroix was brought in as designer and artistic director for the house, and he brought excitement and, ultimately, controversy to the stoic institution.

After six years, Lacroix unexpectedly broke his contract with the House of Patou to found his own house with the financial backing of Bernard Arnault. The House of Patou claimed that Lacroix's abrupt departure made it impossible to sell his final collection, sued for breach of contract in 1987, and won a $6.5 million judgment against Lacroix.

Embroiled in controversy, the House of Lacroix, founded in 1986, showed its first collection in July 1987. Despite the conflict with Patou, Lacroix was an immediate success. His collection brought new life to couture. His primer collection featured brightly colored crinoline dresses with Louis XIV powdered wigs. Lacroix's designs embody the spirit of true couture. He draws on his historic costume background to develop decadent garments in luxurious fabrics which are the epitome of conspicuous consumption. He incorporates baroque style and elegance into extravagant one-of-a-kind concoctions with fur, lace, brocade, embroidery, and beadwork.

The attention Lacroix received from his couture collection allowed him to expand into other product lines and licensing agreements. In 1988 he launched his first ready-to-wear collection, which was licensed to Mendes in 1992. This line was followed by a menswear collection (1988), Bazar de Christian Lacroix (1994) licensed to Paciflor, and Jeans de Christian Lacroix (1996) licensed to Gilmar. Other lines developed by Lacroix include hosiery, handbags licensed to Louis Vuitton, men's eyewear licensed to Carrera Eyewear, clothing patterns licensed to Vogue Patterns (1988), and men's ties and women's scarves licensed to Mantero. By 1989 Lacroix had seven accessory lines, which were an important component to the "Lacroix look." Three of his jewelry collections, The Signature Group, Calucha, and fer forge, were launched in 1996 under license to the Monet Group. Lacroix also expanded into designing china, tablecloths, cutlery, and crystal for Christofle and home textiles for Nobilis.

These secondary lines play a key role in the economic stability of the House of Lacroix. Since its inception, the house has posted annual losses which have accumulated to approximately $50 million. The expansion to other product lines and licensing agreements helps to keep the house standing, but the introduction of the C'est La Vie perfume in 1991 brought additional financial disaster to Lacroix. Instead of using a perfume distributor, Lacroix launched the scent himself. A novice to the perfume business, Lacroix was not aware of the difficulties in marketing a new scent, and he incurred an additional $30 million in debt before canceling the perfume. In 1999 Parfums Christian Dior, which owns the Lacroix fragrance division, signed a licensing agreement with Inter Parfums to produce future Lacroix fragrances. In 1993 Lacroix was acquired by Moët Hennessy–Louis Vuitton (LVMH), but the house has yet to stabilize financially, calling to question how long the house will retain any financial backing.

In the midst of the 1980s recession, Christian Lacroix opened his couture

house, the first designer to do so since Yves Saint Laurent in 1961. With the opening of his house, Lacroix brought glamor and elegance back to couture. Lacroix's path has not always been an easy or a profitable one, but he continues to generate excitement in what many view as a dying institution. *See also*: Hermès; Jean Patou; Louis Vuitton; Yves Saint Laurent.

Website: http://www.christian-lacroix.fr

REFERENCES

Deeny, Godfrey. "Lacroix Banking on Bazar, Jeans." *Women's Wear Daily* 169 (April 6, 1995): 14–16.
Mulvagh, Jane. *Vogue History of 20th Century Fashion*. New York: Viking, 1988.
Weisman, Katherine. "Lacroix's Survival Strategy." *Women's Wear Daily* 166 (December 14, 1993): 6–8.

A. K.

Karl Lagerfeld

B. 1939

Birthplace: Hamburg, Germany

Awards: Second Prize, International Wool Secretariat Design, 1954
Neiman Marcus Award, 1980
Bath Costume Dress of the Year Award, 1981
Golden Thimble Award (Dé d'Or), 1986
Council of Fashion Designers of America Award, 1991
Fashion Footwear of America Award, 1991

He has been referred to as Kaiser Karl, the Don Corleone of the fashion industry. He seldom appears without a fan in one hand and a Diet Coke in the other, always with his dark glasses, signature pony tail, and white powdered hair. He has houses in Monte Carlo, Hamburg, Brittany, and Paris. He tries to skim one book every day and reads newspapers in four languages, often while listening to music ranging from rock to classical. He is an accomplished illustrator, book critic, and, above all, probably the most famous and influential designer of the twentieth century, producing as many as sixteen collections a year. He is the highly skilled and famously disciplined Karl Lagerfeld.

His appreciation for all things finer—from fine paintings to fine furniture—began when he was quite young. Raised in a German château by wealthy and accomplished older parents who doted on him, he was encouraged to try anything that appealed to him—painting, sketching, pho-

tography—and he was particularly interested in clothing. When Karl was fourteen, the family moved to Paris where, at the age of sixteen, he designed a coat that won second prize from the International Wool Secretariat. (The young Valentino had also recently won a competition sponsored by the same organization.) This recognition reaffirmed his determination to work in the fashion business.

His first position was as design assistant to Pierre Balmain who took Lagerfeld's award-winning coat and put it into production. Four years later, in 1958, he became an art director for Jean Patou, and in 1964 he was commissioned by the House of Chloé, as a freelance designer and eventually became its principal designer. As a freelancer, he also worked on the collections of Charles Jourdan, Max Mara, Krizia, Valentino, and Ballantyne. One of Lagerfeld's most famous collaborations was with Fendi, the Italian leather and fur house established in 1918 by Adele Casagrande. The five Fendi daughters had been designing the luxurious leather and fur collections when Lagerfeld was added to the team in 1966. Lagerfeld created fur collections in exciting new colors, and in furs such as squirrel and ferret, which were previously considered unsuitable for fine coats. His dramatic and innovative treatment of fur brought the Fendi name to the attention of the fashion world.

Undoubtedly his most famous contribution to late twentieth-century fashion was his revival of the House of Chanel. In 1983 Lagerfeld was brought on as "consultant to the couture" and in short order made Chanel the most talked about name in Paris and the world. He reintroduced the Chanel suit of the 1950s by cleverly manipulating the traditional Chanel logo, hiking up skirts, and piling on the gold chains, giving the clothing a sense of humor and newness, thereby attracting a whole new generation.

While working for Chloé, Fendi, and Chanel simultaneously, Lagerfeld found time to develop and license his own ready-to-wear line, Karl Lagerfeld, and his diffusion line, KL. In addition, he has, throughout his career, developed enduring fragrances including Sun Moon Stars, Farenheit, KL, Lagerfeld, and, of course, Chloé, one of the best-selling perfumes in the world. Other licensing agreements include those with Eve Stillman, in the United States, for the production of lingerie; Charles Jourdan S.A., in France, for shoes; and Hutschenreuter, in Germany, for fine china.

Lagerfeld is an expert at creating light, fluid clothing by eliminating linings and extra seaming, which is exactly what he did at Chloé, while maintaining the floating feminine look for which the house was known. He is also a genius at combining the elements of street style with the elegance of haute couture. It is his ability to mix the quirky with the classic that has brought him such notoriety, like pairing tulle skirts with motorcycle boots and leather jackets, virtually changing the direction of modern fashion.

Lagerfeld has said many times that fashion should not be taken too seriously, claiming that it is always changing. "The things you hate one day,

you are very likely to love another," Lagerfeld once told an interviewer. "Fashion is a reflection of the moment." Certainly, Karl Lagerfeld has spent each moment wisely. *See also*: Valentino; Chloé; Gabrielle Bonheur "Coco" Chanel.

Website: http://www.chanel.com

REFERENCES

Collins, Nancy. "Scent of a Man." *Mirabella* 88(3). (November 1994).
Lagerfeld, Karl. *Karl Lagerfeld*. West Germany: Benedikt Taschen Verlag GmbH, 1990.
Lane, Anthony. "The Last Emperor." *New Yorker* 70 (November 7, 1994): 82
Ball, Joanne Dubbs. *Costume Jewelers: The Golden Age of Design*. West Chester Pa.: Schiffer, 1997.
Stegemeyer, Anne. *Who's Who in Fashion*. New York: Fairchild Publications, 1996.

<div align="right">*S. B.*</div>

Kenneth Jay Lane

B. 1932

Birthplace: Detroit, Michigan

Awards: Tobe Award, 1966
 Coty American Fashion Award, 1967
 Harper's Bazaar International Award, 1967
 Neiman Marcus Award, 1968
 Swarovski Award, 1969
 Brides Magazine Award, 1990

Even before 1963, when he began the company that bears his name, Kenneth Jay Lane recognized that every woman likes a little sparkle. "Style," the king of costume jewelry has proclaimed, "has little to do with money and expensive possessions. Attitude makes all the difference."

Perhaps he developed this belief while working in the art department at *Vogue* or while acting as fashion coordinator for Delman Shoes, in New York, or while working as an associate designer for Christian Dior, in Paris. But it was while creating a collection for Scaasi that he developed a technique for pasting flat-backed rhinestones on shoe ornaments and began to experiment with making costume jewelry, and Kenneth Jay Lane, Inc., was born.

Lane has always believed that costume jewelry can be as beautiful and desirable as real jewelry if it is executed with originality and perfection: "I want to make *real* jewelry with *not real* materials" (Martin, p. 236). His

work has been praised from the beginning, featured in fine specialty stores such as Neiman Marcus, and worn by devoted customers including Barbara Bush whose strands of faux pearls by Lane have become her trademark.

Among his many contributions to the fashion world are special stones for use in costume jewelry which he developed. They actually rival the color of true rubies, emeralds, and sapphires. In addition, his reintroduction of the Art Deco jewelry style during the 1970s and 1980s evoked a renewed interest in the look of that era which has continued to the present. His creations have been featured on several television shows and in the Metropolitan Museum's Costume Institute exhibitions orchestrated by Diana Vreeland, whose own personal collection includes many of Lane's designs. As of this writing, his designs are distributed through his own boutiques as well as department and specialty stores around the world. *See also*: Christian Dior.

REFERENCES

Ball, Joanne Dubbs. *Costume Jewelers: The Golden Age of Design*. West Chester Pa.: Schiffer, 1997.
Stegemeyer, Anne. *Who's Who in Fashion*. New York: Fairchild Publications, 1996.

S. B.

Jeanne Lanvin

B. 1867

D. 1946

Birthplace: Brittany, France

Awards: Chevalier de la Légion d'Honneur, 1926
Officier de la Légion d'Honneur, 1938
Dé d'Or Award (Golden Thimble), 1990, 1991

Jeanne Lanvin entered the fashion business in 1890 by opening a millinery house. However, it would not be her headwear designs that would launch her career. In addition to designing headwear, Lanvin was designing charming, youthful garments for her daughter. These creations were noticed by other women, and in 1909 she converted her millinery business to a custom-made children's clothing business. Soon, the composition of Lanvin's business would change again. The clientele who had patronized her for garments for their children also sought her out for garments for themselves. The designs Lanvin developed for these women had the same youthful exuberance as her children's wear, with soft colors and feminine embroidery details.

Lanvin is perhaps best known for her *robe de style*, an adaptation of the eighteenth-century pannier ensemble which she introduced in the early 1920s. Like other designers in the 1920s, Lanvin was creating ensembles for the new, active woman. However, the tea gowns and dinner pajamas she introduced all still reflected her characteristic youthful styling, with romantic, feminine colors and details. During the 1920s and 1930s, Lanvin began to expand her business by adding a menswear line (1926), and the fragrances My Sin (1925), Arpège (1927), Scandal (1931), Runeur (1934), and Pretexts (1937).

After her death in 1946, Lanvin's daughter, Mari-Blanche de Polignac, ran the design house until 1958, at which time other designers were brought into the house. As one of the oldest existing fashion houses, the House of Lanvin has witnessed a succession of talented couture, ready-to-wear, and menswear designers. Through these designers, the House of Lanvin has continued to expand its product offerings to include sportswear, fur, accessories, ready-to-wear, knitwear, cosmetics, and additional fragrances. However, this progression of designers also resulted in conflicting design direction because each designer brought his or her own unique style to the house. Ultimately, the couture line was canceled in 1993, and the house switched its focus to women's and men's ready-to-wear. During the last fifty years, the House of Lanvin has been home to such designers as Antonio del Castillo (1950–1963), Jules-François Crahay (1963–1984), Maryll Lanvin (1985–1989), Claude Montana (1990–1992), Eric Bérgère (1989–1991), Dominique Morlotti (1992–1995), and Ocimar Versolato (1995–1997).

Since 1998 Cristina Ortiz, former design director at Prada, has been the head designer for the House of Lanvin. The House of Lanvin still continues to be known for clothing with "discreet elegance." One of the most prestigious labels in the fashion world, it produces contemporary, sophisticated designs which are the epitome of French elegance for men and women. *See also*: Claude Montana.

REFERENCES

D'Aulnay, Sophie. "Lanvin: There Is a Doctor in the House." *Daily News Record* 24 (May 16, 1994): 14–17.
———. "The Plan for Lanvin." *Daily News Record* 25 (February 13, 1995): 44–47.
Deeny, Godfrey. "Lanvin Signs Versolato as Designer for RTW." *Women's Wear Daily* 170 (July 6, 1995): 2–4.
Milbank, Caroline Rennolds. *Couture: The Great Designers*. New York: Stewart, Tabori and Chang, 1985.
Murphy, Robert. "Waking Up the Men's Luxury Market." *Daily News Record* 29 (September 24, 1999): 28.

A. K.

Estée Lauder (Josephine Esther Mentzer)

B. 1908

Birthplace: Queens, New York

Awards: Neiman Marcus Award for Distinguished Service in the Field of Fashion, 1962, 1992

Outstanding Woman in Business, U.S. Business and Financial Editors, 1967

Spirit of Achievement Award, Albert Einstein College of Medicine, 1968

Cosmetic Executive Women's President's Award, 1989

Living Legend Award, American Society of Perfumers, 1994

Fifi Award for Perennial Success, Fragrance Foundation, 1994

Fifi Awards, Fragrance Star of the Year and Best Women's Fragrance Package, Fragrance Foundation, 1995

Hers is a true American success story—the daughter of immigrants, born in Queens, New York, whose uncle, a chemist by some accounts, a dermatologist by others, helped her mix up a batch of skin creams which she started selling in beauty shops and beach clubs. And sell she did. "Ambition," her son Leonard has often said, is the one word that best describes the force behind his mother's success.

Estée Lauder virtually transformed the beauty business, creating a company which became one of the world's leading manufacturers and marketers of beauty products. Her career began in 1946, when she and her husband, Joseph Lauder, founded the company, offering just four products: Cleansing Oil, Crème Pack, Skin Lotion, and All Purpose Crème. In 1948 she convinced Saks Fifth Avenue to give her some counter space, and once there, she used the personal sales approach for which she became famous. In fact, after forty years in business, she would still turn up at Saks on a Saturday morning to show the sales staff how to work with customers. One of her most brilliant sales-building techniques was to give out free gifts, such as small product samples, a promotional tool now used by every notable company.

Estée Lauder was not one who followed trends; rather, she was a believer in the power of feminine beauty, and this has always been reflected in her products, her packaging, and her advertising. She was, however, an innovator, and she devised new concepts, like the introduction of the first men's skin care line by a woman's cosmetics company, Clinique's Skin Supplies for Men. In addition, she felt no woman should be denied the opportunity to feel and look as beautiful as possible. She often told the story of a customer, who was ignored by the sales staff at a certain store, because she was deemed unlikely to make a purchase. Estée Lauder approached the

woman, offering the special kind of attention for which she was known. The next day, her new customer returned, not only for more products, but with a large group of friends, all of whom wanted to buy whatever Lauder suggested.

By the end of the twentieth century, Estée Lauder Companies, Inc., was selling products in more than 120 countries. The brand was first introduced internationally in London's famous department store Harrod's, in 1960, and made available in Hong Kong in 1961. The company made world headlines when its products were first offered in the Soviet Union in 1981 and again when its very first freestanding boutique opened in Budapest. Today Estée Lauder products are available throughout Europe, Asia, Africa, and the Middle East, along with its impressive family of prestige brands, which include Aramis, Clinique, Prescriptives, Origins, La Mer, M.A.C., Bobbi Brown Essentials, Stila, Aveda, Jo Malone, and Bumble and Bumble.

The company is also the licensee for the beauty products and fragrances of Donna Karan, Timmy Hilfiger, and Kate Spade. Estée Lauder went public in 1995, with Lauder family members maintaining their places in the business, including son Leonard, chief executive officer since 1982, and granddaughter, Aerin, head of creative product development. Today it is estimated that the Estée Lauder Companies control approximately 50 percent of the cosmetics industry in U.S. department stores. *See also*: Donna Karan; Tommy Hilfiger.

Website: http://www.elcompanies.com

REFERENCES

"The Estee Lauder Companies, Inc." Available from http://www.elcompanies.com/company/timeline/history3.html. Accessed November 15, 2000.

Horyn, Cathy. "Estée's Heirs." *Harper's Bazaar* 486 (7) (September 1998).

Mirabella, Grace. "Beauty Queen: Estée Lauder." Available from http://www.time.com/time/time100/builder/profile/lauder.html. Accessed January 10, 2000.

Traub, Marvin. *Like No Other Store—the Bloomingdale's Legend and the Revolution in American Marketing*. New York: Times Books, 1993.

<div align="right">*S. B.*</div>

Ralph Lauren (Lifschitz)

B. October 14, 1939

Birthplace: Bronx, New York

Awards: Coty Award, 1970, 1973, 1974, 1976, 1977, 1981, 1984
 Neiman Marcus Distinguished Service Award, 1971
 American Printed Fabrics Council Tommy Award, 1971
 Council of Fashion Designers of America Award, 1981
 Coty Hall of Fame Award, 1981
 Gentlemen's Quarterly Manstyle Award, 1982
 Neckwear Association Special Achievement Award, 1985
 Retailer of the Year by the Council of Fashion Designers of America,
 1987, 1992
 Council of Fashion Designers of America Lifetime Achievement Award,
 1992
 Woolmark Award, 1992

Some describe Ralph Lauren as a stylist rather than a designer, but he has contributed more to the marketing of fashion than anything else. He became one of the first designers to market the lifestyle behind a fashionable image. Whether it was polo grounds or the frontier west, Lauren captured a glamorous vision of the lifestyle and enticed consumers to purchase clothes that fit it.

Lauren's origins were very different from the lives of leisure and luxury exemplified in his advertisements. He was born in the Bronx and attended the City College of New York for two years. He joined the U.S. Army reserves, worked at Brooks Brothers, and worked for two glove makers.

Wide ties were Lauren's first fashion statement. When he began selling Abe Rivetz's conservative ties, he tried to convince the company to sell wider ties. Another company, Beau Brummell, was more receptive to the wide tie idea and hired Lauren to run its modern tie division in 1967. He named the division Polo Fashions.

In 1968 Lauren was ready to strike out on his own. He purchased the name Polo Fashions and the remaining stock of ties from Beau Brummell. After borrowing money from Norman Hilton, he established a menswear company called Polo by Ralph Lauren.

From the beginning, he connected the company's image with wealth and leisure. He sold high-quality fashions with an Ivy League look. His timing was impeccable; just as clothes were becoming more casual, he introduced clothes that were a formal type of casual which evoked images of relaxing gentlemen at a country estate. His designs epitomized classic nostalgia and featured elements of 1920s fashion. His interest in 1920s fashion peaked in 1974, when he designed the men's costumes for the film *The Great Gatsby*.

In 1971 he introduced Ralph Lauren women's wear at his in-store shop at Bloomingdale's. It was a line of tailored clothing that echoed his menswear. Although self-assured women such as Katherine Hepburn and Greta Garbo were the original inspiration for the line, Diane Keaton's clothing in *Annie Hall* (1977) personified and popularized Lauren's women's wear.

In the 1970s, his women's collections included trousers, Shetland sweaters, tailored shirts, walking shorts, trench coats, and pajamas.

By the late 1970s, Lauren seemed unstoppable. He published his first catalog in 1976 and introduced Polo for Boys in 1978; his version of the tennis shirt was so popular that the style became commonly known as the Polo shirt. In 1978 he launched his first fragrances, Polo for men and Lauren for women.

The American West had always captured Lauren's imagination. In 1978 he introduced the "Prairie look," which featured layered petticoats, into his women's line. His fascination with the West also prompted him to introduce Chaps, a moderately priced line which evoked the image of cowboys; Polo continued to epitomize the Ivy League look.

Lauren introduced the fragrance Chaps to capitalize on the clothing line. In 1980, the year it was introduced, sales of the fragrance amounted to $14 million. Like the clothing, the fragrance was marketed as an inexpensive version of men's Polo. While Polo was sold through department stores, Chaps was sold through chain drugstores. Although Lauren was targeting a different market with his Chaps clothing and fragrance, he remained successful by sticking to his formula of marketing a lifestyle.

Lauren used his lifestyle strategy in his stores as well. Jerry Magnin opened the first Polo store on Rodeo Drive in Beverly Hills, California, in 1971. Since Magnin sold Polo exclusively, Lauren allowed him to forego licensing fees. From the first store, Lauren was involved in the visual display. Always wanting to create his lifestyle image, he carefully selected fixtures and props to support and enhance that image. His flagship store in New York, the Rhinelander Mansion on Madison Avenue, features a fireplace, sculling oars, cricket bats, and even an Old World scent. Even department store boutiques are required to follow the company's rigid merchandising specifications. By 1996 there were more than 170 Polo stores worldwide.

Polo experienced great success during the 1980s. Lauren's high-quality upper-crust designs appealed to the status-conscious consumers of the decade. He continued to use his formula of marketing a lifestyle to win consumers.

Lauren introduced new themes to his designs, but they all referenced a nostalgic view of the past. The women's line evolved from the Old West to the New West. In 1981 he unveiled the Santa Fe look complete with concha belts, prairie skirts, and muted Southwestern colors. In 1982 his collection followed a romantic theme, featuring lace, velvet, and Victorian blouses accented with cameo jewelry.

In 1983 he launched the Ralph Lauren Home Collection. Unlike other designers, who simply selected patterns and colors for their home collections, Lauren created collections that revolved around themes. Consumers could chose from a diverse array of themes, like the Serape, English Coun-

tryside, or Safari collections. By 1987 the 2,200-item home collection list included bedding, towels, table linens, rugs, robes, and furniture. More recently, the company added an interior paint line.

In the 1990s, Lauren began to move away from designing historically inspired clothes. In an effort to attract younger consumers, he launched Polo Sport in 1992, Polo Jeans Co. in 1996, and RLX, an extreme sportswear line, in 1999. Although these lines were successful, they began eroding the company's reputation for updated classics which allowed a consumer to purchase part of a lifestyle. By 1999 Lauren had closed nine stores, and the stock price was falling. At the end of the 1990s, the world's most successful designer seemed to be falling off his pedestal.

In 1996 Lauren had retail revenues of $5 billion. The company's net sales were $900 million, while competitor Tommy Hilfiger's net sales were only $478 million. Most of Lauren's profits come from licensing. Currently, the company produces all of its products through independent contractors, and it has twenty-six licensees and about 180 contract manufacturers. Jones Apparel Group and Warnaco, which produce sportswear, are two of the company's largest partners. The following is a selected list of current licensees: Pietrafesa (men's tailored clothing), Peerless (Chaps men's clothing), Sun Apparel (Polo jeans), Cosmair (fragrance), Rockport/Reebok (footwear), WestPoint Stevens (sheets, towels, and bedding), Sherwin-Williams (paint), and Reed and Barton (flatware).

Early in his career, Lauren used licensing as a means to realize his designs. In 1973 he showed his first licensed shoe collection, which was produced by Kayser-Roth. In 1975 Hishiya Co., Ltd., acquired the Japanese rights to distribute Polo ties, making it Polo's first Japanese licensee. L. Greif became the licensee for the Chaps collection in 1974, and Lauren licensed a line of Vogue patterns. In one of his most ambitious licensing ventures, Lauren teamed up with The Gap, Inc., to produce Polo Western wear. In 1979 the line debuted in department and specialty stores, but it was canceled within a year because the two companies disagreed over how to market it.

Today the company is named Polo/Ralph Lauren, as it has been since the name was changed in 1987. In 1997 the company went public, and in that year, 52 percent of the business was menswear. Fragrances, housewares, accessories, and women's wear each constituted 10 percent of the sales, and children's apparel made up the remainder. *See also:* Tommy Hilfiger; The Gap, Inc.

Website: http://www.polo.com

REFERENCES

Caminiti, Susan. "Ralph Lauren: The Emperor Has Clothes." *Fortune* (November 11, 1996): 80.
"Ralph's Rough Ride." *Time* 153 (March 15, 1999): 68.

Tractenberg, Jeffery A. *Ralph Lauren: The Man Behind the Mystique*. Boston: Little, Brown, 1988.

 A.T.P.

∂❧❧∂

Hervé Léger (Hervé Peugnet)

B. 1957

Birthplace: Bapaume, France

Léger's "bender dresses" are designed to perfect the female body, and that they do. Made of bands that stretch and mold, the creations of Hervé Léger are often compared with those of Azzedine Alaïa, the well-known "King of Cling." Léger's sensual creations are body conscious, sophisticated, and carefully designed for each client from narrow fabric bands of Lycra and spandex, which are hand cut, sewn, and made especially for the woman who is not shy about her femininity.

Having started his design career as a hat maker, he mastered the difficult techniques involved in creating custom hats, which must be perfectly crafted, and he uses this ability in the execution of his made-to-order garments. Like a milliner, Léger first takes the client's measurements. He then makes a wood and cloth mannequin with her exact dimensions and constructs the dress on the form, with the best features of the client in mind. Having designed swimwear for both Fendi and Coco Chanel, he makes use of that knowledge, as well. His dresses are decidedly extensions of swimsuit shapes which are glamorous in their simplicity and completely without ornamentation. He also worked for Jeanne Lanvin, Chloé and Charles Jourdan before debuting the first collection under his own name in 1992.

Clearly Léger intends to elevate the female form to goddess-like proportions, accentuating its beauty by sculpting it to perfection. One of the finest examples of his work is a wedding dress of white elastic ribbon with tulle sleeves and train, an ultra-flattering ultra-feminine confection for the woman who does not wish to hide her sexuality. The House of Léger is currently planning the introduction of a new fragrance to be distributed in the United States of America through Giorgio of Beverly Hills.

In 2000 Hervé Léger was fired from the company bearing his name by its new owners. In late summer of the same year, he changed his name to Hervé Leroux and, as of this writing, is designing a line for the famous hosiery and bodywear company Wolford. *See also:* Azzedine Alaïa; Gabrielle Bonheur "Coco" Chanel; Jeanne Lanvin; Chloé.

REFERENCES

Martin, Richard, ed. *Contemporary Fashion*. Detroit: St. James Press, 1995.
Szish, Katrina. "Index Scoop." *Vogue* (September 2000): 652

S. B.

☙❧

Judith Leiber

B. 1921

Birthplace: Budapest, Hungary

Awards: Coty American Fashion Critics Award, 1973
 Neiman Marcus Award, 1980
 Handbag Designer of the Year Award, 1992
 Council of Fashion Designers of America Award, 1993
 Council of Fashion Designers of America Lifetime Achievement Award,
 1994

Is it art or is it fashion? Those who admire the jeweled minaudières, or handbags, of designer Judith Leiber would definitely say it is both, and they would also point out that the technical excellence evident in each witty and wonderful piece, with shapes ranging from Buddhas to butterflies, is incomparable.

The daughter of a jeweler and a homemaker, she was born Judith Peto. Her parents hoped she would become a chemist and a successful cosmetologist, as was her cousin in Romania. The month she was to begin classes in England, World War II broke out. As a Jew, she was not allowed to take advantage of any professional opportunities, so she joined an artisan's guild and began her training as a maker of handbags. Throughout the war, she worked her way up from apprentice to master, and learned every stage of making a handbag, from cutting to sewing, from framing to polishing.

Fate intervened when the Peto family faced deportation to the concentration camps. They were able to obtain a special pass through a distant friend, which guaranteed their safety. By the end of the war, young Judith had all the skills needed to become an accomplished handbag maker, and she began crafting clever designs using whatever materials were available, including drapery trim.

Judith Peto became Mrs. Gerson Leiber in 1945 and left Budapest for Brooklyn, her husband's hometown. In New York, the young bride worked in a succession of handbag companies and eventually secured a job with a firm which rewarded her talents with successive promotions. After fourteen years with the company, in 1963, she and her husband opened their own business, and the rest is handbag history.

All Leiber bags come in a flannel pouch and contain a small, round mirror and a little, tasseled comb. Among the skins used in many of the day bags are karung snakeskin, lizard, goatskin, calfskin, ostrich, and suede. The frames are all enhanced with semiprecious stones such as lapis, onyx, garnet, carnelian, and hematite. The metal evening bags are made of brass, gold plated and lined in kidskin. The beading of each bag with crystals and rhinestones requires the most painstaking handwork, and these are the bags for which Judith Leiber is best known. Hinges, locks, screws, and any other necessary hardware are all put on by hand as well.

It is no wonder, then, that these little works of art command as much as $10,000 and are collected by famous women around the world from Beverly Sills and Mary Tyler Moore to Nancy Reagan and Barbara Bush. From pigs to bears, from eggs to fans, the whimsical minaudières and art-inspired day bags of Judith Leiber are treats to be treasured for generations. Although she retired in 1998, the company continues in the Leiber tradition, making dazzling handbags in whimsical shapes, all featuring exquisite detailing. Many of the original wearable art pieces are in the permanent collections of the Smithsonian Institution and the Metropolitan Museum of Art for all to enjoy.

REFERENCES

Goodman, Wendy. "To Have and to Hold." *Harper's Bazaar* (November 1994): 68
Monget, Karyn. "The Status Bag Lady." *W* (March 1998): 256
Nemy, Enid. *Judith Lieber: The Artful Handbag.* New York: Harry N. Abrams, 1995.
Wadyka, Sally. "Small Wonders." *Vogue* 185 (March 1995): 233

<div align="right">*S. B.*</div>

Lerner New York

See The Limited, Inc.

The Limited, Inc.

The Limited was the biggest success story in the history of retailing. Throughout the 1980s, The Limited grew at an unprecedented rate. Sales rates and stockholder equity climbed at a rate of 46 percent per year, with earnings increasing 63 percent annually. In 1984 The Limited sold over

200 million garments, which averages out to three for every woman between the ages of fifteen and fifty-five. By 1985 The Limited controlled 5 percent of the $50 billion per year women's clothing business. So what happened to this retailing giant? Rapid expansion and market saturation, combined with poor-quality products and lack of brand image, eroded the customer base.

Leslie Wexner was studying to be a lawyer at Ohio State University in 1961 when he decided he would rather work at his family's store in Columbus, Ohio. Wexner's father, a Russian immigrant, had been a manager for the Miller-Wohl clothing store chain when he decided to open his own store, which he named Leslie's, after his son. Wexner and his father consistently disagreed on how to run the family business. Wexner wanted to focus on women's sportswear, which sold faster than career wear or formal wear. Wexner's father believed a clothing store needed to have a diverse range of products to survive. Two years later, Wexner borrowed $5,000 from his aunt and opened his own store in Columbus which offered a "limited" selection of clothing. The Limited carried only moderately priced women's sportswear. Sales the first year were $165,000, vastly surpassing his father's business. His father closed Leslie's, and joined his son as chairman of The Limited and, in 1969, with six stores, the company went public.

In 1970 Wexner's first annual report predicted that "The Limited would become the largest retailer of women's specialty clothing in America." By 1976 Wexner was on his way to realizing that boast with 100 stores. Wexner was one of the first businessmen to engage in niche retailing. The Limited marketed to the emerging baby-boom generation with moderately priced jeans, pants, skirts, and tops. As his customer base aged, The Limited's merchandise mix began to incorporate career clothing. The Limited was also one of the first vertically integrated stores. Vertical integration allowed Wexner quickly to produce private-label goods inexpensively through a network of foreign manufacturers. The rapid response inventory and distribution strategies developed by Wexner allowed The Limited to respond to changes in fashion trends faster than their competition. The third key to The Limited's success was store presentation. The design of the storefronts and merchandise display reflected the brand image Wexner wanted to project. The Limited store interiors were modern, captivating, and glamorous.

The Limited's success in the 1980s came from their product development philosophy: "We don't set the style, we follow it. We try to be fast followers (Edelson)." Wexner traveled the world looking for hot products and fashion trends which could be knocked off at lower prices and sold in large volumes. The pivotal product in The Limited's success was the Forenza sweater of 1984. Wexner noted that the "preppy look," which had dominated women's fashions for the past two years, was reaching a saturation point, but what would be next? The status-conscious 1980s was a time

when Americans craved the sophisticated, sleek, modern look of European products. Wexner invented Forenza, an Italian sounding word, and decorated the interiors of his stores with Italian flags and slogans. He declared Forenza "official . . . accept no substitute." And women agreed. The shaker-knit Forenza sweater became the most successful sweater in American retailing history, selling more than 3 million units at $29 a piece. By 1985 The Limited appeared to be "limitless" in its market domination.

With The Limited installed as the dominant retailer in the twenty-to-thirty-five-year-old women's sportswear market niche, Wexner was ready to capitalize on other marketing niches. In 1980 Wexner added a new division to The Limited, Inc.: Limited Express. Express was targeted at females from fourteen to twenty-five, who wanted fashion-forward looks that mirrored the latest runway trends. The stores were bold and bright with whimsical fixtures. Express was another success for Wexner, and within three years the division had opened 161 stores. In 1982 Wexner purchased the clothing chain Lane Bryant. Lane Bryant, a leader in plus-size fashions, had lost touch with its core customer. Wexner revitalized the chain by upgrading the apparel to moderately priced fashionable sportswear targeted to the younger plus-size customer. Wexner's next acquisition was the 800-store Lerner New York chain in 1984 from Rapid-American Corporation. The store carried a vast assortment of budget-priced merchandise targeted to women between the ages of twenty and thirty. The capstone to The Limited, Inc., women's business came with the 1985 acquisition of the prestigious Henri Bendel department store. Henri Bendel was originally founded in 1896 as a hat shop, but later became an upscale retailer of women's bridge and designer fashions. The Bendel acquisition put The Limited, Inc., on the same playing field as Bergdorf Goodman, I. Magnin, and Neiman-Marcus.

In 1988 Wexner began to expand The Limited, Inc., into menswear. Abercrombie & Fitch, the first menswear acquisition, was positioned to compete with Ralph Lauren, Tommy Hilfiger, and Calvin Klein. The division was so successful that Wexner offered Abercrombie & Fitch as an IPO in 1996. In 1991 The Limited opened Structure, a chain of men's retail stores which provide moderately priced, contemporary, Armani-inspired looks for casual work environments. Next, Wexner expanded The Limited into the sporting goods market, dominated by Patagonia, L.L. Bean and Eddie Bauer, by purchasing the majority interest in Galyan's Trading Company in 1995. Galyan's, opened in 1982 in Indianapolis by Patrick Galyan, provided sporting goods and apparel targeted to the outdoor sports enthusiast.

The Limited also acquired Victoria's Secret, Cacique, White Barn Candle Company, and Bath & Body Works during the 1980s and 1990s and spun them into a separate division in 1995 known as Intimate Brands, Inc. Of the four divisions in Intimate Brands, Inc., Victoria's Secret has experienced

the most phenomenal success. Victoria's Secret boldly positioned itself in malls, with seductive window displays that declared it acceptable for women to purchase sexy, romantic lingerie. In 1999 The Limited created one last spin-off from their company, The Limited, Too. The Limited, Too, Inc., is a 321-store retail chain of trendy girls' clothing. However, unlike the Intimate Brands, Inc., and the Abercrombie & Fitch spin-offs, The Limited, Inc., does not hold ownership interest in The Limited, Too.

By 1985 The Limited consisted of 2,500 stores. The expansions of the late 1980s and early 1990s seem to position The Limited for continued increases in market share and profits. As the 1980s drew to a close, The Limited consisted of 746 stores, Express of 751, and Lerner of 877. In 1990, when other retailers were struggling with the economic recession, The Limited doubled their stock prices and increased earnings by 15 percent to $398 million on $5.25 billion in sales. However, as early as 1987, there were signs of trouble for the women's divisions. The Limited had never developed a strong product development or branding strategy. Throughout the 1980s and 1990s, the company continued to merchandise the stores by knocking off hot sellers, instead of developing brand-specific product lines. Virtually identical products appeared simultaneously in each of the four women's divisions. The identities of each division became confused. There was no consistent design direction. Price points went up and down. The product line switched from sportswear to career wear and back again. The divisions were also plagued by poor-quality merchandise. Boredom and monotony settle over The Limited, Inc.

By 1993 sales at The Limited fell 25 percent, net income dropped 14 percent, and stock prices remained at the 1987 rate. The 5,600-store chain which encompassed thirteen retail divisions was still the largest women's specialty retailer in the United States, but it was suffering from extreme growing pains. To save its core business, The Limited, Express, and Lerner, Wexner decided to close down poorly performing stores, sell off select divisions, and spin off others with IPOs. Between 1995 and 1999, The Limited, Inc., closed over 750 stores from The Limited, Express, Lerner New York, and Henri Bendel divisions. Abercrombie & Fitch, Intimate Brands, and The Limited, Too, were all spun off through highly successful IPOs. Cacique was shut down in 1998, and the majority interest in Gaylan's Trading Company was sold in 1999.

Next, Wexner had to refocus the brand identities of each of the divisions. In 1997 The Limited, Inc., formed a new design studio to redefine the target market for each division and concentrate on cohesive product development. In 1999 The Limited, Inc., devoted considerable resources to advertising their redefined brands. As a company, The Limited, Inc., has never utilized advertising to drive traffic to its stores or differentiate itself in the marketplace. Finally, The Limited, Inc., established new standards for product quality to regain trust with consumers.

In 1999 the Express division of The Limited, Inc., began to see an increase in earnings, while The Limited's sales were flat. Lerner New York, Lane Bryant, and Structure all continued to experience losses. As of 2000, The Limited, Inc., has been reduced to nearly 3,000 stores which generate approximately $4 billion in net sales. From its peak growth of 750 stores, The Limited has been reduced to 443. Despite the long-term brand strategies currently in place, many question whether The Limited division of The Limited, Inc., will survive. The Limited, Express, and Lerner New York continue to canabilize each other's customer bases, and without clearly defined niches, there may not be room in the marketplace to operate all three. *See also*: Ralph Lauren; Tommy Hilfiger; Calvin Klein.

Website: http://www.limited.com

REFERENCES

Cunningham, Thomas. "The Turnaround Is Real." *Women's Wear Daily* (February 23, 2000): 1.

Dentzer, Susan. "Parlaying Rags into Vast Riches." *Newsweek* (December 30, 1985): 30–32.

Edelson, Sharon. "Limited's Search for Identity." *Women's Wear Daily* 170 (November 22, 1995): 8–10.

Edelson, Sharon. "Concern Deepens over Fate of Limited Stores." *Women's Wear Daily* (February 24, 1999): 1.

Ethridge, Mary. "Success Is Fashionably Late for Columbus, Ohio Based The Limited, Inc." *Knight-Ridder/Tribune Business News* (June 2, 1999): 3.

O'Reilly, Brian. "Leslie Wexner Knows What Women Want." *Fortune* (August 19, 1985): 154–60.

Weiner, Steven. "The Unlimited?" *Forbes* (April 6, 1987): 76–80.

Zinn, Laura. "Did Leslie Wexner Take His Eye off the Ball?" *Business Week* (May 24, 1993): 104–8.

———. "Maybe the Limited Has Limits after All." *Business Week* (March 18, 1991): 128–29.

A. K.

The Limited Express

See The Limited, Inc.

LVMH

See Louis Vuitton.

M

Bob Mackie

B: 1940

Birthplace: Monterey Park, California

Awards: Emmy Award, 1967, 1969, 1976, 1978, 1985
 Costume Designers Guild, Fashion Award, 1975
 Oscar Award, 1968, 1972, 1981

Bob Mackie, inspired by visits to the local movie theater, started fanta-sizing about clothing at an early age. Mackie attended college until the age of twenty-two, when he quit to focus on his dream, designing costumes. Mackie's first job was for Frank Thompson, a costume designer at Para-mount Studios, where he sketched costume designs. Mackie was also able to work with renowned costume designer Edith Head from 1960 to 1963.

The exposure and experience Mackie gained by working at Paramount Studios enabled him to land a position as assistant designer to Ray Aghayan for the *Judy Garland Show* on television. The position gave Mackie his first screen credit and launched his career. As a result of his association with the *Judy Garland Show* and Aghayan, Mackie was able to work on the costume designs for the television movie *Alice Through the Looking Glass*, and he created costumes for *The King Family Show* in 1965. He also designed costumes for Mitzi Gaynor's nightclub acts in 1966 and formed a partnership with Ray Aghayan and Elizabeth Courtney to design clothing for Mackie's Beverly Hills boutique.

In 1967 television star Carol Burnette took notice of Mackie's work and hired him to design costumes for her show. Mackie was very successful in

developing costumes that conveyed the characteristics of the various characters in the sketches for *The Carol Burnette Show*. While still designing for *The Carol Burnette Show*, Mackie was asked to design costumes for the *Sonny and Cher Show* and later for the *Sonny and Cher Comedy Hour*. For a decade, from 1967 to 1977, Mackie designed extravagant costumes with lots of beading and embellishment for Cher. Mackie continued to design the wardrobes for *The Carol Burnette Show* until it ended in 1978. After the show ended, Mackie designed costumes for the stars of such film classics as Barbara Streisand in *Funny Lady* (1968), Bernadette Peters in *Pennies from Heaven* (1981), and Dianna Ross in *Lady Sings the Blues* (1972). For each of these productions, Mackie was awarded the Oscar for Best Costuming, and he earned the nickname "Mr. Show Business."

Despite a hectic film and television schedule, Mackie still found time to venture into other areas of fashion design. In 1976 he designed a line of swimwear for Cole of California, in 1979 he wrote a book called *Dressing for Glamour*, and in 1982 he launched a ready-to-wear line with the manufacturer the Re-Ho Group. In 1988 Mackie entered into a licensing agreement with Diamond Bridal Collection, Ltd., to produce a line of bridal dresses. The agreement lasted for three years, until 1991, when Mackie decided to produce the line himself. That same year, Mackie signed an agreement with the Pedre Watch Company to produce his new jewelry line.

Throughout the 1990s, Mackie continued to pursue new ventures and licensing agreements for his designs. Mackie join the QVC craze in 1994 to sell his men's and women's accessories. Also in 1994 Mackie launched a line of men's tailored clothing and a holiday collection through the Men's Apparel Group. The next year, in 1995, Mackie formed licensing agreements with Henry Craig, Ltd., for neckwear and San Siro Shirtmakers for dress shirts, and he entered into a joint venture with Abraham Talass and United Designers to manufacture his evening wear and cocktail line. Mackie also added a coat and suit line for spring 1997 through the manufacturer Lavan Fashion, Inc. By the late 1990s, Mackie had accumulated over fifteen licensing agreements, including perfumes by Riviera Concepts, furs by Corniche Furs, Abraham Talass, Inc., for bridge dresses, Lai Apparel for scarves, Creative Optics, Inc., for eyewear, American Drew for home collection, and several others. He also entered into some licensing agreement for some rather unusual product lines including a collection of Barbies for Mattel, jewelry for the Franklin Mint, Barbie collectible plates, music boxes and figurines for Enesco Corporation, and stationery for Padre Publishing.

In 1999 Mackie decided to convert his ready-to-wear line to a made-to-order line. He also created and developed a line of furniture and lighting fixtures for QVC, where he still promotes his men's and women's accessories and women's blouses. Mackie still continues to do what he is most noted for, creating glamorous costumes for the stars. His work in the the-

ater and the cinema has won him thirty Emmy Award nominations, seven Emmy Awards, and three Oscar Awards.

REFERENCES

Gellers, Stan. "Suit Biz about to Be Hit by the Mackie Trunk." *Daily News Record* 24 (August 1, 1994): 68.
Kerwin, Jessica. "Mackie Is Backie." *Women's Wear Daily* 171 (February 28, 1996): 12.
Milbank, Caroline Rennolds. *New York Fashion: The Evolution of American Style.* New York: Harry N. Abrams, 1989.
Staples, Kate. "Bob Mackie: A Designer Original." *Women's Wear Daily* 161 (February 25, 1991): NY 16(2).
Wray, Kimberley. "Bob Mackie Now Set to Dress the Home." *HFN The Weekly Home Furnishing Network* 72 (August 31, 1998): 6.

N. S.

Mainbocher (Main Rousseau Bocher)

B. October 24, 1890

D. December 27, 1976

Birthplace: Chicago, Illinois

Award: Navy's Meritorious Public Service Citation, 1960

Mainbocher was born Main Rousseau Bocher on Chicago's west side. He studied at the Lewis Institute and the Chicago Academy of Fine Arts until 1909. After moving to New York, he studied at the Art Students' League and worked as a part-time lithographer. He returned to Chicago to attend the University of Chicago in 1911, but the death of his father forced him to leave school and take a job in the Complaints Department at Sears, Roebuck and Company. After studying at the Königliche Kunstgewerbe-museum in Munich, Germany, from 1911 to 1912, he worked as a sketch artist in New York for the clothing manufacturer E.L. Mayer.

World War I called him into service with the American Ambulance Corps and Intelligence Corps from 1917 to 1918. When the war ended, he remained in Europe and took a job as an illustrator for *Harper's Bazaar*. He held that job until 1922 when he was hired as a fashion correspondent and later as the editor of French *Vogue*. Tired of reporting about fashion, in 1929 he bought himself dress forms and, using cheesecloth, taught himself to cut and drape clothes.

When Mainbocher opened his couture house in Paris in 1930, he created an image of an exclusive designer who produced the most elegant and

expensive fashions. His designs were simple, conservative, and always made from the finest materials with excellent workmanship. His experience at *Vogue* taught him to predict what would become fashionable. He used this skill to create popular designs, making him the first American to run a financially successful couture house in Paris.

To preserve his elite reputation, only the top magazines and newspapers were allowed to attend his collections. In an effort to minimize copies of his designs, he required buyers and manufacturers to pay an admission fee (the price of dress) to enter his salon.

Mainbocher's admiration of Madeleine Vionnet is evident in his 1930s bias-cut evening dresses. His 1932 collection of cotton evening dress shocked Paris. Instead of satin and velvet, he chose checked gingham, linen toweling, and cotton piqué to create dramatic, floor-length gowns with trendy halter necklines. This collection solidified his reputation for evening wear.

Predating Christian Dior's New Look, Mainbocher introduced the boned, strapless bodice in 1934. A few years later, he featured garments with tiny, cinched waists, another characteristic of the New Look. These styles were a radical departure from the uncorseted, natural looks popular in the 1920s and 1930s. His use of the corset led to a collaboration with Warner to produce a wasp-waisted corset in 1940.

In 1939, as World War II was starting in Europe, Mainbocher left Paris and established his couture house in New York. At that time his popular, slim silhouette was a perfect complement for wartime regulations which limited the use of materials. He started to present short evening dresses and one of his signature designs, the cashmere evening sweater. These luxurious evening sweaters, worn over dresses, were adorned with beads, lined with silk, and fastened by jeweled buttons. He introduced another practical wartime solution, the "glamour belt," an apron or overskirt adorned with sequins or beads which transformed a plain dress into an evening dress.

Throughout his career, Mainbocher preserved his image of his designs by refusing to license his name or open branches or stores. Until 1950 all of his clothing was made to order. In that year he opened La Galerie, a department in his salon which offered clothes in standard sizes. In 1948 he introduced White Garden perfume, his only nonclothing offering.

While Mainbocher was an expert in creating high-fashion chic, he also created what he called "working chic." This type of chic was expressed in the numerous uniforms he designed. In 1942 Mainbocher volunteered to design the U.S. Navy WAVES uniform, which was also adopted by the Women's Reserve of the Coast Guard. Also, he designed uniforms for the American Girl Scouts in 1946, the American Red Cross in 1948, and the Women's Marine Corps in 1951.

During the 1950s, he continued to produce multiple-use dresses which were transformed by adding a glamour belt, jacket, or cardigan sweater.

In the 1960s, Mainbocher's conservative designs were considered old-fashioned in the new youth-oriented society. In response to changing styles, he offered some evening trouser ensembles in addition to his standards: the long wool coat, box-jacket suits, and glamour belts. He continued designing bias-cut evening dresses reminiscent of his 1930s garments, but the bias-cut's popularity did not return until the 1970s.

By the time Mainbocher retired in 1971, his designs were the most expensive in the country. He retired because his clothes no longer fit the needs of Americans; instead of traditional, costly fashions, Americans were looking for affordable clothes which kept up with the quickly changing trends. *See also*: Sears, Roebuck and Company; Madeleine Vionnet; Christian Dior.

REFERENCES

Lee, Sara Tomerlin, ed. *American Fashion: The Life and Lines of Adrian, Mainbocher, McCardell, Norell, Trigère.* New York: Quandrangle, 1975.

Milbank, Caroline Rennolds. *Couture: The Great Designers.* New York: Stewart, Tabori and Chang, 1985.

Samek, Susan. *Uniformly Feminine: The Fashions of Mainbocher.* Chicago: Chicago Historical Society, November 21, 1992 to April 4, 1993.

A.T.P.

Claire McCardell

B. May 24, 1905

D. March 22, 1958

Birthplace: Frederick, Maryland

Awards: Coty Award, 1943
 Merit Award, Mademoiselle Magazine, 1944
 Dé d'Or Award (Golden Thimble), 1946
 Neiman-Marcus, Distinguished Service in Fashion, 1946
 Sports Illustrated, American Sportswear Designer, 1956
 Coty Hall of Fame, 1958

Claire McCardell was born on May 24, 1905 in Frederick, Maryland. Her father, Adrian Leroy McCardell, was the president of the Frederick County National Bank, and a state senator, and her mother, Eleanore, was born in Jackson, Mississippi, where she was raised to be a proper lady. Her mother was very in tune with American and European fashions, and she kept McCardell current by supplying her with fashion magazines. Ann Koogle, a local dressmaker, was another important influence in Mc-

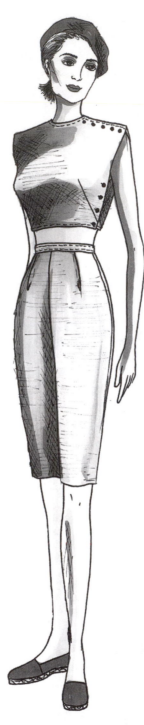

Claire McCardell: McCardell defined women's activewear in the 1940s. The comfortable, functional, and attractive ensembles she designed were not just for lounging. Her ensembles were for active women who skied, biked, swam, and played tennis.

Cardell's life. McCardell frequently observed Koogle as she designed and executed the technical steps that were involved in creating clothing. Her observations of this American-born dressmaker of German descent provided the foundation she needed to become a successful designer.

McCardell attended Hood College from 1923 to 1925, where she majored in home economics. Originally, she had hoped to attend the Parson School of Design in New York, but her father felt she was too young. Finally, after two years of being uninspired, she got her wish and found herself en route to New York. McCardell could not wait to start designing and sewing garments; however, she did not realize that Parson's curriculum emphasized art over sewing. Anxious to understand garment construction, McCardell disassembled designer garments to analyze the components and construction techniques. McCardell participated in Parson's study abroad program to complete the final two years of her education. Her experience in Paris exposed her to unique fabrics, European fashions, and couture collections, of which her favorite was Vionnet.

Upon graduation McCardell took odd jobs until she landed her first full-fledged design position in 1929 with Robert Turk, an independent sportswear designer. She was employed with Mr. Turk for two years when he was appointed head designer at Townley Frocks. McCardell followed Turk to Townley Frocks as an assistant designer where she assumed the role of head designer after Turk's death in 1932. McCardell had a realistic, practical philosophy for clothing design; she felt that women should look good and at the same time feel comfortable.

McCardell's first success was in 1938 with the bias-cut, no-waist, free-flowing "Monastic Dress." Unfortunately, a lack of financial backing forced Townley Frocks to close its doors. McCardell immediately moved into a position with Hattie Carnegie designing clothes for socialites, but she did not receive recognition for her designs. She continued working for Carnegie until 1940 when Townley Frocks reopened under the ownership of Adolph Klein, who asked McCardell to return as head designer. Mc-Cardell agreed to take the position under one condition: that she could design under her own name.

McCardell felt that when a woman worked in the kitchen and garden she should not sacrifice appearance for comfort. Her practical yet intricate clothing was affordable to the average American woman. One dress which embodied the spirit of the American working women was the "pop-over dress." This work dress was originally fabricated from denim as a wrap-around, loose silhouette with rolled-up sleeves, large utilitarian pockets, and detachable pot holders. This attractive, durable, and functional dress became the uniform of the American working woman during World War II.

McCardell played a large role in the development of women's active wear. She developed wool jersey and cotton sportswear ensembles for ac-

tivities such as skiing, bicycling, swimming, and tennis. Her interest in sportswear design began in her youth when she participated in sports with her brothers and recognized the distinct lack of proper athletic attire for women. McCardell's sportswear designs followed the same philosophy as her dress designs: clothing should be comfortable and attractive. Other signature looks the designer developed include halter top dresses, leotards, and play clothes for women and children which featured spaghetti straps, cinch belts, and sashes in leather, cotton, and jersey. She also contracted Capezio shoes to manufacture a line of ballet slippers in fabrics that coordinated with her dresses.

McCardell shaped the face of modern women's sportswear. Her ability to understand the needs of the average American woman earned her the honor of appearing on the 1943 cover of *Life* magazine, one of only three designers ever to achieve this distinction. She took pride in her designs and generously shared them with fresh inquisitive minds. McCardell continued to design until her death in 1958, at which time her contributions to American sportswear history were recognized with a posthumous induction into the Coty Hall of Fame.

REFERENCES

Kirkland, Sally. *American Fashion.* New York: Fashion Institute of Technology, Quandrangle/New York Times Book, 1975.

Kohle, Yohannan, and Nancy Nolf. *Claire McCardell, Refining Modernism.* New York: Harry Abrams, 1998.

Milbank, Caroline Rennolds. *Couture: The Great Designers.* New York: Stewart, Tabori and Chang, 1985.

————. *New York Fashion: The Evolution of American Style.* New York: Harry N. Abrams, 1989.

N. S.

Jessica McClintock

B. June 19, 1930

Birthplace: Frenchville, Maine

Awards: Ernie Award, 1981
 California Designers Award, 1985
 Tommy Award, American Printed Fabric Council, 1986
 Press Appreciation Award, 1986
 Dallas Fashion Award, 1988
 Merit Award in Design, 1989
 DEBI Lifetime Achievement Award, 1999

Jessica Gagnon, whom is now known as Jessica McClintock, attended Boston University from 1947 to 1949. In 1949 Jessica Gagnon married Al Staples and settled into domestic life as Jessica Staples. In 1963 she obtained her bachelor of arts degree from San Jose State University in California. Shortly after completing her education, Staples's husband passed away and she began teaching high school. Jessica Staples then met Fred McClintock, becoming at last, Jessica McClintock.

In 1969 McClintock, after divorcing her husband, decided to leave teaching to pursue an interesting new opportunity: a local dress manufacturer was looking for investors. McClintock took $5,000 from her savings to invest money in fabrics for a firm called Gunne Sax. McClintock became a partner in Gunne Sax and was directly involved with the design and marketing of the new dress line.

At its inception, the company was known for feminine dresses constructed of calico fabrics targeted to a young customer. During McClintock's first year at Gunne Sax, she expanded the company's offerings to include a line of prom dresses and lace-embellished wedding gowns. McClintock became known for putting the romance back in special-occasion dressing. She drew the inspiration for her silhouettes and details from times past to create charming, feminine, moderately priced lines.

Under McClintock's direction, Gunne Sax continued to increase in popularity. Two new lines were added in 1979: one targeted to girls under the Gunne Sax label, and a secondary contemporary line with McClintock's name on the label. The success of the lines allowed McClintock to open her own retail stores. The first store was opened in San Francisco in 1981.

The following year, McClintock's son, Scott McClintock, joined the company to manage the misses dress and sportswear divisions which would be manufactured under the labels Scott McClintock Dresses and Scott McClintock Sport. In 1987 McClintock renamed Gunne Sax to her namesake, Jessica McClintock, and added new sleepwear lines, a signature collection, and a perfume.

By the mid-1990s McClintock had opened fourteen boutiques, and her dress lines were carried in department and specialty stores across the United States and in several other countries. In total, McClintock's lines include Gunne Sax, Gunne Sax Girls, Scott McClintock Sport, Jessica McClintock Dresses, Jessica McClintock Bridal and Bridesmaids, and Scott McClintock Dresses. McClintock provided the first alternative to traditional bridesmaid, wedding, mother-of-the-bride, and flower-girl dresses. She also popularized matching mother and daughter ensembles. McClintock will always be remembered for her romantic interpretations of the past.

Website: http://www.mcclintock.com

REFERENCES

Milbank, Caroline Rennolds. *New York Fashion: The Evolution of American Style.*
New York: Harry N. Abrams, 1989.

N. S.

❧❧

Alexander McQueen

See Hubert de Givenchy.

❧❧

Nicole Miller

B. 1952

Birthplace: Lenox, Massachusetts

Awards: Dallas Fashion Award, 1991
Girl Scouts of America Award, New York, 1994

Nicole Miller's practical yet fun design philosophy has made her re-
markably successful. Some of Miller's inspirations stem from her child-
hood. Her father, an engineer, fascinated Miller with his interesting
gadgets, while her mother sparked her interest with French fashion maga-
zines. After high school, Miller attended the Rhode Island School of Design
in Providence. During her sophomore year, she had the opportunity to
travel abroad to Paris where she attended L'Ecole de la Chambre Syndicale
Parisienne. This haute couture school developed Miller's technical skills and
provided her with insight into the aesthetics of clothing. The most impor-
tant skill Miller received from her training was an understanding of how
to achieve a proper cut, an aspect crucial to dress design.

After Miller finished her intensive studies, she went to New York to
pursue a career in fashion. Her first significant design position was with
the rainwear company Rain Cheetahs in 1975. Although beneficial and
inspiring, Miller left herself open for other opportunities and pursued a
position as head dress designer with P.J. Walsh. Miller was selected for the
position over 200 other applicants.

Miller's definition of a good dress design consists of proper cut, overall
proportion, and simple but unique details. Miller's guiding philosophy
made her so successful at P.J. Walsh that the company president, Bud Kon-
heim, made her a partner in 1982 and renamed the company Nicole Miller.
Her next success came as a surprise; in 1987, as she prepared to open her

first store, a stock shortage required her to act quickly, and she ordered silk to be printed for scarves. The scarves were instantly popular, and Bud Konheim suggested that Miller also produce a line of men's ties in the same prints. The whimsical, eye-catching prints, based on themes such as sports, foods, and animals, appealed to a range of personalities. Her inspirations for the prints came from her observations of New York City and her other travels. The success of Miller's ties led her to design a line of men's printed boxers and robes.

Although known mainly for her prints, Miller has also established herself as a cocktail and bridesmaid dress designer. She combines simple silhouettes with unusual fabrics. Miller has established a niche for herself by designing bridesmaid's dresses that are both affordable and practical and can be worn again for other functions. Miller's dresses can be found throughout the country in her boutiques and in various bridal shops. Miller has also expanded her business to include several other product lines. She designs a swim line, which is manufactured by Cole of California, a lingerie line, fragrances for both men and women, handbags, socks, footwear, and a skin-care line which she introduced in 1999 through a partnership with Melaleuca.

Miller is renowned for her witty prints, which have made a huge impact on the apparel and textile industry and are now replicated by several other manufacturers. Her immediately identifiable designs are widely worn by various celebrities. Miller's key to success is her ability to keep things simple and practical by implementing trends into fun, refreshing designs. *See also*: Cole of California.

Website: http://www.nicolemiller.com

REFERENCES

Larson, Soren. "Nicole: A Modern Miller." *Women's Wear Daily* 174 (December 19, 1997): 6.
Milbank, Caroline Rennolds. *New York Fashion: The Evolution of American Style*. New York: Harry N. Abrams, 1989.

N. S.

Nolan Miller

B. 1935
Birthplace: Texas

Nolan Miller first became interested in fashion while watching his idols act in Saturday matinees as a boy in Texas. Miller's fascination with fash-

ion led him to Los Angeles, California, to attend the Choinard Art Institute. While in school, Miller worked in a Beverly Hills flower shop waiting to be "discovered." Fortunately for Miller, the flower shop he worked in was patronized by television producer Aaron Spelling.

Miller is most noted for the fashions he created for Spelling's 1980s television dramas. He created the wardrobes, and the images, for many of Spelling's shows including *Dynasty, Fantasy Island, Love Boat,* and *Hotel.* Through Miller's designs, the characters were transformed to wealthy, glamorous, powerful, business tycoons. Viewers tuned in each week not only to watch the dramas unfold, but also to see what everyone was wearing. Of all his productions though, Miller is probably most remembered for the fashions he created for Joan Collins and Linda Evans on *Dynasty.* The clothes these women wore were glamorous, sophisticated, and magnificently accessorized. When he incorporated big shoulder pads into the designs, the fashion community took notice. Soon, all fashions from haute couture to mass-merchandised ready-to-wear apparel displayed the broadshouldered silhouette which came to dominate the 1980s.

As the 1980s drew to a close, the economy took a downturn and the glamor ended. Television shows portraying high-powered families leading lavish lifestyles were no longer popular. Everything became much simpler, including fashion, and television programming reflected that change. When Spelling's television "dynasty" collapsed, Miller channeled his design talents into new outlets. In 1987 he began designing a line of designer pricepoint special-occasion suits for the Leslie Fay Company. After Leslie Fay went bankrupt in 1995, Miller decided to purchase a factory and manufacture his own line. However, Miller discovered manufacturing and marketing one's own line is exhausting and expensive, so he closed the business after only one and a half years. During the late 1990s, Miller developed a costume jewelry line which is sold on the QVC home shopping network, and he signed a licensing agreement with Morgan Miller for a line of suits.

Miller's passion for fashion design came from the glamor of Hollywood. Miller had the opportunity to design wardrobes for many of his boyhood idols including Barbara Stanwyck, Lana Turner, Joan Crawford, Bette Davis, and Jane Wyman. At the height of Nolan Miller's career, he was the highest paid costume designer in Hollywood, simultaneously designing wardrobes for six television productions. Although Miller continues his custom-made design business in Los Angeles, he has no plans to return to fashion design for television or film. "Actresses today are more likely to wear casual clothing than couture-style gowns . . . There's no real excitement in dressing somebody who wears blue jeans and a sweatshirt throughout the movie" (Taub).

REFERENCES

Friedman, Arthur. "Nolan Miller Back in New York." *Women's Wear Daily* 175 (September 9, 1998): 27.

Taub, Daniel. "Hot Hollywood Designer Recalls His Days of Glory." *Los Angeles Business Journal* 21 (July 19, 1999): 56.

A. K.

❧❧

Missoni

Awards: Neiman Marcus Award, 1973
Bath American Printed Fabric Council Tommy Award, 1974
Gold Metal of Civic Merit Award, Milan, 1979
Fragrance Foundation Award, 1982
Arancia Award, given to Tai Missoni, 1986
Commendatore al Merito Della Repubblica Italiana, Rosita Missoni, 1986
Fashion Group International Design Award, 1991
Munich Mode-Woche Award, 1992

In 1946 Ottavio Missoni and Rosita (Jelmini) Missoni started a manufacturing business focusing on knitwear apparel. The couple met in London during the 1948 Olympics where Ottavio was a finalist in the track and field competition. Ottavio and Rosita had three children—Vittorio, Luca, and Angela—all of whom are today involved in the family business.

The company's first collection appeared in the Rinascente Stores in 1954 featuring knit active wear. The Missoni label appeared four years later in 1958, when they introduced a striped knit shirtdress that paved the way for sportswear design. Ottavio's use of rich, blended colors and interesting patterns, for example, stripes, zigzags, waves, and patchworks, made the Missoni product so unique that it was perceived as a piece of art.

Missoni's grand debut was in Paris in 1967. Their introduction to the American market took place in New York in 1969. Missoni received a tremendous amount of international attention for unique signature looks, which consisted of knit dresses, sweaters, coats, and skirts for women and men. This global recognition allowed Missoni to open their first boutiques in Milan and New York in 1976. The 1970s and 1980s were so successful for Missoni that the company expanded into a fragrance line in 1981, Missoni Sport and the Missoni Uomo in 1985, manufactured under the license by Malerba, and Example Missoni, a men's bridge line, manufactured by Marzotto.

In 1997 Rosita Missoni appointed daughter Angela as creative director of the company. Ottavio continued his involvement in textile design but reduced his other responsibilities. Angela's first goal was to review the Missoni customer, whom she considered to be vibrant and uninhibited. Next, she updated the previously classic line to a modern, sleek appearance developing silhouettes which were more form fitting.

In 1999 Missoni launched a new bridge collection for men and women called Missoni M. The line, targeted to customers between the ages of twenty and forty-five, is manufactured and distributed under license by Marzotto. Missoni also expanded to include a line of footwear by Vicini, and fine machine and handmade contemporary rugs manufactured by Roubini, Inc.

Ottavio's knowledge of intricate knitwear allowed him to fill a market niche that was not being pursued by any other knitwear company. The company's vibrant colors and unusual, complicated patterns set a new standard for knitwear design in the apparel industry. Furthermore, Missoni's application of sophisticated knitting equipment and computer technology is responsible for its ability to produce knitwear as fine pieces of art.

REFERENCES

Milbank, Caroline Rennolds. *New York Fashion: The Evolution of American Style.* New York: Harry N. Abrams, 1989.
"Missoni: Italian Fashion House." *Women's Wear Daily* 175 (February 24, 1998): 16B.
"Missoni Sets New Line Aiming at Bridge Market." *Women's Wear Daily* 175 (January 9, 1998): 13.

 N. S.

Issey Miyake

B. April 22, 1938

Birthplace: Hiroshima, Japan

Awards: Japan Fashion Editors Club Award, 1974
 Mainichi Newspaper Fashion Award, 1976, 1984
 Pratt Institute Design Excellence Award, 1979
 Council of Fashion Designers of America Award, 1983
 Neiman Marcus Award, 1984
 Officier de l'Ordre des Arts et Lettres, France, 1989
 Hiroshima Art Prize, 1991
 Honorary Doctorate, Royal College of Art, London, 1993
 Chevalier de l'Ordre National de la Légion d'Honneur, Paris, 1993

Kazumaru "Issey" Miyake, who was born in Hiroshima, was seven on August 6, 1945, the day the world changed forever. He experienced firsthand the devastation of the atomic bomb; his mother suffered severe burns and only lived for four years after the attack. On the other hand, the American occupation of Japan introduced Miyake to Marilyn Monroe, Mickey Mouse, and the American dream.

Issey Miyake: Miyake's organic designs often reflect his Japanese heritage. His experimentations with shape and texture blur the distinction between art and fashion.

In 1959 Miyake enrolled as a graphic arts student at Tama Art University in Tokyo. During the early 1960s, he worked as a freelance graphic designer. Miyake left Tokyo in 1965 to study fashion design in Paris at the Ecole de la Chambre Syndicale de la Couture Parisienne, which led him to design positions at Guy Laroche (1966–1968), Givenchy (1968–1969), and Geoffrey Beene (1969–1970). Miyake returned to Tokyo in 1970 to open the Miyake Design Studio. Through his design studio, he began to research fabrics and design techniques, combining ancient Japanese techniques with modern textile technology. He began experimenting with geometric shape, body movement, and unisex clothing, and he questioned, "What is fashion?"

Miyake's first collection "Second Skin," was a line of sheer, stretch garments with an allover pattern inspired by tattoos. For the next several years, Miyake continued to experiment with shape, form, and fabric. In 1981 he launched the "Plantation" collection, a line of affordable, natural-fiber clothing. In the early 1990s, Miyake finally created what would become his signature look: pleats. Miyake developed a new multidirectional pleating process in which the finished garment, not the raw yardage, is pleated. "Pleats Please," a line targeted to younger customers, was launched in 1994. The line included comfortable, functional, practical pieces which provided an alternative to jeans and khakis. "Pleats Please" also allowed Miyake to collaborate with other artists whom he invited to design individual pieces for the 1996 collection. Over the course of his career, Miyake has launched three perfumes: L'Eau d'Issey (1993), L'Eau d'Issey pour Homme (1995), and Le Feu d'Issey (1998); designed jackets for the Lithuanian Olympic team in the 1992 Barcelona Olympic Games; and designed clothing for theater and dance.

Miyake does not consider himself a fashion designer; he is an artist working in the medium of textiles. He does not believe in, or participate in, fashion trends. His clothing transcends seasons, is neither Eastern nor Western, and can be worn by woman of all ages and body types. Miyake combines the natural with the synthetic, the hand woven with the high tech, to create tactile sensations. He makes us question what "dress" represents, designing from a perspective of clothing as body covering not fashion statement. His work blurs the line between art and fashion and is frequently exhibited in fine art museums around the world. *See also*: Hubert de Givenchy; Geoffrey Beene.

Website: http://www.isseymiyake.com

REFERENCES

"Giving Pleats a Chance." *Art News* 97 (December 1998): 82–84.
"Miyake and Japanese Tradition." *Art in America* 87 (February 1999): 81.
"Miyake Modern." *Art in America* 87 (February 1999): 78–83.

Wood, Dana. "Miyake's Lust for Life." *Women's Wear Daily* 172 (December 18, 1996): 32.

A. K.

๑๐ ๐๙

Isaac Mizrahi

B. 1961

Birthplace: Brooklyn, New York

Awards: Council of Fashion Designers of America Award, 1988, 1989
 Fashion Industry Foundation Award, 1990
 Michaelangelo Shoe Award, 1993
 Sundance Film Festival Audience Award for *Unzipped*, 1995

He refers to his witty film, *Unzipped*, about one stressful season in the life of a fashion designer (himself, of course), as a "frockumentary." His comic book, *Sandee the Supermodel*, parodies the lifestyles of divas in demand. And his admitted love affair with Technicolor has given birth to such surprising pieces as a pink satin parka and colors he calls "Lorne Green" and "James Brown." The perpetually head-banded Isaac Mizrahi debuted his first collection in 1988, and fashion watchers everywhere fell in love with the man and his merchandise.

Fashion was in Mizrahi's blood. His mother adored and amassed fine clothing, and his father was a children's wear manufacturer. Young Isaac started sewing at an early age, creating clothing for friends and even selling to a few boutiques when he was just a teenager. He also studied dancing and acting, enjoying his years at the High School of the Performing Arts in New York City. After graduating from Parsons School of Design, he became an assistant to Perry Ellis, Jeffrey Banks, and ultimately Calvin Klein. By the time he reached the age of twenty-five, he was ready for fame and began his own business in 1987 with the money left to him by his father.

Referred to as "Le Miz" by *Women's Wear Daily*, Mizrahi produced high-priced sportswear inspired largely by the sophisticated pieces of sportswear creator Claire McCardell, and the classic style of America's pop heroines, such as Katherine Hepburn, Mary Tyler Moore, and Lucille Ball. But he also added clever twists of his own like his strapless ballerina dress in tartan plaid and his trousers, gathered at the waist like a paper bag. He was a master at putting together the most unlikely but appealing concepts, pairing sporty with dressy, pink and peppermint with peach, serious with fun. All of his original ideas were born of his love for American style, resulting in a witty and versatile clothing.

In 1992 the House of Chanel, who became Mizrahi's financial partner, encouraged him to produce a department store line, Isaac, introduced in 1994, but discontinued in 1997. Mizrahi preferred to create rather than watch the bottom line, and Mizrahi and Chanel parted company in 1998. Mizrahi told the public that he was going to Hollywood to begin a new career and, as of this writing, his name is appearing on some very chic, moderately priced shoes, sold through stores such as Bergdorf Goodman and Neiman Marcus.

No matter which career path Mizrahi chooses, his influence on American fashion will be felt for a long time to come. His ability to reinterpret classic pieces in ingeniously clever, yet wearable, ways will always be appreciated. *See also*: Perry Ellis; Calvin Klein; Claire McCardell; Gabrielle Bonheur "Coco" Chanel.

REFERENCES

Agins, Teri. *The End of Fashion: The Mass Marketing of the Clothing Business.* New York: William Morrow, 1999.
Gan, Stephen. *Visionaire's Fashion 2000: Designers at the Turn of the Millenium.* New York: Universe Publishing, 1997.
Gandee, Charles. "Zippity-doo-da." *Vogue* 254 (2) (September 1995).

S. B.

Edward H. Molyneux

B. 1891

D. 1974

Birthplace: London, England

Pursuing his desire to become a painter, Molyneux studied art and initially made a living by sketching for advertisements and magazines. After his sketch of an evening dress won a design contest, he was hired by the contest's sponsor, Lucile (Lady Duff Gordon). In 1911 he began by working as her sketch artist and was promoted to designer for her Paris operations.

Molyneux's career took a brief detour beginning in 1914 when he served in World War I. He was wounded three times and earned the rank of captain, a title by which he would be known for the remainder of his life. After the war he renewed his career in fashion by moving to Paris and opening his own house in 1919. He achieved immediate success with simple, elegant styles which expressed the modern aesthetic of the 1920s.

Earlier in the 1900s, lace, ruffles, and embellishment had been part of the fashionable look, but the war began to popularize a more utilitarian look which evolved into the more minimal, boyish look of the 1920s and the sleek, sweeping lines of the 1930s. Molyneux embraced this movement and became one of the leaders of fashion during this period. In addition to dresses, he designed furs, hats, lingerie, and perfume. He introduced his most famous scent, Numéro Cinq, in 1926 and followed it with Vivre in 1930 and Rue Royale in 1943.

Molyneux's designs centered on simplicity, versatility, and refinement. Most of his work was crafted from luxurious fabrics in neutral colors such as black, navy, beige, and gray. His clothes embodied a restrained elegance enhanced sometimes by fanciful embroidery or beading. Most important, his dresses had the flexibility to be worn with a variety of jackets and hats, allowing the wearer to transform the look of a single garment.

The 1920s and 1930s were Molyneux's heyday; he dressed members of the social elite including actress Getrude Lawrence and Princess Marina of Greece. During the 1920s, he echoed the changing moral attitudes about divorce by ending his 1928 collection with two wedding dresses: one for the traditional bride and the other for the growing population of second-time brides. His designs of the 1920s and 1930s won him the admiration of fashion luminaries Christian Dior and Pierre Balmain. Balmain was his apprentice during the late 1930s.

At the height of his popularity, Molyneux fled Paris when it fell to the Germans during World War II. He escaped to England and spent the remainder of the war bolstering the Allied war effort. He donated the proceeds from his London operations to the British Defense Budget. Also, he helped design clothes that met the strict requirements of British wartime clothing regulations. In France he opened a camp for war victims and a school for couture workers.

He returned to Paris in 1946, after the war, but his health began to fail. On December 31, 1950, he closed his business and gave the Paris location and much of his clientele to Jacques Griffe. He began painting again, and his health gradually returned. In 1965, he produced a ready-to-wear line called Studio Molyneux, which achieved only limited success. *See also*: Christian Dior.

REFERENCES

Martin, Richard, ed. *Contemporary Fashion*. New York: St. James Press, 1995.

Milbank, Caroline Rennolds. *Couture: The Great Designers*. New York: Stewart, Tabori and Chang, 1985.

O'Hara, Georgina. *The Encyclopedia of Fashion*. New York: Harry N. Abrams, 1986.

A.T.P.

Claude Montana

B. 1949

Birthplace: Paris, France

Awards: Best Women's Collection, Paris Opera, 1985
 Best European Designer, Munich, 1987
 Balenciaga Prize—Best Designer, Madrid, 1989
 Prix Medicis, 1989
 Fragrance Foundation Award, 1990
 Dé d'Or Award (Golden Thimble) (for Lanvin), 1990, 1991

Claude Montana grew up in a well-to-do family, but he did not want to pursue the professional career his family would have preferred. After leaving home in his late teens and getting by on odd jobs, including one as an extra at the Paris Opera, he went to London where he started to make jewelry out of papier-mâché and rhinestones with Michelle Costas. It was the early 1970s, a time when "anything goes" was still the fashion mantra; hence, their unlikely combinations of paper and sparkle won them quite a bit of attention and even a write-up in British *Vogue*.

Upon his return to Paris in 1973, he worked as an accessories and ready-to-wear designer for a Parisian manufacturer. Although he insists that he knew nothing about making clothes, he learned quickly. A friend recommended him for a design assistant's position at MacDouglas Leathers, and, in less than a year, he was promoted to head designer. By 1975 he was doing freelance work for Complice and beginning to formulate the technique and silhouette that would make him the essential designer of the 1980s. He founded his own company in 1979, debuted his menswear in 1981, and opened his first Paris shop in 1983.

The moment was right for the sharp-edged, tough chic shapes for which Montana became internationally famous. His razor-like cuts defined the 1980s woman, providing her with body-conscious clothing that made her look bold, powerful, and even somewhat dangerous. It was this aggressive shape, created with boldly padded shoulders, oversized collars, and the top-heaviness of biker and military jackets, which brought him notoriety and, also, criticism. He was called a misogynist for creating such impractical clothes and faced loud protest for his use of leather and heavy metal: chains, buckles, and studs. Nevertheless, his futuristic silhouette was the one that defined the moment.

Montana, who loved to adorn his clothing, called on fellow designers Walter Steiger and Jean Colonna to help him create accessories. Lucrative

licenses with the Italian fashion giant GFT, eyeglasses with Alian Mikli, and the introduction of his trendsetting Parfum de Peau, one of several successful fragrances, made his company highly profitable. In 1989 Montana became head couture designer for the House of Lanvin, winning professional praise, breathing new life into the ailing house, and becoming the first designer in history to win two consecutive Golden Thimble Awards. In 1992 he launched a well-received secondary line, the State of Claude Montana, which brought further success.

In the mid-1990s, problems began to plague the designer. The company changed manufacturers for apparel and fragrances, as well as partners in the Japanese market, putting the company in financial straits. Montana's wife of two years committed suicide, and some blamed his mistreatment of her. His top senior associate and trusted aide for twenty years, resigned soon afterward. In 1997 Montana was forced to file for protection from creditors.

Since 1998, however, Montana has been preparing for a comeback, and fashion history has shown that a great name can always be revived. In 1999 everything was in place for the reintroduction of a new sportswear/city wear collection, Montana Blu, in partnership with the Baumler Group, which will handle the product development, marketing, and distribution of Montana's lines, described by Baumler as young, modern, and more understated than in the past. So far the reaction from the fashion press has been quite favorable. *See also*: Jeanne Lanvin.

Website: http://www.claude-montana.com

REFERENCES

Larenaudie, Darah R. "Claude's Lament." W (February 1998): 214.
Martin, Richard, ed. *Contemporary Fashion*. New York: St. James Press, 1995.

S. B.

Hanae Mori

B. January 8, 1926

Birthplace: Tokyo, Japan

Awards: Neiman Marcus Award, 1975
 Medaille d'Argent, City of Paris, 1978
 Symbol of Man Award, Minnesota Museum, 1978
 Croix de Chevalier des Arts et Lettres, 1984
 Avant-garde Japon, Centre Pompidou, Paris, 1986
 Purple Ribbon Decoration, Japan, 1988

Asahi Prize as Pioneer of Japanese Fashion, 1988
Chevalier de la Légion d'Honneur, 1989
Person of Cultural Merit, Japan, 1989
Hanae Mori: 35 Years of Fashion, Tokyo, 1989, Monte Carlo, 1990, and
 Paris, 1990
Japonism in Fashion, Kyoto Costume Institute, 1994
Japanese Design: A Survey Since 1950, Philadelphia Museum of Art, 1994
Orientalism, Metropolitan Museum of Art, New York, 1994–1995.

Hanae Mori was one of the first Asian designers to cross over into West-
ern fashion. Ever since the East was opened to the West, Europeans have
borrowed Asian style elements for design and art, but this influence has
always been a Western interpretation of Eastern design. As a native of
Japan, Mori designs Asian-inspired clothing from an Eastern perspective
and remains tied to her Japanese roots.

Initially Mori did not study design. She earned a degree in Japanese lit-
erature from Tokyo Christian Women's University in 1947. After World
War II, she attended design school and began producing her own designs
in 1955. For the next several years, she created clothes for private clients
and costumes for films and plays.

Mori entered into the international fashion scene in 1965 when she
showed her first ready-to-wear collection in New York and opened a bou-
tique in Tokyo. By 1977 she had solidified her reputation in the fashion
world with the introduction of a haute couture line. That same year she
became the first Japanese member of the exclusive Chambre Syndicale de
la Haute Couture.

In 1985 Mori opened a boutique in Paris, followed by one in Monte
Carlo in 1986; by 1993, she owned more than seventy boutiques through-
out the world. Mori and Cosmetique et Parfum International, a licensee,
introduced a women's fragrance in 1996. In addition, Mori has signed
license agreements for menswear, children's wear, golf clothes, and acces-
sories such as jewelry, belts, and shoes. Some of her more recent license
agreements include Hermès for scarves, Revman Industries for bedding, and
Plaid Clothing Group for men's and boys' clothing.

Mori was able to expand her business through licensing and retailing
based on her success with her women's clothing lines. Known for her eve-
ning wear, Mori uses flowing, patterned textiles specially manufactured by
her husband's company. Her love of art is evident in the patterns she
chooses; they range from OpArt to flowers and her trademark butterfly.
Drawing from the Japanese aesthetic, many of her designs incorporate
asymmetry, kimono sleeves, and Mao collars. During her forty-five years
of designing, Mori has consistently produced simple, elegant shapes which
focus on the draping of the fluid silks she employs. As one of the first Asian
designers to cross over successfully into Western fashion, Mori opened the

door for the popularity of the Asian aesthetic in the 1980s and the endurance of Asian style in Western design.

Website: http://www.morihanae.co.jp

REFERENCES

Gellars, Stan. "Plaid, Mori sign Clothing Licensing Deal." *Daily News Record* 24 (March 16, 1994): 2.

Martin, Richard, ed. *Contemporary Fashion*. New York: St. James Press, 1995.

"Mori Nets Art School Butterflies." *Women's Wear Daily* 172 (October 18, 1996): 7.

A.T.P.

Thierry Mugler

B. 1948

Birthplace: Strasbourg, Alsace, France

Thierry Mugler's early training was in the fine arts; he was a member of the Rhine Opera Ballet from 1965 to 1966, and he attended the Strasbourg School of Fine Arts from 1966 to 1967. At the age of twenty, Mugler moved to Paris to pursue a career in the fashion industry. He worked as an assistant designer for the Gudule boutique in 1968, as a designer for André Peters in London in 1969, and freelanced for several houses in Paris and Milan between 1970 and 1973. In 1973 Mugler created his own label, Café de Paris, and a year later, he founded his own house.

Unlike most designers, Mugler's signature line is a cross between ready-to-wear and haute couture, containing elements of both mass production and made-to-measure wear. His work is extravagant, innovative, and filled with iconography. He draws on such postmodern themes as Hollywood glamor, sexual fetishes, science fiction, and politics. His annual collection presentations are more theatrical performances than runway, choreographed like musicals starring top models, porn stars, transvestites, and pop icons. His body-conscious clothing, which draws inspiration from New York nightclubs, is frequently characterized by extremely exaggerated proportions of one area of the body: padded shoulders, wasp waists, or panniered hips.

Mugler's menswear line is as trendy and theatrical as his women's line. In 1992 he expanded his menswear offerings by launching Mugler par Thierry Mugler, a collection of classic staples designed to complement his signature collection. Mugler's other product lines and license agreements include a men's footwear line licensed by Transatlantique; women's hand-

bags, scarves, and accessories; and men's ties licensed by Lafargue. Mugler also produces men's and women's fragrances under license by Clarin's. Angel, a fragrance line for women, was introduced in 1992 featuring an ecologically minded refillable bottle; it expanded in 1999 to include Angel Secrets, a line of body products. A Men (Angelmen), the male counterpart to Angel, was launched in 1996.

REFERENCES

Brubach, Holly. "Whose Vision Is It, Anyway?" *New York Times* (July 17, 1994): 646.

Spindler, Amy. "The Hyper House of Thierry Mugler." *Women's Wear Daily* 165 (January 11, 1993): 6–8.

———. "Monsieur Mugler." *Women's Wear Daily* 164 (July 22, 1992): 4–6.

A. K.

N

꧁꧂

Nike

As of 1999, Nike was the number-one shoe company in the world, and it accounted for 40 percent of the athletic shoe market in the United States. The company originated as Blue Ribbon Sports (BRS), a company formed by William J. Bowerman and Phil Knight in 1964 to distribute Japanese-made Tiger Shoes in the United States.

Bowerman coached track and field at the University of Oregon from 1949 to 1972. He trained Steve Prefontaine, a 1970s record breaking track star, as well as NCAA, Olympic, and All-American athletes. One of his athletes from the University of Oregon was Phil Knight, who went on to earn an MBA from Stanford. In his master's thesis Knight asserted that inexpensive, high-tech shoes from Japan could end German dominance of the U.S. athletic shoe market. He presented this idea to his former coach, Bowerman, and BRS was born.

Bowerman, the creative force behind the business, originated a light nylon upper which was introduced in a 1967 marathon. In 1968 he designed the Cortez for Tiger, and it became the company's best-selling shoe. While Bowerman focused on shoe innovations, Knight worked on marketing the shoes. He hired Jeff Johnson in 1965 to sell the shoes, and the company opened its first retail outlet in Santa Monica, California, in 1966.

1971 was a watershed year for the company. The duo broke from Tiger after a disagreement and renamed the company Nike after the Greek goddess of victory. They paid a design student, Carolyn Davidson, $35 to develop a logo, and she came up with the swoosh. During this year, the company introduced the Waffle, a shoe with a lightweight sole which Bowerman created by pouring rubber into his wife's waffle-iron. The shoe sold originally for $3.30

a pair, and four of the top seven marathon finishers in the 1972 Olympics wore the revolutionary shoes. While the Waffle was quickly becoming America's best-selling shoe, the popularity of jogging, running, and physical fitness increased in the 1970s. In 1979 Nike introduced air cushioning, and the company captured 50 percent of the running-shoe market.

During the 1980s, the company experienced some of its greatest successes. It started the decade by going public in 1980. In 1985 it took a chance by marketing a shoe named after a Chicago Bull rookie, Michael Jordan. The Air Jordan, like its namesake, skyrocketed in popularity and fame. In 1988 the company introduced its memorable "Just Do It" marketing campaign, which solidified the company's reputation for footwear for making serious athletes.

In addition, the company began to expand through acquisitions and retailing. In 1988 Nike acquired Cole Haan, a dress shoe company. Two years later, it opened the first Niketown in Portland, Oregon. This chain of large-scale sporting-good stores attracts hard-core athletes and tourists allured by the engaging merchandise displays. In 1994 Nike purchased Canstai, the largest manufacturer of hockey equipment, including Bauer ice skates.

Nike's success did not come without controversy. During the 1990s, human-rights activists criticized the company for the conditions in its overseas factories. Nike responded by raising wages and prohibiting children from working in its plants.

Currently, Nike produces athletic shoes for a variety of sports including baseball, cheerleading, volleyball, and wrestling. Also, it offers athletic clothing and equipment. As of 2000, the company was looking to diversify its product mix through acquisitions.

Website: http://www.nike.com

REFERENCES

Collins, David R. *Philip Knight: Running with Nike*. Ada, Okla.: Garrett Educational Corporation, 1992.

Katz, Donald. *Just Do It: The Nike Spirit in the Corporate World*. Holbrook, Mass.: Adams Publishing, 1994.

Solnik, Claude. "Co-founder of Nike Dies Christmas Eve." *Footwear News* 56 (January 3, 2000): 2.

A.T.P.

Norman Norell

B. April 20, 1900
D. October 25, 1972

Birthplace: Noblesville, Indiana

Awards: Neiman Marcus Award, Dallas, Texas, 1942
 Coty American Fashion Critics Award, 1943, 1951, 1956, 1958, 1966
 Parsons Medal for Distinguished Achievement, 1956
 Honorary Doctor of Fine Arts, Pratt Institute, 1962
 Sunday Times International Fashion Award, London, 1966
 City of New York Bronze Medallion, 1972

Norman Norell, known in his earlier years as Norman David Levinson, was raised by his parents, Harry and Nettie Levinson, who owned a men's hat store. In 1905 the family moved to Indianapolis where they opened Harry Levinson and Company, a men's clothing store, which is still owned by the Levinson family and managed by Norell's great great nephews, Paul and Carl.

Following high school, Norell joined the military, since he had no interest in joining the family business. After he returned from the service, Norell's mother realized her son's talent in clothing design. She helped to finance his trip to New York to study illustration at the Parsons School of Design, as well as figure drawing and costume design at Pratt Institute from 1920 to 1922.

After college, Norell worked building movie sets and designing costumes for the Astoria Studio of Paramount Pictures in Long Island from 1922 to 1923. The studio closed in 1923, and Norell joined the Brooks Costume Company as a theatrical designer from 1924 to 1928. In 1928 Norell approached Hattie Carnegie for a design position, offering to use his own fabrics and to pay personally for any mistakes he made. She agreed to his terms, and Norell came on board to design dresses for Hollywood actresses and other socialites. Norell's experience with Carnegie allowed him to travel to Paris to review collections, to meet influential clients, and, most important, to perfect his art.

In 1941, after twelve years with Hattie Carnegie, he obtained a position with Anthony Trainer, a prominent dress manufacturer. Norell, who had always been behind the scenes, finally received recognition by sharing the Traina label. Norell was now at the peak of his career, designing ready-made clothing that resembled couture. Like most designers of this era, wartime restrictions limited the materials Norell had at his disposal, but this did not stop Norell from giving the American woman what she wanted.

During the 1940s, Norell developed signature looks that he would carry throughout his career. Wool jersey shirt-waisted dresses with exaggerated bow collars, jersey town coats, fur trims on tops and jackets, shirtdresses with slim silhouettes for daytime, and leopard prints characterized the Norell look. In the 1950s he began mixing jersey with organdy, taffeta, and satin in both his day-wear and evening-wear ensembles of slim tops paired

with full skirts. Norell also popularized the flyaway bolero jacket and short overcoat accompanied by a simple blouse with an exaggerated bow. In 1960, with the help of investors, Norell purchased Traina-Norell after Traina's death. Norell was soon the first American designer to have his name on a clothing label.

The daring sixties brought shorter skirt lengths exposing the knees. Norell showed a short-length belted chemise dress, a new shorts suit with his now famous culottes, and a masculine jumpsuit as a new direction for women's fashions. His striking evening wear was often trimmed in fur or embellished with jeweled necklines. In 1968 Norell was the first American designer to launch a perfume, Norell, produced by Revlon. Norell, a perfectionist, took pride in being involved in developing the scent of the perfume and would not release it until the aroma was just right.

In his final years, Norell's signature silhouettes and fabrics were still carried throughout his lines, with the addition of contrasting colors in the seventies. His final collection consisted of shirt-waisted dresses, short jackets with pants, and overcoats with bias-cut pockets in his usual silhouettes, made of grey, beige, and white checked wool. Norell was a kind, gentle man who shared his knowledge by volunteering at Parson's school, where a room was named in his honor. Norell struggled with cancer for over ten years but still found time to pursue his favorite passion, designing clothes. Norell was known to be one step ahead of the European designers. He had the gift of keeping clothing simple and practical, but still striking. His clothes are considered fine-quality classics. Unfortunately, a stroke prevented Norell from viewing the fifty-year retrospective of his work given by the Metropolitan Museum of Art. Norell will not be forgotten; his ideas continue to live in the work of other designers' creations. *See also*: Charles Revson.

REFERENCES

Milbank, Caroline Rennolds. *Couture: The Great Designers*. New York: Stewart, Tabori and Chang, 1985.

———. *New York Fashion: The Evolution of American Style*. New York: Harry N. Abrams, 1989.

Morris, Bernadine. *American Fashion*. New York: Fashion Institute of Technology, Quandrangle/New York Times Book Co., 1975.

Norell, Paul. Interview by author. Indianapolis, Indiana, June 17, 1999.

N. S.

O

Oilily

Award: National Retail Federation's Retailer of the Year, 1999

Oilily originated in Alkmaar, Netherlands, in 1963 and was founded by Marieke and Willem Olsthoorn after the arrival of their twins. The Olsthoorns wanted exciting clothing that contained vivid colors and interesting prints and textures for their children, but they found very few options on the market. Following this design concept, Marieke developed fabrics and designs for children's clothing containing elements that capture the emotions of children.

The name Oilily, a variation of Olly's, the parent company name, was created through a children's contest sponsored by Olly's. The guiding principle behind Oilily is to see through the eyes of a child, to offer clothes that are fun and full of energy. Typical Oilily designs incorporate stripes, checks, florals, and bright colors in mix and match pieces. The small in-house design staff creates many of the unique prints; however, the majority are custom made by outside contractors.

Oilily engages in limited advertising campaigns; instead, they reach their customers through the Oilily fan club, magazine, and website. The fan club has been integral to the success of the children's line, allowing children to voice their ideas on what they would like to see in the collection. Eighty thousand members worldwide receive newsletters, stickers, and cards on their birthdays. The club also sponsors contests to award merchandise.

The outstanding success of the infants' and children's wear collections prompted the 1988 launch of a women's wear line under the creative di-

rection of Dutch designer Nico Berhey. The women's wear line was first carried in Arnhem, Holland, and then later added to all stores, including those in the United States. Oilily has grown tremendously, branching out into other product lines such as Jeans for Babies, Oilily for Girls (Juniors), Tirke Dungha, shoes, ski apparel, backpacks, stationary, accessories, watches for women and children, perfume and cosmetics for kids, bath products, and optical frames. These products can be found in exclusive Oilily stores in forty countries plus numerous specialty stores across the United States, Europe, Asia, India, Switzerland, and the United Kingdom.

Oilily has revolutionized the children's clothing industry, providing fun, imaginative clothing children are excited to wear. Unlike many companies, Oilily maintains control over design and quality-control regulations by manufacturing in-house through a European licensee, Zamasport. Oilily's decision to manufacture in-house allows them to concentrate on customer satisfaction. The Oilily customer expects quality to equal price, and color and texture to equal fun and energy.

Website: http://www.oilily-world.com

REFERENCES

Edelson, Sharon. "Oilily: From Cult to Kudos." *Women's Wear Daily* (January 28, 1999): 9.
Fearnley-Whittingstall, Sophy. "Oilily shows its colors in N.Y." *Women's Wear Daily* 166 (July 27, 1993): 8.
"How Oilily Was Born: Think Color, Think Oilily." Available from http://www.oilily.com

 N. S.

❧❧

Todd Oldham

B. 1961

Birthplace: Corpus Christi, Texas

Awards: Council of Fashion Designers of America Perry Ellis Award, 1991
 Crystal Apple Award, AIDS Project Los Angeles Fund-raiser, 1996

As a child, Todd Oldham had the opportunity to express his creativity through sewing and painting. Oldham's desire for sewing clothing came from his grandmother, Mildred Jasper, who taught Oldham how to sew at the age of nine. By the time he was fifteen, Oldham was creating clothes for his sister, Robin. In 1980, after high school, Oldham took an alterations position at a Ralph Lauren Polo shop which allowed him to increase his knowledge of garment construction. A year later, he was inspired to take

his talent further, and he began experimenting with manipulating and dying fabric. Anxious to begin his career, he asked his parents for $100 to buy fabric to create a line of dyed silk t-shirts and skirts, which he then sold to Neiman Marcus.

This initial success prompted Oldham to move to New York in 1988 to start his new company, L-7, with partner Tony Longoria. The L-7 company structure was different from most design firms. It was run by Oldham's mother, Linda, his grandmother, Mildred Jasper, his brother, Brad, and his sister, Robin. The new company produced Times 7, a contemporary-priced shirt line, Oldham's signature line, and private-label products. The Times 7 lines consisted of avant-garde clothing centered around themes such as a "Garage Sale" or "Old Master's–New Mistress" with fabric embellishments of paint, beads, buttons, and embroidery. In the early 1990s funding from Onward Kashiyama allowed Oldham to produce and distribute a more substantial line, including a women's separates line.

In 1991 Oldham expanded his business into accessories, adding a line of handbags through a licensing agreement with Carlos Falchi. Nontraditional materials such as Lamontage (a felted synthetic fiber), glass, and marble were combined using unique construction techniques. Another unexpected addition to his business in the early nineties was a button line, which combined novelty designs with unique materials resulting in Swarovski crystal bugs, hand-lacquered fruits and vegetables, and Oldham's fingerprints imprinted on a hand-wrought metallic button. The button line was manufactured by Streamline Industries, Inc., for the home sewing market. Oldham also signed a licensing agreement with Vogue Patterns to produce a pattern for his oversized novelty button shirt from his Times 7 line.

The mid-1990s continued to be a period of great success for Oldham. He developed a moderately priced shoe line, manufactured by Lerre and shown by Bucci Footwear; introduced a fragrance, produced by Parlux; and even entered the home furnishings market. Oldham's most exciting accomplishment, however, came through the MTV network. Oldham, along with two other designers, Marc Jacobs and Isaac Mizrahi, participated in a new marketing concept sponsored by the MTV network. Oldham offered an exclusive clothing line targeted to the teen and college markets on *The Goods* on MTV and VH1. He also had *Todd Time*, a five-minute home-decorating advice segment on MTV's *House of Style* with Cindy Crawford, and his home furnishing and kitchenware lines were featured on *Nick at Night*. Oldham became one of the first designers to participate in the fledging home-shopping industry.

Oldham was presented with another unique opportunity in 1994. He was offered a three-year contract as a creative consultant with Escada for the Escada Margaretha Ley and Escada Couture collections. The position presented Oldham with a new challenge as a designer: not only would he have to work with a design team to select silhouettes, colors, and patterns

for the line, but his designs traditionally targeted a younger customer than Escada's. Oldham rose to the challenge and was able to give Escada a fresh new look which incorporated his mastery of fabric embellishing and finishing. Despite this success, Escada decided to limit the launch of his spring 1998 bridge label, Todd Oldham Apriori, to the European market only. However, Oldham was asked to sign another three-year contract, with Escada USA as a general consultant to provide insight into trends in the U.S. market.

The most significant expansions to Oldham's business came in 1995. First, he signed a licensing agreement with Nikon, Inc., to produce a line of eyewear to be sold in Oldham boutiques, department stores, and specialty stores. Next, he was approached by Warner Bros. Studio to produce a Batman Forever collection of apparel and accessories. Oldham was only the second person ever chosen to design limited-edition film merchandise for Warner Bros. Studio. Finally, Oldham signed a licensing agreement with Sun Apparel to produce his men's and women's denim line. The line would be targeted to his young audience through the segment on MTV.

In a surprising move in 1998, Oldham discontinued wholesaling his Times 7 line, deciding to produce the line exclusively for his own boutique through a licensing agreement with Japan's Itochu Fashion Systems Co., Ltd. Also, to the surprise of many, he stopped participating in fashion week runway shows. While discontinuing these relationships, Oldham was busy forging a new one with Crunch Fitness, an elite health club in New York, to design an upscale men's and women's active-wear line to be distributed through eight health clubs across the United States.

In 1999 Oldham introduced a lower-priced jeans line, TO2, to continue his earlier expansion into the rapidly growing teen and college market. This junior line, also produced by Sun Apparel, was marketed through Oldham's interactive website. Through the website, visitors can flip through a virtual catalogue, download promotion materials; review "Todd's Tips" on music, shopping, and food; and engage in other interactive activities targeted at junior customers.

By comparison to many, Oldham is a relative newcomer to the American fashion industry. However, in a brief period of time, he has propelled himself to the forefront of American fashion by participating in innovative marketing strategies through cable television and the World Wide Web. He is also one of the few designers to develop product lines targeted at the emerging teen market. Despite his youth, his unique use of color, pattern, and fabric has earned him recognition as one of the top designers in America.

Website: http://www.toddoldham.com

REFERENCES

Larson, Soren. "Oldham Scent to Bow at Neiman's." *Women's Wear Daily* 168 (December 9, 1994): 4.

Lender, Heidi. "Hot Today." *Women's Wear Daily* 163 (May 8, 1992): 6.
"Todd Oldham to Create Batman Line." *Daily News Record* 25 (April 21, 1995): 4.

N. S.

❧❧❧

Old Navy

See The Gap, Inc.

❧❧❧

Rifat Ozbek

B. 1955

Birthplace: Istanbul, Turkey

Awards: Woman Magazine, Designer Award, 1986
 British Fashion Council, Designer of the Year Award, London, 1988, 1992
 British Glamour Award, 1989

Rifat Ozbek is inspired by adornment. He is an observer of culture and subculture, from Tibetan to American Indian, and his interest in decoration is evident in his ornamental clothing. Born in Istanbul, Ozbek left to study architecture at Liverpool University but soon recognized that his interest in constructing buildings was not as compelling as his desire to decorate them.

Ozbek graduated from London's St. Martin's School of Art in 1977, and for several years he worked for a company called Monsoon, known for its production of clothing made from Indian fabrics. In 1984 he began designing clothing under his own label. He soon gained notoriety by combining the decorative symbols and shapes of diverse cultures, such as the Far East, Africa, and his native Turkey, with the classic silhouettes of the West. Ozbek created eclectic clothing which encouraged the urban consumer to embrace "ethnic chic." His use of embroidery, tassels, and vivid colors like turquoise and fushia was completely at odds with 1980s power dressing; nevertheless, his antifashion approach to modern dressing received quite a bit of attention from those who appreciated the departure from sharp-edged suiting. In 1987 the production of his studio line, Future Ozbek, was licensed to Aeffe SpA, in Italy, and his notoriety continued to grow.

Ozbek's designs reflected both club scene and New Age influences, when in 1990, he made clear his faith in spiritualism by presenting an all-white collection. His popularity continued throughout the 1990s as he continued

his investigation of culture and subculture, taking street fashion to the runway with the addition of baseball caps covered in sequins.

The fall 1999/spring 2000 collections of many designers reflected the very aesthetic that Ozbek valued for over a decade—the artful mixing of unlikely patterns, shapes, and ornamentation, along with bits and pieces borrowed from a global grab bag.

REFERENCES

Martin, Richard, ed. *The St. James Fashion Encyclopedia: A Survey of Style from 1945 to the Present*. Detroit: Visible Ink Press, 1996.

Seeling, Charlotte. *Fashion: The Century of the Designer*. Cologne, Germany: Konemaan Verlagsgesellschaft mbH, 1999.

S. B.

P

Paquin

B. Unknown
D. 1936
Birthplace: Unknown
Award: Légion d'Honneur, 1913

Madame Paquin was the first important female couturier, but very little is known about her personal life. Even her first name has been lost to history. After training at Maison Rouff, she founded her house in Paris in 1891. Her husband served as administrator, financier, and supporter to Madame Paquin. This arrangement was unusual, because at the time men usually did the designing and their wives served as inspiration and models.

Since men designed most women's garments at the turn of the century, fashionable clothes were often uncomfortable and restrictive. Paquin's clothes were different; she understood what women wanted to wear and opposed any trends toward more confining clothing.

Paquin marketed her designs in innovative ways. She often dressed her mannequins all alike and sent them to the races or the opera. Each season she sent a list of fashion needs to each of her clients to help keep them up to date with fashion trends. By organizing the fashion segment of the 1900 Paris Exposition, she was able to create an elaborate display of her own designs for the world to see. She even sent mannequins to tour major U.S. cities.

Her couture house was the first to set up branches outside Paris. After opening a branch in London in 1912, she formed branches in Madrid and

Buenos Aires. Since fur was one of her trademarks, her New York store specialized in it.

Paquin was a leader of Paris fashion. She became the first woman designer to be awarded the Légion d'Honneur, and she served as the first female president of the Chambre Syndicale from 1917 to 1919. These were the first inroads made by a woman into this male-dominated industry.

Royalty and actresses dressed in Paquin's exotic, yet feminine designs. She chose to use vivid colors, while other designers chose pastels. By using black as an accent color, she transformed the traditional mourning color into a fashionable color. She used Oriental motifs on opera cloaks and evening dresses during the 1910s. Her most popular designs featured draped lace and flowers. Even her tailored designs were accented with braids, crocheted lace, and her ever-present fur. The house was most known for its coats. After Paquin stopped designing, coats became the house's only product.

When her husband died shortly after World War I, Paquin relinquished the design role and gave it to Mademoiselle Madeleine. She designed the collections during the 1920s, and Madame del Pombo created the designs until the house closed in 1956, twenty years after Paquin's death.

REFERENCES

Milbank, Caroline Rennolds. *Couture: The Great Designers*. New York: Stewart, Tabori and Chang, 1985.
Callan, Georgina O'Hara. *The Thames and Hudson Dictionary of Fashion and Fashion Designers*. New York: Thames and Hudson, 1998.

A.T.P.

❦❧

Jean Patou

B. September 27, 1887
D. March 8, 1936
Birthplace: Normandy

Today, the House of Jean Patou is known primarily for producing Joy, the most expensive perfume in the world, first introduced in 1930. But Patou's contributions to modern fashion were not restricted to perfumes, although there were many, each with a cleverly seductive name, from Moment Supreme, 1929, and Divine Folie, 1933, to l'Heure Attendue, first offered in 1946, after his death.

The couturier's talents included more than developing desirable fra-

grances. He was an innovator whose quest for quality was constant, from his first collection in 1914 to the fashion revolution he created when he dropped the hemline and raised the waistline in 1929. (Although his biggest rival, Coco Chanel, is often credited with this dramatic change in silhouette, it was Patou who actually did it first.)

Prior to serving as a captain in World War I, Patou worked with his father in the family's fur tannery and, in 1914, he opened a small dress-making facility in Paris. He returned home in 1919, reopened his salon, and soon began to create clothing for the ideal woman of the 1920s—one who exhibited physical health, fitness, and atheletic prowess, all signs of her newly found independence. Wimbleton tennis star Suzanne Lenglen and aviator Ruth Elder were two women who epitomized this new image. Recognizing the value of public relations, Patou created clothing for both of them, as well for other celebrities who engaged in sports, or at least wanted to look as if they did. Inside his couture house, he created a boutique-like series of rooms called *Le Coin des Sports*, where he displayed outfits suitable for tennis, riding, boating, and piloting a plane, among others, all properly accessorized. Then, like Chanel, he opened shops in Deauville, Biarritz, and other centers for the vacationing rich, offering chic and leisurely ready-to-wear apparel to his clientele.

Patou is best known for his Cubist sweaters; sleeveless cardigans; long, pleated skirts; and the introduction of his knit bathing suits, which resisted fading and stretching. Patou is also credited with promoting couture among American women. Inspired by the lean American silhouette, he brought six models to Paris from the United States to show his 1924 collection, a move that attracted much attention. He was the first to put his monogram, JP, on sportswear . . . the first designer label. Patou remained a tremendous force in both couture and ready-to-wear until his death. The house has endured, employing such greats as Marc Bohan, Karl Lagerfeld, and Christian Lacroix. The name of the House of Patou's latest fragrance, introduced in 1992, best describes the lasting effects of the couturier's insight and creativity on the modern woman's wardrobe—Sublime. *See also*: Gabrielle Bonheur "Coco" Chanel; Karl Lagerfeld; Christian Lacroix.

REFERENCES

Callan, Georgina O'Hara. *Thames & Hudson Dictionary of Fashion*. New York: Thames and Hudson, 1998.

Edleman, Amy Holman. *The Little Black Dress*. New York: Simon and Schuster, 1997.

Lynam, Ruth, ed. *Couture*. Garden City N.Y.: Doubleday, 1972.

Milbank, Caroline Rennolds. *Couture: The Great Designers*. New York: Stewart, Tabori and Chang, 1985.

S. B.

Walter Plunkett

B. June 5, 1902

D. 1982

Birthplace: Oakland, California

Awards: Academy Award, Costume Design: *An American in Paris* (1951)
　　　　Academy Award Nominations, Costume Design: *The Magnificent Yankee*
　　　　(1950), *Kind Lady* (1951), *The Actress* (1953), *Young Bess* (1953),
　　　　Raintree County (1957), *Some Came Running* (1958), *Pocket Full of*
　　　　Miracles (1961), *How the West Was Won* (1963)

Walter Plunkett gave up the study of law at University of California, Berkeley, to become an actor and became one of the greatest costume designers in movie history. He was known for the elaborate wardrobes he created for Hollywood's most glorious period films. His best known, most influential costumes, in terms of impact on the fashion industry, began with *Cimarron* (1931), in which his dresses for Irene Dunne helped popularize the broad-shouldered silhouette. His success continued with such classics as *Little Women* (1933) and *Mary of Scotland* (1936). For *Little Women*, Plunkett scoured publications from the 1860s, rediscovering and reintroducing ginghams and calicos which were promptly copied for the retail market. Plunkett's designs for *Mary of Scotland*, starring Katherine Hepburn, began several fashion trends, from red satin slippers and velvet berets to suede gloves and gold medallions.

Probably the most attention ever paid to costumes in any film was the result of Plunkett's wardrobe for Vivien Leigh as Scarlett O'Hara in David O. Selznick's epic *Gone with the Wind* (1939). According to fashion historians, Scarlett's green and white "barbecue dress" was the most copied, most coveted dress in movie history. It was produced in dozens of fabrics and price ranges, as was her wedding gown with its huge petticoats and cinched waist.

Plunkett's career started in 1926 when he began working at RKO Studios as an assistant. In 1935 he joined Metro-Goldwyn-Mayer, where he worked until his retirement in 1965. He designed garments for as many as 250 films, and his influence on fashions created by both New York and Paris designers is legendary. His dedication to authenticity and accuracy in his interpretations of historic costume kept audiences entranced and the fashion industry delighted when he created pieces that could be adapted for modern wardrobes. Among his later work was the costuming of Haley Mills in Walt Disney's *Pollyanna* (1960), which inspired drop-waisted dresses with sailor collars, pleated skirts, and ribbon sashes along with dark

stockings or tights, impacting children's clothing producers and retailers as well.

REFERENCES

Engelmeier, Regine, Peter W. Engelmeir, eds., and Barbara Einziq. *Fashion in Film*. Munich, Germany: Prestel-Verlag, 1990.
Maider, Edward. *Hollywood and History*. New York: Thames and Hudson, 1987.

S. B.

Polo

See Ralph Lauren.

Paul Poiret

B. April 20, 1879

D. 1943

Birthplace: Paris, France

Paul Poiret received a baccalaureate in science and business from the Ecole Massillon, all the while sketching and draping fashions inspired by his love of theater and fine art. After school, Poiret's father, a cloth merchant, wanted his son to experience the business world and learn a professional trade, and he secured him an apprenticeship in an umbrella design shop. While working for the umbrella shop, Poiret continued sketching and sold his designs to the couture houses of Cheruit, Worth, Redfern, Doucet, and Paquin.

At nineteen, Jacques Doucet offered Poiret a position in his couture house as an assistant tailor. The position revealed Poiret's true talent for designing. As Poiret honed his sewing, cutting, and pattern-making skills, he earned the respect of Doucet, who eventually allowed him to design clothing for some of his clients. However, Poiret was fired by Doucet after allowing a client to have his designs made by a local dressmaker for a fraction of the cost, instead of by Doucet's seamstresses.

Even though Poiret had an inherent gift for design, he lacked social skills and he did not work well with others. In 1901 Poiret accepted a position with the renowned couturier Charles Frederick Worth, but the two clashed and Poiret departed. Poiret's only option was to open his own house. In

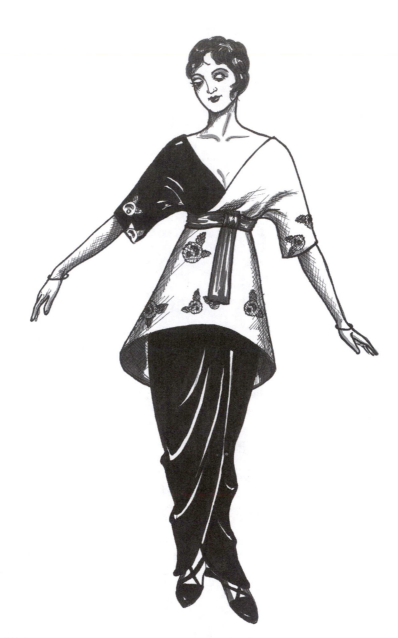

Paul Poiret: Poiret combined elements of Eastern dress into a new fashion silhouette: a dress composed of a draped tunic top and a narrow, pegged skirt. This ensemble freed women from corsets but entombed their legs.

1903 Poiret founded Maison Poiret. The decorative window displays lured clients into Poiret's house, and soon he had a loyal clientele.

Poiret began designing during the Directoire Period, a time when most women were corseted into rigid "S-curve," or monobosom, silhouettes with full skirts. Poiret disapproved of the restrictive fashion, and instead, in 1906, he promoted the empire silhouette with a slim skirt which followed the natural curves of the body. The silhouette he developed was inspired by his wife Denise, whom he wanted to free from corsets, and the drapery of classical Greek dress. Poiret continued to develop new design variations on this same theme, incorporating elements of Eastern dress, such as kimonos, until his designs evolved into a new silhouette: a dress which had the appearance of a tunic and a skirt he paired with a turban.

Poiret aggressively promoted his designs. He created fashion booklets entitled *Les Robes de Paul Poiret* which were illustrated by artist Paul Iribe. He also promoted his designs through lavish garden parties and theme parties where models paraded among guests wearing his fashions. His collections were so successful that they were featured in journals throughout Europe. Between 1909 and 1912, Poiret did something quite unique: He initiated a series of fashion lecture tours across Europe to promote his fashions. He traveled to Berlin, Frankfurt, Munich, and Vienna to present the new, corsetless silhouette he had developed.

Poiret's empire waist, tunic silhouette continued to evolve into another new silhouette, the "Hobble Skirt," a long, straight skirt that was so narrow that the wearer could not take full strides when walking, nor bend at the knee to climb stairs, thus "hobbling" with each step. The silhouette, introduced in 1911, drew worldwide attention and was frequently the subject of satirical drawings mocking women who adopted the fashion. Despite the impracticality, women all around the world adopted the fashion. Almost simultaneously, Poiret introduced another silhouette, harem pants, which gave women's bodies the freedom they deserved. Ironically, this fashion was not widely adopted; it was still considered taboo for women to wear pants.

Excited about his new designs, Poiret decided to begin another lecture tour in 1913, this time in America. Poiret was the first couturier to bring his designs to New York for a fashion show. Much to his surprise and indignation, Poiret discovered that American women were already wearing knock-off versions of his fashions. Enraged, Poiret canceled his tour and returned to Paris. In 1914 Poiret, president of Le Chambre Syndicale de la Couture, convened a meeting to write Le Syndicale de Defense de la Grande Couture Française, legislation that would make it illegal for anyone to copy another's designs. The legislation did not pass until 1950.

During World War I, Poiret enlisted in the French infantry as a tailor, after temporarily closing his couture house. When he returned, he relaunched his couture house, but society and fashions were changing, and Poiret

was not interested in changing with them. In 1922 Poiret arranged a second fashion tour of the United States hoping to sell his "American collection" as samples for exportation. Poiret hoped to find a manufacturer who would buy the samples and pay him royalties for reproducing the designs. Unfortunately, Poiret was not able to find a suitable arrangement for his apparel line, but he did sign an exportation contract with a manufacturer for his accessories.

The 1920s were not kind to Poiret. His designs were out of touch with the new, active woman, and he was forced to close his couture business. He also divorced his wife, who had always been his inspiration. Poiret continued to live an elaborate lifestyle, but he no longer had the financial means to support himself. Attempting to resurrect his career in the 1930s, Poiret accepted a design position with the French department store Printemps, but he soon left. Poiret spent his remaining years in a charity hospital, in relative obscurity, painting until his death in 1943.

In Poiret's brief, but spectacular, career he bridged the gap between nineteenth- and twentieth century fashions; between women as objects and women as active members of society. His work paved the way for designers such as Chanel to create fashions for the new, modern woman in the 1920s. *See also*: Charles Frederick Worth; Paquin; Gabrielle Bonheur "Coco" Chanel.

REFERENCES

Milbank, Caroline Rennolds. *Couture: The Great Designers*. New York: Stewart, Tabore and Chang, 1985.
Morris, Bernadine, and Barbara Walz. *The Fashion Makers*. New York: Random House, 1978.
Murray, Maggie Pexton. *Changing Styles in Fashion: Who, What, Why*. New York: Fairchild Publications, 1989.

N. S.

Prada

Award: CFDA Award, 1993

In 1913 Mario Prada founded Fratelli Prada, a leather-goods company which produced what the Italians call *oggetti di lusso*, objects of luxury, becoming best known for a very expensive leather travel case fitted with crystal vessels. His granddaughter, Miuccia, inherited the company and reluctantly took it over in 1978, at first conflicted about becoming a designer, regarding it as "women's work." She had planned to use her degree in political science and her interest in social issues to do something she

considered "intellectual." As it turned out, she was able to combine her personal convictions with her love of beautiful things—antique fabrics, fine workmanship, and modern art—and become one of the most successful designers of the late twentieth century.

The Prada collections, including secondary line Miu Miu, are all the reflections of Miuccia Prada's own taste and her efforts to create clothing that is not intended for the woman who wants to look like a particular type: a socialite, sexpot, or career woman. Rather, she designs pieces that encourage freedom from what others think and the flexibility to change one's look from moment to moment. Her menswear, shoes, and bags also express her love of combining opposites, like past and present, to create looks that are both new and different—almost kitsch. With one black nylon backpack, she transformed the family leather-goods company into a producer and purveyor of the most coveted, well-made, and unconventional products of the 1990s, from dresses adorned with celluloid strips to outré shoes nominated several times for "worst of the year" status.

Many have tried to define exactly why Prada clothing and accessories were among the most coveted items of the 1990s. Is it the combination of technological fabrics and retro silhouettes, the contrast between feminine touches—like transparency and embroidery and industrial shapes—or the melding of what was and what is next? Of course, there is no single answer, but Miuccia Prada and her husband/partner, Patrizio Bertelli, have made owning anything bearing the Prada label a statement of both status and spirit.

In 1999 Patrizio Bertelli arranged the acquisition of Jil Sander, the twenty-year old German fashion house, in an effort to build a new European luxury goods group. Five months later, due to often reported disputes between Bertelli and founder Jil Sander, she resigned from her position as chief designer, causing a tremendous stir in the fashion world. As of this writing, Prada's plans for its new division are not known. *See also*: Jil Sander.

Website: http://www.prada.com

REFERENCES

Gandee, Charles. "Miuccia Prada Takes Stock of Fashion on the Precipice of the Twenty-first Century." *Vogue* (November 1999): 498.
Horyn, Cathy. "Prada Central." *Vanity Fair* (August 1997): 120.

S. B.

Emilio Pucci

B. November 20, 1914
D. November 29, 1992

Birthplace: Naples, Italy

Awards: Nieman-Marcus Award, 1954, 1967
 Sports Illustrated Award, 1955, 1961
 Burdine Fashion Award, 1955
 Sunday Times Award, London, 1963
 Association of Industrial Design Award, Milan, 1968
 Drexel University Award, 1975
 Italy-Austria Award, 1977
 Knighthood, Rome, 1982
 Medaille de la Ville de Paris, 1985
 Council of Fashion Designers of America Award, 1990
 Fashion Excellence Award, Dallas Fashion Awards, 2000

While many fashion designers draw inspiration from historic periods such as the Renaissance, few can trace their ancestry to that extraordinary time. Emilio Pucci, born Marchese Emilio Pucci di Barsento, has a lineage that dates to thirteenth-century Florence when his ancestors were painted by such artists as Botticelli and Leonardo da Vinci. Pucci, an Italian nobleman, attended the University of Milan (1933–1935) to study agriculture, the University of Georgia (1935–1936) to study animal husbandry, Reed College (1936–1937) to complete a master's of art in social science, and the University of Florence to complete a Ph.D. in political science (1941).

A passion for skiing first brought Pucci into the fashion realm. He designed his own uniform to wear as a member of the 1934 Italian Olympic ski team, and at Reed College he designed uniforms for his entire ski team. These early forays into fashion design landed Pucci a position designing women's ski clothing for Lord and Taylor in 1948 under the White Stag label. Two years later, he opened his own couture house with boutiques across Italy and in New York. The ski pants he designed became the original "Capri" pant. Coco Chanel was the first to introduce pants for women in the 1930s, but Pucci made pants a way of life for women in the 1950s. The Capri pant was the antithesis to Christian Dior's constructed New Look. This sporty casual wear complemented the American woman's new lifestyle. By 1951 Lord and Taylor, Saks Fifth Avenue, Marshall Fields, and Neiman Marcus were ordering large quantities of Pucci's Capri pants, and a sportswear revolution was born.

It is for fabric designs, though, that Pucci became world renowned. Drawing on heraldic banners, nature, architecture, and his world travels, Pucci developed multicolored printed fabrics in geometric and organic patterns. His initial designs placed spaced motifs on solid grounds, but his style quickly evolved into intricately patterned, allover designs featuring up to fifteen different colors. The textile designs were an immediate success. They mirrored the Pop Art of the 1960s, and women became walking can-

vases in swirls of blue, magenta, gold, acid green, and pink. Pucci popularized bright colors for the first time since World War II and made his canvases into short, sexy, clingy clothes for women. His timing was perfect. Women's roles in society were changing, and women were looking for clothing to reflect these changes. The bright, wild prints were constructed into simple silhouettes for dresses, shirts, and sportswear which provided comfortable and practical clothing for the new, active woman. Members of the prosperous American middle class, who sought readily identifiable status symbols, became Pucci's biggest clients, and his tights and silk scarves allowed woman of all classes to own a Pucci. At the peak of his popularity, in the mid-1960s, Pucci was exporting over $1.5 billion a year in apparel products to fifty-nine countries around the world.

Pucci was constantly expanding his business to include new home-furnishing, accessory, and intimate-apparel products. He designed men's shirts, pants, ties, and handkerchiefs, as well as suits lined with his signature prints. In 1967 he designed sheets and towels for Spring Mills. During the 1960s, he launched his own perfumes, Vivara, Zadig, and Signor Pucci, and he became the vice president and designer of intimate apparel for Formfit International. He also developed an elasticized silk shantung fabric manufactured by Trabaldo in the 1960s. He was commissioned to design uniforms for Braniff International Airlines in 1965, uniforms for Qantas Airways in 1974, ceramic vases and dinnerware for Rosenthal China from 1961 to 1977, a Lincoln Continental Mark IV in 1977, a Vespa motorcycle for Fiat in 1977, and candy wrappers with matching scarves for Perugina in the late 1970s. In 1971 he completed his most prestigious commission: designing the emblem for the Apollo 15 Space Mission.

Pucci fabrics may be the most widely copied fashion item ever, something the Pucci family finds both flattering and frustrating. They appear across all price points and throughout all product categories; they are a global phenomenon. After two decades of astonishing success, an oversaturated market, combined with a shift to tailored garments and the popularity of jeans, reduced Pucci to the periphery of fashion in the late 1970s. However, a Pucci Renaissance began in the late-1980s and early 1990s when neon colors and body-conscious fashions became popular. Lycra-clad aerobic classes vibrated with Pucci prints, and the miniskirts of the New Wave music craze were often paired with tights that resonated "Pucci."

Under the creative direction of Pucci's daughter, Laudomia, the Pucci label continues to produce a limited range of products through licensing agreements. In the late 1990s Laudomia brought a series of designers to the House of Pucci, including Stephan Janson and Antonio Berardi, to re-develop the men's and women's collection. However, it was not until 2000 when Pucci was purchased by Moët Hennessey–Louis Vuitton (LVMH) that the Pucci label had the financial backing necessary to mount a full-scale relaunch of the collections. LVMH retained Laudomia Pucci as image

director for the house but hired designer Julio Espada to provide the new creative direction. Espada, born in Puerto Rico, formerly designed for Perry Ellis and Esprit. As the new head designer, Espada was charged with the daunting task of reinterpreting the classic, jet-setting Pucci look for today's market. *See also*: Louis Vuitton; Perry Ellis; Esprit.

REFERENCES

Conti, Samantha. "Newest LVMH Conquest: Jetsetting House of Pucci." *Women's Wear Daily* (February 18, 2000): 1.

"Emilio Pucci Dead at 78." *Women's Wear Daily* 164 (December 1, 1992): 24.

Haber, Holly. "LVMH Primes Pucci Revival." *Women's Wear Daily* (October 26, 2000): 9.

Kennedy, Shirley. *Pucci: A Renaissance in Fashion*. New York: Abbeville Press, 1991.

Shields, Jody. "Pucci." *Vogue* (May 1990): 254.

A. K.

Q

Mary Quant

B. 1934

Birthplace: London, England

Awards: Woman of the Year, London, 1963
 Sunday Times International Fashion Award, London, 1963
 O.B.E. Order of the British Empire, 1966
 British Fashion Council Hall of Fame Award, 1990

Booby traps and bacon savers . . . bras and panty hose, that is, for those who were not around when *the* designer of the 1960s, Mary Quant, started a fashion revolution. Quant opened her first Bazaar store on London's King's Road in 1955 with her husband/partner Alexander Plunkett Greene, and before long she was known throughout the world for creating the look that defined a decade.

Mary Quant's antiestablishment garb was representative of a new era in clothing. Credited with inventing the miniskirt in 1965 (except by André Courrèges, who claims the idea was his), Quant had a style that was appealing to young women for what it represented—freedom and liberation from the ideals of the 1950s. Her clothes put the fun into the anything-goes sixties. She was known for incorporating unlikely fabrics like denim and vinyl into her youthful designs. Along with her contemporaries, Vidal Sassoon, Terence Conran, Rudi Gernreich, Andy Warhol, Twiggy, and the Beatles, all of whom epitomized the spirit of the moment, Mary Quant turned fashion upside down with her new shapes, her outrageous fabrics, and her candy-colored cosmetics.

Mary Quant: Quant captured the rebellious nature of youth with her miniskirts in the 1960s. This youthful fashion phenomenon defined the mod look of the 1960s.

Young people quickly adopted this rebellious anti-grownup mode of dress, thrilled that they finally had access to clothing made just for them. Outraged parents watched as British fashion and music trends swept through Europe and the United States. In 1964 both the Beatles and the miniskirt arrived in America and, within weeks, Mary Quant was the best-known fashion designer in the United States. By 1965 Quant's clothing was available in more than 450 stores in England and the United States. J.C. Penney was the first chain store in America to carry her clothing. Quant's less-expensive group of separates featured short, little, baby-doll skirts worn with baby shoes and English schoolboy-inspired looks including waistcoats and knickers. Called the Ginger Group, this line was distributed throughout the United States as well.

Short shifts, jumpers, oversized sweaters worn as dresses . . . these were some of the silhouettes popularized by Mary Quant, creator of the mod look. Of course, mod clothing needed modern underwear, so in 1965 her first collection of undergarments appeared, featuring a new softness and flexibility which resulted in less curling and twisting of straps and bindings, further demonstrating the freedom and youthful chic embodied by Quant's clothing.

Although Quant's stature as a fashion innovator diminished during the 1970s, she was able to continue building her business through licensing agreements for jewelry, neckties, eyeglasses, and a collection of home fashions, marketed under the name Quant at Home, which included linens and carpets.

Along with her innovative clothing, Quant's makeup helped define the look she had created, with colors ranging from psychedelic brights to frosty neutrals. Introduced in 1966, it was cleverly packaged in a paintbox with crayons and dedicated to the idea that one's skin should not be covered with heavy foundation, an idea that endures today, as does her cosmetics line, which is available throughout Europe and Japan, along with skin-care products. Quant's Madison Avenue boutique, which opened in New York in 1999, offers an extensive selection of makeup, nail polish, and skin-care products plus t-shirts that feature Quant's well-known daisy logo. *See also:* Rudi Gernreich.

Website: http://www.maryquant.co.uk

REFERENCES

Quant, Mary. *Color by Quant*. New York: McGraw-Hill, 1985.
———. *Quant by Quant*. London: Cassell, 1966.
Stegemeyer, Anne. *Who's Who in Fashion*. New York: Fairchild Publications, 1996.
Wells, Gully. "Quantum Leap." *Vogue* (February 1999): 163.

S. B.

R

Paco Rabanne (Francisco Rabaneda-Cuervo)

B. February 18, 1934

Birthplace: San Sebastián, Spain

Awards: Beauty Products Industry Award, 1969
Fragrance Foundation Recognition Award, 1974
L'Aiguille d'Or Award, 1977
Dé d'Or Award (Golden Thimble), 1990
Chevalier de la Légion d'Honneur, 1989
Officier del Ordre d'Isabelle la Catholique, 1989

Paco Rabanne's education in architecture at the Ecole des Beaux-Arts in Paris from 1952 to 1955 prepared him to become one of the most inventive designers of modern times. He combined space-age futurism with architectural fashion to create clothes that were indicative of the 1960s. Instead of working with fabric, he looked to new technologies and materials to create clothing that seemed ahead of its time.

Rabanne started his career as an accessories designer for Cristóba Balenciaga, Hubert de Givenchy, and Christian Dior. He introduced his first collection, aptly titled "Twelve Unwearable Dresses," in 1964 and opened his own house in 1966. Like André Courrèges and Pierre Cardin, Rabanne was inspired by the space race and futuristic technology which permeated world culture during the late 1950s and 1960s.

Rabanne translated this inspiration into variations of chain-mail clothing. Some of these chain-mail designs were made of metal mesh; others were crafted from less predictable items. By linking together materials such

as plastic, metal discs, and aluminum Ping-Pong balls, he created wild and sometimes barely wearable dresses. In one notable 1967 example, he linked bits of fur with metal rings. His experiments with chain mail led to his use of other nonfabric materials including fiber optic wire, paper, plastic bottles, plastic cutlery, and Scotch tape. In 1971 he designed a raincoat molded from a single piece of plastic. Even the buttons were incorporated into the design.

Rabanne's couture designs earned him a reputation of innovation, but these radical designs failed to make money. Ready-to-wear and licensing agreements financially supported Rabanne's artistically extravagant yet impractical couture lines until his last showing in 1999. As the sustenance of the business, licensing agreements numbered 140 by the 1990s. Agreements were signed for products such as bags, belts, home furnishings, leather goods, men's ready-to-wear, scarves, sunglasses, and umbrellas.

The most successful licensing area was fragrance. Since Calandre debuted in the late 1960s, the scents became a financially and popularly successful portion of Rabanne's business. Other fragrances include Paco Rabanne pour Homme (1973), Metal (1979), La Nuit (1985), Sport (1985), Tenere (1988), and XS. The latest fragrance, Paco, was introduced in 1996. This unisex scent coordinated with Rabanne's new brand, Paco, which featured eccentric simplicity and included apparel and accessories sold in Paco boutiques.

Rabanne, who was once considered ahead of the times, enjoyed a renewed popularity of the 1960s during the 1990s. By that time his company was owned by the Puig Group, a Spanish fashion and cosmetics company which also owned Carolina Herrera and Nina Ricci. Over a span of thirty years, Rabanne helped introduce new technologies into clothing manufacture and push fashion forward, forcing designers and consumers to reexamine the concept of couture. See also: André Courrèges; Pierre Cardin; Nina Ricci.

Website: http://www.pacorabanne.com

REFERENCES

Connikie, Yvonne. *Fashions of the Decade: The 1960s*. New York: Facts on File, 1990.

"Paco Rabanne to Discontinue Couture Line After July Show." *Women's Wear Daily* 178 (July 6, 1999): 2.

Raper, Sarah. "Paco's Parade of Fashion Products." *Women's Wear Daily* 171 (February 23, 1996): 6.

A.T.P.

Revlon

See Charles Revson.

Charles Revson

B. October 11, 1906

D. August 24, 1975

Birthplace: Boston, Massachusetts

Charles Revson sold dresses and sales-motivation materials before found-ing Revlon. In 1932 he and his brother, Joseph, teamed up with nail-polish supplier Charles Lachman to distribute nail polish. By combining an "l" for Lachman into Revson, they created the name Revlon. The company marketed a unique nail polish which used pigments instead of dyes to pro-duce a variety of opaque, vivid colors. Department and drugstores carried the product, and in 1933, the first full year of business, sales totaled more than $11,000. By the time Revson died in 1975, Revlon was a multimillion dollar company.

Revson introduced several marketing innovations to the cosmetics in-dustry. During the 1950s he became one of the first cosmetics sponsors of the new medium, television. He paired matching lip and nail colors, and twice a year he launched nail polish and lipstick promotions that were coordinated with seasonal clothing fashions. His most influential marketing practice involved offering multiple brands, such as Natural Wonder and Ultima II, to cater to different market segments. Revlon's innovations, which modernized the cosmetics industry from the 1930s through the 1970s, have become common practices in the industry today.

Revson's approach toward models set a standard for the industry as well. European models were the most fashionable models of the 1960s, but Rev-son popularized the "American Look" by using U.S. models. Also, he used famous models, such as Lauren Hutton in 1973, to promote his products. Continuing the tradition, Revlon's most recent advertisements feature such high-profile models as Halle Berry, Cindy Crawford, Melanie Griffith, and Salma Hayek.

Over the years, Revlon has introduced many new products including a full range of cosmetics, fragrances, hair products, and hair dye. One of its most popular products, Charlie, a bold modern fragrance, was introduced

in the early 1970s. Its advertising campaign capitalized on the rise of the feminism movement and projected the image of a young, independent, confident working woman. The fragrance was immediately successful and became a top-selling fragrance. Currently, Revlon's brands include Revlon, Age Defying, Almay, ColorStay, Flex, Streetwear, and Ultima II.

The company itself has experienced a number of changes over the years. In 1955 it offered its first public stock. Thirty years later the company was sold to a subsidiary of MacAndrews and Forbes Holdings. The company went public again in 1996, and its stock is exchanged on the New York Stock Exchange under the ticker symbol REV. In 1999 Revlon represented 25 percent of the U.S. drugstore cosmetics volume, and Almay accounted for another 8.7 percent.

Website: http://www.revlon.com

REFERENCES

Diamond, Kerry. "Charles Revson." *Women's Wear Daily* 175 (September 28, 1998): 212.
Klepacki, Laura, Thomas Cunningham, and Faye Brookman. "Revlon Stays Its Course." *Women's Wear Daily* 177 (May 14, 1999): 8.
Rawsthorn, Alice. *Yves Saint Laurent: A Biography.* New York: Doubleday, 1996.

A.T.P.

Zandra Rhodes

B. September 19, 1940

Birthplace: Chatham, Kent, England

Awards: Designer of the Year, English Trade Fashion, 1972
 Royal Designer Industry, Royal Society of Arts, 1977
 Fellow of the Society of Industrial Arts, 1978
 Moore College of Art Award, Philadelphia, 1978
 Emmy Award, Best Costumes, "Romeo and Juliet on Ice," 1979
 British Designer, Clothing and Export Council and National Economic Development Committee, 1983
 Women of Distinction Award, Northwood Institute, Dallas, 1986
 Number One Textile Designer, Observer Magazine, 1990
 Hall of Fame Award, British Fashion Council, 1995
 C.B.E. (Commander of the British Empire, Queen Elizabeth II), 1997

Zandra Rhodes was born to a working-class family. Her mother, a fitter at the House of Worth, instilled her love of fashion and a strong work ethic in Rhodes at an early age. Rhodes attended Medway College of Art from 1959 to 1961 to study screen printing and lithography where she was

inspired by textile design instructor Barbara Brown. In 1961 Rhodes reci-
eved a scholarship to attend the Royal College of Art, and she graduated
in 1964 with a degree in home furnishings textile design.

After college, Rhodes established a dressmaking firm with Sylvia Ayton
in 1964 and a textile design studio with Alexander McIntyre in 1965, and
she became a partner and designer in the Fulham Clothes Shop from 1967
to 1968. Struggling to establish herself, Rhodes worked as a freelance de-
signer from 1968 to 1975, producing her first apparel line in 1969 which
was purchased by Fortnum and Mason. In 1975 Rhodes launched Zandra
Rhodes UK, Ltd., and Zandra Rhodes Shops, Ltd., with partners Anne
Knight and Ronnie Stirling.

Rhodes is primarily known as a print designer and colorist. She entered
the fashion industry during 1960s swinging London, and was influenced
by pop artists Roy Lichtenstein and Andy Warhol as well as textile designer
Emilio Pucci. Rhodes draws her inspiration from everyday objects, nature,
and textures. She works by repeatedly sketching motifs until they are highly
stylized and abstract. Her prints contain whimsical interpretations of lip-
stick tubes, lightbulbs, shells, lilies, chain knits, laces, ruffles, and feathers.
Rhodes brought the pop art of the 1960s to textile design and, in turn, to
apparel design. The silhouettes of Rhodes's apparel are dictated by the
textile design. Her tendency to design large-scale directional motifs places
limitations on the apparel she can design. Rhodes primarily designs gar-
ments with long flowing panels to show her textiles motifs to their full
advantage.

Rhodes has expanded her business through several product lines and
licensing aggreements. In 1976 she licensed Wamsutta to produce her first
collection of bedding, in 1977 she launched a line of lingerie, and in 1991
she created a line of men's ties from her signature prints. Fabergé intro-
duced Zandra Rhodes, her first fragance, in 1983, followed by Brut Royale
for men. In 1996 Rhodes launched Zandra Rhodes II, a ready-to-wear
collection featuring hand-painted silks, followed by the "Zandra by the
Sea" ready-to-wear collection in 1997. She also contributed costume de-
signs to the 1970 production of *Georgy* and designed costumes for the rock
group Queen. *See also*: Emilio Pucci.

Website: http://www.zandrarhodes.com

REFERENCES

Rhodes, Zandra (with Anne Knight). *The Art of Zandra Rhodes*. New York: Zan-
 dra Rhodes, 1985.
Schaeffer, Claire B. "Zandra Rhodes Couture." *Threads* (June/July 1990).
Steele, Valerie. *Women of Fashion: 20th Century Designers*. New York: Rizzoli,
 1991.

A. K.

Nina (Mari Nielli) Ricci

B. 1883

D. November 29, 1970

Birthplace: Turin, Italy

Awards: Fragrance Foundation Hall of Fame Award, 1982
 Dé d'Or Award (Golden Thimble), 1987
 Chevalier de la Légion d'Honneur,
 Bijorca d'Or Award, 1987, 1988
 Fragrance Foundation Perennial Success Award, 1988
 Venus de la Beauté, 1990
 Trophée International Pardum/Couture, 1991
 Prix d'Excellence "Créavitié," 1992
 Trophée de la Beauté de Dépêche Mode, 1992
 Prix Europeen de la P.L.V., 1992
 L'Oscar du Mecenat d'Entreprises, 1993

Nina Ricci, born Maria Nielli in Turin, Italy, moved to France at age seven with her family. Ricci was drawn to the fashion business early in life; at fourteen, she apprenticed to a Parisian dressmaker, at eighteen she was head of the atelier, and at twenty-two she became the chief designer. At age forty-nine, Ricci finally decided to open her own fashion house.

Founded in 1932, Nina Ricci is one of the longest standing fashion houses in Paris. Ricci's couture designs have long been a symbol of Parisian elegance: feminine, understated, chic designs for society women. Ricci retired in 1954, naming Jules François Crahay as head designer. In 1964 Gérard Pipart replaced Crahay as head designer. Pipart continued Ricci's tradition of designing fashionable, feminine apparel with every gather, tuck, and drape positioned to flatter the mature figure.

Ricci's greatest success came through her perfume business, Nina Ricci Parfums SA. Coeur-Joie was introduced in 1946, followed by L'Air du Temps in 1948, Capricci in 1961, Farouche in 1974, Signoricci in 1975, Fleur de Fleurs in 1980, Nina in 1987, and Ricci Club in 1989. L'Air du Temps, Ricci's most successful perfume, celebrated its fiftieth anniversary in 1998. Originally distributed through mass merchandisers like J.C. Penney's, the scent has been repositioned for distribution through department stores. In 1993 Ricci also expanded into cosmetics and skin treatments with the line Le Teint Ricci.

The house was under the direction of Ricci's son Robert from 1954 until his death in 1988. Robert Ricci expanded the house to include women's ready-to-wear, menswear, lingerie, and accessories, and he contracted nu-

merous licensing agreements. Since the late 1980s Nina Ricci has struggled through many financial difficulties. In 1998 the Sanofi Company sold their controlling interest in Nina Ricci to the Puig Group who discontinued Ricci's signature collection, but retained production of two of the diffusion or secondary lines, and continues to concentrate on the perfume business.

Website: http://www.ninaricci.fr

REFERENCES

"Nina Ricci" Fashion Live website available from http://www.worldmedia.fr/fashion/

Raper, Sarah. "Nina Ricci: Staying a Family Affair." *Women's Wear Daily* 164 (July 20, 1992): 6–8.

A. K.

Marcel Rochas

B. 1902

D. 1954

Birthplace: Paris, France

In 1924 Marcel Rochas abandoned his career as a lawyer to open a couture house as a means to provide his attractive, new wife with appropriately exquisite clothes. Soon after opening the house, he became known for his innovative and unique designs. During the 1920s he introduced blouses that were designed to be worn with men's neckties and dramatic beach pajamas with pleats inset at the knees.

The 1930s were the years of Rochas's greatest innovation: He introduced a gray flannel trouser suit in 1932 and alleged that he had coined the word "slacks" in the early 1930s. The idea of pants as street wear was revolutionary in an age when women wore trousers only for recreation or extremely informal situations. The trouser suit seemed to embody his guiding principle of "Youth, Simplicity and Personality." Along with Gilbert Adrian and Elsa Schiaparelli, Rochas introduced the exaggerated, padded shoulders that characterized the 1930s. Rochas's inspiration for the shoulder came from the costumes of Javanese and Balinese dancers at the 1931 Exposition Coloniale. He expanded his business in 1937, when he opened a store in New York which sold both ready-to-wear and made-to-order clothes.

During the 1940s, Rochas seemed to anticipate the direction in which fashion trends were heading. In 1941 his designs included longer skirts, a trend that reemerged in 1947 as part of the New Look. In 1942 he pre-

sented the *guêpière*, a corset that created a wasp waist, another key aspect of the New Look.

Throughout his career, Rochas incorporated drama and uniqueness into his designs. He often used unusual and witty prints and buttons, such as burlap print cloth and buttons in the shape of lipstick. Sometimes, the designs themselves were the focal point. Crocheted beach shorts and a tweed coat with an empire waist were among his distinctive creations.

In 1944 Rochas established his perfume company with the introduction of Femme, a perfume he dedicated to his third wife Hélène as a wedding present. The packaging of the perfume included black lace from his *guêpière* corset. After Rochas's death, Hélène gained control of the company, and two perfumes were added: Madame Rochas in 1960 and Mystère in 1978. Madame Rochas is still produced and sold today.

In addition to designing fashion garments, Rochas designed costumes for the films *L'Eternal Retour* (1943) and *Falbalas* (1944). Also, in 1950, he published *25 Years of Elegance*, a book which examines the relationships between fashion, society, and art. In 1953 he closed his house and died a year later. *See also*: Christian Dior.

REFERENCES

Martin, Richard, ed. *Contemporary Fashion*. New York: St. James Press, 1995.

Milbank, Caroline Rennolds. *Couture: The Great Designers*. New York: Stewart, Tabori and Chang, 1985.

O'Hara, Georgina. *The Encyclopedia of Fashion*. New York: Harry N. Abrams, 1986.

A.T.P.

Sonia Rykiel

B. 1930

Birthplace: Paris, France

Awards: Oscar for Contributions to the Fashion Industry, Fashion Group International, 1986

Officier de l'Ordre des Arts et Lettres, French Minister of Culture, 1993

Award for Design Excellence, Chicago Historical Society's Costume Committee, 1994

Officier de l'Ordre National de la Légion d'Honneur, French Minister of Culture, 1996

Sonia Rykiel, the "Queen of Knits," began designing slim, sophisticated knitwear in 1962 when she was pregnant and unable to find soft sweater-like maternity clothes. The rest, as they say, is fashion history.

Rykiel turned French fashion upside down when she first introduced her knitwear ensembles. Known for her sleek and fluid knits, including shrunken poor boys, wide trousers, and cardigan sweaters with raglan sleeves, Rykiel has built an empire that has even been the subject of a song, "Who in the Hell Is Sonia Rykiel?" by Malcolm McClaren, as well as a film, *Prêt à Porter* by Robert Altman.

She trims her knits with marabou, creates rhinestone bras to be worn under long knitted coats, and puts fox stoles over tiny striped sweaters; whatever she creates, "Coco Rykiel," as she is called by some, does it with complete devotion. From the opening of her first boutique in 1968 in the Saint Germain-des-Pres area of Paris to being the first to offer designer clothing by mail, this author, interior designer, and illustrator has enjoyed over thirty years of international fame.

Rykiel's approach to fashion is playful, unexpected, and witty. She mixes and matches and shows clothing with seams on the outsides of her garments. She puts velvet in her jogging togs and Lurex in her loungewear. She has "dressed" the rooms of hotels and hospitals (Hôtel de Crillon, Hôtel Lutetia, and the American Hospital of Paris); she has created costumes for the theater; and she has recorded albums and appeared in film. Her licensed products include a Laguiole knife, stationery, fragrances, ties, eyeglasses, watches, and porcelain dinnerware. In addition, she has written five books, including a novel, and she is an active member of the Association of Women Writers.

Her boutiques around the world feature not only her irreverent and irresistible women's wear, but also a children's line, Sonia Rykiel Enfant, and a men's line, Rykiel Homme. In 1999 she celebrated thirty years in fashion. It should come as no surprise that the Pierre Guillot rosaries has created the Sonia Rykiel Rose, a tribute to one of the true flowers of French fashion.

Website: http://www.soniarykiel.fr

REFERENCES

Martin, Richard, ed. *The St. James Fashion Encyclopedia: A Survey of Style from 1945 to the Present.* Detroit: Visible Ink Press. 1996.
Mauries, Patrick. *Sonia Rykiel.* France: Editions Assouline, 1997.
Milbank, Caroline Rennolds. *Couture: The Great Designers.* New York: Stewart, Tabori and Chang, 1985.
Watson, Linda. *Vogue: Twentieth-Century Fashion.* London: Carlton Books, 2000.

S. B.

S

Yves Saint Laurent (Yves Mathieu-Saint-Laurent)

B. 1936

Birthplace: Oran, Algeria

Awards: Third Prize, International Wool Secretariat, 1953
First Prize, International Wool Secretariat, 1954
International Fashion Award, Council of Fashion Designers of America, 1982
Yves Saint Laurent: 25 Years of Design, Metropolitan Museum of Art, 1983
Chevalier de la Légion d'Honneur, 1985

Yves Saint Laurent began designing in the 1950s, an era when women were expected to conform to a traditional feminine ideal. As he continued to design, women's roles began to change as women fought for civil, reproductive, and workplace rights. His designs helped define the new image of the assertive, independent 1970s woman.

In 1936 Oran, Algeria, was an exotic country populated by French and Arabs. Yves Saint Laurent was born to a French bourgeois family who resided in this North African city on the coast of the Mediterranean Sea. His upbringing in Oran and his frequent childhood visits to Paris had a lifelong impact on his interests, inspirations, and designs. Fascinated by art and the theater, young Saint Laurent entertained himself by drawing theater costumes and set designs.

Saint Laurent's design talent was formally recognized in 1953 when he

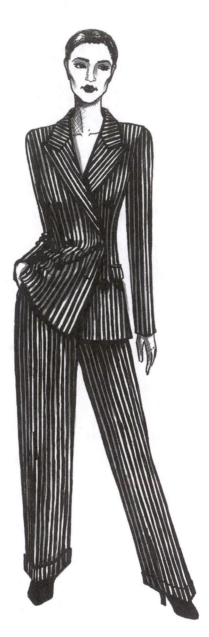

Yves Saint Laurent: Yves Saint Laurent introduced the androgynous trouser suit ensemble for women in 1966. The trouser suit became the symbol for equality for the new assertive, independent woman of the 1970s.

won third prize in the International Wool Secretariat competition. A year later, the seventeen-year-old Saint Laurent won first prize in three out of four categories in the competition. Shortly after receiving the prize, he met with the editor of Paris *Vogue*, Michel de Brunhoff, who encouraged him to attend the Ecole Chambre Syndicale de la Couture Parisienne. While attending the school he created a portfolio which further impressed de Brunhoff, prompting the editor to introduce him to Christian Dior.

Like de Brunhoff, Dior immediately recognized Saint Laurent's potential and hired the young man as his first and only design assistant. Dior incorporated many of Saint Laurent's design ideas into his collections, including a long, narrow evening dress with an asymmetric swag of material. This dress was immortalized in a Richard Avedon photograph of Suzy Parker, who posed between two elephants while wearing the striking dress. When Dior succumbed to a fatal heart attack in 1957, Saint Laurent was named the chief designer of Dior's couture house.

Following Dior's tradition of dictating a new silhouette each season, Saint Laurent's first collection was the well-received "Trapeze" line, which introduced a trapezoidal silhouette. The House of Dior built its reputation by catering to wealthy, middle-aged woman. In 1960 Saint Laurent, who was attracted by the emerging youth movement, began designing couture interpretations of street clothes instead of designing for Dior's loyal clientele.

His spring/summer 1960 collection, the "Beat Look," featured an outrageous black crocodile skin jacket with mink trim and a black mink "crash helmet." Dior's customers, who were accustomed to traditional feminine designs, were appalled by this new collection. Shortly thereafter, Saint Laurent began his compulsory military service, which resulted in his first nervous breakdown in a long history of depression. Upon his return from service, he found that Marc Bohan had replaced him as head designer at Dior.

The following year, Saint Laurent won a legal suit against the House of Dior for unfair dismissal. During that same year, Saint Laurent and Pierre Bergé became business partners and secured funding from an American businessman, J. Mack Robinson, to open Saint Laurent's own house. Cassandre designed his intertwined YSL logo in 1961. His first couture collection, unveiled in 1962, received mixed reviews from critics.

Despite this uncertain start, the 1960s proved to be Saint Laurent's decade of successful innovation. Using the geometric paintings of Dutch abstractionist Piet Mondrian as inspiration, he created the critically acclaimed "Modrian" dresses in 1965. Acclaim turned to controversy in 1966 when he debuted his "Pop Art" collection inspired by the work of Andy Warhol, Tom Wesselman, and Roy Lichtenstein. Since then, museums and fashion historians have recognized these dresses as masterful reflections of modern art's permeation into all aspects of 1960s society.

During the 1960s, Western society renewed its fascination and appreciation of ethnicity, especially the exotic and diverse cultures of Africa. Saint Laurent helped fuel this interest of ethnicity with his 1967 collection inspired by African art. His slinky dresses in brown African-print fabrics embellished by strands of wood and glass beads complemented the rail-thin figure of popular model Twiggy. The following year he introduced his safari jacket, a signature style he reinvented numerous times. His 1982 version featured a longer peplum and heavier gabardine.

The trouser suit proved to be Saint Laurent's most influential and lasting statement of the 1960s. Although women had worn trousers since the 1920s, it was not until Saint Laurent introduced the trouser suit in 1966 that they became acceptable for women to wear on the street or in the office. During the mid-1960s feminism emanated from academic circles to emerge as a popular movement. Women were establishing careers, fighting for contraception, and seeking to improve their legal rights, and the trouser suit symbolized their goal of equality.

Widespread acceptance of the trouser suit was not immediate. Women who wore the new fashion trend were sometimes banned from restaurants. Despite early opposition to the trouser suit, however, it became an integral part of a woman's wardrobe during the 1970s, and Saint Laurent crafted hundreds of different variations including the famous smokings, his women's tuxedos.

Another of Saint Laurent's notable designs, the transparent look, originated during the dynamic 1960s. He debuted this see-through look in 1966 with a sheer organza dress which revealed the breasts. Continuing this theme through the 1970s, 1980s, and 1990s, he translated the look into blouses for pinstripe suits, sequined shifts, and lace tank tops. The transparent look shocked people in the 1960s but became acceptably sensuous in the more sexually liberated 1970s.

In keeping with Saint Laurent's attraction to the youth movement, he opened the first Rive Gauche boutique in Paris in 1966. Aimed at younger women, the boutique stocked a full range of ready-to-wear clothes and accessories at lower prices than the couture line. The store was an immediate financial success. In 1969 he opened a Rive Gauche store in London and introduced a Rive Gauche men's line. Eventually, Rive Gauche expanded to 160 branches worldwide.

In addition to fashion design, Saint Laurent pursued theater design during the 1960s. He designed sets and costumes for numerous plays and ballets. When he designed Catherine Deneuve's wardrobe for *Belle de Jour* in 1965, he initiated a lifelong friendship with the actress.

The 1970s marked a transition for Yves Saint Laurent, the company. Charles of the Ritz, a subsidiary of Squibb, had purchased J. Mack Robinson's interest in the company in 1965. In 1972 Saint Laurent and Pierre

Bergé purchased the fashion house from Squibb for $1.1 million. For the remainder of the 1970s and much of the 1980s, Saint Laurent and Bergé retained almost absolute control over the business.

Realizing the importance of his growing ready-to-wear business, Saint Laurent announced in 1971 that he would stop showing haute couture to concentrate on prêt-à-porter. That same year he introduced Rive Gauche perfume. His hiatus from haute couture was relatively brief, as he quickly discovered that the haute couture collections fueled the demand for ready-to-wear clothing. For much of the decade, Saint Laurent designed collections that emphasized classic styles and reinvented versions of his standard pieces: the smoking, the trouser suit, the tunic, and the safari jacket.

Eau Libre, Saint Laurent's genderless scent, was introduced in the midst of the lean, simple styles and the sexual ambiguity of the mid-1970s. Intended to appeal to both sexes, the cool, crisp scent seemed appropriately timed during this period of heightened gay rights and popular androgynous glam rock stars. Its advertising featured an image of one black and one white hand clutching a bottle of Eau Libre. The image strongly resembles the popular and successful Benetton ads of the 1980s, but the imagery was too provocative for the 1970s; some publications refused to carry the advertisement. Eventually Eau Libre's poor sales forced it off the market. Judging by the popularity of cK One during the 1990s, Eau Libre was ahead of its time.

The luxurious "Ballet Russes" collection of 1976 was a dramatic departure from Saint Laurent's other designs of the 1970s. The extravagance of this collection was in tune with the decadence of the emerging disco scene. Sweeping skirts, heavily embroidered fabrics, and fur trim epitomized this highly praised collection. Shortly thereafter, ethnic fashions at every price point proliferated on the fashion scene.

Saint Laurent himself capitalized on the success of the Ballet Russes collection by launching the perfume Opium in 1977, which immediately achieved high sales. His 1977 Chinese collection had qualities that were similar to the Ballet Russes collection, but it did not achieve equal acclaim. In 1978 he introduced a cosmetics line, and the dramatic No. 19 purple lipstick became the line's most popular product.

During the 1980s and 1990s, Saint Laurent's stylish suits became a central theme in his collections. Also, he introduced the exquisitely embroidered "Sunflowers" and "Irises" jackets in 1988. During these two decades, Saint Laurent spent less and less time designing. Embroiled in financing issues, the company went public in 1989.

Elf-Sanofi, a French pharmaceutical company, purchased YSL in 1993. Upon introducing YSL's new fragrance, Champagne, the company embarked upon a two-year legal battle with the champagne industry, resulting in YSL's loss of the use of the name in 1995. In 1994 Saint Laurent became

the first designer to present his haute couture collection on the Internet, and he designed all of the stadium and formal dress worn by officials and organizing committee members of the 1998 World Cup of Soccer.

Capitalizing on his early successes, Saint Laurent licensed his name to lines of men's ties and women's stockings in the early 1960s. During the 1970s, Saint Laurent and Bergé signed over 190 licensing deals to produce 130 products, including sunglasses, scarves, belts, shirts, handbags, and even cigarettes. Although the company had exploited the full financial potential of its name, it failed to maintain rigorous control over the licensees. The reputation of the company eroded during the 1980s as lax licensees inundated the market with poor-quality products bearing the Yves Saint Laurent name.

The licenses that had made Saint Laurent a household name were destroying the exclusivity of the name. Bergé countered the decay of the brand image in 1992 by becoming more involved in the designing and marketing of licensed products and imposing stricter control over licensees. In the 1990s, the licensing business experienced a boom owing to the sudden popularity of YSL men's sportswear among British soccer fans.

Saint Laurent's influences on fashion are numerous. He was one of the first designers to employ the trickle-up theory of fashion by creating couture versions of street clothes. His interest in African and Eastern ethnic motifs in fashion was immediately copied by other designers. Finally, his trouser suit became the uniform of the new assertive, liberated woman of the 1970s and 1980s. *See also*: Christian Dior.

Website: http://www.yslonline.com

REFERENCES

Connikie, Yvonne. *Fashions of the Decade: The 1960s*. New York: Facts on File, 1990.

Milbank, Caroline Rennolds. *Couture: The Great Designers*. New York: Stewart, Tabori and Chang, 1985.

Rawsthorn, Alice. *Yves Saint Laurent: A Biography*. New York: Doubleday, 1996.

<div align="right">A.T.P.</div>

<div align="center">❧❦❧</div>

Fernando Sanchez

B. 1934

Birthplace: Spain

Awards: International Wool Secretariat Competition, 1954
 Coty Special Award for Lingerie, 1974
 Fashion Critics Award, 1975, 1981
 Fashion Designers of America Award, 1981

Sanchez began his design training at the Ecole de la Chambre Syndicale de la Couture Parisienne, the school he attended from 1951 to 1953. Afterward, Maggy Rouff employed him as assistant designer until 1956, when he went to work for Christian Dior. At Dior, he spent two years designing for Dior Boutiques and then created knitwear and lingerie designs for the company in the 1960s. From 1961 to 1973, and again from 1984 to 1985, he designed fur for Revillon.

In 1973 Sanchez opened his own company. He quickly gained a reputation for loungewear separates. Sanchez's coordinating camisoles, pajama pants, jackets, robes, and slip dresses appealed to women in the 1970s, who were attracted by the individuality that they could achieve by creating different combinations. He frequently used synthetic satin to produce a fluid drape in his garments. In the 1980s, the decade in which he introduced his ready-to-wear line, he began using lace appliqués, most notably his trademark fan-shaped motif. Sanchez was one of the first designers to promote underwear as outerwear, and he continues to focus on this area of design today. *See also*: Christian Dior.

Website: http://www.fernandosanchezltd.com

REFERENCES

Martin, Richard, ed. *Contemporary Fashion*. New York: St. James Press, 1995.
Milbank, Caroline Rennolds. *New York Fashion: The Evolution of American Style*. New York: Harry N. Abrams, 1989.
Rawsthorn, Alice. *Yves Saint Laurent: A Biography*. New York: Doubleday, 1996.

A.T.P.

Jil Sander

B. 1942

Birthplace: Wesselburen, Germany

"Pure" is the word most often used by Jil Sander's many admirers, not "poor," as those who do not appreciate her clothing aesthetic might view it. Pared down, minimal, simple, and androgynous are other words that describe her creations along with modern, elitist, luxe, and elegant. By 1999 Sander was head of a company generating more than $200 million a year, producing clothing, cosmetics, and perfume coveted by men and women who understand her no nonsense, unadorned vision of quiet beauty.

Born outside of Hamburg in 1942, Sander is referred to by many as the Coco Chanel of Germany as well as the queen of good taste and understatement, characteristics highly valued by the country's well-to-do. She was the first German fashion designer to show a ready-to-wear collection

in Milan and is often compared to Giorgio Armani. Each takes credit for the invention of the unlined jacket, and each likes simplicity of line and color. All three—Chanel, Armani, and Sander—created clothing that answered the needs of the modern women of their time. But Sander's almost sterile suit is probably the most basic "uniform" a liberated woman has ever been offered: the most severe, the most unglamorous, and the most discreet, a kind of secret only the wealthiest can afford, fabricated from the finest cashmeres, wools, silks, and linens.

Sander's menswear collections reflect the same exclusivity and simplicity as her women's wear. Even her fragrances express this cool chic. The most famous, called No. 4 (named with a number, à la Chanel), is presented in a cleanly shaped bottle and smells straightforwardly fresh. Her perfume, skin-care, and cosmetics lines, manufactured and distributed by Lancaster Group AG, are ranked as top sellers among the unpretentious rich of Austria, Germany, and Switzerland. Other licensed products include small leather goods produced by Goldpfiel and eyewear produced by Menrad, both German companies. However, in 1999, the Jil Sander company was acquired by Italy's Prada Group; therefore, it is likely that other licensing agreements will be made with non-German companies. To Sander and her devotees, one thing will always be true: overdesigned, overdecorated *anything* is never stylish. True power lies in understatement.

In late January 2000, just five months after Jil Sander AG was purchased by the Prada Group, Prada Chief Patrizio Bertelli announced that Jil Sander, founder of the fashion house, had resigned her position as chairman and chief designer. As of this writing, Sander's last collection for the company was her fall-winter 2000 collection. *See also*: Gabrielle Bonheur "Coco" Chanel; Giorgio Armani; Prada.

Website: http://www.jilsander.com

REFERENCES

Buck, Genevieve. "Jil Sander Designs Expansion." *Chicago Tribune* (September 19, 1994): 4, 1.
Colacello, Bob. "The Queen of Less Wants More." *Vanity Fair* 57 (October 1994): 202.
Conti, Samantha, and Luisa Zargani. "The End of the Affair." *Women's Wear Daily* 179 (January 2000): 1.

S. B.

Elsa Schiaparelli

B. September 10, 1890
D. November 14, 1973

Birthplace: Rome, Italy

Awards: Neiman Marcus Award, 1940 *Hommage à Elsa Schiaparelli*, Pavillion des
 Arts, Paris, 1984
 Fashion and Surrealism, Fashion Institute of Technology, and Victoria
 and Albert Museum, London, 1987–1988

Schiapperelli experimented with art and wit to create outrageously fun
clothes which captured the fascination with fantasy of the 1930s. This ad-
venturous designer revised the idea of chic for the modern woman. To her,
designing was not a job, it was an art.

Interestingly, this rebel of the fashion world had a conservative, Italian
upbringing. After she married, she moved to New York in 1919. Soon after
her daughter was born, her husband abandoned her, and she moved to
Paris in 1923.

Schiaparelli 's first designs were gowns she created for herself and her
friends in 1915. She showed her first collection in 1925 and opened the
House of Schiaparelli in 1928. Her early designs focused on sportswear.
One of her first successes was the trompe l'oeil sweater which was deco-
rated with a bow that was knitted along the neckline. The house was an
instant success, and it offered clothes for golf, skiing, swimming, and tennis.

In 1930 she added day wear and evening wear to her already popular
sportswear. This was the beginning of her heyday. Her slender, sinuous
dresses and suits epitomized the silhouette of the decade. She opened a
branch in London in 1933 and a Paris boutique in 1935.

Schiaparelli closed the house during World War II and reopened it in
1945. Like many other French designers after the war, she found that her
formula for success no longer worked. Her whimsical designs did not ap-
peal to war-weary European women, and she stopped creating couture gar-
ments in 1954. She continued to license items, including costume jewelry,
stockings, sunglasses, swimsuits, men's ties, and wigs.

Although Schiaparelli's period of popularity was short, her influence on
fashion was great. She was the first couturier to feature zippers as a style
element. She first used brightly colored zippers on sportswear in 1930. Then
she used them again in 1935 on evening dresses. While other designers were
using zippers simply as a fastener, Schiaparelli was using them to create
visual interest in garments.

The use of playful buttons and unusual materials was another of Schia-
parelli's trademarks. She used buttons in the shape of astrological symbols,
bullets, bumblebees, clowns, drums, and peanuts. Rhodophane, cellophane,
anthracite (a type of rayon), and treebark (a crinkled matte crepe) were
among her fabric choices. In 1938 one of her collections featured a circus
theme complete with acrobat-shaped buttons and carousel horses decorat-
ing a silk brocade jacket.

Many people considered Schiaparelli's designs to be shocking, which was often her intent. In 1936 she introduced her trademark color which she called "shocking pink." It was a bright pink color, and its popularity led to the unveiling of Shocking perfume in 1937. This was not her first fragrance; she had presented Salut, Soucis, and Schiap in 1934. Her other fragrances included Sleeping (1938), Snuff for Men (1939), Le Roi Soleil (1946), Zut (1948), Succès Fou (1953), Si (1957), and S (1962).

Inspired by the leading artists of her day, she played with the ideas of fashion and good taste. As the Dada art movement mocked good art, Schiaparelli mocked fashion by creating hats in the shape of lamb cutlets, brains, and shoes. She commissioned such artists as Christian Bérard, Jean Cocteau, and Salvador Dalí to design embellishments ranging from a beaded depiction of a woman's head to a drawer-pull style pocket. Renowned jewelry designer Jean Schlumberger created some of her costume jewelry and buttons.

Schiaparelli's adventure and wit created some of the most memorable clothes during a period of depression in the United States and Europe. She helped redefine the notion of fashion and good taste. Finally, she connected the contemporary art movements to fashion design. *See also*: Hubert de Givenchy.

REFERENCES

Milbank, Caroline Rennolds. *Couture: The Great Designers*. New York: Stewart, Tabori and Chang 1985.
Schiaparelli, Elsa. *Shocking Life*. New York: Dutton, 1954.
White, Palmer. *Elsa Schiaparelli: Empress of Paris Fashion*. London: Aurum Press, 1995.

A.T.P.

Sears, Roebuck and Company

Richard Warren Sears, one of the pioneers of mail order, contributed to the fashion industry by introducing new strategies for marketing apparel. He entered into the mail order business in 1886 when he founded the R.W. Sears Watch Company in North Redwood, Minnesota. As the middleman between watchmakers and the railroad station managers who sold the watches, Sears concentrated on low profit margins, rapid turnover, and high volume. This strategy was successful because he supported it with extensive advertising to attain a wider customer base.

In 1887 he moved the company to Chicago and took on Alvah Curtis Roebuck, a watchmaker, as his partner. Two years later, they sold the

business for $70,000, and started a new mail-order business. The new venture sold watches and other jewelry through a catalog which featured satisfaction guarantees and extravagant product claims written by Richard Sears. By 1893 the company was selling merchandise ranging from clothing and china to fishing tackle and firearms. In that same year, the company adopted the name of Sears, Roebuck and Company.

In 1895 Sears, Roebuck and Company produced a 532-page catalog with a rapidly growing circulation. In 1907 the company distributed more than 3 million catalogs, and by 1927 that number was 15 million. To meet its printing needs, Sears, Roebuck and Company constructed its own printing plant in 1903.

Richard Sears used several techniques to increase the distribution of catalogs including advertising in magazines and setting up distribution networks. The networks were headed by a distributor, who received batches of catalogs. The distributor passed out the catalogs and received premiums based on the amount of sales resulting from the distributed catalogs.

In 1895 Julius Rosenwald bought into the company and became its vice president. He handled organization and administration, while Sears continued to focus on marketing. Roebuck resigned owing to poor health. The company went public when Sears and Rosenwald sold stock to acquire capital in 1906.

Robert E. Wood, who would later become president and board chairman of Sears, Roebuck and Company, led the company's expansion into retail stores. By 1920 the United States had transformed from a rural to an urban nation, and customers were no longer limited to shopping from catalogs. Wood took advantage of this trend and opened an experimental store in the company's Chicago mail plant in 1925. The store was so successful that he opened seven additional stores by the end of the year. By 1933 Sears, Roebuck and Company operated 400 stores.

In the 1930s store sales began to exceed catalog sales. To maximize store sales, Sears created a store planning and display department in 1932. The department designed new store buildings around the merchandise. By focusing on customer flow and the requirements of merchandise, the department designed the store from the inside out. The first store designed using this innovative concept opened in 1935 in Glendale, California.

By 1969 Sears was so successful that it began building the 1,454-foot Sears Tower in downtown Chicago, which was the world's tallest building when it was opened in 1973. During the 1980s, the company expanded, and the retail portion of the business was renamed the Sears Merchandising Group. The parent company, Sears, Roebuck and Company also owned Allstate Insurance Group, Dean Witter Reynolds Organization, Inc., Coldwell Banker and Company, Sears World Trade, and the Discover Card.

During the 1990s, the company restructured. The Sears Merchandise Group shut the doors on many of its underperforming department stores,

specialty stores, and catalog merchandise distribution operations. Then Sears divested Dean Witter, Allstate, Coldwell Banker, the Sears Mortgage Banking Group, and the Homart Development Company. At the same time, the company moved its corporate headquarters from the Sears Tower to Hoffman Estates, Illinois.

By the end of 1997, Sears operated 833 department stores and 1,325 furniture, hardware, and automotive parts stores. In Canada, it owned 110 full-line stores and eight furniture stores. In the 1990s, the company returned its focus to retail, the aspect of the business that had made it a successful company from the beginning. Although its origins lie in catalog retailing, in today's society, Sears has found more profit in store retailing.

Website: http://www.sears.com

REFERENCES

Emmet, Boris, and John E. Jeuck. *Catalogues and Counters: A History of Sears, Roebuck and Company.* Chicago: University of Chicago Press, 1950.
"Profile of the Week: Sears, Roebuck and Co." *Advertising Age* 69 (December 14, 1998): 52.
Sansoni, Silvia. "The Odd Couple." *Forbes* 162 (October 19, 1998): 56.

A.T.P.

Skechers

After graduating from beauty school, Robert Greenberg owned and operated several wig stores in the Boston area. Tired of the cold Boston winters, Greenberg left Boston for Los Angeles in 1978 where he opened a roller-skate rental shop. Sunny, warm California was the birthplace of the fitness craze that swept the United States in the late 1970s and early 1980s. People everywhere were becoming more health conscious, working out to Jane Fonda's tapes, jogging, and joining gyms, and Greenberg saw an opportunity to capitalize on this trend. In 1983 Greenberg founded L.A. Gear to provide fashionable athletic footwear for this new breed of dedicated and not-so-dedicated athletes. By 1990 the popularity of the athletic look had faded, and L.A. Gear, having failed to adapt their limited product line to the changing marketplace, defaulted on their bank covenant and witnessed their stock crash. Greenberg, and his son, Michael, were both ousted by investors.

Two years later, in 1992, Greenberg, with his son Michael, founded a new footwear company, Skechers, in Manhattan Beach, California. Skechers was founded to capitalize on another footwear trend, sports utility shoes. The footwear market was saturated with athletic footwear endorsed by sports superstars such as Michael Jordon and Shaquille O'Neal. Skech-

ers provided a comfortable, affordable alternative to athletic footwear for casual wear. Greenberg did not want to repeat the mistakes he made at L.A. Gear. Skechers diversified from its original utility line to add three other lines: Skechers Collection, casual dress shoes for men; Skechers USA, casual, trendy footwear for men, women, and children; and Skechers Sport, active footwear for men, women, and children.

The 1990s witnessed a rapid growth in the active and casual wear apparel markets. The funky designs created by Skechers were the perfect complement to the new skateboarder, snowboarder, and grunge looks. The chunky styles, platform soles, and color palette provide Generation X and Y with fun, funky, and affordable footwear. Skechers designs over 600 styles which range in price from $45 to $130.

Success has not come only from closely following fashion trends, but also from pursuing a strategic product distribution. Originally, Skechers tried to differentiate itself by limiting its distribution to independent surf, skate, and alternative clothing stores. This plan generated only limited sales and prevented the products from reaching smaller markets such as Dubuque, Iowa, where this type of stores did not exist. Soon, Skechers began to sell to prestigious retailers such as Nordstrom and Macy's, specialty retailers such as Famous Footwear, and discount retailers such as J.C. Penney. However, they segmented their product line to provide exclusive distribution of selected styles to independent retailer and high-end department stores. In 1995 Skechers began opening their own retail and outlet stores. In 1998 they launched their first mail-order catalog and website. Today, Skechers are sold in retail establishments in 125 countries, in forty-three company-owned retail stores and outlets, and twenty-four hours a day through the Internet and mail order.

"Skecher," a street term for an energetic person who cannot sit still, applies not only to the Skecher target market, but also to the company itself. In 1993 the company posted $42.7 million in sales; by 1997 that number had more than quadrupled to $183.8 million. In 1995 Skechers began expanding into men's and boy's sportswear lines through licenses with Genova, Inc., and plans to continue building its private-label apparel offerings. In only seven years, Skechers has gone from a small start-up business to a publicly traded company. Skechers has redefined the footwear industry through its offerings of utility boots, tennis shoes, casual dress shoes, and sandals. The company analyzes the lifestyle factors of their Gen X and Y target markets and translates their sporting activities, Web surfing, and musical preferences into footwear designs.

Website: http://www.skechers.com

REFERENCES

Butler, Simon. "Family Matters." *Footwear News* 53 (October 13, 1997): 10–14.
Gorchov, Jolie. "Skechers' Latest Shoe Line Is a Good Fit for Investors." *Los Angeles Business Journal* 22 (May 8, 2000): 35.

Heiderstadt, Donna. "Robert Greenberg Still Shifting Gears." *Footwear News* 49
 (October 4, 1993): 4.
Marlow, Michael. "Skechers Ready to Get Dressed." *Daily News Record* (April
 29, 1998): 3.
Rotenier, Nancy. "Fancy Footwork." *Forbes* 152 (September 27, 1993): 154–156.
Solnik, Claude. "S Is for Success." *Footwear News* 54 (December 7, 1998): 28.

<div align="right">*A. K.*</div>

Paul Smith

B. 1946

Birthplace: Nottingham, England

Awards: Number One Men's Wear Designer, Journal du Textile 1992, 1993, 1994

It is rare for men's fashions to change direction significantly. Only three designers are noted for redirecting men's fashions: Pierre Cardin in the 1960s with tapered jackets and flared pants, Giorgio Armani in the 1980s with broad-shouldered power suits, and Paul Smith in the 1990s with high buttoned suits. Smith executed a simple change in men's suit jackets: he moved the top button from the navel to the chest and added narrow cut pants to create what would become the standard yuppie uniform.

Paul Smith was born in Nottingham, England, the son of a door-to-door textile salesman. At sixteen, while managing a small boutique, he meet Pauline Denyer, a design teacher. Denyer provided training and guidance to the fledging designer. In 1970 Smith founded a small 12-foot by 12-foot store in Nottingham, open only on the weekends so that he could work odd jobs during the week to finance the operating expenses. Over the next four years, Smith worked to establish himself and refine his design skills, and in 1974 he launched his own label. Two years later, he opened his first store in London and began showing his collections in Paris.

Smith's early work was very conventional, but in 1982 he redirected his designs to reflect his own extravagant, unconventional personality. He used vibrant colors such as raspberry and turquoise, lined traditional dark suits with bright red silk, and adorned his basic white dress shirts with wineglass cuff links and pistol buttons. He brought a new direction to menswear by infusing color and whimsy into both tailored and casual menswear fashions.

Behind Smith's eccentric façade lies a shrewd businessman. He has maintained joint ownership of his company with his partner and companion Pauline Denyer. Smith, England's most successful designer, with stores throughout England, Australia, and the Far East, outsells both Armani and

Ralph Lauren in Japan. He has expanded his company to include accessory, women's, and children's lines, and he holds several licensing agreements including eyewear with Oliver Peoples (1994), men's footwear with Overland Group (1999), neckwear and cuff links with Insignia Design Group (1998), women's wear with Gibo (1993), and fragrance and beauty products with Inter Parfums SA (2000). In 1991 he purchased the R. Newbold factory where he has been manufacturing his shirts since 1977, and in 1993 he launched the R. Newbold line of men's casual clothing.

The final frontier for Smith lies in the United States. Smith currently owns one store in New York and is looking for a partner to finance his expansion into the competitive U.S. market. H&S International Holding Company previously held Smith's license for men's casual wear in the United States, but he discontinued the agreement in 1990 when he was realized he was known in the United States solely as a casual-wear designer. Smith will not reenter the U.S. market until he can find a distributor for both his couture and casual-wear lines. Conquering the U.S. market will mark the ultimate achievement for this otherwise globally renowned, trendsetting men's fashion designer. *See also*: Giorgio Armani; Ralph Lauren.

Website: http://www.paulsmith.co.uk

REFERENCES

Fallon, James. "On Exhibition: The World of Paul Smith." *Daily News Record* 25 (November 10, 1995): 4.

———. "Paul Smith to Unveil Beauty License Deal." *Women's Wear Daily* 174 (December 15, 1998): 5.

Morais, Richard C. "We're Finally Ready." *Forbes* 155 (April 24, 1995): 102–7.

A. K.

Willi Smith

B. February 29, 1948

D. April 17, 1987

Birthplace: Philadelphia, Pennsylvania

Awards: iInternational Mannequins Designer of the Year, 1978
 Coty American Fashion Critics Award, 1983

When Willi Donnell Smith died, at age thirty-nine, a *New York Daily News* fashion writer called him "the most successful black designer in fashion history" (Martin, p. 383). However, as Richard Martin pointed out in a biographical sketch of Smith, there were "countless fans of his sportswear style who may never have known—or cared—whether he was Black,

White, or any other color" (Martin). In fact, Smith was often annoyed by the attention given to the fact that he was black, although he did admit that it had some advantages, explaining that while other designers had to go to Paris for inspiration, he only had to go to Sunday church services in Harlem.

Willi Smith arrived in New York in 1965, at the age of seventeen. Having studied fashion illustration at the Philadelphia Museum College of Art, he was ready to attend Parson's School of Design on a scholarship. During his two years at Parson's he worked as an illustrator/sketcher for Arnold Scaasi, a designer of expensive, entrance-making ensembles and gowns. He went on to work for several other clothing companies, including Bobbie Brooks, Digits, and Talbott. By 1976, after several unsuccessful attempts to open a business of his own, Smith established WilliWear, Ltd., and produced exuberantly charming women's wear, using high color and natural fabrics. In 1978 he added menswear, intending to create a category of clothing that would bridge the gap between suits and jeans, a visionary concept that marked the start of the trend toward the casual dress that became popular in the late 1980s and 1990s. By 1986 WilliWear was enjoying annual sales of $25 million.

Preferring comfortable and functional fabrics, Willi Smith created brightly colored, loose-fitting, moderately priced, and utterly wearable separates. His Indian cottons were especially popular with young people who loved his lively, witty mix of slouchy shapes and easy care. He traveled to India several times a year to supervise the making of his original textiles and clothing, referring to his collections as "street couture." His pieces were consistent in their oversized silhouettes and could be easily mixed from year to year. His blazers, dirndls, dhoti pants, and oversized shirts were youthful and delightfully unserious.

Willi Smith was a designer in demand. He designed textiles for Bedford Stuyvesant Design Works, upholstery for Knoll International, and patterns for Butterick. He created the linen blazers and white pants worn by the groomsmen in the 1983 Caroline Kennedy/Edwin Schlossberg wedding, as well as the double-breasted navy suit and silver tie, both linen, worn by the groom himself. His modern alternative approach to dress was one that appealed to "real people," as Smith liked to say.

The plans for his first store in New York were well along at the time of his death, and it opened several months later. The obituary in the *Village Voice* said of Willi Smith's clothing that it expressed "the designer's democratic urge: to clothe people as simply, beautifully and inexpensively as possible" (Martin, p. 383). In that, he certainly succeeded. His name continues to be licensed and appears on WilliWear sportswear and Willismith loungewear.

REFERENCES

Martin, Richard. *The St. James Fashion Encyclopedia: A Survey of Style from 1945 to the Present*. Detroit: Visible Ink Press.
Milbank, Caroline Rennolds. *New York Fashion: The Evolution of American Style*. New York: Harry N. Abrams, 1989.

<div align="right">

S. B.

</div>

Levi Strauss and Company

B. February 26, 1829

D. September 28, 1902

Birthplace: Buttenheim, Bavaria

Awards: Smithsonian Institution, Levi's preserved, 1966
 German Apparel Supplier of the Year, 1990
 National Business Hall of Fame inductee, 1994
 National Business and Labor Award for Leadership on HIV/AIDS, the United States Centers for Disease Control, 1997
 Ron Brown Award for Corporate Leadership, 1998

There is no more distinctly American item of apparel than blue jeans. For close to 150 years, Levi's jeans have captured the attitude and spirit of Americans of all ages. Levi Strauss and Company spans five generations of American history, witnessing economic, social, and technological changes including war, space travel, the telegraph, the automobile, and the Internet. Levi's blue jeans have the unique distinction of being the only item of apparel developed in the nineteenth century that is still made today.

Levi (Loeb) Strauss, a Bavarian immigrant, came to New York with his mother and sisters in 1847 to join his brothers in their dry-goods business. In 1853 Strauss followed the migration of miners and settlers west to San Francisco to open his own dry-goods business. His business prospered, but it would be almost twenty years before Strauss received the business proposition that would change fashion forever. A Nevada tailor, Jacob Davis, who frequently purchased fabric from Strauss, had developed a pair of pants with metal rivet at the stress points on the pockets and fly, but he lacked the funds to apply for a patent. In exchange for a one-half share of the company, Strauss agreed to fund the patent application and on May 20, 1873, the patented was granted and Levi's waist overalls were officially "born."

The new waist overalls were immediately popular, but not just because of their durability. The waist overalls shrank to fit the body; the loose fit

of other pants caused blisters when riding horseback. Strauss's success allowed him to expand his business and he bought Mission and Pacific Woolen mills in 1874 to develop a line of blanket-lined coats and pants. In 1890 Strauss incorporated his dry-goods business as Levi Strauss and Company and continued to prosper as a manufacturer of sturdy work apparel. Strauss died in 1902, leaving the business to his four nephews, who had been working with him since 1876.

The history of Levi Strauss and Company (LS & Co.) reads like a chronology of U.S. political and social history. During World War II U.S. soldiers who wore Levi's jeans overseas, introduced them to an international audience. As America moved into the television age, Levi's were there, making their first television commercial in 1966. During the birth of the women's liberation movement, Levi's expanded into women's apparel in 1968. In 1984, LS & Co. was the official outfitter of the U.S. Olympic Team. The introduction of Dockers in 1986 and Slates in 1996 revolutionized menswear and blazed a path for the now standard casual Fridays.

Levi Strauss and Company is privately held. Public shares were issued in 1971 to finance expansion, but in 1985 the shares were all repurchased by family members. LS & Co. is one of the largest manufacturers of men's, women's, and children's jeans and sportswear, employing nearly 30,000 people in three international divisions in the United States, Europe, and Asia. As a corporation, LS & Co. has contributed over $20 million internationally to educational scholarships, HIV/AIDS programs, and community support programs, and has developed global sourcing and operating guidelines that established standards for fair labor practices and business operations for all companies conducting business with it.

However, LS & Co. has seen its share of problems and has sustained losses in market share. The first blow to Levi's jeans came during the 1980s designer jean craze, when jeans by designers such as Calvin Klein became an important status symbol. During the 1990s, Levi's jeans suffered from the growth of private-label lines carried in department stores such as J.C. Penny and Sears, Roebuck and Company, and the rise of private-label retailers such as The Gap, Inc., and Eddie Bauer. Levi's also failed to incorporate new fashion trends into their product offerings, and designers such as Tommy Hilfiger came to define the new classic American image.

Since the late 1990s Levi Strauss has made a concerted effort to redefine its image and regain lost market share. The company discontinued its sixty-seven-year relationship with advertising agency Foote, Cone and Belding and hired the Chiat/Day agency to create new advertising campaigns targeted at Generation X. The one-time uniform of youthful rebellion, which was worn by James Dean in *Rebel without a Cause* (1955) and Marlon Brando in the *Wild One*, (1954) was now abandoned by Gen X. Levi's were not "cool" anymore. They were replaced by The Gap, Inc., among the college set and FUBU among the hip-hop crowd. To reach these lost

audiences, Levi Strauss began to sponsor a wide range of events such as Lillith Fair, Lauren Hill concerts, and skateboarding expositions, and created a line of clothing for the *Mod Squad* remake. However, the split focus of these new advertising and public relations events only perpetuated the existing brand confusion and saw little regain in lost market share.

LS & Co. was also late in establishing an Internet retail business. The first site they established had features such as a "Fit Calculator," "Style Finder," and "Changing Room," which provided custom-fit ordering and a virtual dressing room but not on-line sales. They also refused to allow any of their retail outlets to sell Levi's through their websites leaving on-line shoppers with only one choice—to buy private-label jeans. When companies such as Eddie Bauer and The Gap went online in 1995 and 1997, respectively, Levi's jeans suffered yet another blow. When Levi Strauss finally decided to accept online sales transactions in 1998, customers were already conditioned to purchasing private-label goods from other sources.

A traditional pair of Levi's jeans requires one and three-quarter yards of denim, 213 yards of thread, five buttons, and five rivets. Very few changes have been made to the design of the original Levi's jeans. The rivets on the back pockets were removed in 1937 after complaints that they scratched school desk chairs and saddles. Later, in 1967, thread bar tacks were applied to the back pockets as a substitute for the rivets. The Arcuate Design on the back pockets, made from a double row of stitching, is the oldest apparel trademark currently in use, and it was painted on during World War II materials rationing. However unchanged this quintessentially American garment is, it has stood witness to monumental changes in world history and will continue to provide a substructure for American society. *See also*: The Gap, Inc.; Calvin Klein; FUBU.

Website: http://www.us.levi.com

REFERENCES

Feuerstein, Adam. "Coming Apart at the Seams." *San Francisco Business Times* (December 14, 1998): 1.

"Keep Reinventing the Brand or Risk Facing Extinction." *Marketing* (February 25, 1999): 5.

Kroll, Luisa. "Digital Denim." *Forbes* 162 (December 28, 1998): 102.

"Sagging Sales of Flagship Brand Cut Levi's Revenues. *Daily News Record* (February 17, 1999): 16.

<div align="right">*A. K.*</div>

Structure

See The Limited, Inc.

Anna Sui

B. 1955

Birthplace: Dearborn Heights, Michigan

Award: Perry Ellis Award, 1993

Anna Sui, the daughter of Chinese immigrants, grew up in a small suburb of Detroit, Michigan, where she spent her time designing evening wear for her dolls. After high school, Sui convinced her parents to send her to New York to study fashion at the Parsons School of Design. Sui left Parsons in 1975, after two years of study. Over the next several years, Sui worked for a series of design firms, including Bobbie Brooks and Glenora, and she freelanced as a stylist for photographer Steven Meisel. Sui also continued to work on developing a collection of her own, and in 1980 she received her big break. She had sold a few pieces to Macy's which appeared in their full-page advertisement in the *New York Times*. This was the exposure Sui needed to launch her career, and she set up a sewing machine in her apartment and started her own business.

Sui's new business initially met with limited success. The eclectic looks she created were not in line with the glamorous, status-conscious 1980s. Sui came of age in the 1970s, and the influence of the music and fashions of that time period can be seen in her clothes. She combines funk and vintage to create whimsical looks that some consider a cross between Coco Chanel and Haight Ashbury. It was not until the grunge look became popular in the 1990s that Sui's unique fashion sensibilities really came into demand. Her baby-doll dresses became a fashion staple among grunge enthusiasts.

The 1990s proved to be a decade of growth for Sui. She added a menswear line in 1992, a shoe line in 1997, and a special-occasion party dress line, Anna Sui Party, in 1997. In 1995 she launched a bridge line, Sui by Anna Sui, targeted to a more classic and reserved customer than her signature collection. She also became a consultant for the Cento X Cento collection produced by the Milan-based Gilmar Group.

Sui's clothes are in hot demand by the young and hip. Many of Hollywood's young up-and-coming actors, as well as musicians, are frequently seen sporting Anna Sui fashions. Sui did not hold her first runway show until 1991, but when she did supermodels Naomi Campbell, Linda Evangelista, and Christy Turlington all lined up to model for free in exchange for Sui's clothes. *See also*: Gabrielle Bonpreur "Coco" Chanel.

Website: http://www.annasuibeauty.com/site

REFERENCES

"Anna Sui." Fashion Live website available from http://www.worldmedia.fr/fashion/

Appel, Stacy. "Anna Sui." Fashion Windows website available from http://www.fashionwindows.com/

James, Laurie. "Sui Success." *Harper's Bazaar* 125 (September 1992): 274.

A. K.

T

❧❧

Tiffany and Company

B. February 18, 1848

D. January 17, 1933

Birthplace: New York City; New York

Awards: Paris Exposition Universelle, 1889, 1900
World's Columbian Exposition, Chicago, 1893
Pan-American Exposition, Buffalo, 1901
Turin International Exposition, 1902
Lousiana Purchase Exposition, Saint Louis, 1904
Panama Pacific World Exposition, San Francisco, 1915
New York World's Fair, 1939

On its first day of business, in 1837, Tiffany and Young took in $4.98. By the beginning of the twentieth century, Tiffany and Company had more than 1,000 employees and branches in Paris, London, and Geneva. This dazzling ascent had everything to do with the fact that two of the greatest designers in America's history were at the helm of Tiffany and Company: Paulding Farnham and Louis Comfort Tiffany, son of Charles, the founder.

Farnham's pieces with enamel and gems, gold and silver, were proclaimed masterpieces by critics of the time and can be seen today at museums all over the world. Louis Tiffany's glassmaking genius yielded not only magnificent jewelry but also accessories, ranging from clocks, paperweights, and vases to stained-glass lamps and windows.

From the Arts and Crafts style of the early 1900s through the eras of Art Nouveau, Art Deco, and Modernism, Tiffany's creations have mirrored

the tastes and changes that defined the twentieth century in America, all the while reflecting the beauty in nature and simplicity of design. Perhaps their most enduring contribution to the world of jewelry is the classic, six-prong Tiffany setting for diamond solitaire rings, introduced in the 1870s.

Tiffany's long list of famous customers include painter Mary Cassatt, Mrs. Andrew Carnegie, Mrs. Rudyard Kipling, Mrs. Jacqueline Kennedy Onassis, dukes and duchesses, sultans, actors, and burlesque queens.

It was not only the gems and art objects that attracted the attention of the world; in 1885, Tiffany was invited by the U.S. government to redesign the Great Seal which, to this day, appears on the one dollar bill.

Beside the creation of many one-of-a-kind designs, Tiffany is credited with some of the most innovative merchandising ever seen by the retail industry. For example, the direction of visual merchandising was forever changed through the company's artistic reinvention of the window display, initiated by Walter Hoving, controlling owner of the company from 1956 to 1980, and Gene Moore, window designer extraordinaire. Moore, known for witty displays combining magnificent jewels with unlikely props and paraphernalia, joined Tiffany in 1956 and remained with the company until 1995.

A second example of Tiffany and Company's innovative merchandising was the creation of the design director position. Since the death of Louis Comfort Tiffany in 1933, the company had been without a "tastemaker," and Hoving, believing there should be a policy maker for design decisions, as well as for production and finance, hired Van Day Truex, who would be Tiffany's design director from 1956 to 1979. Truex not only redesigned Tiffany's china, crystal, and silver merchandise, but also recommended that the company hire the world's best-known jewelry designer since the late 1930s, Jean Schlumberger. This alliance became one of Tiffany's greatest triumphs.

Hoving's public relations activities were legendary. Probably the greatest coup was allowing the filming of *Breakfast at Tiffany's* to take place in the Fifth Avenue and 57th Street store in 1960. Audrey Hepburn helped immortalize Tiffany's by wearing Schlumberger's jewelry designs in her publicity photos, as well.

Wearing Schlumberger jewelry became the ultimate status symbol of the 1960s, and his fabulous pieces were photographed time and again for *Vogue, Harper's Bazaar,* and *Town and Country* by Helmut Newton, Hiro, Richard Avedon, and Skrebneski. The 1960s ended on another high note for Tiffany and Company when the company introduced an exotic blue gem to the world, negotiating exclusive marketing rights for a recently discovered stone, tanzanite, named for the nation from which it comes, Tanzania.

During the 1970s Tiffany and Company concentrated on international expansion with the opening of its first in-store boutique in Tokyo's Mit-

sukoshi Department Store. The company also added two more stars to the growing constellation of great designers—Elsa Peretti in 1974 and Angela Cummings in 1975. Peretti's "open heart" is probably the premier icon of contemporary jewelry design, and her "diamonds by the yard" are legendary. Cummings created elegant pieces with floral and leaf motifs by mixing metals, crystal, wood, and precious stones.

Paloma Picasso was the next designer to join the Tiffany group. Her bold designs were a complete departure from the sensual shapes of the 1970s. Tiffany presented her first collection of sculpted gold jewelry with brightly colored stones in 1980, and the Tiffany-Picasso relationship continued through the remainder of the century.

Tiffany's entrance into the luxury goods market took place under a new chairman, William R. Chaney, who began his reign in 1984. Along with John Loring, design director since 1979, the company introduced leather goods and accessories, neckties and scarves, fragrances and tableware, all part of the licensing agreements Tiffany and Company forged with famous designers.

By the year 2000, Tiffany and Company had 120 stores in forty countries. From Munich to Milan, from Singapore to Sydney, from 1837 to the present, the Tiffany name has been trusted and admired for classic design, remarkable beauty, fine craftsmanship, and, of course, the most recognizable blue box in the world.

Website: http://www.tiffany.com

REFERENCES

Loring, John. *Tiffany's 20th Century: A Portrait of American Style.* New York: Harry N. Abrams, 1997.
Snowman, A. Kenneth, ed. *The Master Jewelers.* New York: Harry N. Abrams, 1990.

S. B.

Ellen Tracy

Awards: Dallas Fashion Award, 1986, 1987

There is no Ellen Tracy. The company, was founded in 1949 by Herbert Gallen to manufacture blouses for the junior market. Gallen, a veteran of the garment trade, invented the name Ellen Tracy, believing a woman's blouse manufacturer should be named after a woman. However, in 1962, Gallen hired the woman who would come to personify Ellen Tracy: Linda

Allard, a Kent State University fine arts graduate who came to New York City with $200 in her pocket to pursue her dream of becoming a fashion designer. Allard grew up in a small town in Ohio with five brothers and sisters and was taught to sew by her mother when she was ten. Now, instead of designing clothes for her dolls, she would be designing clothes for Gallen, drawing a salary of $60 per week.

Gallen hired Linda Allard as a design assistant to design packaged shirts and t-shirts for the junior blouse market. However, while working on the shirt line, Allard designed a sailor-style pant and pea coat. The new pieces were an immediate success, Ellen Tracy was launched into the sportswear market, and Allard was promoted to director of design. After this initial success, Gallen and Allard decided to reposition Ellen Tracy to target the newly emerging female workforce. As the women who entered in the workforce in 1960s were beginning to climb the corporate ladder in the 1970s, they needed a professional yet stylish wardrobe to wear in the workplace. Allard, one of the first designers to cater to this new demographic, created the new "woman executive" look.

The Ellen Tracy label not only provided women with the wardrobe they needed to succeed in the workplace, it also became the anchor for the newly emerging bridge market that filled the gap between designer fashions and mass merchandisers. In 1984 Linda Allard's name was added to the Ellen Tracy label to recognize Allard's work and to create a "designer" feel for the line. However, Ellen Tracy is run as a fashion business, not a fashion house, with an emphasis on the profitable. Each line is designed with the consideration that the majority of women do not have the bodies of fashion models, but still want to wear fashionable clothes.

Throughout the 1980s and 1990s, the Ellen Tracy label continued to grow under Allard's design direction. Divisions for petites (1981), dresses (1985), plus sizes (1993), and evening wear (1993) were launched. A new sportswear line, Company, was launched in 1991, and licensing agreements were signed with Collection XIIX for scarves, Buckray for shoes, Private Eyes Sunglass Corporation for eyewear, Susan Gail Handbags for bags, and Revlon for fragrance.

In 1999 Ellen Tracy celebrated its fiftieth anniversary. Over the past fifty years, the Ellen Tracy label has become synonymous with quality fabrics, unique color stories, and fashions for real women. Every piece in the collection is sold separately to allow women to interchange pieces to create their own unique looks as well as to ensure a good fit. To Allard, couture fashion has little relevance to most women's lives. "The extreme end of fashion is over-rated. It gets a lot of coverage by the press, but it doesn't mean anything to a lot of women. We mean more to real women" (Martin, p. 16).

Website: http://www.ellentracy.com

REFERENCES

Daria, Irene. "Linda Allard: Growing Up with Ellen Tracy." *Women's Wear Daily*
 (June 2, 1986).
"Fashion Fortitude." *Vogue* (June 1999): 98–102.
Martin, Richard, ed. *The St. James Fashion Encyclopedia: A Survey of Style from
 1945 to the Present.* Detroit: Visible Ink Press, 1996.

<div align="right">A. K.</div>

Trifari

Known as the "founding fathers" of the costume jewelry industry, Gustavo Trifari and Leo F. Krussman were both working in the same field—hair ornament design, manufacture, and sales—when they merged their talents to create their company in 1918. In 1925 Carl Fishel joined the firm, and by 1930 the noted designer Alfred Philippe, whose designs had been sold in both Cartier and Van Cleef and Arpels, completed the team that would become one of the most revered names in the industry.

Philippe brought to Trifari the idea of using of Austrian crystals in their creations, a relatively new concept at that time. These brilliantly colored stones were hand set, just as fine jewelry, with glittering results. One of the best-known Trifari pieces is the crown pin of 1941, made of sterling silver, overlaid with gold, and set with faux cabochons and rhinestones, which became one of their signature designs.

Trifari creations sparkled throughout the 1940s, 1950s and 1960s, appearing in several Broadway productions. The company is renowned for its delicate and intricate design of highly stylized brooches, fur clips, and patriotic jewelry such as flags, eagles, and military symbols, including England's Royal Air Force emblem, created during World War II.

Using the influences of Art Deco and Art Moderne, Trifari designs reflected understated elegance for both day and evening in the form of cuffs, bibs, and parures. The company was the first fashion jewelry firm to advertise nationally, beginning in 1938, placing the Trifari name in the mind of the costume-jewelry buying woman of style.

Undoubtedly, First Lady Mamie Eisenhower was one of the admirers of Trifari who helped make certain the company's name would go down in history when she commissioned Alfred Philippe to design the pieces she would wear on the evening of her husband's 1953 inauguration. As the first-ever president's wife to wear a pink ballgown, she was also the first to wear costume jewelry to an Inaugural Ball and did so again in 1957. On both occasions, she wore Trifari faux pearls. Her triple-strand choker is permanently exhibited at the Smithsonian Institution.

REFERENCES

Baker, Lillian. *Fifty Years of Collectible Fashion Jewelry*. Paducah, Ky.: Collector Books, 1986.

Klein, Mim. *A Look at Three Great Costume Jewelry Houses: Monet, Trifari, Haskell*. West Chester, Pa.: Schiffer, 1998.

S. B.

Pauline Trigère

B. November 4, 1912

Birthplace: Paris, France

Awards: Coty American Fashion Critics Award, 1949, 1951, 1959
 Neiman Marcus Award, Dallas, 1950
 National Cotton Council of America Award, 1951
 Filene Award, Boston, 1959
 Silver Medal, City of Paris, 1972

Trigère was born in Paris, France, to Julles Ferry, a dressmaker, and Victor Hugo, a skilled technician and wholesale clothing contractor. Her mother introduced Trigère to the world of marketing and design. Her first official training took place at Martial et Armand, a prestigious tailoring institute. After six weeks of studying dressmaking skills, including the bias cut, Trigère's teacher felt she was a superior dressmaker and required no further training.

In 1933 Trigère began her career as a freelance designer in Paris and later moved, with her sons Jean-Pierre and Philippe, to Chile. En route to Chile, the family was detained in New York, where Trigère decided to remain. Trigère's uncle, Adele Simpson, referred her for a position with designer Ben Bershel. After her four years with Bershel, Trigère left to take a position with Hattie Carnegie where she was employed as Travis Banton's design assistant. Due to the bombing of Pearl Harbor, Trigère's job at Hattie Carnegie ended in 1942 when business slowed during the war. Anxious to start her own business, she branched off and founded the House of Trigère with her brother in 1942. She designed the clothes while he traveled the country selling her fabulous dresses. Just three years later, Trigère acquired her own New York label.

In the 1940s Trigère blossomed and she provided American women with the best finely tailored suits and coats one could imagine. Her selection of fabrics made it possible to create suits and coats that transitioned from day into evening. Her silhouettes were not ordinary; they involved such com-

Pauline Trigère: Trigère's finely tailored suits and coats incorporate complex structural details.

plex structural details as bias cuts, princess seams, asymmetrical lines, and diamond insets. Her tailored suits were practical, refined, and classic.

In the late 1960s and early 1970s, Trigère offered wide-leg pants which looked like skirts and she called "bisected skirts," culottes with matching blouses in bold chiffon prints and vivid colors, and chiffon dresses which incorporated ostrich feathers and plumes. Her coat designs also included unusual details. Her famous "Caliph Coat" was made of a diagonal tweed with large-scale covered buttons and a scarf. Trigère was swinging in the seventies with her fabulous full capes made of wool jerseys, tweeds, and mohair with matching ensembles for day and evening. Her use of color, pattern, and jeweled trim, and, most important, fit, captured the eyes of many women. Trigère also enticed her clients with her wool suits, embellished with black, silver, or Norwegian blue fox cuffs, collars, and hem treatments.

Trigère expanded into other areas of design. In 1963 she felt the need for women to have better support under their garments, so she created a line of undergarments for Form Fit Rogers. After designing bras, girdles, and bias tops and bottoms, her mission was complete and she moved on to other challenges. In the seventies, Trigère became interested in jewelry design. She developed a line of brooches, barrettes, and necklaces in diamonds and crystallized strontium titanate. Trigère also challenged herself by creating her own perfume. After three years of hard work, she finally developed the perfect Trigère scent.

Trigère's last ready-to-wear collection, in 1993, consisted of her classic silhouettes and high-quality fabrics. Overall, Trigère has made a tremendous impact on the industry with her suit, coat, cape, day dress, and evening wear designs. Her magic hands have enabled her to work with a variety of difficult fabrics, draping structured characteristics with precision fit into fabulous articles of clothing.

REFERENCES

Epstein, Eleni Sakes. *American Fashion*. New York: Fashion Institute of Technology, Quandrangle/New York Times Book Co., 1975.

Milbank, Caroline Rennolds. *New York Fashion: The Evolution of American Style*. New York: Harry N. Abrams, 1989.

Morris, Bernadine, and Barbara Walz. *The Fashion Makers*. New York: Random House, 1978.

N. S.

U

Emanuel Ungaro

B. February 13, 1933

Birthplace: Aix-en-Provence, France

Awards: Neiman Marcus Award, 1969
Dallas Fashion Award, Designer Women's Wear, 1996

Emanuel Ungaro was born in France to a family of Italian immigrants. Ungaro's love of fashion was instilled in him at an early age by working for his father's tailoring business. Without any formal training, Ungaro moved to Paris in 1955, and three years later he landed a coveted apprenticeship with Cristóbal Balenciaga. From Balenciaga he learned how to manipulate color and line and to create classic fashions. Ungaro left Balenciaga in 1964 to work for André Courrèges for two seasons, where he was influenced by Courrèges's youthful, modern fashions.

In 1965, with $5,000, Ungaro and textile artist Sonja Knapp founded the House of Ungaro in a small Paris studio, and he launched his first collection of only twenty pieces. His first collections reflected a direct influence from his work with Courrèges. The designs were edgy, space-aged, and futuristic with hard geometric lines. His early work was similar to that of many young designers of this era who were designing to appeal to the new youth market. For several years, Ungaro experimented with different looks, and in the late 1970s he developed what was to become his signature style: ultrafeminine silhouettes in fabrics which broke the golden rule: Never mix your patterns. Ungaro combined florals, plaids, and stripes in the same garment, creating chaos and elegance with vibrant color combi-

nations inspired by the lush countryside of Provence. The strategically draped and shirred body-conscious designs were sensuous and rich, seductive without being vulgar. The bold patterns combined with soft feminine silhouettes became the epitome of 1980s women's fashions, representing the duality of women's roles.

The majority interest in Ungaro was bought by Salvatore Ferragamo in 1996, although Ungaro retains creative control. Over the course of his career, Ungaro has launched several lines of men's and women's apparel and has licensed other product lines. Ungaro's European lines include Parallele, a boutique collection, was introduced in 1971; Ungaro Ter, a women's knitwear line, produced from 1988 to 1991; and Solo Donna, a women's ready-to-wear line. Ungaro produces two menswear lines: Ungaro pour l'Homme Paris and Classics by Ungaro. Three additional lines are designed by a New York team under the direction of Ungaro for exclusive distribution in the United States: Emanuel by Emanuel Ungaro, introduced in 1991 as a women's bridge collection of sportswear; Emanuel Petite, introduced in 1994; and Ungaro Woman, a plus-size collection introduced in 1996. GFT USA Corp (a subsidiary of Gruppo GFT) holds the exclusive licensing agreement for the production and distribution of these Ungaro lines worldwide, excluding Japan and South Korea. Other product lines licensed by Ungaro include intimate apparel by Warnaco, bedding by Crown Crafts, men's knitwear by Franco Ziche, men's neckwear by Mantero, men's shirts by Biemme, men's sportswear and outerwear by Belfe, men's leather goods and shoes by Ferragamo, and a bridge line of men's suits and sportswear by Ermenegildo Zegna.

Parfums Ungaro, owned by the Bulgari Group and Ferragamo, has launched several fragrances. Ungaro, his first scent, was launched in 1977, followed by Diva in 1982, Senso in 1987, and Fleur de Diva in 1997. Three men's fragrances have been introduced: Pour l'Homme I, Pour l'Homme II, and Pour l'Homme III. In 1993 Ungaro released a limited edition of Ombre de la Nuit, his personal scent, to commemorate his tenth year in business. Ungaro, Senso, Pour l'Homme I, and Pour l'Homme II were all phased out in 1997. *See also*: Cristóbal Balenciaga; André Courrèges; Salvatore Ferragamo.

REFERENCES

Barone, Amy. "Ungaro's New Diva." *Women's Wear Daily* 173 (October 17, 1997): 8.

Loebenthal, Joe. *Radical Rags: Fashions of the Sixties*. New York: Abbeville Press, 1992.

Perschetz, Lois, ed. *W, The Designing Life*. New York: Clarkson N. Potter, Inc., 1987.

A. K.

V

Valentino (Valentino Clemente Ludovico Garavani)

B. 1933

Birthplace: Voghera, Italy

Awards: Neiman Marcus Award, 1967
 Grand'Ufficiale dell'ordine al Merito, 1985
 Ufficiale di Gran Croce, 1986
 National Italian American Foundation Award, 1989

In 1998 one of the world's most revered couturiers, Valentino, and his longtime business partner, Giancarlo Giammetti, sold 100 percent of their company to the Italian industrial giant Holding di Partecipaziono Industriali (HdP). After almost forty years, their couture house became one of several purchased during the final decades of the twentieth century by a larger company wishing to claim a piece of the fashion/luxury market.

By the end of the century, the couture business had become a losing one. In 1960, when Valentino first opened his *maison*, his couture clientele was the house's primary source of revenue; however, by the time the company was sold, he and Giammetti admitted they had been taking only a limited number of couture orders each season. It had become impossible to make a profit, considering the huge cost of producing a single garment. It had become clear that publicity was the key to success in the fashion business, and that only huge funds would enable companies like Valentino's to compete with massive conglomerates like Bernard Arnault's LVMH, owner of Dior and Givenchy, among many. .

How different it was when Valentino first came to Paris in 1950, from his home in northern Italy, where he had taken fashion design courses and studied French to prepare for his move to the world's fashion capital. He took courses at the Ecole Chambre Syndicale de la Couture and won a competition sponsored by the International Wool Secretariat, the same organization that sponsored a competition for which Karl Lagerfeld received recognition, shortly thereafter. He worked under Jean Desses for five years, under Guy LaRoche for two, and then as assistant to Princess Irene Galitzine. By 1959 Valentino was living in Rome, where he opened a small atelier on the Via Condotti.

In 1962 the young designer was invited to show his fall collection at a fashion show held at the Pitti Palace in Florence, which became the first of many triumphs. By that time Valentino had met his future partner, Giammetti, and the two set about creating an international business, recognized by the winning "V", a logo now recognized around the world. Jacqueline Kennedy helped put Valentino on the map when she started wearing his creations. He designed an entire wardrobe for her 1967 trip to Cambodia. That same year he showed his very modern "White Collection," which was considered quite radical, and a challenge to London's stronghold on 1960s fashion. In 1968 Valentino was dubbed the "Sheik of Chic," having created the dress Kennedy wore for her marriage to Aristotle Onassis. By the end of the decade, he had opened ready-to-wear boutiques in Milan and Paris, the first of many which now exist throughout the world.

Valentino began the 1970s by dropping a fashion bombshell—bringing the miniskirt down from thigh-high to mid-calf. His business continued to flourish throughout the decade, renowned for elegant clothing which reflected refinement, sophistication, and superior workmanship. His use of fire-engine red color, which became his signature, is now legendary. In 1972 Valentino presented his first menswear collection; in 1973 Valentino Piu, his home fashion and gift division opened; and in 1978 his signature fragrance debuted.

By the time the 1980s began, it was evident that Valentino would remain a star, combining his commitment to elegance with fresh, youthful ideas. In 1982 he presented his fall collection at New York's Metropolitan Museum, and in 1984 he celebrated both the company's twenty-fifth anniversary and his fiftieth couture collection with a fashion show and gala in Rome's Piazza d'Espagna. In a career filled with highlights, perhaps the presentation of his 1991 "Peace" dress, a white crepe column, embroidered with silver beads spelling the word "peace" in fourteen languages, is still one of fashion history's most talked about moments.

Today, the Valentino empire includes boutiques in Europe, Japan, and the United States of America, with licensing agreements for a multitude of products ranging from furs, swimwear, sunglasses, and umbrellas to wallpaper, upholstery fabrics, and children's wear. The company's ready-to-

wear is made by Italy's manufacturing giant GFT, which is also owned by HdP. Other lines, including men's ties, socks, and belts are produced under the names Miss V and Oliver.

Valentino's wide appeal is evidenced by the list of famous customers who have worn his creations, from Sophia Loren, Elizabeth Taylor, and Nancy Reagan to Nicole Kidman, Sharon Stone, and Ashley Judd, all of whom are among his devoted followers. What is it about his clothing that transcends time and the ages of his customers? Some say it is impeccable cut, others the combination of luxury and practicality; some credit his uncanny ability to make women look feminine, but never frilly—impeccably dressed, but never overdressed. Whatever his technique, he has managed to retain his spirit, enthusiasm, and success, weathering, in his own words, "every storm of fashion." *See also*: Louis Vuitton, Christian Dior; Hubert de Givenchy.

REFERENCES

Costin, Glynis. "Valentino: Coming to America." *W* (September 14, 1992): 10.
Milbank, Caroline Rennolds. *Couture: The Great Designers*. New York: Stewart, Tabori and Chang, 1985.
Pelle, Marie Paule, and Patrick Mauries. *Valentino: Thirty Years of Magic*. New York: Abbeville Press, 1991.
Peres, Daniel. "Power House: Fresh from the Sale of their Fashion Empire, Valentino and Giancarlo Giammetti Discuss How the House Will Change—and How It Won't." *W* (March 1998): 390.

S. B.

Theadora Van Runkle

B. c. 1935

Birthplace: California

Awards: Academy Award Nominations, Costume Design, *Bonnie and Clyde* (1967), *Godfather, Part II* (1974) and *Peggy Sue Got Married* (1986)

When we look back at the reemergence of certain trends in women's fashions during the twentieth century, it becomes clear that the Depression era look of the 1930s had a tremendous influence on the styles of the 1960s and 1970s. American filmmakers played a major role in fostering this trend, bringing the 1930s to the moviegoing masses in such films as *They Shoot Horses Don't They?* (1969), *The Damned* (1969), and *The Prime of Miss Jean Brodie* (1969). Probably the biggest impact on the fashions of the

1960s and 1970s came from the mind of one daring costume creator, Theadora Van Runkle, who dressed actress Faye Dunaway in what ultimately became known as "the poor look." Her costumes shocked and delighted young shoppers who wanted to look like the Hollywood version of outlaw Bonnie Parker, as she was portrayed in the groundbreaking movie *Bonnie and Clyde*.

Van Runkle, said to have rejected kindly the suggestion of Edith Head, who told her to dress Dunaway in chiffon, is generally credited with tapping into the collective pulse of 1967, dressing the Bonnie Parker character in soft sweaters, long cardigans, and midi-skirts, which skimmed the calf, when the popularity of miniskirts was at its peak. When Dunaway's Bonnie donned a beret, posing in one scene with a cigar in her mouth, beret sales doubled. And, the character's braless chest, evident in her silky blouses and fitted tops, mainstreamed a look that lasted over a decade. Van Runkle is said by many to have changed the course of 1970s fashions with her resurrection of the 1930s, making make-do clothing attractive and desirable. Her costumes sent young women into attics and thrift stores, looking for items that would help them achieve the look of Depression chic, and designers promptly brought skirt lengths down.

Also a talented painter and artist, Van Runkle is able to create costumes which not only embody the characters' personalities but also enhance the actors' portrayals of their characters. Her costumes are not simply representations of a certain time period, but character studies as well. She is known for the extensive research she conducts prior to every film.

She came into the industry at a time when studios were cutting budgets left and right, but the impact of films was stronger than ever. Clearly she was able to meet the challenge by creating outstanding costumes while keeping costs down. Van Runkle is also known for her distinguished work on the original version of *The Thomas Crown Affair* (1968), *Bullitt* (1968), *Gore Vidal's Myra Breckinridge* (1970), *Mame* (1974), and many others.

REFERENCES

Kirgo, Julie. "AMC Looks at the Academy Awards." *Exclusive Interviews: Theadora Van Runkle*. Available from http://www.amctv.com/oscars//exclusive interview.html. Accessed October 10, 2000.

Maider, Edward. *Hollywood and History*. New York: Thames and Hudson, 1987.

S. B.

Gloria Vanderbilt

B. 1924

Birthplace: New York City, New York

Awards: Neiman Marcus Fashion Award, 1969
 Fashion Hall of Fame, Elected 1969
 Woman of Achievement Award, Anti-Defamation League, 1981
 Citation of Merit, National Arts Club, 1982

She has been in the public eye all of her life. Descended from American "royalty," including the Vanderbilt, Whitney, Morgan, and Payne families, Gloria Laura Vanderbilt was thrust into the center of a vicious custody battle at the age of ten, between her aunt, Gertrude Vanderbilt Whitney, sister of her deceased father, and her mother, Gloria Morgan Vanderbilt. Despite her difficult and very public upbringing, Vanderbilt put her skill at painting, writing, and business to excellent use. She has authored three critically acclaimed books and has contributed to several magazines; her artwork has been exhibited at many galleries and museums; and Hallmark has used her pastels and collages in a line of paper products, Gloria Vanderbilt Collections.

Vanderbilt's triumphs and tribulations were tracked with great interest. She married several famous and successful men, dominated New York's Best Dressed List during the 1960s, worked diligently for major charities, and raised two sons. However, she will probably be best remembered, not for the fortune she inherited at age twenty-one, but for the second fortune she made through her extraordinary licensing agreement with a company known as Murjani International. By giving permission to Murjani in 1978 to use her name on their jeans, she became the first "designer" name to appear on the derrieres of American women, launching the designer-jeans phenomenon.

By the 1980s Gloria Vanderbilt's jeans were the best-selling jeans in America, with Vanderbilt herself appearing in commercials and at in-store events all over the country. Her licensing agreements quickly expanded to include luggage, jewelry, handbags, home furnishings, and fragrances including Vanderbilt, with its signature swan logo, introduced in 1981, and Glorious, launched in 1987. She even licensed her name to a low-calorie dessert.

The Gloria Vanderbilt brand name endured through the rest of the century. Gitano acquired the apparel line in 1990 and sold it to an investment group in 1993, which continued distribution through J.C. Penney and Kohl's in the United States, and Zeller's, owned by the Hudson Bay Company, with approximately 340 stores in Canada. In 2000, Vanderbilt introduced a new junior line called Glo, by Gloria Vanderbilt Apparel.

REFERENCES

"Northwood University Distinguished Women: Gloria Vanderbilt." Available from http://www.northwood.edu/dw/1985/vanderbilt.html. Accessed October 3, 2000.
Vanderbilt, Gloria. *Woman to Woman*. New York: Doubleday, 1979.

S. B.

e>e<d

Gianni Versace

B. December 2, 1946

D. July 25, 1997

Birthplace: Calabria, Italy

Awards: Occhio d' Oro Award, Milan, 1982, 1984, 1990, 1991
 Cutty Sark Award, 1983, 1988
 Council of Fashion Designer of America International Award, 1993

Gianni Versace did not receive a formal education in fashion design. He did, however, study architecture in Calabria from 1964 to 1967. Versace's preparation for fashion design came informally, through his mother. As a child, Versace spent time in his mother's dress shop where he was exposed to fabrics and embellishments and often assisted in the research and selection of beads, crystals, stones, and braids to trim his mother's creations. Versace also observed his mother engaged in the creative process, watching her make design decisions through fittings. Versace continued working in his mother's studio, from 1968 to 1972, as a designer and buyer.

By 1970 Versace was experimenting with his own designs. He began by combining colors and fabrics in contradiction to traditional fashion design aesthetics. He designs combined silk and fur and cotton all into one garment, a practice that later became part of the signature Versace look. In 1972 Versace moved to Milan to pursue a career as a fashion designer. His work brought him to the attention of three design houses: Callaghan, Complice, and Genny. Versace was hired to design a leather collection for Complice, under the label Complice by Versace, and a dress collection for Genny, under the Genny by Versace, label. These opportunities raised Versace's profile in the fashion community and allowed him to launch his first women's collection, under his own label, in 1978. The following year, Versace launched his first menswear collection. To market his lines, Versace hired American photographer Richard Avedon to shoot catalogs of his collections. The two also collaborated on several books featuring Versace's work.

The opulent 1980s were the era of Versace. Versace's sexy, body-conscious silhouettes were executed in vibrant colors and patterns with rich surface embellishment. His often risqué garments were characterized by asymmetrical details which seductively revealed the body and created focal points through combinations of embroidery, pearls, beads, and crystals. The inspiration for Versace's textile designs and surface embellishments came from classic Greek and roman motifs and Art Deco. His love of theater and costuming can also be seen in his designs.

Versace was known for dressing film and music celebrities. His designs exuded a "rock 'n' roll" attitude. Leather, animal prints, denim, metal mesh, and stretch knits became staples of his flashy designs. While some considered the designs crass, or just plain trashy, other extolled Versace for his flamboyant use of color, texture, and pattern. Celebrities such as Madonna, Michael Jackson, Grace Jones, Sting, George Michael, and Eric Clapton flocked to Versace for ensembles that matched the images they wished to project. He also designed costumes for his friend, and favorite performer, Elton John, for his world tour in 1992.

Versace's tremendous popularity allowed him to expand rapidly into other product lines. He launched his first women's fragrance in 1981, Donna, followed by his first men's fragrance, Versace l'Homme, in 1984. The fragrances Versace Redux, Blonde, Baby Rose Jeans, Baby Blue Jeans, The Dreamer, Green Jeans, Yellow Jeans, Black Jeans, White Jeans, and V/S were also added to the line. Versace developed several licensing agreements for products that would complement his customers' lifestyles, including sunglasses by Color Optics, neckwear by Ermenegildo Zegna, and watches by Franck Muller. He also licensed a home accessory collection, a rug collection, and a line of porcelain dishes designed to replicate the colors and patterns in Versace's apparel. Versace also designed costumes for several theater productions including Richard Strauss's ballet *Josephlegende* in 1982, Gustav Mahler's ballet *Lieb und Leid* in 1982, and Donizetti's ballet *Dionysus* in 1984. He continued as the head designer at the House of Genny until 1994.

In 1997 Gianni Versace was tragically killed by a gunman in front of his Miami home. The nation was shocked at the loss of such a gifted designer. Two years prior to this tragic incident Versace had been diagnosed with cancer. To prepare for the inevitable difficulties that lay ahead, Versace persuaded his sister Donatella to take a stronger role in the company. As image consultant she was responsible for the extravagant runway productions, fashion show parties, and advertising campaigns. Donatella also designed the junior Versus label. Versace's brother-in-law, Paul Beck, managed the marketing for the menswear collections and organized the photography for the advertising campaigns. After Versace's death, Donatella became the head designer for Versace. Although she lacked the technical training of a designer, she executes the collection by staying true to Versace's philosophy, "Don't be afraid of breaking the rules." Fashion designers from around the world and close friends gathered at the Metropolitan Museum of Art in New York City on September 8, 1997, for a memorial service for Gianni Versace. A few months later, Versace's life and work commemorated in an exhibition at the Costume Institute at the Metropolitan Museum of art. The exhibition provided to reflect on Versace's life, work, and contributions to the fashion world.

Website: http://gianniversace.com

REFERENCES

Costin, Glynis. "Gianni Versace." *WWD Profile* (September 1999): 36.
Foley, Bridget. "Donatella's First Collection." *Women's Wear Daily* 174 (October 1, 1997): 1.
Milbank, Caroline Rennolds. *New York Fashion: The Evolution of American Style*. New York: Harry N. Abrams, 1989.
Reed, Paula, Chris Endean, and Nicholas Moss. "Fashion Victim." *The European* 3 (July 17, 1997): 14.

N. S.

Victoria's Secret

See The Limited, Inc.

Madeleine Vionnet

B. June 22, 1876

D. March 2, 1975

Birthplace: Chilleurs-aux-Bois, France

Awards: *Three Women: Madeleine Vionnet, Claire McCardell and Rei Kawakubo,*
Fashion Institute of Technology, New York, 1987
Retrospective, Musée de Marseille, 1991

Madeleine Vionnet was born along the Swiss border of France. She showed a prowess for math at an early age, but she quit school at the age of twelve to apprentice with a Parisian seamstress. At seventeen she moved to Paris and worked as an assistant at the House of Vincent. In 1895 she moved to London and assisted Kate Reilly, a house which purchased and copied French designs. In 1901 she returned to Paris and became the assistant to Mme. Marie Gerber, the oldest of the Callot Soeurs. Then she spent five years as a designer with Jacques Doucet. Her first Doucet collection consisted of lingerie dresses (*déshabillés*), uncorseted dresses which could be worn in public.

In 1912 she opened her own house. Although the house did well, she had difficulties with her financial manager and closed the house during World War I. The war years brought a much-needed break and allowed Vionnet to begin thinking about her innovations in dress design. She reopened in 1919 after the war and closed the house for a final time in 1939.

Madeleine Vionnet: The slip-like biased-draped dresses of Vionnet, which empha-
sized the human form, softly glided over the figure.

Her approach to design focused on the natural body. She wanted each garment to adapt uniquely to each wearer. Corsets and even interfacing got in the way of her emphasis on the human form, and she refused to use either of them. Compared to the rigid, corseted clothing of the 1910s, Vionnet's designs seemed like underwear worn as outerwear.

Vionnet was the master of the bias cut; her skill with bias earned her many devotees and copyists. Early in her career, beginning with some of her work at Callot Soeurs, she worked with merely hanging fabric on the bias. Later, her impressively inventive designs would be cut and sewn on the bias. Because of her knowledge of fabric, she preferred using silks, jerseys, crepe de Chine, crepe romain, and charmeuse. To accommodate her bias-cut designs, she had two-meter-wide fabrics made to her specifications. The ability of these designs to slip over the head of the wearer made them unique in an era of numerous buttons and hooks. Taking her devotion to bias cut even further, she became the first designer to place furs on the bias.

Another characteristic of Vionnet's designs was her use of geometry. Beginning after World War I, her designs used the rectangular silhouette, which was composed of a loose tube with a few darts for fitting. As her work evolved, she began to use geometric shapes for gussets and to create decorative seams. Much of this work was inspired by Cubism, an art movement popular during the 1910s and 1920s. All of Vionnet's designs were draped on a miniature model before a pattern would be made. This way she could ensure the proper drape for each of her complex designs.

Vionnet selected pale colors for most of her garments, and she chose decoration very carefully. She used beading, especially during the 1920s, and employed Marie-Louise Favot to design and oversee all of the beading. Vionnet preferred nature themes in decoration. Her favorite motif was the rose. Fringe, fur trim, handkerchief hems, woven panels, and accordion pleating were other common elements in her designs. Her frequent use of the cowl and halter necks helped popularize the two styles.

Vionnet's approach to the fashion business was as innovative as her designs. She opened a school in 1927 to teach new apprentices how to use the bias; the training program lasted three years. When she built a new building to house operations, she included a medical clinic and a gymnasium. She offered her employees free lunch, coffee breaks, paid vacations, and medical and dental care. Also, she personally arranged maternity leave for her workers.

Vionnet found herself plagued by copyists. To combat the theft of her designs, she housed a dying facility on premises to change colors just prior to an opening. Also, she was known to develop new designs just prior to a show. Knock offs were described as "Vionnet-inspired" or "Vionnet-cut,"

and by the end of the 1920s they were described as being from the "Vionnet School of Design."

Twice, Vionnet tried to capitalize on America's enthusiasm for her designs. In 1924 she formed Madeleine Vionnet, Inc., to sell one-size-fits-all dresses. The venture was initially successful, but she ended it in six months. Two years later she manufactured a line of forty ready-to-wear dresses. They were available in three sizes and nine colors for the price of $150 at John Wanamaker's. Although her ready-to-wear success was short lived, Vionnet's impact on fashion has endured. Designers such as Azzedine Alaïa, Geoffrey Beene, Halston, Claire McCardell, and Issey Miyake have been influenced by Vionnet. Also, her emphasis on the natural form ushered in a new approach to women's clothing during the 1920s and 1930s. *See also*: Callot Soeurs; Azzedine Alaïa; Geoffrey Beene; Halston; Claire McCardell; Issey Miyake.

REFERENCES

Demornex, Jacqueline. *Madeleine Vionnet*. New York: Rizzoli, 1991.
Kirk, Betty. *Madeleine Vionnet*. San Francisco: Chronicle Books, 1999.
Milbank, Caroline Rennolds. *Couture: The Great Designers*. New York: Stewart, Tabori and Chang, 1985.

A.T.P.

Roger Vivier

B. November 13, 1907

D. October 2, 1998

Birthplace: Paris, France

Awards: Neiman Marcus Award, 1961
 Knighted, France, 1988
 Daniel and Fischer Award
 Riberio d'Oro

Roger Vivier enrolled at the Ecole des Beaux Arts at the age of nineteen to study sculpture. After working briefly in a shoe factory, Vivier, the "Fabergé of Footwear," launched his footwear design career in 1937 designing for Pinet and Bally in France, Delman in the United States, and Rayne and Turner in the United Kingdom. He designed a cork-soled platform shoe for Elsa Schiaparelli in 1939, and in 1940 he signed an exclusive contract with Delman. Wartime shortages made footwear production difficult. During the war, Vivier teamed with Suzanne Remy to establish Suzanne and Roger, a

millinery shop in New York, but returned to Delman to design exclusively for them from 1945 to 1947.

In 1948 Vivier returned to Paris to pursue freelance work until signing a contract with Christian Dior in 1953, establishing the Delman-Christian Dior label. Vivier designed the footwear counterpart to Dior's New Look, creating new heel and toe shapes which proclaimed femininity with the same voice of Dior's hourglass silhouette. The 8-cm (3 inches) stiletto high heel created by Vivier in 1954 for Dior was the first of its type. It sent a clear signal that women were out of the factory and back in the home. Vivier's contribution to fashion trends were so significant that in 1955 Dior consented to change his footwear label to read Christian Dior crée par Roger Vivier, the first time a couturier ever shared label credit with a footwear designer. Vivier's partnership with Dior lasted until Dior's death in 1963.

Vivier opened his own design studio in Paris in 1963 and created his own signature line. Combining historic fashion and modern engineering, Vivier pioneered new footwear silhouettes including the "comma," a heel with reversed comma point aimed at the arch (which he developed with aeronautical engineers), and the "choc or shock," with a concave heel structure. He was one of the first to experiment with vinyl, metallic leather, fake and real furs, and stretch fabrics. Vivier closed his house in the mid-1970s.

Over the course of his career, Vivier designed footwear for several of the top design houses, including Yves Saint Laurent, Emanuel Ungaro, Coco Chanel, Hermès, Nina Ricci, Jean Patou, Guy Laroche, Cristóbal Balenciaga, André Courrèges, Balmain, and Madame Grès. The elegant curves and feminine silhouettes of Vivier's designs elevated footwear design to an art form. He brought fantasy to footwear, treating each design like a sculpture. Vivier's work has been exhibited in art galleries in New York and Paris. Vivier continued to design for Delman in New York until 1994 when he signed a new five-year licensing agreement with Rautureau Apple Shoes in France. Vivier died in 1998 at the age of ninety designing until the very end. *See also*: Christian Dior; Yves Saint Laurent; Cristóbal Balenciaga; Jean Patou; André Courrèges, Nina Ricci; Gabrielle Bonheur "Coco" Chanel; Emanuel Ungaro; Hermès; Madame Grès.

REFERENCES

Baber, Bonnie, et al. "The Design Masters." *Footwear News* 51 (April 17, 1995): 28–33.

Infantino, Vivian. "Roger Vivier, 1907–1998." *Footwear News* (October 26, 1998): 19.

Weisman, Katherine. "Roger Vivier, 90, Mourned by Shoe World." *Footwear News* (October 12, 1998): 2.

A. K.

Diane von Furstenberg

B. 1946

Birthplace: Brussels, Belgium

Awards: Fragrance Foundation Award, 1977
City of Hope Spirit of Life Award, 1983
Savvy Magazine Award, 1984, 1985, 1986, 1987, 1988
Mayor's Liberty Medal, 1986

Diane von Furstenberg's wrap dress, the most recognizable fashion phenomenon of the 1970s, if not the century, hangs today in the Smithsonian Institution. As a result of its astonishing success—she sold five million dresses in five years—the Jewish girl who married a German prince at age twenty-two became not only one of the most photographed, talked about, and envied "beautiful people" of her era, but also head of her own company and the hottest designer in the world.

In Diane von Furstenberg's 1998 autobiography, she writes about the famous dress with both modesty and pride. "The dress was nothing, really—just a few yards of fabric with two sleeves and a wide wrap sash. But the v-neck wrap design fit a woman's body like no other dress. . . . Dressed up . . . [it] was ready to wear to a serious lunch or dinner; dressed down . . . it was comfortable to wear in an office. But mostly, the wrap was sexy in the way many women wanted to feel: chic, practical and seductive" (von Furstenberg, p. 80).

Raised in Brussels, educated in Switzerland, England, and Spain, von Furstenberg had traveled extensively by the time she was eighteen, vacationing in Gstaad at nineteen and working for an agent in Paris who represented famous fashion photographers when she was twenty. Her group included David Bailey, the hot fashion photographer married to Catherine Deneuve; Marisa Berenson, granddaughter of Elsa Schiaparelli; and J. Paul Getty, Jr. She moved to New York when she married Prince Egon Von Furstenberg, where she became friendly with artist Andy Warhol, jewelry designers Elsa Peretti and Kenneth J. Lane, Bianca Jagger, and *Vogue* editor Diana Vreeland, one of the first to recognize that the princess was on to something. And what was that something? A simple, sexy, practical little dress that was a washable blend of cotton and rayon, which made it both wrinkle-free and carefree. Much social significance has been attached to the wrap dress over the years. It has been described as the dress for the liberated woman, both sexually and socially, and as the bridge between expensive designer clothing and hippie chic. Whatever it symbolized, it definitely showed that women were ready for a change.

Diane von Furstenberg: von Furstenberg's wrap dress was chic, sexy, and comfortable for work and play.

The Diane von Furstenberg name quickly became attractive to licensees who convinced her to let them use it on luggage, scarves, furs, sleepwear, and eyewear. Sears hired her to design a line of linens exclusively for them. Soon she developed a fragrance with the leading perfume house, Roure Du Pont, launching Tatiana, named for her daughter, in 1975. In addition, she created a highly successful cosmetics line, the Color Authority, soon after realizing that her dresses had saturated the marketplace and were no longer in such great demand.

In 1992 Diane von Furstenberg, who had sold her cosmetics company to Beecham Cosmetics in 1983 and spent the intervening years living a rich and cultured life in Paris, reconnected once more to the world of American design when she entered the QVC studio in West Chester, Pennsylvania. Silk Assets was the name of the silk separates line she created for the teleshopping network, taking in $1.3 million in its two-hour debut. Her most recent design coup came in 1997 when she and her daughter-in-law updated the wrap dress, and Saks Fifth Avenue enthusiastically purchased the line. Once again, the princess proved her uncanny sense of what is right for the moment.

REFERENCES

von Furstenberg, Diane. *Book of Beauty*. New York: Simon and Schuster, 1976.
———. *Diane: A Signature Life*. New York: Simon and Schuster, 1998.

S. B.

Louis Vuitton

B. 1811
D. 1892
Birthplace: France

Louis Vuitton became an apprentice *layetier* (luggage packer), when he arrived in Paris in 1837. He became so proficient in his work that he became *layetier* to Empress Eugénie of France. In 1854 he founded a company to sell his well-designed luggage. Rounded top trunks were the norm during this period, but Vuitton sold flat-top trunks, which were easier to stack. To make his trunks distinctive, he covered them in a canvas called Trianon Grey.

Vuitton's high-quality trunks were immediately successful, and they spawned many imitators. In an effort to thwart imitations, he changed the canvas design several times. In 1876 he adopted a beige and brown striped pattern, in 1888 he changed to the words "Marque deposée Louis Vuitton"

woven into a checkerboard patterned canvas, and in 1896 his son patented the current design of the initials "LV" among stars and flowers. Knockoffs continue to be a problem for the company, and it combats the problem with a team of investigators and lawyers, who identify and prosecute offenders around the world.

Today, Louis Vuitton luggage is handmade using the same painstaking methods as it did in the nineteenth century. Tiny nails secure the leather and canvas of suitcases, and the poplar wood of the trunk frames is dried for four years. Fine leathers, like crocodile, ostrich, and lizard cover the luggage.

While maintaining its tradition of high quality, Louis Vuitton has updated its designs to reflect today's luggage needs. It offers items like backpacks for everyday use. In 1996 it introduced special designs like totes and shoulder bags by Helmut Lang, Manolo Blahnik, and Romeo Gigli to celebrate the 100th anniversary of its trademark fabric.

In 1997 Louis Vuitton branched out and introduced men's and women's ready-to-wear clothing. Marc Jacobs was hired as artistic director in March 1997, and Jacobs has created youthful, yet conservative designs which appeal to a broad market. Although the clothes are understated, they have playful touches, and some items, like the motorcycle helmet embellished with the LV logo, are downright whimsical.

In the 1980s the company evolved into a luxury goods conglomerate. Henry Racamier, who had been chairman of the company since 1977, took the company public in 1986. Louis Vuitton merged with Moët-Hennessey (LVMH) in 1987, and Bernard Arnault bought up enough LVMH shares to gain leadership of the company. Throughout the 1980s and 1990s, the company purchased other luxury goods companies to become the largest luxury goods company in the world.

Today the company sells five main types of goods: champagne and fine wine, including Moët & Chandon and Veuve Cliquot; cognac and spirits, including Hennessey and Hines and Pelisson; perfumes and beauty products, Dior, Guerlain, and Givenchy; luggage and leather goods, Louis Vuitton; and other activities, such as designer clothes (including Givenchy, Kenzo, and Christian Lacroix couture) horticultural products, and the publication of economic newspapers. Luggage and leather goods made up 26 percent of the company's 1998 sales, and other activities including designer clothes made up another 26 percent. The company operates more than 150 Louis Vuitton stores, two Paris department stores, thirty-two Guerlain shops, 180 duty free shops (DFS), and more than fifty Sephora stores.

In 2000 LVMH continued to build sales in U.S. markets, and it continued to expand by acquiring Emilio Pucci. While Louis Vuitton set the standard for finely produced luggage, LVMH has set the standard for fashion and luxury as big business. Just as Vuitton had to protect himself from copyists, LVMH must protect itself from the new luxury goods competitors that are

following its model for success. *See also*: Marc Jacobs; Manolo Blahnik; Christian Dior; Hubert de Givenchy; Christian Lacroix; Emilio Pucci.

Website: http://www.vuitton.com

REFERENCES

Martin, Richard, ed. *Contemporary Fashion*. New York: St. James Press, 1995.

Wallace, Charles. "Vuitton's Hot Market: The U.S." *Fortune* 137 (May 11, 1998): 37.

"Vuitton's 100-Year Dash." *Women's Wear Daily* 171 (January 22, 1996): 8.

A.T.P.

W

Vera Wang

B. June 27, 1949
Birthplace: New York City, New York

As a child, Vera Wang was interested in ice skating and art and she wanted to attend an art school, but her father wanted her to choose a more lucrative career. Following her father's advice, Wang attended Sarah Lawrence College, where she received her bachelor of arts in liberal arts. After college, Wang worked as an editor for *Vogue* magazine for seventeen years, and then as a design director for Ralph Lauren for two years.

Wang's first exposure to the bridal and evening-wear market came during her search for a bridal gown for her own wedding. Frustrated with the selection of gowns targeted toward maidenly brides, she gave up her search and commissioned a dressmaker. Realizing there was a target market that was not being reached, six months later she established Vera Wang Bridal House, Ltd., a retail house for bridal gowns. Wang was fortunate to obtain money to finance her business from her family. She located her retail business at the Carlyle Hotel temporarily until her Madison Avenue boutique was finished. In 1990 Wang opened her doors for business featuring contemporary bridal labels, including her own line, ranging in price at that time from $1,200 to $4,000, as well as custom-order evening gowns averaging $10,000 and up.

Wang's use of "illusion" in costumes inspired her to incorporate similar features in her bridal gowns. Her simple silhouettes feature complex constructions. The dresses are pieces of architecture, structured like buildings,

Vera Wang: The understated designs of Vera Wang have redefined contemporary bridal gowns. The elegant gowns feature luxurious fabrics, simple silhouettes, and clean style lines instead of embellished surfaces.

appearing very sleek with clean lines, deceiving the viewer of the complexity beneath. The sophisticated and simple silhouettes Wang developed revolutionized the bridal industry.

In 1992 and 1993 Wang ventured into the lower price point market by offering ready-to-wear bridal gowns and evening wear. She also ventured into costume design in 1994 when she designed Nancy Kerrigan's outfit for the Winter Olympics. Wang's love and talent for ice skating inspired her to make an artistic contribution to the sport.

Wang continued to expand her business in 1995 by adding bridesmaid dresses in crepe-back satin and matte jersey in simple silhouettes and contemporary colors. The line was the antithesis of typical bridesmaid dresses, which are impractical and cannot be worn again. In 1997 Wang joined shoe manufacturer Rossimoda, an Italian manufacturer, to develop a shoe line. Wang considers her shoes "cosmetic footwear," believing that her shoes should complement her dresses, continuing the same simple silhouette.

In addition to her creative use of fabric, color, and silhouette, Wang contributes her success to her customer service strategies. After a dress is delivered to the client, a stylist is assigned to advise the future bride on any accessories to complement the gown. The consultant may even be asked to advise on other aspects of the wedding such as flowers or the ceremony. Wang's creations can be seen at I. Magnin, Marshall Field's, Woodward and Lothrop, and her Madison Avenue shop.

Website: http://www.verawang.com

REFERENCES

Burns, Veronica, and Elizabeth M. Sporkin. "A Designing Women." *People Weekly* 35 (July 8, 1991): 65.

Lorusso, Maryann. "Retracing Her Steps." *Footwear News* (November 30, 1998): 4S, 1.

Milbank, Caroline Rennolds. *New York Fashion: The Evolution of American Style.* New York: Harry N. Abrams, 1989.

Sample, Ann. "Designer to the Stars—Vera Wang." Available from Women to Watch, http://www.womenswire.com

N. S.

(Aaron) Montgomery Ward

B. February 17, 1844

D. December 8, 1913

Birthplace: Chatham, New Jersey

Montgomery Ward created the first modern mail-order company in 1872 when he sent out a single-page price list to the members of the Patrons of Husbandry, an association of farmers commonly known as the Grange. Ward used his experience as a salesman in Chicago and Saint Louis during the 1860s to learn what consumers wanted: quality goods at affordable prices. By marketing his goods through a catalog, Ward disseminated the fashionable garments of the upper classes to lower-class and rural Americans.

During the last half of the nineteenth century, farmers made their purchases at the general store. Shipping expenses and middlemen raised the prices of the goods, and store owners often raised prices further because there was nowhere else for customers to shop. Ward realized that, by eliminating the middleman and purchasing in volume, he could sell goods directly to consumers at greatly reduced prices.

Before he could pursue his idea, he had to overcome two obstacles: lack of capital and the distrust of consumers. With the help of partners, Ward pooled $1,600 and published his first price list in 1872. To earn the trust of consumers, Ward enlisted the help of the Grange. Ward's became the official supplier for the farmers' fraternal organization. He printed signed testimonials from secretaries of Granges in the catalogues. To help foster the confidence needed to entice farmers to buy goods without seeing them, Ward offered a no-risk satisfaction guarantee. He continued to build relationships with customers by giving his personal attention to the correspondence he received from them.

Ward's efforts to earn the trust of consumers paid off, and the company grew at a rapid pace. By 1884 the catalog consisted of 240 pages complete with illustrations. Families referred to it as the "wish book" and used it to purchase necessities as well as luxuries.

Few changes occurred in the company over the next decades. In 1926 Ward's opened its first freestanding retail store in Plymouth, Indiana. With success in Plymouth, the company launched more stores and in 1961 adopted a revolving credit plan. In 1968 it formed Marcor after merging with Container Corporation of America, and Mobil Oil Corporation acquired the new company in 1976.

1985 was a year of change for Ward's. The company adopted a new marketing strategy in which it tried to transform its reputation as a mass merchandiser into a group of specialty stores including Electric Avenue, the Apparel Store, and Home Ideas. In an effort to concentrate on the new retail strategy, Ward's discontinued its catalog. Senior management, encouraged by the success of the specialty store strategy, bought out the company for $3.8 billion in 1988.

The 1990s held more changes for Ward's. In 1997 the company filed for bankruptcy shortly after it revised it marketing strategy to "brand" Ward's as an entire shopping experience. After the bankruptcy filing, the company

restructured its operations, and by the end of 1999 it opened forty-three new prototype stores in thirteen states. Although the company seemed to be regaining its footing in retail, it closed all of its stores in 2000.

Montgomery Ward's innovations in direct-mail retail have been copied by thousands of other merchants. Almost every imaginable form of merchandise is sold through direct mail, and the no-risk satisfaction guarantee has been adopted by traditional and nonstore retailers alike.

Website: http://www.wards.com

REFERENCES

Asher, Louis E. *Send No Money*. Chicago: Argus, 1942.

Baeb, Eddie. "Ward's Crunch Time." *Crain's Chicago Business* 23 (October 23, 2000): 57.

Berss, Marcia. "Montgomery Ward: Help Wanted, Retailing Expansion." *Forbes* 157 (May 6, 1996): 97.

A.T.P.

Vivienne Westwood

B. April 8, 1941

Birthplace: Glossop, Derbyshire, England

Awards: British Designer of the Year, 1990, 1991
 Fashion Group International Award, 1996
 Order of the British Empire, 1992
 Queen's Export Award, 1998

Born Vivienne Isabel Swire, Westwood came of age in London during the birth of the punk rock movement. Westwood, who was a schoolteacher in the 1960s, never had any intention of working in fashion. However, this self-taught fashion designer came to define the look of two major youth movements: punk rock in the 1970s and the New Romantics in the 1980s.

When Westwood meet Malcolm McLaren, the manager of the seminal British punk band the Sex Pistols, the two formed a collaboration which continued until 1984. Together, Westwood and McLaren opened a clothing store in 1971 on King's Road and became the parents of the punk movement. The store, alternately known as Let it Rock (1971), Too Fast to Live, Too Young to Die (1972), Sex (1974), Seditionaries (1977), and World's End (1980), became an outlet for fashions which reflected the basic tenets of the punk rock movement: sex and violence. Westwood's leather bondage garments, t-shirts with situational slogans and pornographic images, and ripped and safety-pinned clothing captured the antiestablishment, antifash-

Vivienne Westwood: Westwood is noted for her outrageous collections which regularly feature underwear as outerwear. Her bustiers and "mini-crini" skirts embrace the provocative, naughty side of fashion.

ion attitude of the rebellious youth movement. Then, the unthinkable happened; the Sex Pistols folded and the punk movement faded. Westwood, who had never thought of herself a designer, was contemplating her next pursuit, when she realized the fashions she had created were influencing the Paris runways.

Westwood decided seriously to pursue a career in fashion design. In 1981 she held her first runway show in London. Her "Pirate" collection launched a new fashion trend and drew Westwood international attention. Two years later, in 1983, she debuted her collection on the Paris runways, the first British designer since Mary Quant to show in Paris. Over the course of the next two decades, Westwood continued to present outrageous, provocative, and sexually charged collections which usually drew praise, but were always noticed. Her collections have featured underwear as outerwear, bustiers, corsets, "mini-crini" short hooped skirts, mink G-strings, satin codpieces, bustles, and leather bondage ensembles.

Westwood designs and presents one collection divided into two parts: the Red Label is the inexpensive core of the collection; the Gold Label provides a small selection of high-fashion pieces. Her collections have always integrated menswear, but in 1990 Westwood presented her first full menswear collection. In 1997 Westwood added the Anglomania line for men and women, under license to GTR, to target a younger customer. She also launched a handbag collection in 1992, a footwear line licensed to Guido Pasquali in 1994, and a fragrance, Boudoir, in 1998.

When Westwood first entered the fashion arena, it was to shock society. Her first line was made from rubber negligees she ordered out of a pornographic catalogue. Since then, Westwood has become a master tailor. She has even received awards for her use of the classic British fabric: wool. Westwood continues to grow and mature as a designer, developing a more sophisticated style with every collection, while still retaining a touch of youthful rebellion. *See also*: Mary Quant.

Website: http://www.viviennewestwood.co.uk

REFERENCES

Lohrer, Robert. "Birds of Paradise." *Daily News Record* 28 (January 16, 1998): 12.

Ozzard, Janet. "Forever Viv." *Women's Wear Daily* 168 (September 13, 1994): 20.

Spindler, Amy. "Viva Vivienne." *Women's Wear Daily* 164 (November 18, 1992): 4–6.

A. K.

Whiting and Davis

Edward Davis, a partner in Wade and Davis, a sterling-silver jewelry manufacturing firm formed in 1876, and Charles Whiting, the firm's errand boy, who ascended the corporate ladder over a ten-year period, became partners and renamed their company Whiting and Davis. By 1907 the company that was founded in Plainville, Massachuetts, was solely owned by Charles Whiting.

The first mesh handbag, the handbag treatment for which Whiting and Davis is known, was produced by Charles Whiting in 1892, and from its inception through 1912, the partners made each one of their small gold and silver purses by hand, individually linking the metal rings to create a woven mesh fabric. They were aided by many New Englanders who were hired to solder these metal rings together, a very slow and laborious process. With the help of A.C. Pratt, who invented the world's first automatic mesh machine in 1909, Whiting and Davis became the exclusive makers of machine-made mesh bags.

Over the years, the Whiting and Davis mesh bag evolved with the times, taking cues from such renowned designers as Paul Poiret, who inspired the pouch bag of 1929 made in beautifully colored mesh. More recently the company has supplied mesh fabric for use in film, including the garments worn in the 1996 version of Shakespeare's *Romeo and Juliet* with Leonardo diCaprio. The company has also made its mark in other areas of fashion as well. In 1990 designer Anthony Ferrara designed a $532,000 18-karat gold mesh dress and a $100,000 sterling-silver dress for Absolut Vodka's 1990 advertising campaign. In 1996 both Richard Tyler and Michael Kors used Whiting and Davis mesh fabric in their collections.

Today, Whiting and Davis is owned by WDC Holdings, Inc., and it is still producing metal mesh in Massachusetts as it has for well over a century. *See also*: Paul Poiret; Michael Kors.

REFERENCES

Rezazadeh, Fred. *Costume Jewelry: A Handbook and Value Guide*. Paducah Ky.: Collector Books, 1998.
The Whiting & Davis Metallic Mesh Story. Attleboro Falls, Mass.: WDC Holdings, 1999.

S. B.

WilliWear, Ltd.

See Willi Smith.

Charles Frederick Worth

B. 1825

D. 1895

Birthplace: England

The French Revolution had finally ended, and adoring subjects of the beautiful Empress Eugénie flocked to the Tuileries Palace in Paris, dressed in their glittering best. A fashion renaissance was under way in France, and lavish gowns were de rigeur. The moment was right for a young Englishman, who spoke not a word of French, to become the originator of French couture.

In 1845, at the age of twenty, with only 117 francs, Charles Frederick Worth arrived in Paris to work in the fabric trade, after apprenticing from the age of twelve at London's famous store Swan and Edgar, where he had had the opportunity to learn all about fabrics and trimmings while observing the tastes of the privileged. Upon his arrival in the French capital, he secured a job at one of its most fashionable shops, Gagelin and Opigez, where he met and then married a sales assistant, Marie Vernet. Worth made his young wife several dresses, which were much admired by both her colleagues and her customers; in effect, she became couture's first mannequin. Worth was permitted to set up a small dressmaking department in Gagelin and eventually was made a partner in the firm when, in 1851, at London's Great Exhibition, Gagelin won the only gold medal awarded to France for its elegant dresses.

By 1858 Worth, then the father of two sons, left Gagelin to open his own salon on the Rue de la Paix, a fortunate choice of location as a new opera house was soon to open in the area, making it a center of activity. By this time, Worth was well known for his crinoline, a style he is said to have originated, although a version of it had been popular in the 1500s and again in the 1700s. Worth's cage-like hoops were covered in luxurious yards of silk, satin, lace, and detailing and were worn by the most elegant women of the era. His first royal customer, Princess Pauline de Metternich of Austria, wore a Worth crinoline to the Tuileries Palace, whereupon Empress Eugénie summoned him to court for a wardrobe consultation the very next morning. Worth's fame continued to spread, and he went on to dress a variety of women known throughout the world, from Queen Victoria and the czarina of Russia to a notorious courtesan, Cora Pearl; and the 1860s became known as "The Age of Worth."

Worth's desire for perfection and his ability to "build" garments with the precision of an engineer contributed to the beauty and desirability of his creations. He designed sleeves, for example, that were interchangeable

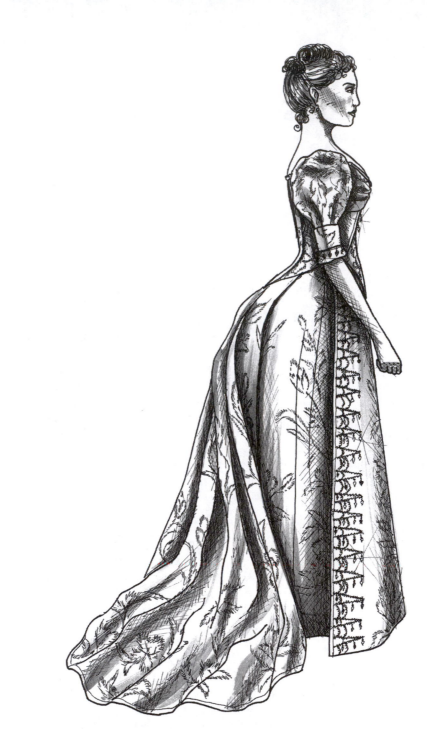

Charles Frederick Worth: The "Father of Haute Couture" launched many new fashions during his career, including the massive hoop skirt of the 1860s and the bustle of the 1870s and 1880s. The bustle silhouette involved elaborate substructures to support the volume of the draped fabric.

and could be used with several different bodices, and those bodices could be used with several different skirts. In addition, his close friendships with his customers enhanced his influence; hence, he was able to effect several dramatic changes. In 1866 he introduced the princess dress, much slimmer than the crinoline, and the *fourreau*, or sheath dress. Soon customers adjusted to a narrower look, and by 1869 the bustle became the predominant silhouette. Another of his famous inventions was the evening wrap, decorated with tassels, which stayed in fashion for more than twenty years. Worth was also a great promoter of French textiles.

In 1874 Worth's two sons, Jean-Pierre and Gaston, came to work in the company. Although the house's business declined during the Franco-Prussian War, at which time the elite clientele was forced to leave Paris, those newly in power were just as willing to spend lavishly on their wardrobes; thus, the Worths continued to prosper. By his death in 1895, Paris was once again as elegant and extravagant as the city he had known in the 1860s. Haute couture was preparing for *L'Esposition Universalle* of 1900, during which over a million visitors would come to Paris and view *les Toilettes de la Collectivitée de la Couture*, an exhibit featuring the creations not only of Worth, but also of Paquin, the Callot Soeurs, Drecoll, Rouff, and other new couturiers. Paris couture became known as the culture in which the seeds of fashion germinated.

As a result of Charles Frederick Worth's role as the originator of haute couture, La Chambre Syndicale de la Couture Parisienne was developed by his son, Gaston Worth, not only to give prestige to the industry, but also to control the fierce rivalry that existed among the couture houses. Members agreed to adhere to the policies of this professional organization, realizing the benefits of unification, and the Chambre Syndicale exists to this day as couture's governing body.

The House of Worth declined in importance during the 1920s and 1930s, although his great grandsons, Roger and Maurice, tried to continue the tradition until 1952 when the house was sold to Paquin. Parfums Worth, originally established in 1900, endures to this day; with Je Reviens is its best-known fragrance. *See also*: Paquin; Callot Soeurs.

REFERENCES

DeMarly, Diana. *History of Haute Couture*. New York: Holmes and Meier, 1980.
———. *Worth: Father of Haute Couture*. New York: Holmes and Meier, 1990.
Lynam, Ruth. *Couture*. Garden City, N.Y.: Doubleday, 1972.
Milbank, Caroline Rennolds. *Couture: The Great Designers*. New York: Stewart, Tabori and Chang, 1985.

S. B.

Y

Yohji Yamamoto

B. 1943

Birthplace: Yokohama, Japan

Awards: Fashion Editors Club Award, 1982, 1991, 1997
 Mainichi Grand Prize, 1984
 Chevalier de l'Ordre des Art et des Lettres, French Ministry of Culture,
 1994
 Fashion Group Night of Stars Honoree, 1998
 Art e Moda Award, Florence, Italy, 1998

Fashion watchers are always claiming to understand the essence of Yohji Yamamoto's designs. He has been called visionary, avant-garde, antifashion, nondirectional, and so on. Many have said he subscribes to the Japanese belief that beauty does not come naturally, but rather is expressed through the manipulation of the colors and textures of clothing. However, Yamamoto believes that glamor, sex appeal, and elegance come from the inside.

Who is this law school graduate turned fashion designer who set Paris on its ear when his new clothing aesthetic first appeared, along with those of his contemporaries, Rei Kawakubo and Issey Miyake, in the early 1980s? He is, everyone agrees, a pioneer who believes that there should be interaction between the wearer and the clothing, between old and new, between spirit and sensibility, between East and West. While taking much of his inspiration from traditional Japanese dress, which has been developed and perfected over centuries, he has admittedly been influenced by haute cou-

ture and has applied some of the concepts of Coco Chanel and Christian Dior to his work.

Yamamoto, who grew up in post–World War II Japan, has said that having been raised by his mother, a widow who worked as a dressmaker, he learned to look at the world through the eyes of women. Apparently he did not like everything he saw. His mother's customers wanted him to duplicate the latest Paris fashions, but he concentrated on creating designs of his own, mostly in black, the color his mother always wore and the one he continues to use, almost exclusively, today. In 1969 he went to Paris, having won a scholarship to study there, then back to Tokyo in 1972 where he established his own ready-to-wear company. In 1976 he showed his first collection in Tokyo and made his Paris debut in 1981, where he both delighted and dismayed the fashion world.

Yamamoto is known for the use of thick, dark fabrics which are draped, layered, and wrapped, unstructured and asymmetrical, without detail or decoration, producing a kind of alternative glamor that appeals to a diverse audience. His menswear line has also been extremely successful, and his first fragrance, Yohji, manufactured by the House of Jean Patou, was introduced in 1996. With headquarters in both Paris and Tokyo, Yohji Yamamoto's complicated, yet wearable, pieces will continue to ignite the imaginations of artists and creators of fine clothing for decades to come. *See also*: Issey Miyake; Commes de Garçons; Gabrielle Bonheur "Coco" Chanel; Christian Dior; Jean Patou.

Website: http://www.yohjiyamamoto.co.jp

REFERENCES

Buxbaum, Gerda, ed. *Icons of Fashion: The 20th Century*. Munich: Prestel-Verlag, 1999.

Lehnert, Gertrud. *A History of Fashion in the 20th Century*. Cologne: Konemann Verlagsgesellschaft mbH, 2000.

Martin, Richard, ed. *The St. James Fashion Encyclopedia: A Survey of Style from 1945 to the Present*. Detroit: Visible Ink Press, 1996.

S. B.

David Yurman

B. c. 1940

Birthplace: New York

Award: Honoree, Lab School of Washington, D.C., 1998

In the late twentieth-century fine-jewelry arena, designer David Yurman reigned supreme. Early in his career, he recognized the potential of combining the craftsmanship and beauty of fine jewelry with current fashion aesthetics to create a distinctive look, coveted by a cultlike following of American women. Yurman is best known for his cable motif, a twisted, ropelike tube of silver and/or gold, used in almost all of his pieces. His designs, which defined the look of fashionable jewelry during the 1980s and 1990s, were desired by a large group of avid collectors.

Yurman and his wife/partner, Sybil, began as artists who have collaborated since the late 1970s on their signature jewelry line. He is a sculptor and metallurgist, and she is a respected painter. (A collection of the Yurmans' artwork is on permanent display in their New York gallery, which is contained within their Madison Avenue store.) Together they paved the way for the popularization of a new category of fine jewelry—designer branded jewelry—which was virtually nonexistent prior to the introduction and active promotion of the David Yurman brand.

The design philosophy exhibited in Yurman's sterling silver and 18k-gold pieces is based on the forms and symbols of the ancient architectural pieces that inspire him. His distinctive combinations of bezel-set colored stones and his familiar cable motif, which he has managed to keep fresh with subtle design changes from season to season, have been interpreted in bracelets, earrings, rings, and neckpieces, as well as in men's accessories, from cuff links to belt buckles. Most recently, his Swiss-made timepieces, presented under the name of David Yurman's Thoroughbred Collection, have been added to his growing array of highly recognizable and desirable pieces. Yurman's jewelry is among the most imitated in the industry. It is for this reason that he was recently awarded creative ownership of his cable look. All Yurman pieces are copyrighted and hallmarked.

There is no doubt that the widespread availability of the product, coupled with strong and successful branding efforts, has greatly contributed to making the David Yurman name famous; however, the appeal of his modern classics and the company's dedication to quality should not be underestimated.

Website: http://www.davidyurman.com

REFERENCES

Curan, Catherine M. "Accessories Firms Put Accent on Uniqueness for Success." *Daily News Record* 26 (March 6, 1996): 6.

Hessen, Wendy. "The Brand Behemoth: He's Already an Industry Powerhouse, but David Yurman Is Just Getting Warmed Up." *Women's Wear Daily* (May 24, 1999): 36.

S. B.

Z

❦

Zoran (Ladicorbic Zoran)

B. 1947

Birthplace: Belgrade, Yugoslavia

His devotees, called "Zoranians," are a group of socialites, celebrities, and high-powered businesswomen who have given up their jewelry, their couture gowns, and any other superfluous ornamentation to embrace his pure and consistent aesthetic. His clothes are sans buttons, bows, beads, cuffs, collars, snaps, zippers, ruffles, prints . . . anything that might be considered unnecessary. His fabrics are limited primarily to cashmere, silk, cashmere, linen, and, of course, cashmere. He is Zoran.

From year to year, his collections vary little and are based primarily on five to seven pieces in five to seven colors. His philosophy is clear: minimal silhouettes in opulent fabrics yield the most comfort and elegance. In his ready-to-wear business, which opened in New York in 1976, he has remained true to his fashion philosophy: simplicity is everything. Zoran has never courted department store buyers or staged lavish fashion shows. He has avoided putting his name on cosmetics, sunglasses, and fragrances. Yet, women who believe that spare is more refined than splash wear it and want it, even more as the years go by.

Culture watchers believe Zoran's unadorned creations are a sign of the times. A one-time student of architecture, Zoran uses linear, clean lines which were, and still are, refined, spiritual, and simple, in keeping with the spirit of understatement that pervaded modern fashion during the final years of the last millennium.

REFERENCES

Agins, Teri. *The End of Fashion: How Marketing Changed the Clothing Business Forever.* New York: William Morrow, 1999.

Seelig, Charlotte. *Fashion: The Century of the Designer.* Cologne: Konemann Verlagsgesellschaft mbH, 1999.

S. B.

Glossary

Bridge: A price category that "bridges" the price point gap between designer collections and better fashions in men's and women's apparel.

Designer: The price category for high-fashion collections with limited production and distribution. These collections are often referred to as "signature collections."

Direct Mail: A form of retail sales where materials such as catalogues or letters are mailed directly to individual customers.

Fad: A short-lived fashion which is rapidly adopted and then quickly discarded and has little or no impact on the direction of fashion.

Fashion: The styles presented each season that are adopted and worn by the majority of a demographic group.

Haute Couture: A French term applied to the original garments, or high fashions, designed by couture houses. Haute couture fashions are distinguished by luxury fabrics, fine detailing, hand sewing, and custom fit.

Licensing: A contractual agreement between a manufacturer and designer which allows the manufacturer to apply the designer's name to the merchandise it produces and market it in exchange for a percentage of sales. The designer may or may not take an active role in the design of the products being produced.

Mass Merchandiser: Retailers who sell mass-produced fashions at moderate to low price points.

Merchandiser: An individual responsible for researching the fashion preferences of a company's target customer and directing the creative processes of the designer to ensure the designs developed are consistent with the customers' preferences.

Multichannel Distributor: A manufacturer who sells goods to wholesalers and retailers and who sells goods to the ultimate consumer through manufacturer-owned retail operations.

Prêt à Porter: A French term for ready-to-wear collections produced in France. French prêt à porter retains aspects of haute couture while integrating manufacturing techniques of mass merchandisers.

Private Label: Merchandise that is designed and manufactured by a retailer for exclusive sale through its retail operations.

Product Development: A team approach utilized by manufacturers to design product lines targeted to specific customers. The design team typically comprises a merchandiser, a designer, and a product manager.

Ready-to-Wear: Apparel manufactured in factories based on standardized measurements and size classifications.

Retailer: A business that sells goods purchased from wholesalers and manufacturers to the ultimate consumer.

Wholesaler: A distributor or vendor who purchases products from a manufacturer and sells them to retailers.

Appendix A: Designers and Retailers by Decade

Designer Name	19th Century	1900	1910	1920	1930	1940	1950	1960	1970	1980	1990	2000
Adidas				x	x	x	x	x	x	x	x	x
Adrian, Gilbert				x	x	x	x					
Alaïa, Azzedine									x	x	x	x
Amies, Hardy					x	x	x	x	x	x	x	
Anthony, John									x	x		
Armani, Giorgio									x	x	x	x
Ashley, Laura							x	x	x	x	x	x
Balenciaga, Cristóbal					x	x	x	x	x	x	x	x
Banton, Travis				x	x	x						
Barnes, Jhane									x	x	x	x
Bass, G.H.	x	x	x	x	x	x	x	x	x	x	x	x
Beene, Geoffrey							x	x	x	x	x	x
Benetton								x	x	x	x	x
Blahnik, Manolo									x	x	x	x
Blass, Bill						x	x	x	x	x	x	x
Body Glove							x	x	x	x	x	x
Boss, Hugo				x	x	x	x	x	x	x	x	x
Brioni						x	x	x	x	x	x	x
Brooks Brothers	x	x	x	x	x	x	x	x	x	x	x	x
Buchman, Dana										x	x	x

330

Designer												
Bugle Boy									X	X	X	X
Bulgari	X	X	X	X	X	X	X	X	X	X	X	X
Burberry, Thomas	X	X	X	X	X	X	X	X	X	X	X	X
Callot Soeurs	X	X	X							X	X	X
Cardin, Pierre				X		X	X		X	X	X	X
Carolee									X	X	X	X
Cartier	X	X	X	X	X	X	X	X	X	X	X	X
Cassini, Oleg			X	X	X	X	X		X	X	X	X
Castelbajac, Jean-Charles de								X	X	X	X	X
Catalina	X	X	X	X	X	X	X	X	X	X	X	X
Cerruti, Nino			X	X	X	X	X	X	X	X	X	X
Chanel, Gabrielle "Coco"		X	X	X	X	X	X	X	X	X	X	X
Chloé			X	X	X	X	X	X	X	X	X	X
Clark, Ossie						X	X	X	X			
Cole of California			X	X	X	X	X	X	X	X	X	X
Cole, Kenneth									X	X	X	X
Comme des Garçons			X					X	X	X	X	X
Converse	X	X	X	X	X	X	X	X	X	X	X	X
Costa, Victor						X	X	X	X	X	X	X
Courrèges, André	X	X	X				X	X	X	X	X	X
Daché, Lily		X	X	X	X	X	X					

Designer Name	19th Century	1900	1910	1920	1930	1940	1950	1960	1970	1980	1990	2000
de la Renta, Oscar									x	x	x	x
Delaunay, Sonia				x	x	x	x	x	x			
Delia's											x	x
Dior, Christian						x	x	x	x	x	x	x
Doc Martens						x	x	x	x	x	x	x
Eiseman, Florence						x	x	x	x	x	x	x
Ellis, Perry									x	x	x	x
Esprit									x	x	x	x
Factor, Max		x	x	x	x	x	x	x	x	x	x	x
Fashion Fair Cosmetics									x	x	x	x
Fath, Jacques					x	x	x	x	x	x	x	x
Féraud, Louis							x	x	x	x	x	x
Ferragamo, Salvatore				x	x	x	x	x	x	x	x	x
Fiorucci, Elio								x	x	x	x	x
Fogarty, Anne							x	x	x	x		
Fortuny, Mariano		x	x	x	x	x	x	x	x	x	x	
Fox, Harold C.						x	x	x	x	x	x	
Frederick's of Hollywood							x	x	x	x	x	x
FUBU											x	x
The Gap, Inc.								x	x	x	x	x
Gaultier, Jean-Paul									x	x	x	x

Gernreich, Rudi	X								X	X	X			
Givenchy, Hubert de									X	X	X	X	X	X
Gottex									X	X	X	X	X	X
Green-Field, Benjamin Benedict					X		X		X	X	X			
Grès, Madame						X	X	X	X	X	X	X	X	
Gucci					X	X	X	X	X	X	X	X	X	X
Halston									X	X	X	X	X	X
Haskell, Mariam					X	X	X	X	X	X	X	X	X	X
Head, Edith					X	X	X	X	X	X	X			
Hermès	X				X	X	X	X	X	X	X	X	X	X
Hilfiger, Tommy									X	X	X	X	X	X
Hobé et Cie	X				X	X	X	X	X	X	X	X	X	X
Jacobs, Marc									X	X	X	X	X	X
James, Charles					X	X	X	X						
Jantzen, Inc.				X	X	X	X	X	X	X	X	X	X	X
Joan and David					X	X	X	X	X	X	X	X	X	X
Jockey International	X				X	X	X	X	X	X	X	X	X	X
Joe Boxer Corporation									X	X	X	X	X	X
John P. John					X	X	X	X	X	X	X			
Johnson, Betsey									X	X	X	X	X	X
Julian, Alexander						X	X	X	X	X	X	X	X	X
Kamali, Norma						X	X	X	X	X	X	X	X	X

Designer Name	19th Century	1900	1910	1920	1930	1940	1950	1960	1970	1980	1990	2000
Kanai, Karl										x	x	x
Karan, Donna										x	x	x
Kelly, Patrick										x		
Kieselstein-Cord, Barry									x	x	x	x
Klein, Anne						x	x	x	x	x	x	x
Klein, Calvin								x	x	x	x	x
Kors, Michael										x	x	x
Lacoste, René					x	x	x	x	x	x	x	x
Lacroix, Christian										x	x	x
Lagerfeld, Karl							x	x	x	x	x	x
Lane, Kenneth Jay								x	x	x	x	x
Lanvin, Jeanne	x	x	x	x	x	x	x	x	x	x	x	x
Lauder, Estée						x	x	x	x	x	x	x
Lauren, Ralph								x	x	x	x	x
Léger, Hervé									x	x	x	x
Leiber, Judith								x	x	x	x	x
The Limited, Inc.								x	x	x	x	x
Mackie, Bob								x	x	x	x	x
Mainbocher					x	x	x	x	x			
McCardell, Claire					x	x	x					
McClintock, Jessica									x	x	x	x



Designer	1	2	3	4	5	6	7	8	9	10	11	12	13
Miller, Nicole										X	X	X	X
Miller, Nolan											X	X	X
Missoni						X		X		X	X	X	X
Miyake, Issey						X			X	X	X	X	X
Mizrahi, Isaac										X	X	X	
Molyneux, Edward				X		X	X	X		X			
Montana, Claude									X	X	X	X	X
Mori, Hanae						X		X		X	X	X	X
Mugler, Thierry								X	X	X	X	X	X
Nike						X	X	X		X	X	X	X
Norell, Norman				X		X	X	X	X	X			
Oilily								X	X	X	X	X	X
Oldham, Todd									X		X	X	X
Ozbek, Rifat									X	X	X	X	X
Paquin	X	X	X	X	X	X	X	X		X			X
Patou, Jean			X	X	X	X	X	X	X	X	X	X	X
Plunkett, Walter				X	X	X	X	X	X				
Poiret, Paul	X	X	X	X	X	X							
Prada			X	X	X	X	X	X	X	X	X	X	X
Pucci, Emilio						X		X		X	X	X	X
Quant, Mary						X	X	X		X	X	X	X
Rabanne, Paco						X	X	X	X	X	X	X	X

Designer Name	19th Century	1900	1910	1920	1930	1940	1950	1960	1970	1980	1990	2000
Revson, Charles					x	x	x	x	x	x	x	x
Rhodes, Zandra								x	x	x	x	x
Ricci, Nina					x	x	x	x	x	x	x	x
Rochas, Marcel				x	x	x	x					
Rykiel, Sonia								x	x	x	x	x
Saint Laurent, Yves							x	x	x	x	x	x
Sanchez, Fernando									x	x	x	x
Sander, Jil									x	x	x	x
Schiaparelli, Elsa				x	x	x	x	x	x			
Sears, Roebuck and Company	x	x	x	x	x	x	x	x	x	x	x	x
Skechers											x	x
Smith, Paul									x	x	x	x
Smith, Willi								x	x	x		
Strauss, Levi	x	x	x	x	x	x	x	x	x	x	x	x
Sui, Anna									x	x	x	x
Tiffany and Company	x	x	x	x	x	x	x	x	x	x	x	x
Tracy, Ellen						x	x	x	x	x	x	x
Trifari				x	x	x	x	x	x	x	x	x

336

Name												
Trigère, Pauline						x	x	x	x	x	x	
Ungaro, Emanuel						x		x	x	x	x	x
Valentino						x	x	x	x	x	x	x
Van Runkle, Theadora							x	x	x			
Vanderbilt, Gloria								x	x	x	x	x
Versace, Gianni								x	x	x	x	x
Vionnet, Madeleine	x	x	x									
Vivier, Roger				x	x	x		x	x	x	x	
von Furstenberg, Diane								x	x	x	x	x
Vuitton, Louis	x	x	x	x	x	x		x	x	x	x	x
Wang, Vera									x	x	x	x
Ward, Montgomery	x	x	x	x	x	x		x	x	x	x	x
Westwood, Vivanne								x	x	x	x	x
Whiting and Davis	x	x	x	x	x	x		x	x	x	x	x
Worth, Charles Frederick	x	x	x	x	x	x		x	x	x	x	x
Yamamoto, Yohji								x	x	x	x	x
Yurman, David								x	x	x	x	x
Zoran								x	x	x	x	x

Appendix B: Designers and Retailers by Country

ENGLAND

Amies, Hardy
Ashley, Laura
Blahnik, Manolo
Burberry, Thomas
Clark, Ossie
James, Charles
Ozbek, Rifat
Quant, Mary
Rhodes, Zandra
Smith, Paul
Westwood, Vivienne

FRANCE

Alaïa, Azzedine
Balenciaga, Cristóbal
Callot Soeurs
Cardin, Pierre
Cartier
Castelbajac, Jean-Charles de
Chanel, Gabrielle "Coco"
Chloé
Courrèges, André
Delaunay, Sonia
Dior, Christian
Fath, Jacques
Féraud, Louis
Gaultier, Jean-Paul
Givenchy, Hubert de
Grès, Madame

Hermès
Kelly, Patrick
Lacoste, René
Lacroix, Christian
Lagerfeld, Karl
Lanvin, Jeanne
Léger, Hervé
Mainbocher
Molyneux, Edward
Montana, Claude
Mugler, Thierry
Paquin
Patou, Jean
Poiret, Paul
Rochas, Marcel
Rykiel, Sonia
Saint Laurent, Yves
Schiaparelli, Elsa
Ungaro, Emanuel
Vionnet, Madeleine
Vivier, Roger
Vuitton, Louis
Worth, Charles Frederick

GERMANY

Adidas
Boss, Hugo
Doc Martens
Sander, Jil

ISRAEL

Gottex

ITALY

Armani, Giorgio
Benetton
Brioni
Bulgari
Cerruti, Nino
Fiorucci, Elio
Fortuny, Mariano
Gucci
Missoni
Prada

Pucci, Emilio
Ricci, Nina
Valentino
Versace, Gianni

JAPAN

Comme des Garçons
Miyake, Issey
Mori, Hanae
Yamamoto, Yohji

NETHERLANDS

Oilily

SPAIN

Rabanne, Paco
Sanchez, Fernando

UNITED STATES

Adrian, Gilbert
Anthony, John
Banton, Travis
Barnes, Jhane
Bass, G.H.
Beene, Geoffrey
Blass, Bill
Body Glove
Brooks Brothers
Buchman, Dana
Bugle Boy
Carolee
Cassini, Oleg
Catalina
Cole of California
Cole, Kenneth
Converse
Costa, Victor
Daché, Lily
de la Renta, Oscar
Delia's
Eiseman, Florence
Ellis, Perry

Esprit
Factor, Max
Fashion Fair Cosmetics
Fogarty, Anne
Fox, Harold C.
Frederick's of Hollywood
Ferragamo
FUBU
The Gap, Inc.
Gernreich, Rudi
Green-Field, Benjamin Benedict
Halston
Haskell, Mariam
Head, Edith
Hilfiger, Tommy
Hobé et Cie
Jacobs, Marc
James, Charles
Jantzen
Joan and David
Jockey International
Joe Boxer
John P. John
Johnson, Betsey
Julian, Alexander
Kamali, Norma
Kanai, Karl
Karan, Donna
Kieselstein-Cord, Barry
Klein, Anne
Klein, Calvin
Kors, Michael
Lane, Kenneth Jay
Lauder, Estée
Lauren, Ralph
Leiber, Judith
The Limited, Inc.
Mackie, Bob
Mainbocher
McCardell, Claire
McClintock, Jessica
Miller, Nicole
Miller, Nolan
Mizrahi, Isaac
Nike
Norell, Norman
Oldham, Todd
Plunkett, Walter

Revson, Charles
Sears, Roebuck and Company
Skechers
Smith, Willi
Strauss, Levi
Sui, Anna
Tiffany and Company
Tracy, Ellen
Trifari
Trigère, Pauline
Van Runkle, Theadora
Vanderbilt, Gloria
von Furstenberg, Diane
Wang, Vera
Ward, Montgomery
Whiting and Davis
Yurman, David
Zoran

Appendix C: Designers and Retailers by Specialty

Specialty	Name
Accessories	Cole, Kenneth
Accessories	Leiber, Judith
Accessories	Whiting and Davis
Children's	Eiseman, Florence
Children's	Oilily
Cosmetics	Factor, Max
Cosmetics	Fashion Fair Cosmetics
Cosmetics	Lauder, Estée
Cosmetics	Revson, Charles
Costume Design	Adrian, Gilbert
Costume Design	Banton, Travis
Costume Design	Head, Edith
Costume Design	Plunkett, Walter
Costume Design	Van Runkle, Theadora
Costume Jewelry	Carolee
Costume Jewelry	Haskell, Mariam
Costume Jewelry	Hobé et Cie
Costume Jewelry	Kieselstein-Cord, Barry
Costume Jewelry	Lane, Kenneth Jay
Costume Jewelry	Trifari
Costume Jewelry	Yurman, David
Fine Jewelry	Bulgari
Fine Jewelry	Cartier
Fine Jewelry	Tiffany

Footwear	Adidas
Footwear	Bass, G.H.
Footwear	Blahnik, Manolo
Footwear	Cole, Kenneth
Footwear	Converse
Footwear	Doc Martens
Footwear	Ferragamo, Salvatore
Footwear	Joan and David
Footwear	Nike
Footwear	Skechers
Footwear	Vivier, Roger
Headwear	Benjamin Benedict Green-Field
Headwear	Daché, Lily
Headwear	Halston
Headwear	James, Charles
Headwear	John P. John
Intimate Apparel	Frederick's of Hollywood
Intimate Apparel	Jockey International
Intimate Apparel	Joe Boxer
Intimate Apparel	Sanchez, Fernando
Juniors Ready-to-Wear	Delia's
Juniors Ready-to-Wear	Fogarty, Anne
Knitwear	Benetton
Knitwear	Missoni
Knitwear	Rykiel, Sonia
Leather Goods	Gucci
Leather Goods	Hermès
Leather Goods	Vuitton, Louis
Mass Merchandiser	The Gap, Inc.
Mass Merchandiser	The Limited, Inc.
Mass Merchandiser	Sears, Roebuck and Company
Mass Merchandiser	Strauss, Levi
Mass Merchandiser	Ward, Montgomery
Men's Designer Fashions	Amies, Hardy
Men's Designer Fashions	Armani, Giorgio
Men's Designer Fashions	Barnes, Jhane
Men's Designer Fashions	Boss, Hugo

Men's Designer Fashions	Brioni
Men's Designer Fashions	Cerruti, Nino
Men's Designer Fashions	Comme des Garçons
Men's Designer Fashions	Ellis, Perry
Men's Designer Fashions	Fiorucci, Elio
Men's Designer Fashions	Fox, Harold C.
Men's Designer Fashions	Lauren, Ralph
Men's Designer Fashions	Prada
Men's Designer Fashions	Sander, Jil
Men's Designer Fashions	Smith, Paul
Men's Ready-to-Wear	Bugle Boy
Men's Ready-to-Wear	Brooks Brothers
Men's Ready-to-Wear	Burberry, Thomas
Men's Ready-to-Wear	FUBU
Men's Ready-to-Wear	Hilfiger, Tommy
Men's Ready-to-Wear	Julian, Alexander
Men's Ready-to-Wear	Kanai, Karl
Men's Ready-to-Wear	Lacoste, René
Swimwear	Body Glove
Swimwear	Catalina
Swimwear	Cole of California
Swimwear	Gottex
Swimwear	Jantzen
Textiles	Ashley, Laura
Textiles	Delaunay, Sonia
Textiles	Rhodes, Zandra
Women's Couture	Alaïa, Azzedine
Women's Couture	Balenciaga, Cristóbal
Women's Couture	Callot Soeurs
Women's Couture	Castelbajac, Jean-Charles de
Women's Couture	Chanel, Gabrielle "Coco"
Women's Couture	Chloé
Women's Couture	Courrèges, André
Women's Couture	de la Renta, Oscar
Women's Couture	Dior, Christian
Women's Couture	Fath, Jacques
Women's Couture	Féraud, Louis

Women's Couture	Fortuny, Mariano
Women's Couture	Gaultier, Jean-Paul
Women's Couture	Givenchy, Hubert de
Women's Couture	Grès, Madame
Women's Couture	James, Charles
Women's Couture	Lacroix, Christian
Women's Couture	Lagerfeld, Karl
Women's Couture	Lanvin, Jeanne
Women's Couture	Léger, Hervé
Women's Couture	Mainbocher
Women's Couture	Miyake, Issey
Women's Couture	Molyneux, Edward
Women's Couture	Mori, Hanae
Women's Couture	Mugler, Thierry
Women's Couture	Paquin
Women's Couture	Patou, Jean
Women's Couture	Poiret, Paul
Women's Couture	Rabanne, Paco
Women's Couture	Ricci, Nina
Women's Couture	Rochas, Marcel
Women's Couture	Saint Laurent, Yves
Women's Couture	Schiaparelli, Elsa
Women's Couture	Ungaro, Emanuel
Women's Couture	Versace, Gianni
Women's Couture	Vionnet, Madeleine
Women's Couture	Worth, Charles Frederick
Women's Couture	Yamamoto, Yohji
Women's Designer Fashions	Amies, Hardy
Women's Designer Fashions	Anthony, John
Women's Designer Fashions	Armani, Giorgio
Women's Designer Fashions	Beene, Geoffrey
Women's Designer Fashions	Blass, Bill
Women's Designer Fashions	Buchman, Dana
Women's Designer Fashions	Cardin, Pierre
Women's Designer Fashions	Cassini, Oleg
Women's Designer Fashions	Clark, Ossie

Women's Designer Fashions	Comme des Garçons
Women's Designer Fashions	Costa, Victor
Women's Designer Fashions	Ellis, Perry
Women's Designer Fashions	Fiorucci, Elio
Women's Designer Fashions	Halston
Women's Designer Fashions	Jacobs, Marc
Women's Designer Fashions	Johnson, Betsey
Women's Designer Fashions	Kamali, Norma
Women's Designer Fashions	Karan, Donna
Women's Designer Fashions	Kelly, Patrick
Women's Designer Fashions	Klein, Calvin
Women's Designer Fashions	Kors, Michael
Women's Designer Fashions	Lauren, Ralph
Women's Designer Fashions	Mackie, Bob
Women's Designer Fashions	Miller, Nicole
Women's Designer Fashions	Miller, Nolan
Women's Designer Fashions	Mizrahi, Isaac
Women's Designer Fashions	Montana, Claude
Women's Designer Fashions	Norell, Norman
Women's Designer Fashions	Oldham, Todd
Women's Designer Fashions	Ozbek, Rifat
Women's Designer Fashions	Prada
Women's Designer Fashions	Pucci, Emilio
Women's Designer Fashions	Sander, Jil
Women's Designer Fashions	Smith, Willi
Women's Designer Fashions	Sui, Anna
Women's Designer Fashions	Tracy, Ellen
Women's Designer Fashions	Valentino
Women's Designer Fashions	von Furstenberg, Diane
Women's Designer Fashions	Westwood, Vivanne
Women's Designer Fashions	Zoran
Women's Ready-to-Wear	Esprit
Women's Ready-to-Wear	Gernreich, Rudi
Women's Ready-to-Wear	Klein, Anne
Women's Ready-to-Wear	Lacoste, René
Women's Ready-to-Wear	McCardell, Claire

Women's Ready-to-Wear	Quant, Mary
Women's Ready-to-Wear	Trigère, Pauline
Women's Ready-to-Wear	Vanderbilt, Gloria
Women's Special Occasion	McClintock, Jessica
Women's Special Occasion	Wang, Vera

Appendix D: Colleges with Fashion Design Programs

CALIFORNIA

American Intercontinental University
1651 Westwood Boulevard
Los Angeles, CA 90024
800–333–2652

The Art Institute of San Francisco
1170 Market Street
San Francisco, CA 94102
888–493–3261

FLORIDA

The Art Institute of Fort Lauderdale
1799 S.E. 17th Street
Fort Lauderdale, FL 33316
800–275–7603

Florida State University
William Johnston Building
Tallahassee, FL 32306
800–644–2525

International Academy of Design and Technology—Tampa
5225 Memorial Highway
Tampa, FL 33634
813–881–0007

GEORGIA

American Intercontinental University
3330 Pearchtree Road, N.E.
Atlanta, GA 30326
800–255–6839

Savannah College of Art and Design
342 Bull Street
Savannah, GA 31401
800–869–7223

KANSAS

Kansas State University
Justin Hall
Manhattan, KS 66506
785–532–6011

ILLINOIS

College of DuPage
425 22nd Street
Glen Ellyn, IL 60137–6599
630–942–2800

Columbia College
600 S. Michigan Avenue
Chicago, IL 60605
312–663–1600

William Rainey Harper College
1200 West Algonquin Road
Palatine, IL 60067–7398
847–925–6000

The Illinois Institute of Art—Chicago
Apparel Center
350 N. Orleans
Chicago, IL 60654
800–351–3450

International Academy of Merchandising and Design—Chicago
One North State Street, Suite 400
Chicago, IL 60602
312–980–9200

INDIANA

Ball State University
150 PA Building
Muncie, IN 47306
800–482–4278

IOWA

Iowa State University
1052 Lebaron Hall
Ames, IA 50011
515–294–4111

MICHIGAN

Eastern Michigan University
Roosevelt Hall
Ypsilanti, MI 48197
734–487–1849

Michigan State Unversity
204 Human Ecology
East Lansing, MI 48824
517–355–1855

Western Michigan University
Kohrman Hall
Kalamazoo, MI 49008
616–387–1000

MINNESOTA

University of Minnesota
McNeal Hall
1985 Buford Avenue
Saint Paul, MN 55108
612–625–5000

MISSOURI

Stephens College
P.O. Box 2042
Columbia, MO 65215
800–876–7207

University of Missouri
230 Jesse Hall
Columbia, MO 65211
573–882–7786

NEW YORK

Cornell University
Information and Referral Center
Day Hall Lobby
Ithaca, NY 14853
607–254–4636

Fashion Institute of Technology
7th Avenue at 27th Street
New York, NY 10001
212–217–7999

Marymount College
100 Marymount Avenue
Tarrytown, NY 10591
800–724–4312

Parsons
66 5th Avenue
New York, NY 10011
800–252–0852

OHIO

Kent State University
Rodgers & Silverman School
Kent, OH 44242
330–672–2444

Ohio State University
1787 Neil Avenue
Columbus, OH 43210
614–292–OHIO

OREGON

The Art Institute of Portland
2000 SW Fifth Avenue
Portland, OR 97201
888–228–6528

PENNSYLVANIA

The Art Institute of Philadelphia
1622 Chestnut Street
Philadelphia, PA 19103
800–275–2474

Drexel University
Nesbitt College
Philadelphia, PA 19104
215–895–1318

RHODE ISLAND

Rhode Island School of Design
2 College Street
Providence, RI 02903
800–364–7473

TEXAS

The Art Institute of Dallas
Two North Park East
8080 Park Lane, Suite 100
Dallas, TX 75231
800–275–4243

WASHINGTON

The Art Institute of Seattle
2323 Elliott Avenue
Seattle, WA 98121
800–275–2471

WISCONSIN

Mary Mount College
2900 Menomonee River Parkway
Milwaukee, WI 53222
800–321–6265

University of Wisconsin—Stout
124 Bowman Hall
Menomonie, WI 54751
800–44–STOUT

CANADA

International Academy of Design—Montreal
1253 McGill College, 10th Floor
Montreal, PQ, Canada
H3B 2Y5
549–875–9777

International Academy of Design—Toronto
31 Wellesley Street, East
Toronto, Ont., Canada
M4Y 1G7
416–922–3666

Appendix E: Museums with Costume Collections

Art Institute of Chicago
111 S. Michigan Avenue
Chicago, IL 60603
312–443–3600

Bata Shoe Museum
327 Bloor Street West
Toronto, ON M5S 1W7 Canada
416–979–7799

Chicago Historical Society
1601 N. Clark Street
Chicago, IL 60614
312–642–5035

Cincinnati Art Museum
Eden Park Drive
Cincinnati, OH 45202
513–721–5204

Cleveland Museum of Art
11150 East Boulevard
Cleveland, OH 44106
216–421–7340

Colonial Williamsburg Foundation
P.O. Box 1776
Williamsburg, VA 23187
757–220–7508

Detroit Historical Society
Historic Fort Wayne, Bldg B
6325 W. Jefferson
Detroit, MI 48209
313–297–8378

Detroit Institute of Art
5200 Woodward Avenue
Detroit, MI 48202
313–833–7900

Elizabeth Sage Historic Costume Collection
1430 N. Willis Drive
Bloomington, IN 47404
812–855–4627

Goldstein Gallery
University of Minnesota
240 McNeal Hall
1985 Buford Avenue
Saint Paul, MN 55108
612–624–3292

Henry Ford Museum
P.O. Box 1970
Dearborn, MI 48121
313–271–1620

Indiana State Museum
202 N. Alabama Street
Indianapolis, IN 46204
317–232–5606

Los Angeles County Museum of Art
5905 Wilshire Boulevard
Los Angeles, CA 90036
323–857–6081

Metropolitan Museum of Art
1000 Fifth Avenue
New York, NY 10028
212–570–3908

Minnesota Historical Society
345 Kellogg Blvd, W
Saint Paul, MN 55102
612–297–8094

Missouri Historical Society
Library and Collections Center
Saint Louis, MO 63112
314–746–4548

Museum at the Fashion Institute of Technology
7th Avenue at 27th Street
New York, NY 10001
212–760–7772

Royal Ontario Museum
100 Queens Park
Toronto, ON M5S 2C6 Canada
416–586–5791

Saint Louis Art Museum
#1 Fine Arts Drive, Forest Park
Saint Louis, MO 63110
314–721–0072

Smithsonian Institute
4202 AHB/MRC-610
Washington, DC 20560
202–357–3185

State Historical Society of Wisconsin
816 State Street
Madison, WI 53706
608–264–6551

Victoria and Albert Museum
Cromwell Road, South Kensington
London SW7 2RL England
071–938–8420

Western Reserve Historical Society
10825 East Boulevard
Cleveland, OH 44106
216–721–572

Appendix F: Professional Organizations

American Marketing Association: http://www.ama.org
Computer Integrated Textile Design Association: http://www.citda.org/
Costume Society of America: http://www.costumesocietyamerica.com/
Fashion Group International: http://www.fgi.org
International Textile and Apparel Association: http://www.itaasite.org/
National Retail Federation: http://www.nrf.com

Selected Bibliography

BOOKS

Accessories

Ball, Joanne Dubbs. *Costume Jewelers: The Golden Age of Design*. Atglen, PA: Schiffer, 1997.

Ginsburg, Madeleine. *The Hat: Trends and Traditions*. Hauppauge, N.Y.: Barrons Educational Series, 1990.

McDowell, Colin. *Hats: Status, Style and Glamour*. New York: Thames and Hudson, 1997.

O'Keefe, Linda, and Andreas Bleckmann (photographer). *Shoes: A Celebration of Pumps, Sandals, Slippers & More*. New York: Workman Publishing, 1996.

Prat, Lucy, Linda Wooley, and Sara Hodges. *Shoes*. London: Victoria and Albert Museum, 1999.

Probert, Christina. *Hats in Vogue Since 1910*. New York: Abbeville Press, 1982.

———. *Shoes in Vogue Since 1910*. New York: Abbeville Press, 1981.

Vanderbilt, Tom. *The Sneaker Book: Anatomy of an Industry and an Icon*. New York: New Press, 1998.

Film

Englemeier, Regine, and Peter W. Engelmeier, eds., and Barbara Einziq. *Fashion in Film*. Munich, Germany: Prestel-Verlag, 1990.

Leese, Elizabeth. *Costume Design in the Movies: An Illustrated Guide to the Work of 157 Great Designers*. Mineola, N.Y.: Dover Publications, 1991.

Maider, Edward. *Hollywood and History*. New York: Thames and Hudson, 1987.

History

Anspach, Karlyne. *The Why of Fashion*. Ames: State University Press, 1967.

Batterberry, Michael, and Adriane Batterberry. *Mirror Mirror: A Social History of Fashion*. New York: Holt, Rinehart, Winston, 1977.

Boorstin, Daniel Joseph. *The Americans: The Democratic Experience*. New York: Random House, 1985.

Breward, Christopher. *The Culture of Fashion: A New History of Fashionable Dress*. Manchester, England: Manchester University Press, 1995.

de la Haye, Amy. *The Fashion Source Book*. London: Macdonald, 1988.

Ewing, Elizabeth. *History of 20th Century Fashion*. New York: Charles Scribner's Sons, 1974.

Hollander, Anne. *Sex and Suits, the Evolution of Modern Dress*. New York: Alfred A. Knopf, 1994.

Howell, Georgina. *In Vogue: 75 Years of Style*. London: Conde Nast Books, 1991.

Kidwell, Claudia, and Valerie Steele, eds. *Men and Women: Dressing the Part*. Washington D.C.: Smithsonian Institution Press, 1989.

Lynam, Ruth, ed. *Couture*. Garden City, N.Y.: Doubleday, 1972.

Martin, Richard. *American Ingenuity: Sportswear 1930–1970*. New York: Metropolitan Museum of Art, 1994.

Martin, Richard, and Harold Koda. *Haute Couture*. New York: Harry N. Abrams, 1996.

Milbank, Caroline Rennolds. *Couture: The Great Designers*. New York: Stewart, Tabori and Chang, 1985.

———. *New York Fashion: The Evolution of American Style*. New York: Harry N. Abrams, 1989.

Mulvagh, Jane. *Vogue History of 20th Century Fashion*. New York: Viking, 1988.

Polhemus, Ted. *Streetstyle*. New York: Thames and Hudson, 1994.

Roshco, Bernard. *The Rag Race*. New York: Funk and Wagnalls Company, 1963.

Squire, Geoffery. *Dress and Society 1560–1970*. New York: Viking, 1974.

Steele, Valeria. *Fifty Years of Fashion*. New Haven, Conn.: Yale University Press, 1997.

———. *Women of Fashion: Twentieth Century Designers*. New York: Rizzoli, 1991.

Tapert, Annette, and Diana Edkins. *The Power of Style*. New York: Crown Publishers, 1994.

Watson, Linda. *Vogue: Twentieth-Century Fashion*. London: Carlton Books, 2000.

Wollen, Peter, Fiona Bradley, and Hayward Gall. *Addressing the Century: 100 Years of Art & Fashion*. Los Angeles: University of California Press, 1999.

Lingerie

Fontanel, Beatrice, and Willard Wood, trans. *Support and Seduction: A History of Corsets and Bras*. New York: Harry N. Abrams, 1997.

Newman, Karoline, Karen W. Bressler, and Gillian Proctor. *A Century of Lingerie*. New York: Book Sales, 1998.

Mass Merchandising

Agins, Teri. *The End of Fashion: How Marketing Changed the Clothing Business Forever*. New York: HarperCollins, 2000.

———. *The End of Fashion: The Mass Marketing of the Clothing Business*. New York: William Morrow, 1999.

Kidwell, Claudia, and Margaret Christman. *Suiting Everyone: The Democratization of Clothing in America*. Washington D.C.: Smithsonian Institution, 1974.

Social Psychology of Dress

Damhorst, Mary Lynn, Kimberly A. Miller, and Susan O. Michelman. *The Meaning of Dress*. New York: Fairchild, 1999.

Davis, Fred. *Fashion, Culture, and Identity*. Chicago: University of Chicago Press, 1994.

Hollander, Anne. *Seeing through Clothes*. Los Angeles: University of California Press, 1993.

Sproles, George, and Leslie Davis Burns. *Changing Appearances*. New York: Fairchild Publications, 1994.

Swimwear

Lencek, Lena, and Gideon Bosker. *Making Waves: Swimsuits and the Undressing of America*. San Francisco: Chronicle Books, 1989.

Martin, Richard, and Harold Koda. *Splash! A History of Swimwear*. New York: Rizzoli, 1990.

PERIODICALS AND TRADE JOURNALS

Cosmopolitan. Hearst Corporation.

Daily News Record (DNR). Fairchild Publications.

Earnshaw's. Fairchild Publications.

Footwear News. Fairchild Publications.

Gentlemen's Quarterly (GQ). Conde Nast Publications.

Harper's Bazaar. Hearst Corporation.

Marie Claire. Hearst Corporation.

Town and Country. Hearst Corporation.

Vanity Fair. Conde Nast Publications.

Vogue. Conde Nast Publications.

W. Fairchild Publications.

Women's Wear Daily (WWD). Fairchild Publications.

Index

Boldface page numbers indicate the location of main entries.

About the Authors

ANN T. KELLOGG is a Curriculum Specialist at the Career Education Corporation.

AMY T. PETERSON is a member of the Developmental Faculty at the American InterContinental University.

STEFANI BAY is an Instructor at the Illinois Institute of Art.

NATALIE SWINDELL is an Instructor at the Illinois Institute of Art.